Seventh Edition

A Short Course in
PHOTOGRAPHY

AN INTRODUCTION TO PHOTOGRAPHIC TECHNIQUE

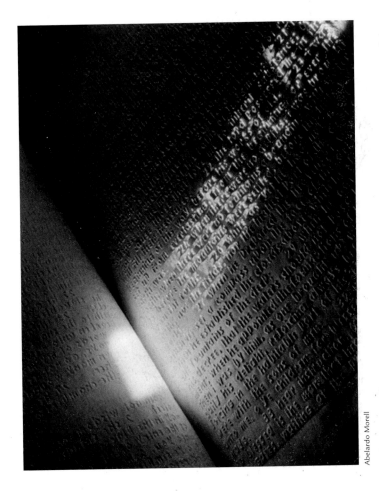

Abelardo Morell

Barbara London ■ Jim Stone

PEARSON
Prentice
Hall

Upper Saddle River, New Jersey 07458

Library of Congress Cataloging-in-Publication Data

London, Barbara
 A short course in photography : an introduction to photographic
technique / Barbara London, Jim Stone. — 7th ed.
 p. cm.
 Includes bibliographical references and index.
 ISBN-13: 978-0-13-603187-1
 ISBN-10: 0-13-603187-0
 1. Photography. I. Stone, Jim. II. Title.
TR146.L618 2008
71—dc22
 2008001021

Editor-in-Chief: *Sarah Touborg*
Senior Acquisitions Editor: *Amber Mackey*
Editorial Assistant: *Carla Worner*
Director of Marketing: *Brandy Dawson*
Executive Marketing Manager: *Marissa Feliberty*
Senior Managing Editor: *Mary Rottino*
Production Editor: *Pine Tree Composition/Jessica Balch*
Project Management Liaison: *Joe Scordato*
Senior Operations Supervisor: *Brian Mackey*
Senior Art Director: *Pat Smythe*
Art Director: *Miguel Ortiz*

Interior Designer: *Michelle Wiggins*
Cover Designer: *Wanda España/Wee Design Group*
Cover Photo: *Pete Turner/Stone/Getty Images*
Director, Image Resource Center: *Melinda Patelli*
Manager, Rights and Permissions: *Zina Arabia*
Manager, Cover Visual Research & Permissions: *Karen Sanatar*
Digital Imaging Technician: *Cory Skidds*
Composition: *Pine Tree Composition*
Full-Service Management: *Pine Tree Composition*
Printer/Binder: *The Courier Companies*
Cover Printer: *Lehigh Lithographers*

Frontispiece: Abelardo Morell. *1841 Book of Proverbs for the Blind, 1995*

Credits and acknowledgments borrowed from other sources and reproduced, with permission, in this textbook appear on
the appropriate page within text, or on page 216.

Pearson Education Ltd., London
Pearson Education Singapore, Pte. Ltd.
Pearson Education Canada, Inc.
Pearson Education—Japan
Pearson Education Australia PTY, Limited

Pearson Education North Asia, Ltd., Hong Kong
Pearson Educación de Mexico, S.A. de C.V.
Pearson Education Malaysia, Pte. Ltd.
Pearson Education Upper Saddle River, New Jersey

PRINTED IN THE UNITED STATES OF AMERICA
10 9 8 7 6 5 4 3 2 1

ISBN-13 978-0-13-603187-1
ISBN-10 0-13-603187-0

Contents

 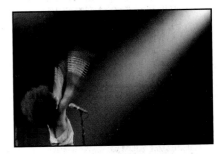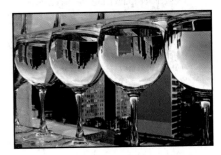

Preface

If you don't know anything about photography and would like to learn, or if you want to make better pictures than the ones you make now, *A Short Course in Photography* will help you. It presents in depth the basic techniques for all of photography, black-and-white, color, and digital:

- How to get a good exposure
- How to adjust the focus, shutter speed, and aperture (the size of the lens opening) to produce the results you want
- How to develop film and make prints in a darkroom
- How to use digital imaging on a computer

Almost all of today's cameras incorporate automatic features, but that doesn't mean that they automatically produce the results you want. *A Short Course in Photography* devotes special attention to:

- Automatic focus and automatic exposure—what they do and, particularly, how to override them when it is better to adjust the camera manually

Some of the book's highlights include:

- Getting Started. If you are brand new to photography, this section will walk you through the first steps of selecting and loading film or a memory card, focusing sharply, adjusting the exposure, and making your first pictures. See pages 4–11.
- Digital Photography. In one sense, digital imaging is just another tool, but it is also an immensely powerful technique that has changed photography and that empowers those who know how to use it. See pages 146–177.
- Projects. These projects are designed to help you develop your technical and expressive skills. See, for example, page 130 or 181.
- Making Better Prints. Includes information about how to fine tune your prints by burning in and dodging (darkening or lightening selected areas), and by cropping the edges to concentrate attention on the portion of the scene you want. See pages 118–120.
- Types of lenses, types of film, lighting, filters.

Photography is a subjective and personal undertaking. *A Short Course in Photography* emphasizes your choices in picture making:

- How to look at a scene in terms of the way the camera can record it

- How to select the shutter speed, point of view, or other elements that can make the difference between an ordinary snapshot and an exciting photograph
- Chapter 9, Seeing Like a Camera, has been expanded and explores your choices in selecting and adjusting the image, and covers how to photograph subjects such as people and landscapes

New to this edition are:

- Up-to-date Chapter 8 on Digital Photography. How to make photographs digitally from start to finish, including new workflow applications
- Many new photographs by some of the greatest artists ever to use a camera
- Technical updates throughout
- The latest information on Health and Safety precautions in the darkroom

This book is designed to make learning photography as easy as possible:

- Every two facing pages completes a single topic
- Detailed step-by-step instructions clarify each stage of extended procedures such as negative development and printing
- Boldfaced headings make subtopics easy to spot
- Numerous photographs and drawings illustrate each topic

Acknowledgments

Many people gave generously of their time and effort in the production of this book. Feedback from numerous instructors was a major help in confirming the basic direction of the book and in determining the new elements in this edition. Julia Grieve, Portland State University; Terry Martin, Salt Lake Community College; and Cinthea Fiss, the Metro State College of Denver reviewed the book and made valuable suggestions. Mary Goodwin was an essential researcher and co-conspirator. At Prentice Hall, Amber Mackey provided editorial support. Joe Scordato supervised the production of the book from manuscript to printer; Cory Skidds helped make the reproductions look like the originals. If, as you read the book or use it in your class, you have suggestions to make, please send them to Photography Editor, Prentice Hall, 1 Lake Street, Upper Saddle River, NJ 07458. They will be sincerely welcomed.

Jim Stone
Barbara London

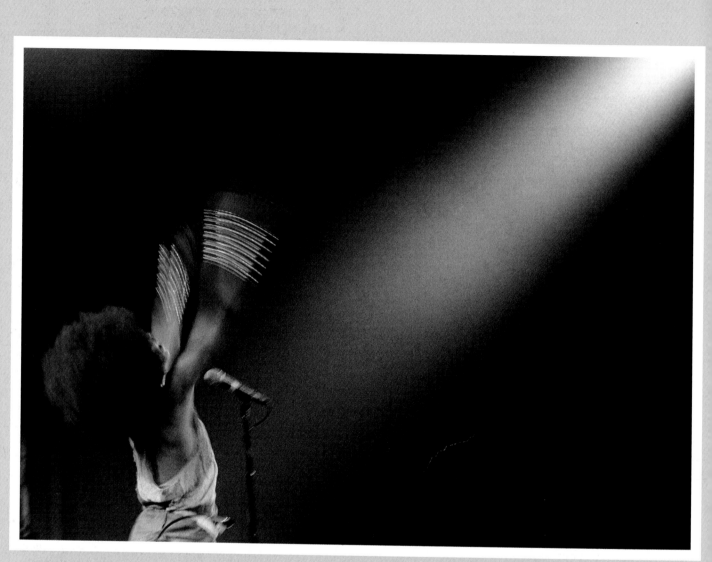

DAVID SCHEINBAUM
Erykah Badu, Sunshine Theater,
Albuquerque, New Mexico, 2003.

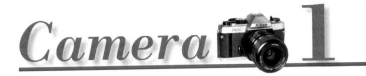

Camera 1

This chapter describes **your camera's most important controls** and how you can take charge of them, instead of always letting them control you. Almost all current digital and 35mm film cameras are equipped with automatic exposure, automatic focus, and automatic flash. If you are interested in making better pictures, however, you should know how your camera makes its decisions, even if the automatic features can't be turned off. If they can, you will want to override your camera's automatic decisions from time to time and make your own choices.

- You may want to blur the motion of a moving subject or freeze its motion sharply. Pages 18–19 show how.
- You may want the whole scene sharp from foreground to background or perhaps the foreground sharp but the background out of focus. Pages 40–41 show how.
- You may want to override your camera's automatic focus mechanism so that only a certain part of a scene is sharp. Page 39 tells when and how to do so.
- You may decide to silhouette a subject against a bright background, or perhaps you want to make sure that you don't end up with a silhouette. See page 78.

Most professional photographers use cameras with automatic features, but they know how their cameras operate manually as well as automatically so they can choose which is best for a particular situation. You will want to do the same because the more you know about how your camera operates, the better you will be able to get the results you want.

If you are just getting started in photography, the next few pages will help you make your first photographs. You can go directly to page 12 if you prefer more detailed information right away.

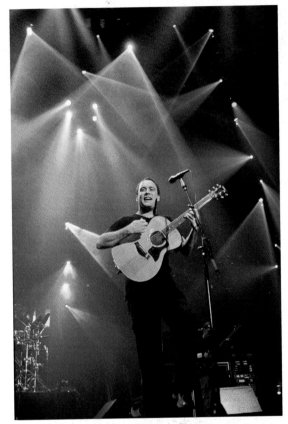

Martin Benjamin. Dave Matthews, 1996. **Framing is a basic control** you have in making a photograph. The two photographs on this page and opposite are about music. Would you concentrate on an action or on a gesture? Horizontal or vertical? Showing the subject's front or back? The whole scene or only a part of it? More about framing on pages 180–181.

Project: EXPOSE SOME PICTURES

YOU WILL NEED

Camera. We suggest a digital or 35mm film single-lens reflex.

Film or digital output. To evaluate your work, it's good to see exactly what you did. Slides can be projected so you can easily see small details. Digital pictures can be displayed unedited on a monitor.

If using film, page 4 tells how to choose one. The accuracy of your exposure will be easier to see if you shoot slides for this project because slide development does not compensate for exposure errors that make pictures too light or too dark, the way printing can. Developing and printing black-and-white film is coming in later chapters.

If you expect to work later mostly with black-and-white film, you can use Kodak T-Max 100 for this project and process it with Kodak's Direct Positive Film Developing Outfit. Be sure to read all instructions before exposing the film. If you shoot color slides, it will be harder to imagine what the picture would have looked like in black and white.

Pencil and notepad to keep track of what you do. Optional, but highly recommended for all the projects.

PROCEDURE See pages 4–9 if you are just beginning to photograph. Those pages walk you through the first steps of selecting and loading film, focusing an image sharply, adjusting the camera settings so your photographs won't be too light or too dark, and making your first pictures. See pages 10–11 if you are using a digital camera.

Have some variety in the scenes when you shoot. For example, photograph subjects near and far, indoors and outside, in the shade and in the sun. Photograph different types of subjects, such as a portrait, a landscape, and an action scene. Page 9 gives some suggestions.

HOW DID YOU DO? Which pictures did you like best? Why? Were some different from what you expected to get? Did some of your camera's operations cause confusion? It helps to read your instruction book all the way through or to ask for help from someone familiar with your camera.

Getting Started

CAMERA AND FILM

A **camera's main functions** are to help you **view** the scene so you can select what you want to photograph, **focus** to get the scene sharp where you want it to be, and **expose** the film so the picture is not too light or too dark.

A camera that uses film is shown here. If you are using a digital camera, see pages 10–11.

The **viewfinder** shows the picture that the lens will focus on the film.

The **lens** can be moved forward and back to bring objects at different distances into sharp focus. If you have a manual-focusing lens, rotate its collar to move it.

The **aperture** adjusts from larger (letting more light pass from the lens to the film) to smaller (letting less light pass).

The **shutter** opens and closes to limit the length of time that light strikes the film.

The **film** records the image transmitted by the lens.

Choose a Film

More about camera controls on pages 16–23.

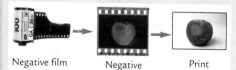

Negative film → Negative → Print

If you want prints, select a negative film, either color or black and white. Developing the film produces a negative image, which is then printed onto paper to make a positive.

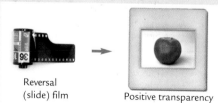

Reversal (slide) film → Positive transparency

If you want slides (transparencies), select a reversal film, which produces a positive image directly on the film that is in the camera. Most reversal films are for color.

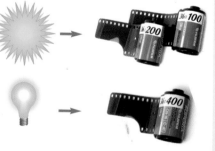

Film speed (ISO 100, 200, and so on) describes a film's sensitivity to light. The higher the number, the less light it needs for a correct exposure (one that is not too light or too dark). Choose a film with a speed of 100 to 200 for shooting outdoors in sunny conditions. In dimmer light, such as indoors, use film with a speed of 400 or higher.

Film speed

Number of exposures

More about film characteristics on page 57.

LOADING FILM INTO THE CAMERA

Open the Camera

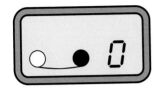

Make sure there is no film in the camera before you open it. Check that the film frame counter shows empty or that your camera's film rewind knob (if it has one) rotates freely. If there is film in the camera, rewind it (page 8).

A camera that loads film automatically probably will have a release lever to open the camera. Turn on the camera's main power switch. Open the camera back by sliding the release lever to its open position.

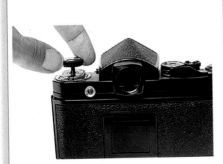

A camera that loads film manually will use its rewind knob at the top, not a release lever, to open the camera for loading. This type of camera usually opens for loading when you pull up on the rewind knob.

Insert and Thread Film

Keep film out of direct sunlight. Load film into the camera in subdued light or at least shield the camera from direct light with your body as you load it.

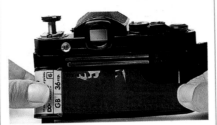

Insert the film cassette. A 35mm single-lens reflex camera usually loads film in the left side of the camera with the extended part of the cassette toward the bottom. The film should lie flat as it comes out of the cassette; if needed, rotate the cassette slightly to the right.

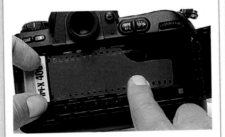

Automatic loading. Pull out the tapered end of the film until it reaches the other side of the camera. Usually a red mark or other indicator shows where the end of the film should be. The film won't advance correctly if the end of the film is in the wrong position.

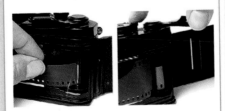

Manual loading. Push down the rewind knob. Pull out the tapered end of the film until you can insert it into the slot of the take-up spool on the other side of the camera. Alternately press the shutter release button and rotate the film advance lever until the teeth that advance the film engage the sprocket holes securely at the top and bottom of the film and any slack in the film is reeled up by the take-up spool.

Advance Film to the First Frame

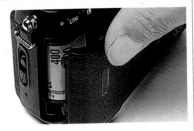

Close the camera back. The part of the film that you pulled out of the cassette has been exposed to light. You'll need to advance the film past this exposed section to an unexposed frame.

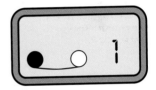

Automatic film advance. Depending on your camera, you may simply need to close the camera back to have the film advance to the first frame. Some cameras require you to also depress the shutter button.

If the film has correctly advanced, the film frame counter will display the number 1. If it does not, open the camera back and check the loading.

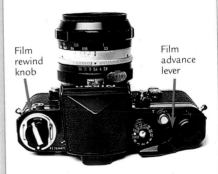

Film rewind knob

Film advance lever

Manual film advance. With the camera back closed, alternately press the shutter release button and rotate the film advance lever. Repeat two times.

If the film is advancing correctly film rewind knob will rotate counterclo you move the film advance leve not, open the camera and che Don't rely on the film frame advance even though the f'

6

Getting Started

FOCUSING AND SETTING THE EXPOSURE

Set the Film Speed

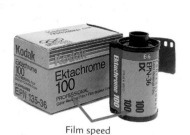

Film speed

Film speed. Set the camera to the speed (ISO) of the film you are using. Film speed is marked on the box and on the film cassette.

DX code

Automatically setting the film speed. On some cameras, the film speed is set by the camera as it loads the film. The film must be DX coded, marked with a bar code that is read by a sensor in the camera. DX-coded films have "DX" printed on the cassette and box.

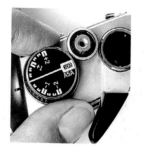

Manually setting the film speed. On some cameras, you must set the film speed manually. Turn the film speed dial (marked ISO or sometimes ASA) to the speed of your film. Here it is set to a film speed of 100.

More about film speed on pages 54–57.

Focus

Focus on the most important part of your scene to make sure it will be sharp in the photograph. Practice focusing on objects at different distances as you look through the viewfinder so that you become familiar with the way the camera focuses.

— Ground glass
— Microprism
— Split image

Manual focusing. As you look through the viewfinder, rotate the focusing ring at the front of the lens. The viewfinder of a single-lens reflex camera has a ground-glass screen that shows which parts of the scene are most sharply focused. Some cameras also have a microprism, a small ring at the center of the screen in which an object appears coarsely dotted until it is focused. With split-image focusing, part of an object appears offset when it is out of focus.

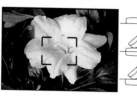

Shutter release button

Part way down: autofocus activated

All the way down: shutter released

Automatic focusing. Usually this is done by centering the focusing brackets (visible in the middle of the viewfinder) on your subject as you depress the shutter release part way. The camera adjusts the lens for you to bring the bracketed object into focus. Don't push the shutter release all the way down until you are ready to take a picture.

More about focus and when and how to override automatic focus on page 39.

Set the Exposure

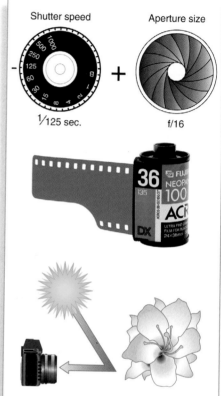

Shutter speed

Aperture size

1/125 sec. f/16

To get a correctly exposed picture, one that is not too light (overexposed) or too dark (underexposed), you—or the camera—set the shutter speed and the aperture depending on the sensitivity of the film (its speed) and how light or dark your subject is. The shutter speed determines the length of time that light strikes the film; the aperture size determines how bright the light is that passes through the lens and shutter to the film.

More about shutter speed and aperture on pages 18–23 and about exposure and metering on pages 65–81.

EXPOSURE READOUT

Exposure Readout

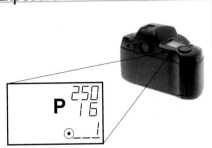

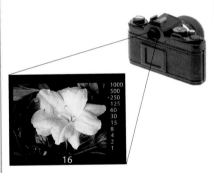

A data panel appears on the body of some cameras, displaying shutter speed and aperture settings (here, ½₅₀ sec. shutter speed, f/16 aperture), as well as other information.

The shutter speed and aperture settings appear in the viewfinder of some cameras. Here, ½₅₀ sec. shutter speed, f/16 aperture.

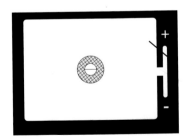

This needle-centering display in the camera's viewfinder doesn't show the actual shutter speed and aperture settings, but it does show when the exposure will be correct. You change the shutter speed and/or aperture until the needle centers between + (overexposure) and – (underexposure).

Manually Setting the Exposure

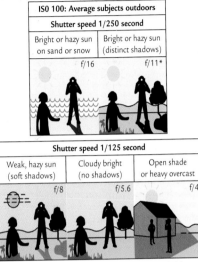

ISO 100: Average subjects outdoors	
Shutter speed 1/250 second	
Bright or hazy sun on sand or snow	Bright or hazy sun (distinct shadows)
f/16	f/11*

Shutter speed 1/125 second		
Weak, hazy sun (soft shadows)	Cloudy bright (no shadows)	Open shade or heavy overcast
f/8	f/5.6	f/4

*f/5.6 for backlighted close-up subjects. Subject shaded from sun but lighted by a large area of sky.

With manual exposure, you set both the shutter speed and aperture yourself. How do you know which settings to use? At the simplest level you can use a chart like the one above. Decide what kind of light illuminates the scene, and set the aperture (the f-number shown on the chart) and the shutter speed accordingly.

Notice that the recommended shutter speeds on the chart are ½₅₀ sec. or ½₂₅ sec. These relatively fast shutter speeds make it easier for you to get a sharp picture when hand holding the camera (when it is not on a tripod). At slow shutter speeds, such as ⅓₀ sec. or slower, the shutter is open long enough for the picture to be blurred if you move the camera slightly during the exposure.

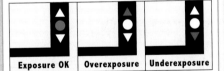

Exposure OK	Overexposure	Underexposure

You can use a camera's built-in meter for manual exposure. Point the camera at the most important part of the scene and activate the meter. The viewfinder will show whether the exposure is correct. If it isn't, change the shutter speed and/or aperture until it is. Here, an arrow pointing up signals overexposure, an arrow pointing down means underexposure. The dot in the center lights up when the exposure is right.

To prevent blur caused by the camera moving during the exposure (if the camera is not on a tripod), select a shutter speed of at least ½₀ sec. A shutter speed of ½₂₅ sec. is safer.

Automatically Setting the Exposure

With automatic exposure, the camera sets the shutter speed or aperture or both for you.

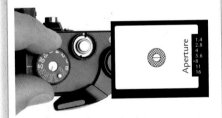

With programmed (fully automatic) exposure, each time you press the shutter release button, the camera automatically meters the light then sets both shutter speed and aperture.

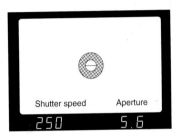

With shutter-priority automatic exposure, you set the shutter speed and the camera sets the aperture. To prevent blur from camera motion if you are hand-holding the camera, select a shutter speed of ½₀ sec. or faster.

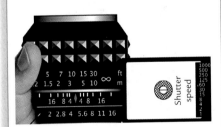

With aperture-priority automatic exposure, you set the aperture and the camera sets the shutter speed. To keep the picture sharp when you hand-hold the camera, check that the shutter speed is ½₀ sec. or faster. If it is not, set the aperture to a larger opening (a smaller f-number).

More about how to override automatic exposure on page 72.

Getting Started

EXPOSING THE FILM

Hold the Camera Steady

For horizontal photographs, keep your arms against your body to steady the camera. Use your right hand to hold the camera and your right forefinger to press the shutter release. Use your left hand to help support the camera or to focus or make other camera adjustments.

For vertical photographs, support the camera from below in either your right or left hand. Keep that elbow against your body to steady the camera.

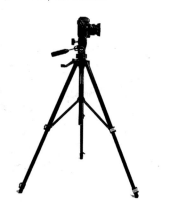

A tripod steadies the camera for you and lets you use slow shutter speeds, such as for night scenes or other situations when the light is dim. Make sure to use a cable release with it.

Expose the Film

Make an exposure. Recheck the focus and composition just before exposure. When you are ready to take a picture, stabilize your camera and yourself and gently press the shutter release all the way down.

Make some more exposures. You might want to try several different exposures of the same scene, perhaps from different angles. See opposite page for some ideas.

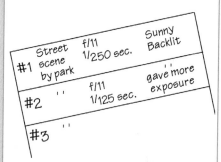

#1	Street scene by park	f/11 1/250 sec.	Sunny Backlit
#2	''	f/11 1/125 sec.	gave more exposure
#3	''		

You'll learn faster about exposure settings and other technical matters if you keep a record of your exposures. For example, write down the frame number, subject, f-stop and shutter-speed settings, direction or quality of light, and any other relevant information. This way you won't forget what you did by the time you develop and print the film.

At the End of the Roll, Rewind the Film

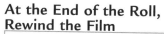

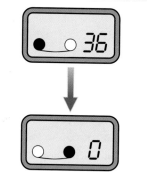

After your last exposure on the roll, rewind the film back into the cassette before opening the camera. Store film away from light and heat until it is developed.

Automatic rewind. Most cameras automatically rewind the film after you make the last exposure on the roll, or the camera may signal the end of a roll and then rewind when you press a film rewind button.

Manual rewind. You'll know that there is no more film left on the roll when the film advance lever will not turn. The film frame counter will also show the number of exposures you have made: 36, for example, if you used a 36-exposure roll of film. Activate the rewind button or catch at the bottom of the camera. Lift the handle of the rewind crank and turn it clockwise until tension on the crank releases.

WHAT WILL YOU PHOTOGRAPH?

Where do you start? One place to start is by looking around through the viewfinder. A subject often looks different isolated in a viewfinder than it does when you see it surrounded by other objects. What interests you about this scene? What is it that you want to make into a photograph?

Get closer (usually). Often people photograph from too far away. What part of the scene attracted you? Do you want to see the whole garden, or are you interested in the person working in it? Do you want the whole wall of a building, or was it the graffiti on it that caught your attention?

Try a different angle. Instead of always shooting from normal eye-level height, try getting up high and looking down on your subject or kneeling and looking up.

Look at the background (and the foreground). How does your subject relate to its surroundings? Do you want the subject centered or off to one side to show more of the setting? Is there a distraction (like a post or sign directly behind someone's head) that you could avoid by changing position? Take a look.

More about backgrounds and the image frame on pages 180–183.

Check the lighting. If this is your first roll, you are most likely to get a good exposure if you photograph a more or less evenly lit scene, not one where the subject is against a very light background, such as a bright sky.

More about lighting on pages 129–145.

Experiment, too. Include a bright light or bright sky in the picture (just don't stare directly at the sun through the viewfinder). In the photograph, darker parts of the scene may appear completely black, or the subject itself may be silhouetted against a brighter background.

Getting Started

USING A DIGITAL CAMERA

There are many advantages to using a digital camera. You can use the camera's display to see the results of each shot as you make it. You can review any of the pictures stored in its memory to confirm that you have covered a job completely and delete undesired photographs to make room for new ones. After you transfer your pictures to a computer or another storage device, you can reuse the same memory card to record more pictures.

Digital cameras let you select the ISO rating (the equivalent of film speed) for each shot. Using a higher ISO can let you shoot in dimmer light. But just as graininess is more visible with high-speed film, random specks (called noise) occur more often in a digital image as you increase the ISO.

You don't need filters over the lens to correct for color when you use a digital camera. Most cameras adjust for the light source automatically (for example, tungsten or fluorescent) so colors are rendered normally.

Zoom lenses seem to have an increased range with digital zoom, a feature found on some digital cameras marketed to amateurs. Digital zoom enlarges a picture electronically, but use it with caution. Optical zoom, which depends on the focal length of the lens to change the image, actually magnifies the scene, but digital zooming only crops the image, enlarging the pixels in the part of the image that's left. The final photograph will not have the quality you'd get by using a longer lens or moving closer for the shot.

The **aperture** adjusts from larger (letting more light reach the image sensor) to smaller (letting less light pass).

The **image sensor** is an array of CCD or CMOS *photosites* (light-sensitive elements) that convert light into digital data in the form of ones and zeros.

The **shutter** may only be used to keep the sensor momentarily dark to initialize (or reset) before an exposure. Some cameras regulate exposure time by turning on and off the sensor.

The **lens** moves forward and back to bring objects at different distances into sharp focus.

The **optical viewfinder** shows the image that the lens focuses on the image sensor.

A **memory card** stores images until you can transfer them to your computer or other storage device.

Cable connections let the image data be transferred from the camera to a computer, printer, or storage device via a cable.

An **LCD monitor** displays pictures you have taken or menu options. On some models it shows a live preview that you can use to frame and focus.

The **data display panel** shows camera settings such as exposure and flash mode, aperture, and shutter speed.

A **jog dial** or mode dial on some models changes ISO rating, white balance, and other picture variables. Settings are visible on the LCD monitor or data display panel.

Slot for memory card.

Prepare the Camera

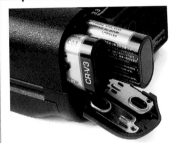

Make sure your camera has fresh batteries. A half-empty symbol will let you know when the battery is low. Carry spares; the camera won't work without batteries.

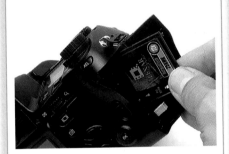

Insert a memory card only with the camera turned off. Then turn on the camera. Make sure you are using the right kind of card for your camera; cards intended for another camera may not operate correctly in yours.

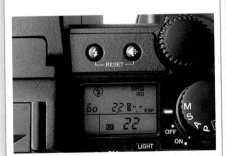

Select the file type and resolution. These affect the image quality and the number of images your memory card can save. A lower resolution or compressed file lets you store more pictures, but at some loss of quality. Saving pictures in the camera's raw format gives the highest quality.

Make Some Exposures (middle column)

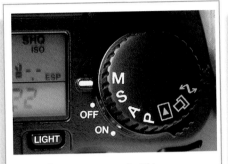

Select the exposure mode. This camera offers programmed (P), aperture priority (A), shutter priority (S), or manual (M). Your camera might have a dial (above) or a menu on the data display panel. It may let you select autofocus (AF) or manual focus (M) with a separate dial or switch.

Turn on the LCD monitor or view the data display panel. Select an ISO rating (the equivalent of film speed). Lower ratings give better results, but higher ratings, like higher film speeds, may be necessary when shooting in low light. Look through the menu for other important settings.

Incandescent Fluorescent

Sunlight Cloudy Shade

Select the white balance (color temperature) for the dominant light source in which you are shooting, such as incandescent (tungsten) bulbs, sunlight, or outdoor shade. A camera set on automatic makes these adjustments for you. If your camera has a raw format option, it leaves the white balance choice until you edit the file.

Make Some Exposures

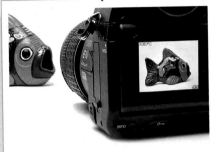

Frame your picture by looking at the LCD monitor or through the viewfinder. Focus and check the exposure, as you would with a film camera. Some models prefocus automatically when you press the shutter button halfway down. Take the picture.

Do not turn the power off until the transfer from image sensor to memory card is complete. If you interrupt the power at this point, you can lose your picture, ruin your memory card, or even damage your camera.

You can review all your pictures on the LCD monitor in thumbnail size. Use the monitor when you need it, but otherwise turn it off to conserve battery power.

Every digital camera is different, although there are many similarities. Read your manual carefully. The steps here are a guide, but the switches, buttons, and menu are often unique to each camera model.

More about memory cards on page 156, exposure modes on page 16, automatic focus on page 39, resolution on page 149, and compression on page 158.

Types of Cameras

What kind of camera is best for you? For occasional snapshots of family and friends, an inexpensive, completely automatic, nonadjustable camera that you just point and shoot will probably be satisfactory. But if you have become interested enough in photography to take a class or buy a book, you will want an adjustable camera, either digital or film, because it will give you greater creative control. If you buy a camera with automatic features, make sure it is one that allows you to manually override them when you want to make exposure and focus choices yourself.

Single-lens reflex cameras (SLRs) show you a scene directly through the lens, so you can preview what will be recorded on the film. You can see exactly what the lens is focused on; with some cameras, you can check the depth of field (how much of the scene from foreground to background will be sharp). Through-the-lens viewing is a definite advantage for close-ups or any work when you want a precise view of a scene.

Most have automatic exposure, automatic focus, automatic flash, and automatic film advance and rewind but allow manual control. Many different interchangeable lenses for SLRs are available.

Most SLRs are digital or use 35mm film. A few models may be used with accessory backs for either medium-format film, in 2¼-inch-wide 120 or 220 rolls, or digital capture. SLRs are very popular with professionals, such as fashion photographers, or with anyone who wants to move beyond making snapshots.

Compact cameras (sometimes called *point-and-shoot* cameras) are mostly designed for amateur photographers but vary considerably in quality. Some are good enough to be used by professionals when they don't want to carry a larger camera; some are made to be thrown away after one use.

Compact film cameras let you see a scene through a peephole, or viewfinder, which shows almost—but not quite—the image that will expose the film. The viewfinder image is used to select the scene to be photographed, but can't be used for focusing because it doesn't show you which part of the scene will be sharply focused on the film. Most compact cameras focus the image for you.

Because this viewing system is in a different position from the lens that exposes the film, you do not see exactly what the lens sees. This difference between the viewfinder image and the lens image, called *parallax error*, increases as objects come closer to the camera.

Compact digital cameras most often do not have a viewfinder, but show the scene instead in real time on an LCD monitor. Because this image is made with the camera's lens, it displays framing exactly. The disadvantage of an LCD display is that it drains the camera's batteries rapidly.

Rangefinder cameras are viewfinder film cameras with a visual focusing system that you use as you look through the viewfinder window. The window shows a split image when an object is not in focus. As you rotate the focusing ring, the split image comes together when the object is focused sharply. Rangefinder cameras let you focus precisely, even in dim light, but you cannot visually assess the depth of field because, except for the split image, all parts of the scene look equally sharp in the viewfinder.

Better rangefinder cameras correct for parallax and have interchangeable lenses, although usually not in as many focal lengths as are available for SLRs. Some use 35mm film; a few (like the one on the page opposite) are for wider roll film.

Rangefinder cameras are fast, reliable, quiet in operation, and relatively small. A few high-quality brands are in demand among professionals.

View cameras have a lens in the front, a ground-glass viewing screen in

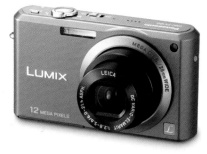

Compact Camera

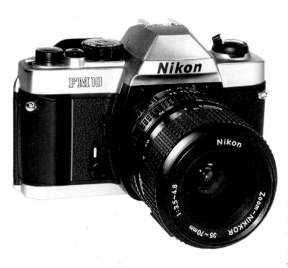

Single-lens Reflex Camera

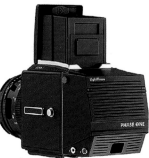

Medium-format SLR with Digital Back

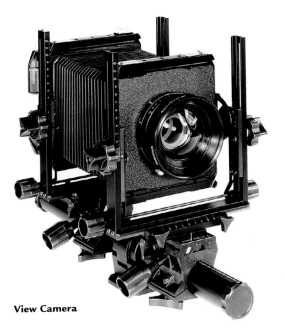

View Camera

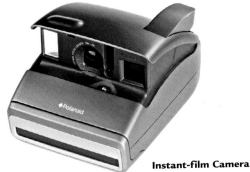

Instant-film Camera

down, and it is usually so dim that you have to put a focusing cloth over your head and the screen to see the image clearly. Nevertheless, when you want complete control of an image, such as for architectural or product photography or for personal work, the view camera's advantages outweigh its inconveniences.

Twin-lens reflex cameras (TLRs) are now made by only two companies, but secondhand models are widely available. They are made only for film and are not easily adapted to digital capture. Each camera has two lenses: one for viewing the scene and another just below it that exposes the film.

A large film format (2¼-inches square) is the TLR's advantage.

The disadvantages are parallax (because the viewing lens is in a different position from the taking lens) and a viewfinder image that is reversed left to right. A few now-discontinued TLRs had interchangeable lenses; adjustments on all models are completely manual.

Some cameras fill a specialized need.

Instant film cameras produce a print within a few seconds, if not instantly. Polaroid and Fuji make film for Polaroid's own instant-print cameras, as well as film for conventional view cameras.

Underwater cameras, both digital and film, are not only for use underwater but for any situation in which a camera is likely to get wet. Some cameras are water resistant, rather than usable underwater. Specially-made underwater housings are available for

many professional camera models.

Panoramic cameras make a long, narrow photograph that can be interesting, for example, for landscapes. Some of these cameras crop out part of the normal image rectangle to make a panoramic shape. Others use a longer-than-normal section of roll film or rotate the lens from side to side during the exposure.

Digital panoramas can be made during editing by stitching several individual frames together; some cameras can display a segment of the previous frame on the side of the monitor to help align the next shot.

Stereo cameras take two pictures at the same time through two side-by-side lenses. The resulting pair of images, a *stereograph*, gives the illusion of three dimensions when seen in a stereo viewer.

the back, and a flexible, accordion-like bellows in between. The camera's most valuable feature is its adjustability: the camera's parts can be moved in relation to each other, which lets you alter perspective and sharpness to suit each scene. You can change lenses and even the camera's back; for example, you can attach a back to make Polaroid pictures or one to record a digital image.

Each film exposure is made on a separate sheet of film, so you can make one exposure in color and the next in black and white, or develop each sheet differently. Film size is large—4 × 5 inches and larger—which makes detail crisp and sharp

even in a big print.

View cameras are slow and rather inconvenient to use compared to smaller handheld cameras. They are large and heavy and must be mounted on a tripod. The image on the viewing screen is upside

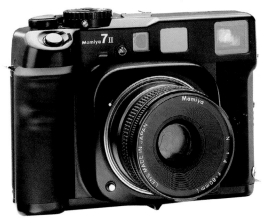

Rangefinder Camera

Basic Camera Controls

Get the pictures you want. Cameras don't quite "see" the way the human eye does, so at first the pictures you get may not be the ones you expected. This book will help you gain control over the picture-making process by showing you how to see the way the camera does and how to use the camera's controls to make the picture you have in mind. Film cameras are shown here. A digital camera will have some or all of these same controls.

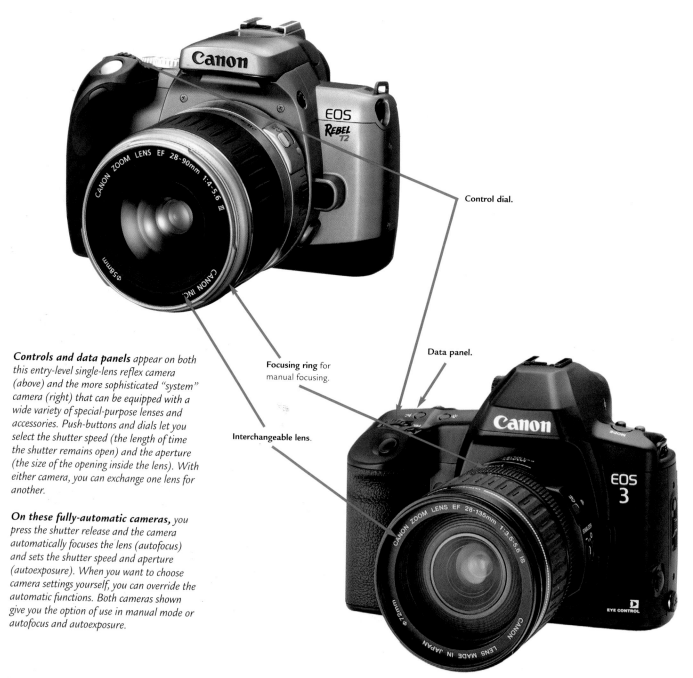

Control dial.

Data panel.

Focusing ring for manual focusing.

Interchangeable lens.

Controls and data panels appear on both this entry-level single-lens reflex camera (above) and the more sophisticated "system" camera (right) that can be equipped with a wide variety of special-purpose lenses and accessories. Push-buttons and dials let you select the shutter speed (the length of time the shutter remains open) and the aperture (the size of the opening inside the lens). With either camera, you can exchange one lens for another.

On these fully-automatic cameras, you press the shutter release and the camera automatically focuses the lens (autofocus) and sets the shutter speed and aperture (autoexposure). When you want to choose camera settings yourself, you can override the automatic functions. Both cameras shown give you the option of use in manual mode or autofocus and autoexposure.

Focusing. *Through the viewfinder window you see the scene that will be recorded, including the sharpest part of the scene, the part on which the camera is focused. A particular part of a scene can be focused sharply by manually turning the focusing ring on the lens, or you can let an autofocus camera adjust the lens automatically. More about focusing and sharpness appears on pages 38–39.*

Keith Johnson

Shutter-speed control. *Moving objects can be shown crisply sharp, frozen in mid-motion, or blurred either a little bit or a lot. The faster the shutter speed, the sharper the moving object will appear. Turn to pages 18–19 for information about shutter speeds, motion, and blur.*

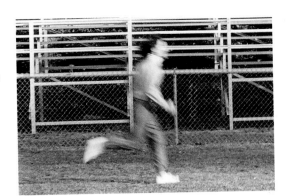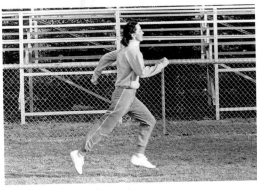

Alan Oransky

Aperture control. *Do you want part of the picture sharp and part out of focus or do you want the whole picture sharp from foreground to back-ground? Changing the size of the aperture (the lens opening) is one way to control sharpness. The smaller the aperture, the more of the picture that will be sharp. See pages 20–21.*

Fredrik D. Bodin

Lens focal length. *Your lens's focal length controls the size of objects in a scene and how much of that scene is shown. The longer the focal length, the larger the objects will appear. See pages 28–35 for more about focal length.*

Alan Oransky

More about Camera Controls

Automatic exposure is a basic feature on most 35mm single-lens reflex cameras. The purpose is to let in a controlled amount of light so that the resulting image is neither too light nor too dark. The camera's built-in meter measures the brightness of the scene and then sets shutter speed, aperture (lens opening), or both in order to let the right amount of light reach the film or a digital camera's recording sensor. As you become more experienced, you will want to set the exposure manually in certain cases, instead of always relying on the camera. More about exposure in Chapter 4, pages 65–81.

You have a choice of exposure modes with many cameras. Read your camera's instruction manual to find out which exposure features your model has and how they work. You may be able to get a replacement manual from the manufacturer, if you don't have one.

With programmed (fully automatic) exposure, the camera selects both the shutter speed and the aperture based on a program built into the camera by the manufacturer. This automatic operation can be useful in rapidly changing situations because it allows you simply to respond to the subject, focus, and shoot.

In shutter-priority mode, you set the shutter speed and the camera automatically sets the correct aperture. This mode is useful when the motion of subjects is important, as at sporting events, because the shutter speed determines whether moving objects will be sharp or blurred.

In aperture-priority mode, you set the lens opening and the camera automatically sets the shutter speed. This mode is useful when you want to control the depth of field or the sharpness of the image from foreground to background because the size of the lens opening is a major factor affecting sharpness.

Manual exposure is also a choice with many automatic cameras. You set both the lens opening and shutter speed yourself using, if you wish, the camera's built-in light meter to measure the brightness of the light.

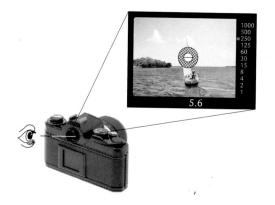

Exposure information appears in the viewfinder of many cameras. This viewfinder shows the shutter speed (here, 1/250 sec.) and aperture (f/5.6). Displays also show you when the flash is ready to fire and give you warnings of under- or overexposure.

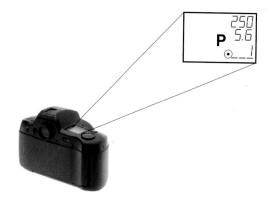

Some cameras have a data panel on the body of the camera that shows information such as shutter speed (here, 1/250 sec.) and aperture (f/5.6). This model also shows the mode of exposure operation (P, for programmed automatic) and the frame number of the film (number 1).

INSIDE A SINGLE-LENS REFLEX CAMERA

All **cameras** have the same basic features:

- A light-tight box to hold the camera parts and film or a recording chip
- A viewing system that lets you aim the camera accurately
- A lens to form an image and a mechanism to focus it sharply
- A shutter and lens aperture to control the amount of light that reaches the recording surface
- A means to hold and advance the film or to hold a digital chip and save its captured information

A. **Body.** The light-tight box that contains the camera's mechanisms and protects the film or chip from light until you are ready to make a photograph.

B. **Lens.** Focuses an image in the viewfinder and on the recording surface: film or sensor.

C. **Lens elements.** The optical glass lens components that produce the image.

D. **Focusing ring.** Turning the ring focuses the image by adjusting the distance of the lens from the recording surface. Some cameras focus automatically.

E. **Diaphragm.** A circle of overlapping leaves inside the lens that adjusts the size of the aperture (lens opening). It opens up to increase (or closes down to decrease) the amount of light reaching the recording surface.

F. **Aperture ring or button.** Setting the ring or button determines the size of the diaphragm during exposure.

G. **Mirror.** During viewing, the mirror reflects light from the lens upward onto the viewing screen. During an exposure, the mirror swings out of the way so light can pass straight to the recording surface.

H. **Viewing screen.** A ground-glass (or similar) surface on which the focused image appears.

I. **Pentaprism.** A five-sided optical device that reflects the image from the viewing screen into the viewfinder.

J. **Metering cell.** Measures the brightness of the scene being photographed.

K. **Viewfinder eyepiece.** A window through which the image from the pentaprism is visible.

L. **Shutter.** Keeps light from the recording surface until you are ready to take a picture. Pressing the shutter release opens and closes the shutter to let a measured amount of light reach the film or chip.

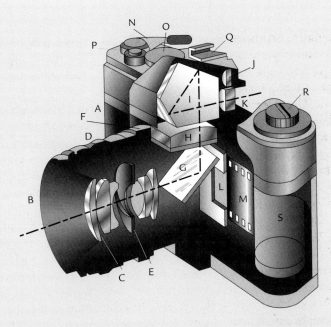

M. **Film.** A light-sensitive material that records the image. The ISO, or film speed (the rating of a particular film's sensitivity), is set into the camera by turning a dial or, on some cameras, is set automatically when you load the film. Digital cameras record images on an image sensor (a CCD or CMOS chip) in the same location.

N. **Film advance.** A lever that advances the film to the next unexposed segment. Most new film cameras advance film automatically; those and digital cameras have no lever.

O. **Shutter-speed dial or button.** Selects the shutter speed, the length of time the shutter remains open. On some models, it also sets the mode of automatic exposure operation.

P. **Shutter release.** A button that activates the exposure sequence in which the aperture adjusts, the mirror rises, the shutter opens, and light strikes the recording surface.

Q. **Hot shoe.** A bracket that attaches a flash unit to the camera and provides an electrical linking that synchronizes camera and flash.

R. **Rewind mechanism.** On manual cameras, a crank you turn to rewind film into its cassette after a roll of film has been exposed. Most new film cameras have a motor to rewind the film automatically.

S. **Film cassette.** The light-tight container in which 35mm film is packaged. Digital cameras use a memory card to store images.

*A **simplified look** inside a single-lens reflex 35mm camera (designs vary in different models). The camera takes its name from its single lens (another kind of reflex camera has two lenses) and from its reflection of light upward for viewing the image.*

Shutter Speed

AFFECTS LIGHT AND MOTION

Light and the shutter speed. To make a correct exposure, so that your picture is neither too light nor too dark, you need to control the amount of light that reaches the film or digital image sensor. The shutter speed (the amount of time the shutter remains open) is one of two controls your camera has over the amount of light. The aperture size (page 20) is the other. In automatic operation, the camera sets the shutter speed, aperture, or both. In manual operation, you choose both settings. The shutter-speed dial (a push button on some cameras) sets the shutter so that it opens for a given fraction of a second after the shutter release has been pressed. The B (or bulb) setting keeps the shutter open as long as the shutter release is held down.

Motion and the shutter speed. In addition to controlling the amount of light that enters the camera, the shutter speed also affects the way that moving objects are shown. A fast shutter speed can freeze motion—$\frac{1}{250}$ sec. is more than fast enough for most scenes. A very slow shutter speed will record even a slow-moving object with some blur. The important factor is how much the image actually moves across the recording surface. The more of the film it crosses while the shutter is open, the more the image will be blurred, so the shutter speed needed to freeze motion depends in part on the direction in which the subject is moving in relation to the camera (see opposite page).

The lens focal length and the distance of the subject from the camera also affect the size of the image on the film and thus how much it will blur. A subject will be enlarged if it is photographed with a long-focal-length lens or if it is close to the camera; it has to move only a little before its image crosses enough of the recording surface to be blurred.

Obviously, the speed of the motion is also important: all other things being equal, a darting swallow needs a faster shutter speed than does a hovering hawk. Even a fast-moving subject, however, may have a peak in its movement, when the motion slows just before it reverses. A gymnast at the height of a jump, for instance, or a motorcycle negotiating a sharp curve is moving slower than at other times and so can be sharply photographed at a relatively slow shutter speed.

See the project on motion, page 187.

Drex Brooks

*A **focal-plane shutter** consists of a pair of curtains usually located in the camera body just in front of the film. During exposure, the curtains open to form a slit that moves across the film.*

The size of the slit is adjustable: the wider the slit, the longer the exposure time and the more light that reaches the film. Focal-plane shutters are found in most single-lens reflex cameras and some rangefinder cameras.

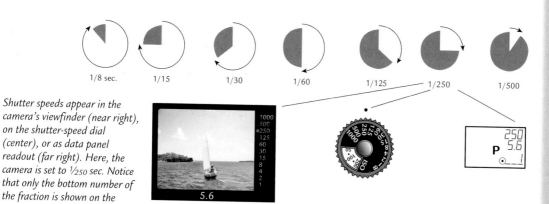

| 1/8 sec. | 1/15 | 1/30 | 1/60 | 1/125 | 1/250 | 1/500 |

Shutter speeds appear in the camera's viewfinder (near right), on the shutter-speed dial (center), or as data panel readout (far right). Here, the camera is set to $\frac{1}{250}$ sec. Notice that only the bottom number of the fraction is shown on the camera.

Shutter-speed settings *are in seconds or fractions of a second: 1 sec., $\frac{1}{2}$ sec., $\frac{1}{4}$, $\frac{1}{8}$, $\frac{1}{15}$, $\frac{1}{30}$, $\frac{1}{60}$, $\frac{1}{125}$, $\frac{1}{250}$, $\frac{1}{500}$, $\frac{1}{1000}$, and sometimes $\frac{1}{2000}$, $\frac{1}{4000}$, and $\frac{1}{8000}$. Each setting lets in twice as much light as the next faster setting, half as much as the next slower setting: $\frac{1}{250}$ sec. lets in twice* as much light as $\frac{1}{500}$ sec., half as much as $\frac{1}{125}$ sec. In automatic operation, shutter speeds are often "stepless;" the camera can set the shutter to $\frac{1}{225}$ sec., $\frac{1}{200}$ sec., or whatever speed it calculates will produce a correct exposure.

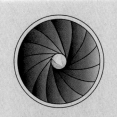
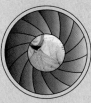

A leaf shutter is usually built into the lens instead of the camera body. The shutter consists of overlapping leaves that open during the exposure, then close again.

The longer the shutter stays open, the more light that reaches the film. Leaf shutters are found on most rangefinder and point-and-shoot cameras, view-camera lenses, large-format single-lens reflex cameras, and twin-lens reflex cameras.

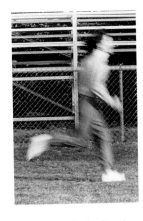

1/30 sec.

Slow shutter speed, subject blurred. *The direction a subject is moving in relation to the camera can affect the sharpness of the picture. At a slow shutter speed, a jogger moving from left to right is not sharp.*

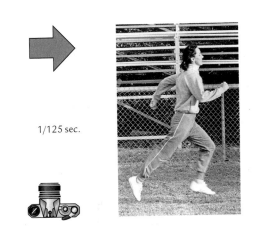

1/125 sec.

Fast shutter speed, subject sharp. *Photographed at a faster shutter speed, the same jogger moving in the same direction is sharp. During the shorter exposure, her image did not cross enough of the recording surface to blur.*

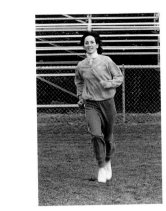

1/30 sec.

Slow shutter speed, subject sharp. *Here the jogger is sharp even though photographed at the slow shutter speed that recorded blur in the first picture. Because she was moving directly toward the camera, her image did not cross enough of the recording surface to blur.*

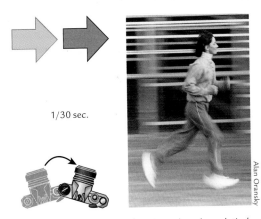

1/30 sec.

Alan Oransky

Panning *with the jogger is another way to keep her relatively sharp. During the exposure, the photographer moved the camera in the same direction that the jogger was moving. Notice the streaky look of the background, characteristic of a panned shot.*

Blurring to show motion. Freezing motion is one way of representing it, but it is not the only way. In fact, freezing motion sometimes eliminates the feeling of movement altogether so that the subject seems to be at rest. Allowing the subject to blur can be a graphic means of showing that it is moving.

Panning to show motion. Panning the camera—moving it in the same direction as the subject's movement during the exposure—is another way of showing motion (bottom right). The background will be blurred, but the subject will be sharper than it would be if the camera was held steady.

 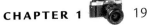

Aperture

AFFECTS LIGHT AND DEPTH OF FIELD

Light and the aperture. The aperture, or lens opening, is the other control that you can use in addition to shutter speed to adjust the amount of light that reaches the film or digital image sensor. Turning a ring on the outside of the lens (pushing a button on some cameras) changes the size of the *diaphragm*, a ring of overlapping metal leaves inside the lens. (In automatic operation, the camera can do this for you.) Like the iris of your eye, the diaphragm can get larger (open up) to let more light in; it can get smaller (stop down) to decrease the amount of light.

f/16
Half as much light as f/11

f/11
Twice as much light as f/16
Half as much light as f/8

f/8
Twice as much light as f/11
Half as much light as f/5.6

f/5.6
Twice as much light as f/8
Half as much light as f/4

f/4
Twice as much light as f/5.6
Half as much light as f/2.8

f/2.8
Twice as much light as f/4
Half as much light as f/2

f/2
Twice as much light as f/2.8

Aperture settings appear on a camera's lens aperture ring (shown above), in the viewfinder (below left), or as data-panel readout (below right). Here, the camera is set to f/5.6.

Light and the aperture. *The size of the lens opening—the aperture, or f-stop—controls the amount of light that passes through the lens. Each aperture is one "stop" from the next; that is, each lets in twice as much light as the next smaller opening, half as much light as the next larger opening. Notice that the lower the f-stop number, the wider the lens opening and the more light that is let in. For example, f/8 is a wider opening and lets in more light than f/11, which lets in more light than does f/16, and so on.*

Aperture settings (f-stops). Aperture settings, from larger lens openings to smaller ones, are f/1, f/1.4, f/2, f/2.8, f/4, f/5.6, f/8, f/11, f/16, f/22, and f/32. Settings beyond f/32 are usually found only on some view-camera lenses.

The lower the f-stop number, the wider the lens opening; each setting lets in twice as much light as the next f-stop number up the scale, half as much light as the next number down the scale. For example, f/11 lets in double the light of f/16, half as much as f/8. Larger openings have smaller numbers because the f/ number is a ratio: the lens focal length divided by the diameter of the lens opening.

Referring to a *stop* is a shorthand way of stating this half-or-double relationship. You can give one stop more (twice as much) exposure by setting the aperture to its next wider opening, one stop less (half as much) exposure by *stopping* (closing) down the aperture to its next smaller opening.

No lens has the entire range of f-stops; most have about seven. A 50mm lens may range from f/2 at its widest opening to f/16 at its smallest, a 200mm lens may range from f/4 to f/22. Most lenses can set intermediate f-stops partway between the whole stops, often in one-third-stop increments. The widest lens setting may be an intermediate stop, for example, f/1.2.

Depth of field and the aperture. The size of the aperture setting also affects how much of the image will be sharp. This is known as the depth of field. As the aperture opening gets smaller, the depth of field increases and more of the scene from near to far appears sharp in the photograph (see photos, below, and pages 40–41). See the depth of field project on page 185.

Depth of field and the aperture. The smaller the aperture opening, the greater the depth of field. At f/16 (left), the entire depth in the scene from foreground to background appears sharp. At a much larger aperture, f/2 (right), there is less depth of field and the background is completely out of focus.

Small Aperture, More Depth of Field

Large Aperture, Less Depth of Field

Shutter Speed and Aperture

BLUR VS. DEPTH OF FIELD

Controlling the exposure. Both shutter speed and aperture affect the amount of light reaching the camera's recording surface. To get a correctly exposed picture, one that is neither too light nor too dark, you need to find a combination of shutter speed and aperture that will let in the right amount of light for a particular scene and film or digital ISO setting. (Pages 65–81 explain how to do this.)

Equivalent exposures. Once you know a correct combination of shutter speed and aperture, you can change one setting and still keep the exposure the same as long as you change the other setting the same amount in the opposite direction. If you want to use a smaller aperture (which lets in less light), you can keep the exposure the same by using a slower shutter speed (which lets in more light), and vice versa.

A stop of exposure change. Each full f-stop setting of the aperture lets in half (or double) the amount of light as the next full setting, a one-stop difference. Each shutter-speed setting does the same. The term stop is used whether the aperture or shutter speed is changed. The exposure stays constant if, for example, a move to the

next faster shutter speed (one stop less exposure) is matched by a move to the next larger aperture (one stop more exposure).

Which combination do you choose? Any of several combinations of shutter speed and aperture could make a good exposure, but the effect on the appearance of the image will be different. Shutter speed affects the sharpness of moving objects; aperture size affects depth of field (the sharpness of a scene from near to far). Shutter speed also helps prevent blur caused by camera motion during the exposure. If you are holding the camera in your hands, you need a faster shutter speed than if you have the camera on a tripod (see page 24 for details).

You can decide for each picture whether stopped motion or depth of field is more important. More depth of field and near-to-far sharpness with a smaller aperture means you would be using a slower shutter speed and so risking that motion would blur. Using a faster shutter speed to freeze motion means you would be using a larger aperture, with less of the scene sharp near to far. Depending on the situation, you may have to compromise on a moderate amount of depth of field with some possibility of blur.

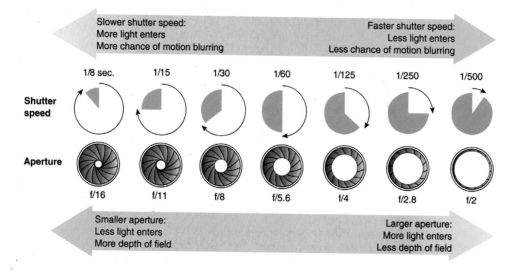

| Slower shutter speed: More light enters More chance of motion blurring | | | | Faster shutter speed: Less light enters Less chance of motion blurring | | |

Shutter speed: 1/8 sec. | 1/15 | 1/30 | 1/60 | 1/125 | 1/250 | 1/500

Aperture: f/16 | f/11 | f/8 | f/5.6 | f/4 | f/2.8 | f/2

| Smaller aperture: Less light enters More depth of field | | | | Larger aperture: More light enters Less depth of field | | |

Shutter speed and aperture combinations. Both the shutter speed and the aperture size control the amount of light. Each setting lets in half (or double) the amount of light as the adjacent setting—a one-stop difference.

If you decrease the amount of light one stop by moving to the next smaller aperture setting, you can keep the exposure constant by also moving to the next slower shutter speed. In automatic operation, the camera makes these changes for you.

Each combination of aperture and shutter speed shown at left lets in the same amount of light; but see the photographs on the opposite page: the combinations change the sharpness of the picture in different ways.

Fast shutter speed (¹⁄₅₀₀ sec.): the moving swing is sharp.
Wide aperture (f/2): the trees, picnic table, and person in the background are out of focus. Only objects the same distance as the foreground posts, on which the lens was focused, are sharp.

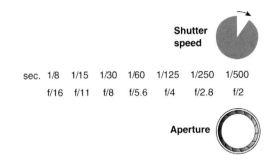

sec.	1/8	1/15	1/30	1/60	1/125	1/250	1/500
	f/16	f/11	f/8	f/5.6	f/4	f/2.8	f/2

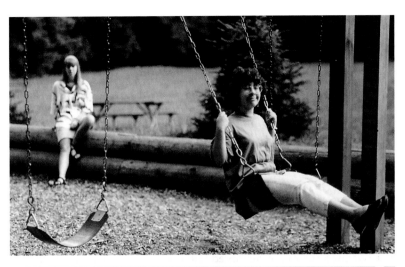

Medium-fast shutter speed (¹⁄₆₀ sec.): the moving swing shows some blur. **Medium-wide aperture** (f/5.6): the background is still a little fuzzy but the middle ground appears in focus.

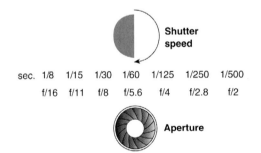

sec.	1/8	1/15	1/30	1/60	1/125	1/250	1/500
	f/16	f/11	f/8	f/5.6	f/4	f/2.8	f/2

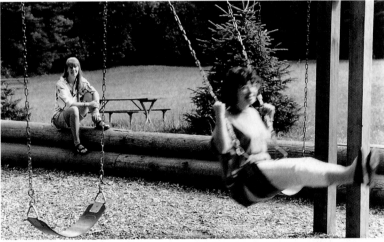

Slow shutter speed (¹⁄₈ sec.): the moving swing is completely blurred. **Small aperture** (f/16): the middle- and background are completely sharp.

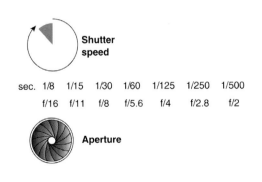

sec.	1/8	1/15	1/30	1/60	1/125	1/250	1/500
	f/16	f/11	f/8	f/5.6	f/4	f/2.8	f/2

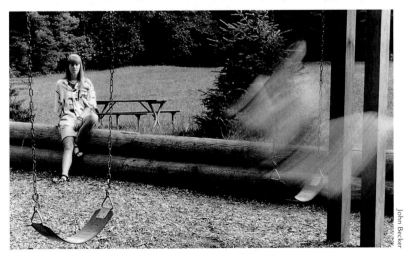

Shutter speed and aperture combinations. *Each of the exposure combinations for this scene lets in the same total amount of light, so the overall exposure stays the same. But the motion of the swing is blurred with a slow shutter speed, sharp with a fast shutter speed. The depth of field (overall sharpness of near-to-far objects) is shallow with a larger aperture, extends farther with a small aperture.*

Getting the Most from Your Camera and Lens

Camera motion causes blur. Though some photographers claim to be able to hand hold a camera steady at slow shutter speeds—$\frac{1}{15}$ sec. or even slower—it takes only a slight amount of camera motion during exposure to cause a noticeable blur in an image. If a sharp picture is your aim, using a fast shutter speed or supporting the camera on a tripod is a much surer way to produce a sharp image.

When hand holding the camera (see right, top and center), use the focal length of your lens as a guide to how fast your shutter speed should be. The longer the focal length, the faster the shutter speed must be, because a long lens magnifies any motion of the lens during the exposure just as it magnifies the size of the objects photographed.

As a general rule, the slowest shutter speed that is safe to hand hold is matched to the focal length of the lens. That is, a 50mm lens should be hand held at a shutter speed of $\frac{1}{50}$ sec. or faster, a 100mm lens at $\frac{1}{100}$ sec. or faster, and so on. This doesn't mean that the camera can be freely moved during the exposure. At these speeds, the camera can be hand held, but with care. At the moment of exposure, hold your breath and squeeze the shutter release smoothly.

The camera itself can affect your ability to hand hold it; some cameras vibrate more than others during exposure. A single-lens reflex camera, with its moving mirror, for example, vibrates more than a rangefinder camera. Some newer lenses have electronic stabilization systems that help you take sharp photographs at longer exposures.

A tripod and cable release (shown right, bottom) will keep the camera absolutely still during an exposure. The tripod supports the camera steadily; the cable release lets you trigger the shutter without having to touch the camera directly. A tripod and cable release are useful when you need a slower shutter speed than is fea-

sible for hand holding; for example, at dusk when the light is dim. They also help when you want to compose a picture carefully or do close-up work. They are always used for copy work, such as photographing another photograph or something from a book, because hand-holding at even a fast shutter speed will not produce critical sharpness for fine details. A view camera is always used on a tripod.

To protect a camera in use, use a neck strap, either worn around your neck or wound around your wrist. It keeps the camera handy and makes you less likely to drop it. Ever-ready cases enclose the camera and have a front that folds down for picture-taking. They provide protection but can be tedious to take off and put on. Lenses can be kept in lens cases or plastic bags to protect them from dust, with lens caps both back and front for additional protection of lens surfaces.

A padded camera bag will protect your equipment from bumps and jolts when it is carried or moved, and it makes your accessories and extra film readily available. Aluminum or molded plastic cases with fitted foam compartments provide the best protection; some are even waterproof. Their disadvantage is that they are bulky and not conveniently carried on a shoulder strap.

Battery power is essential to the functioning of most cameras. If your viewfinder display or other data display begins to act erratically, the batteries may be getting weak. Many cameras have a battery check that will let you test battery strength or an indicator that warns of low power. It's a good idea to check batteries before beginning a day's shooting or a vacation outing and to carry spares in your camera bag. If you don't have spares and the batteries fail, try cleaning the ends of the batteries and the battery contacts in the camera with a pencil eraser or cloth; the problem may just be poor electrical contact. Warming the batteries in the palm of your hand might also bring them back to life temporarily.

To hand hold a camera, keep feet apart, rest the camera lightly against your face. Hold your breath as you squeeze the shutter release slowly.

With the camera in a vertical position, the left hand holds and focuses the lens; the right hand releases the shutter.

A tripod and cable release are essential if you want a sharp image at slow shutter speeds. Keep some slack in the cable release so it doesn't tug the camera.

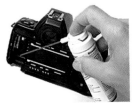

Clean inside the camera. *When you blow or dust inside the camera, tip the camera so the dust falls out and isn't pushed into the mechanism. Don't touch the shutter curtain unless absolutely necessary.*

Clean the lens. *First, blow or brush any visible dust off the lens surface. Hold the lens upside down to let the dust fall off the surface instead of just circulating on it.*

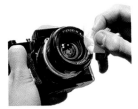

Use lens cleaning fluid. *Dampen a wadded piece of lens-cleaning tissue with the fluid and gently wipe the lens with a circular motion. Don't put lens fluid directly on the lens because it can run to the edge and soak into the barrel. Finish with a gentle, circular wipe using a dry lens tissue.*

Cameras and film in transit should be protected from excessive heat; for example, avoid leaving them in a car on a sunny day. Excessive heat not only damages the quality of film, it can also soften the oil lubricant in the camera, causing the oil to run out and create problems, such as jamming lens diaphragm blades. At very low temperatures, meter batteries and other mechanisms may be sluggish, so on a cold day it is a good idea to keep the camera warm by carrying it under your coat until you're ready to take a picture. When you bring a camera in from the cold, let it warm up before removing the lens cap to keep condensation off the lens. On the beach, protection from salt spray and sand is vital.

If a camera will not be used for a while, turn off any on/off switches, and store the camera away from excessive heat, humidity, and dust. For long-term storage, remove batteries because they can corrode and leak. With a film camera, press the shutter-release button so that the shutter is not left cocked; operate the shutter occasionally because it can become balky if not used.

Protect your camera from dust and dirt. Load and unload film or change lenses in a dust-free place if you possibly can. If changing film, blow or brush around the camera's film-winding mechanism and along the film path. This will remove dust as well as tiny bits of film that can break off and work into the camera's mechanisms. Be careful of the shutter curtain when doing this; it is delicate and should be touched only with extreme care. You may want to blow occasional dust off the focusing mirror or screen, but a competent camera technician should do any work beyond this. Dust and specks that appear in your viewfinder are usually outside the optical path and will likely not appear in your photographs.

Use the right equipment for the job: to blow, a rubber squeeze bulb; to brush, a clean, soft brush designed for photo use. A can of compressed gas produces more force than a rubber squeeze bulb. If you use compressed gas, make sure the product you use does not contain ozone-damaging chlorofluorocarbon (CFC). Never lubricate any part of the camera or lens yourself.

If you have a digital camera, follow the general guidelines for camera body, lens, and battery care. Be especially careful, however, to protect the camera against shock, heat, and sudden temperature changes, and keep it away from strong magnetic fields.

Any lens surface must be clean for best performance, but keeping dirt off it in the first place is much better than frequent cleaning, which can damage the delicate lens coating. Particularly avoid touching the lens surface with your fingers because they leave oily prints that etch into the coating. Keep a lens cap on the front of the lens when it is not in use and add one on the back of the lens if the lens is removed from the camera. During use, a lens hood helps protect the lens surface in addition to shielding the lens from stray light that may degrade the image. UV (ultraviolet) and 1A filters are designed for use with color film but have virtually no effect on black-and-white film, so some photographers leave one on the lens all the time for protection against dirt and accidental damage.

To clean the lens you will need a rubber squeeze bulb or a can of compressed gas, a soft brush, lens tissue, and lens cleaning fluid. Use compressed gas to remove dust, lens cleaner if you have fingerprints or smears. Cans of compressed gas may spray propellant if tilted; keep them vertical for use. Avoid using cleaning products made for eyeglasses, particularly any treated cloths; they are too harsh for lens surfaces. A clean cotton cloth or paper tissue is usable in an emergency, but lens tissue is much better.

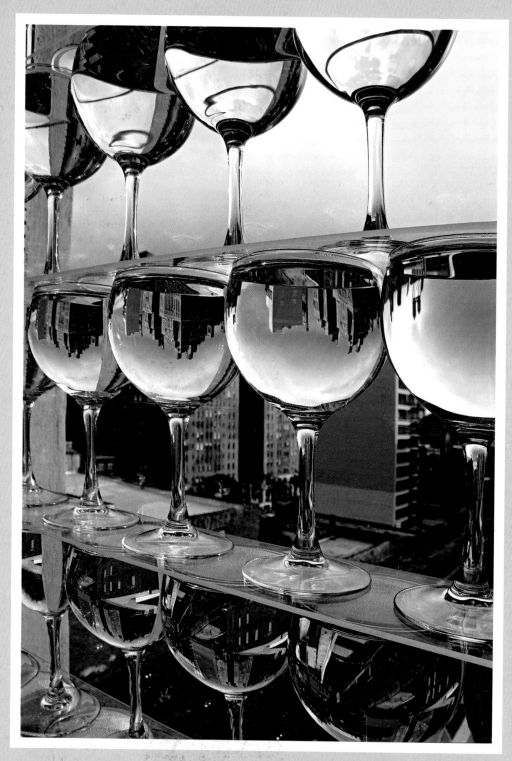

REBECCA CUMMINS
Simply Smashing (Installation view), 2005.
**Any spherical, transparent object forms
an image** *even if it wasn't intended to be a
lens. The view across the street appears in
each water glass just the way it would
appear in a camera. All lenses invert the
image, but the ones made for cameras won't
spill if they are tipped.*

orming an image. Although a good lens is essential for making crisp, sharp photographs, you don't actually need one to take pictures. A primitive camera can be constructed from little more than a shoe box with a tiny pinhole at one end and a piece of film at the other. A pinhole won't make as clear a picture as a glass lens, but it does form an image of objects in front of it.

A simple lens, such as a magnifying glass, will form an image that is brighter and sharper than an image formed by a pinhole. But a simple lens has many optical defects (called *aberrations*) that prevent it from forming an image that is sharp and accurate. A modern compound lens subdues these aberrations by combining several simple lens elements made of different kinds of glass and ground to different thicknesses and curvatures so that they cancel out each other's aberrations.

The main function of a lens is to project a sharp, undistorted image onto the film or image sensor. Lenses vary in design, and different types perform some jobs better than others. Two major differences in lens characteristics are focal length and speed.

Lens focal length is, for a photographer, the most important characteristic of a lens. One of the primary advantages of a single-lens reflex camera or a view camera is the interchangeability of its lenses; photographers own more than one lens so they can change lens focal length. More about focal length appears on the following pages.

Lens speed is not the same as shutter speed. More correctly called *maximum aperture*, it is the widest aperture to which the lens diaphragm can be opened. A lens that is "faster" than another opens to a wider aperture and admits more light; it can be used in dimmer light or with a faster shutter speed.

Focusing ring rotates to bring different parts of the scene into focus.

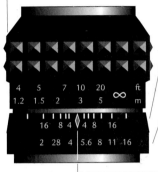

Depth-of-field scale shows how much of the scene will be sharp at a given aperture (explained on page 40).

Aperture-control ring selects the f-stop or size of the lens opening.

Distance marker indicates on the **distance scale** the distance in feet and meters on which the lens is focused.

On the lens barrel (as shown above) are controls such as a ring that focuses the lens. Cameras and lenses vary in design, so check the features of your own camera. For example, some cameras have push-button or dial controls on the camera body instead of an aperture control ring on the lens. Markings on the lens (shown below) always include its focal length and maximum aperture (or a range for each if it is a zoom), usually along with a serial number and the maker's name.

Focal length. The shorter the focal length, the wider the view of a scene. The longer the focal length, the narrower the view and the more the subject is magnified.

Maximum aperture. The lens's widest opening or speed. Appears as a ratio, here 1:2. The maximum aperture is the last part of the ratio, f/2.

Filter size. The diameter in mm of the lens, and so the size of filter needed when one is added onto the lens.

Manufacturer

Lens Focal Length

THE BASIC DIFFERENCE BETWEEN LENSES

Photographers generally describe lenses in terms of their focal length; they refer to a normal, long, or short lens, a 100mm lens, a 75–50mm zoom lens, and so on. Focal length affects the image formed on the film or sensor in two important and related ways: the amount of the scene shown (the angle of view) and thus the size of objects (their magnification).

How focal length affects an image. The shorter the focal length of a lens, the more of a scene the lens takes in and the smaller it makes each object in the scene appear in the image. You can demonstrate this by looking through a circle formed by your thumb and forefinger. The shorter the distance between your hand (the lens) and your eye (the film or digital sensor), the more of the scene you will see (the wider the angle of view). The more objects that are shown on the same size negative or sensor, the smaller all of them will have to be (the less magnification). Similarly, you could fill a negative or sensor either with an image of one person's head or with a group of twenty people. In the group portrait, each person's head must be smaller.

Interchangeable lenses are convenient. The amount of a scene shown and the size of objects can be changed by moving the camera closer to or farther from the subject, but the option of changing lens focal length gives you much more flexibility and control. Sometimes you can't easily get closer to your subject—for example, standing on shore photographing a boat on a lake. Sometimes you can't get far enough away, as when you are photographing a large group of people in a small room.

With a camera that accepts different lenses, such as a single-lens reflex camera, you can remove one lens and put on another when you want to change focal length. Interchangeable lenses range from super-wide-angle fisheye lenses to extra long telephotos. A zoom lens is a single lens with adjustable focal lengths.

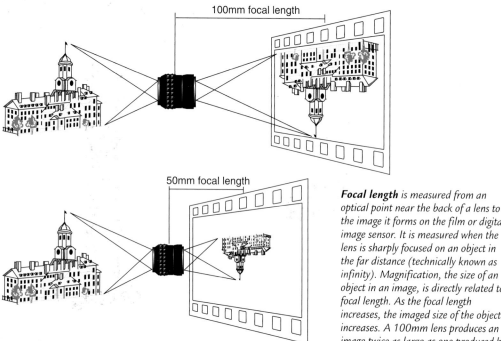

Focal length is measured from an optical point near the back of a lens to the image it forms on the film or digital image sensor. It is measured when the lens is sharply focused on an object in the far distance (technically known as infinity). Magnification, the size of an object in an image, is directly related to focal length. As the focal length increases, the imaged size of the object increases. A 100mm lens produces an image twice as large as one produced by a 50mm lens.

Project:

LENS FOCAL LENGTH

YOU WILL NEED A camera either with a zoom lens or with lenses of two different focal lengths. The greater the difference in focal lengths, the easier it will be to see the difference between them. If you can, use a short-focal-length lens (35mm or shorter) and a long lens (85mm or longer).

PROCEDURE
Put the shorter lens on the camera or adjust the zoom lens to its shortest focal length (its widest view as you look through the camera). Make a head-to-toe photograph of a friend. Note the distance you have to stand from your subject to have his or her feet just touch the bottom edge of the viewfinder frame while the top of the head grazes its upper edge.

Do the same with the longer lens or with the zoom lens adjusted to its longest focal length (its narrowest view). Make a similar pair of views of a house or a chair, fitting your subject exactly into the frame on the film.

HOW DID YOU DO?
Compare the pairs of views. How did the distances you had to be from your subject with the short lens compare to those needed with the long lens? How do the backgrounds in the pairs of views differ? Did the impression of depth in the photographs change when you switched from the short to the long lens? What else changed?

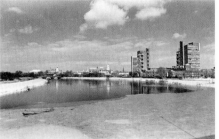

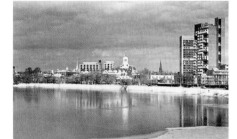

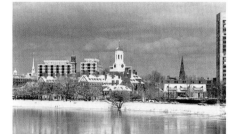

| 24mm | 84° | 50mm | 47° | 100mm | 24° |
| focal length | angle of view | focal length | angle of view | focal length | angle of view |

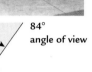
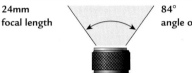
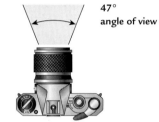
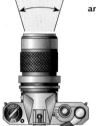

Alan Oransky

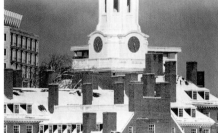

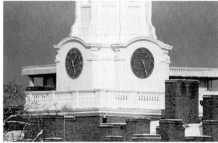

| 200mm | 12° | 500mm | 5° | 1000mm | 2.5° |
| focal length | angle of view | focal length | angle of view | focal length | angle of view |

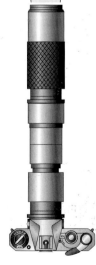

What happens when you change lens focal length? *If everything else stays the same, changing the focal length of the lens changes both the amount of a scene included in the image (angle of view) and the size of objects (magnification). To make this sequence, the photographer changed only the focal length of the lenses; distance from lens to subject remained the same. As the focal length increases (for example, from 24mm to 50mm), the angle of view narrows and the size of objects increases.*

Normal Focal Length

THE MOST LIKE HUMAN VISION

A lens of normal focal length, as you might expect from the name, produces an image on film that seems normal when compared with human vision. The image includes about the same angle of view as the human eye sees clearly when looking straight ahead, and the relative size and spacing of near and far objects appear normal. For 35mm film cameras (or the digital equivalent), this effect is produced by a lens of about 50mm focal length; 35mm single-lens reflex cameras typically are fitted by manufacturers with lenses of that length.

The size of the film (or sensor) used in a particular camera determines what focal length is normal for it; cameras that use film sizes larger than 35mm have proportionately longer focal lengths for their normal lenses. Normal focal length for a film format of 2¼ × 2¾ inches (6 × 7 cm) is 80mm. Normal focal length for a view camera with 4 × 5-inch film is 150mm.

Normal lenses have many advantages. Compared with lenses of much shorter or much longer focal length, normal lenses are generally faster; they can be designed with wider maximum apertures to admit the maximum amount of light. Therefore, they are convenient for use in dim light, especially where action is involved, as in theater or indoor sports scenes or in low light levels outdoors. They are a good choice if the camera is to be hand held because a wide maximum aperture permits a shutter speed fast enough to prevent blur caused by camera movement during exposure. Generally, the normal lens is more compact and lighter, as well as somewhat less expensive, than lenses of much longer or much shorter focal length.

Choice of focal length is a matter of personal preference. Many photographers with 35mm cameras regularly use a lens with a focal length of 35mm rather than 50mm because they like the wider view and greater depth of field that a 35mm lens has compared to a 50mm lens. Some photographers use an 85mm lens because they prefer its narrower view, which can concentrate the image on the central objects of interest in the scene.

Robert Richfield.
Eastbourne, East Sussex,
England, 1993. **A**
normal focal length
lens *produced a*
"normal" view, one that
you might expect to see
from this vantage point.

Henri Cartier-Bresson. *Greece, 1961.* **A lens of normal focal length** *produces an image that appears similar to that of normal human vision. Cartier-Bresson made many of his best-known photographs with a 50mm lens on his 35mm Leica camera. The amount of the scene included in the image and the relative size and placement of near and far objects are what you would expect to see if you were standing next to the camera. The scene does not appear exaggerated in depth, as it might with a short-focal-length lens, nor do the objects seem compressed and too close together, as sometimes happens with a long-focal-length lens.*

Long Focal Length

TELEPHOTO LENSES

A lens of long focal length seems to bring things closer, just as a telescope does. As the focal length gets longer, less of the scene is shown (the angle of view narrows), and what is shown is enlarged (the magnification increases). This is useful when you are so far from the subject that a lens of normal focal length produces an image that is too small. Sometimes you can't get really close—at a sports event, for example. Sometimes it is better to stay at a distance, as in nature photography. An Olympic finish line, the president descending from Air Force One, and an erupting volcano are all possible subjects for which you might want a long lens.

How long is a long lens? A popular medium-long lens for a 35mm film camera (or a digital camera with a sensor the same size as a 35mm frame) is 105mm; this focal length magnifies your view significantly but not so much that the lens's usefulness is limited to special situations. A lens of 150mm has a comparably long focal length for a camera with a 2¼ × 2¾-inch film format, 300mm for a 4 × 5 view camera. The difference between a medium-long lens and an extremely long one (for example, a 500mm lens with a 35mm camera) is rather like that between a pair of binoculars and a high-power telescope. You may want a telescope occasionally, but usually binoculars will do.

A long lens provides relatively little depth of field. When you use long lenses, you'll notice that as the focal length increases, depth of field decreases so that less of the scene is in focus at any given f-stop. For example, when focused at

Andreas Feininger. The Ocean Liner Queen Mary, *New York City, 1946.* **A long lens magnifies a distant subject,** *letting you shoot from a distance. Feininger used a 1000mm lens to shoot across the Hudson River from the New Jersey shore, two miles away.*

Ralph Crane. Los Angeles, California, 1958. **A long lens can seem to compress space.** *Parking meters, cars, and signs seem impossibly squeezed together in this photograph due to the use of a very long focal-length lens. When do you get this effect, and why? See pages 44–45 to find out.*

the same distance, a 200mm lens at f/8 has less depth of field than a 100mm lens at f/8. This can be inconvenient—for example, if you want objects to be sharp both in the foreground of a scene and in the background. But it can also work to your advantage by permitting you to minimize unimportant details or a busy background by having them out of focus.

A medium-long lens is particularly useful for portraits because the photographer can be relatively far from the subject and still fill the image frame. Many people feel more at ease when photographed if the camera is not too close. Also, a moderate distance between camera and subject prevents the exaggerated size of facial features closest to the camera that occurs when a lens is very close. A good working distance for a head-and-shoulders portrait is 6–8 ft. (2–2.5 m), easy to do with a medium-long lens—from 85–135mm focal length—with a 35mm camera.

A long lens, compared with one of normal focal length, is larger, heavier, and somewhat

more expensive. Its largest aperture is relatively small; f/4 or f/5.6 is common. It must be focused carefully because with its shallow depth of field there will be a distinct difference between objects that are sharply focused and those that are not. A faster shutter speed is needed to keep the image sharp while hand-holding the camera (or a tripod should be used for support) because the enlarged image magnifies the effect of even a slight movement of the lens during exposure. These disadvantages increase as the focal length increases, but so do the long lens's unique image-forming characteristics.

Photographers often call any long lens a telephoto lens, or tele, although not all long lenses are actually of telephoto design. The optics of a true telephoto make it smaller than a conventional long lens of the same focal length. A tele-extender or teleconverter contains an optical element that increases the effective focal length of a lens. It attaches between the lens and the camera. The optical performance, however, will not be as good as the equivalent long lens.

Short Focal Length

WIDE-ANGLE LENSES

Eugene Richards. *Reina Cabreras, La Sierra Marcala, Honduras, 1997.* **Short lenses let you put a lot in the picture.** *Here, the photographer was working in a very confined space but still wanted to show as much of the crowded environment as possible. The wide lens gathered all the details.*

Wide-angle lenses are popular with photo-journalists, feature photographers, and others who shoot in fast-moving and sometimes crowded situations. For example, many photojournalists regularly use 35mm or 28mm as their "normal" lens instead of a 50mm lens. These medium-short lenses give a wider angle of view than does a 50mm lens, which makes it easier to photograph in close quarters. Shorter lenses also give you more depth of field, which can let a photographer focus the lens approximately instead of having to fine-focus every shot.

Lenses of short focal length are also called wide-angle or sometimes wide-field lenses, which describes their most important feature—they view a wider angle of a scene than normal. A lens of normal focal length records what you see when you look at a scene with eyes fixed in one position. A 35mm wide-angle lens records the 63° angle of view that you see if you move your eyes slightly from side to side. A 7.5mm fisheye lens records the 180° angle you see if you turn your whole head to look over your left shoulder and then over your right shoulder.

A popular short focal length for a 35mm camera is 28mm. Comparable focal lengths are 55mm for a camera with 6 × 7cm format, and 90mm for a 4 × 5-inch view camera.

A short lens can give great depth of field. The shorter the focal length of a lens, the more of

a scene will be sharp (if the f-stop and distance from the subject remain unchanged). A 28mm lens, for example, when stopped down to f/8 can produce an image that is sharp from less than 6.5 ft. (2 m) to infinity (as far as the eye or lens can see), which often will eliminate the need for further focusing as long as the subject is within the range of distances that will be sharp.

Some digital camera lenses give you unexpected depth of field. The focal length of a lens called normal—or wide or long—depends on the size or format of the film or digital sensor you are using. A 150mm lens is a long lens on a 35mm camera (or a digital camera with a 24 × 36mm sensor), normal on a 4 × 5 view camera, and wide angle on an 8 × 10 view camera. The light-sensitive recording chip in many digital cameras is smaller than the 24 × 36mm frame of

Short lenses show a wide view. *Short-focal-length lenses are useful for including a wide view of an area. They are capable of great depth of field so that objects both close to the lens and far from it will be in focus, even at a relatively large aperture.*

Karl Baden

Objects up close appear larger. *A short lens can produce strange perspective effects. Because it can be focused at very close range, it can make objects in the foreground large in relation to those in the background. With the lens close to the resting man's feet, they look monumental, making a photograph with an entirely different meaning than the one above.*

a 35mm camera. If it is, its normal lens will be shorter than the 50mm lens that is normal for 35mm film.

Digital camera makers often describe lenses as "35mm-equivalent." The compact digital camera pictured at the top of page 12, for example, has a fixed zoom lens (see page 36) with a focal length of 6.0–21.4mm. Because of the small sensor size, it will include the same angle-of-view as would a 28–100mm zoom lens used on a 35mm film camera.

But depth of field depends on the actual focal length of the lens; if everything else stays the same, a shorter lens will always give you greater depth of field. Using the digital camera and zoom lens mentioned above, you would get much greater depth of field for any photograph than you would using its "35mm-equivalent" lens and a 35mm film camera.

Wide-angle "distortion." A wide-angle lens can seem to distort an image and produce strange perspective effects. Sometimes these effects are actually caused by the lens, as with a fisheye lens (page 37 bottom). But, more often, what seems to be distortion in an image made with a wide-angle lens is caused by the photographer shooting very close to the subject.

A 28mm lens, for example, will focus as close as 1 ft. (0.3 m), and shorter lenses even closer. Any object seen from close up appears larger than an object of the same size that is at a distance. While you are at a scene, your brain knows whether you are very close to an object, and ordinarily you would not notice any visual exaggeration. In a photograph, however, you notice size comparisons immediately. Our impression of perspective is based on size relationships that depend on lens-to-subject distance. See the photographs at left.

Zoom, Macro, and Fisheye Lenses

In addition to the usual range of short-, long-, and normal-focal-length lenses, other lenses, such as those described here, can view a scene in a new way or solve certain problems with ease.

Zoom lenses are popular because they combine a range of focal lengths into one lens (see below). The glass elements of the lens can be moved in relation to each other; thus infinitely variable focal lengths are available within the limits of the zooming range. Using a 50–135mm zoom, for example, is like having a 50mm, 85mm, and 135mm lens instantly available, plus any focal length in between. Compared to fixed-focal-length (sometimes called prime) lenses, zooms are somewhat more expensive, bulkier, and heavier, but one of them will replace two or more fixed-focal-length lenses. Zoom lenses are best used where light is ample because they have a relatively small maximum aperture. New designs produce a much sharper image than did earlier zoom lenses, which were significantly less sharp than fixed-focal-length lenses. Most new zoom lenses are also autofocus.

Macro lenses are used for close-up photography (opposite, top). Their optical design corrects for the lens aberrations that cause problems at very short focusing distances, but they can also be used at normal distances. Their disadvantages are a slightly smaller maximum aperture, often f/2.8 for a 50mm lens, and slightly higher cost. (More about making close-up photographs on pages 46–47.)

Macro-zoom lenses combine both macro and zoom features. They focus relatively close, although usually not as close as a fixed-focal-length macro lens, and give a range of focal length choices in one lens.

Fisheye lenses have a very wide angle of view—up to 180°—and they exaggerate to an extreme degree differences in size between objects that are close to the camera and those that are farther away. They actually distort the image by bending straight lines at the edges of the picture (opposite, bottom). Fisheye lenses also produce a great deal of depth of field: objects within inches of the lens and those in the far distance will be sharp.

A zoom lens gives you a choice of different focal lengths within the same lens. The rectangles overlaid on the picture show you some of the very different ways you could have made this photograph by zooming in to shoot at a long focal length or zooming back to shoot at a shorter one.

Robert Richfield

Arlindo Silva. *Red Dragonfly, 1997.*
A macro lens *lets the photographer
get close enough to record very small
details, like this insect close-up. At the
close working distances that this kind
of lens allows, you must be careful to
avoid casting unintentional shadows on
your subject.*

Donald Miralle. *Woodlake Rodeo,
California, 2005.* ***A fisheye lens*** *and
unusual vantage point help capture the
fury of a bull breaking from the gate at
the start of a bull-riding competition.
The fence is bent into a curve by the
lens. Objects at the edge of the
fisheye's image circle are distorted
more than those at the center.*

Focus and Depth of Field

Sharp focus attracts the eye. Sharp focus acts as a signal to pay attention to a particular part of a photograph, especially if other parts of the image are not as sharp. If part of a picture is sharp and part is out of focus, it is natural to look first at the sharply focused area (see photographs, page 185). When you are photographing, it is also natural to focus the camera sharply on the most important area. You can select and, to a certain extent, control which parts of a scene will be sharp.

When you focus a camera on an object, the distance between lens and film (or digital image sensor) is adjusted, usually by rotating the lens barrel until the object appears sharp on the viewing screen. You focus manually by turning the focusing ring on the lens barrel. If you are using an automatic-focus camera, you focus by partially depressing the shutter-release button.

Depth of field. In theory, a lens can only focus on one single distance at a time (the plane of critical focus) and objects at all other distances will be less sharp. But, in most cases, part of the scene will be acceptably sharp both in front of and behind the most sharply focused plane. Objects will gradually become more and more out of focus the farther they are from the most sharply focused area. This region within which objects appear acceptably sharp in the image—the depth of field—can be increased or decreased (see pages 40–41).

Karl Baden

Depth of field is the part of a scene that appears acceptably sharp in a photograph. *Depth of field can be deep, with everything sharp from near to far. In the photograph above, left, it extends from the dog's paws in the foreground to the fluted column behind him. The photographer actually focused on the dog's eye.*

For another picture, above right, the photographer wanted shallow depth of field, with only some of the scene sharp. Here the only sharp part of the picture is the eye on which the lens was focused.

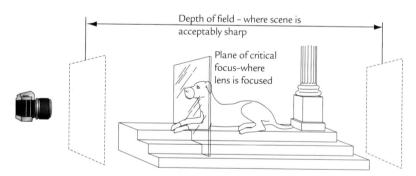

Imagine the plane of critical focus *(the distance on which you focus the lens) to be something like a pane of glass stretched from one side of the scene to the other. Objects that lie along that plane will be sharp. In front of and behind the plane of critical focus lies the depth of field, the area that will appear acceptably sharp. The farther objects are from the plane of critical focus in a particular photograph, either toward the camera or away from it, the less sharp they will be. If objects are far enough from the plane of critical focus to be outside the depth of field, they will appear noticeably out of focus.*

Notice that the depth of field extends about one-third in front of the plane of critical focus, two-thirds behind it. This is true at normal focusing distances, but, when focusing very close to a subject, the depth of field is more evenly divided, about half in front and half behind the plane of critical focus.

Automatic Focus

Automatic focus can mean out of focus when a scene has a main subject (or subjects) off to one side and at a different distance from whatever object is at the center. Most autofocus cameras will focus on the object at the center of the frame, here within the small bracketed area.

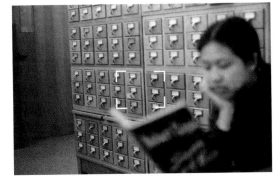

To correct this, first choose the focusing distance by placing the autofocus brackets on the main subject and partially pressing down the shutter-release button. Lock the focus by keeping partial pressure on the shutter release.

Reframe your picture while keeping partial pressure on the shutter release. Push the shutter button all the way down to make the exposure.

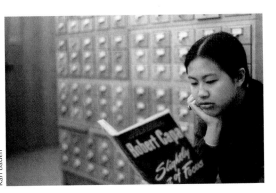

Karl Baden

Automatic focus used to be found only on point-and-shoot snapshot cameras. But now it is standard equipment on almost all 35mm and digital cameras. When you push down the shutter-release button part way, the camera adjusts the lens to focus sharply on what it thinks is your subject—usually whatever object is at the center of the viewing screen.

Sometimes you will want to focus the camera manually. Just as with automatic exposure, there will be times when you will want to override the automatic mechanism and focus the camera yourself. Most 35mm single-lens reflex cameras with automatic focus will also let you focus manually.

The most common problem occurs when your subject is at the side of the frame, not at the center (see photos, left). A camera may also have problems focusing through glass, or if a subject has very low contrast, is in very dim light, or consists of a repetitive pattern.

Moving subjects can also cause problems. The adjustment of the autofocus mechanism can sometimes take long enough for a fast-moving subject, such as a race car, to move out of range. The lens may "hunt" back and forth, unable to focus at all or may make an exposure with the subject out of focus.

Some cameras have more sophisticated electronics to deal with these problems better. Read the instructions for your camera and lens so you know how the autofocus mechanism operates.

Take a moment to evaluate each situation. Override the automatic system when it is better to do so, rather than assume that the right part of the picture will be sharp simply because you are set for automatic focus.

Depth of Field

CONTROLLING SHARPNESS IN A PHOTOGRAPH

Depth of field. Completely sharp from foreground to background, totally out of focus except for a shallow zone, or sharp to any extent in between—you can choose how much of your image will be sharp. When you make a picture, you can manipulate three factors that affect the depth of field (the distance in a scene between the nearest and farthest points that appear sharp in a photograph). Notice in the illustrations opposite that doing so may change the image in other ways.

Aperture size. Stopping down the lens to a smaller aperture, for example, from f/2 to f/16, increases the depth of field. As the aperture gets smaller, more of the scene will be sharp in the photograph.

Focal length. Using a shorter-focal-length lens also increases the depth of field at any given aperture. For example, more of a scene will be sharp when photographed with a 50mm lens at f/8 than with a 200mm lens at f/8.

Lens-to-subject distance. Moving farther away from the subject increases the depth of field most of all, particularly if you started out very close to the subject.

Marc PoKempner. Rev. Ike, Chicago, 1975. **Shallow depth of field lets you draw immediate attention to one area;** *we tend to look first at the sharpest objects in a photograph. The message of preacher Reverend Ike is that God is generous and will give you exactly what you ask for, including, for example, a diamond-studded watch, ring, and cuff links, on which the photographer focused.*

The smaller the aperture (with a given lens), the greater the depth of field. *Using a smaller aperture for the picture on the far right increased the depth of field and made the image much sharper overall. With the smaller aperture, the amount of light entering the camera decreased, so a slower shutter speed had to be used to keep the total exposure the same.*

Large Aperture

Fredrik D. Bodin

Small Aperture

The shorter the focal length of the lens, the greater the depth of field. *Both of these photographs were taken from the same position and at the same aperture. Notice that changing to a shorter focal length for the picture on the far right not only increased the depth of field but also changed the angle of view (the amount of the scene shown) and the magnification of objects in the scene.*

Long Lens

Fredrik D. Bodin

Short Lens

The farther you are from a subject, the greater the depth of field, *at any given focal length and aperture. The photographer stepped back to take the picture on the far right. If you focus on an object far enough away, the lens will form a sharp image of all objects from that point out to infinity.*

Up Close

Karl Baden

Farther Back

More about Depth of Field

HOW TO PREVIEW IT

When photographing a scene, you will often want to know the extent of the depth of field—how much of the scene from near to far will be sharp. You may want to be sure that certain objects are sharp. Or you may want something deliberately out of focus, such as a distracting background. To control what is sharp, it is useful to have some way of gauging the depth of field.

Checking the depth of field. With a single-lens reflex camera, you view the scene through the lens. No matter what aperture setting you have selected, the lens is ordinarily wide open for viewing to make the viewfinder image as bright and easy to see as possible. However, the large aperture size means that you see the scene with depth of field at its shallowest. When you press the shutter release, the lens automatically closes down to the taking aperture. Unless you are taking a picture using the widest aperture, the viewfinder image will not have the same depth of field as the final photograph. Some single-lens reflex cameras have a previewing mechanism so that, if you wish, you can stop down the lens to view the scene at the taking aperture and see how much will be sharp.

Unfortunately, if the lens is set to a very small aperture, the stopped-down image on the viewing screen may be too dark to be seen clearly. If so, or if your camera doesn't have a preview feature, you may be able to read the nearest and farthest limits of the depth of field on a depth-of-field scale on the lens barrel (this page, bottom). Many newer autofocus lenses don't have them, so manufacturers sometimes provide printed tables showing the depth of field for different lenses at various focusing distances and f-stops.

Depth of field with a view camera, which also views through the lens, can be seen on the ground-glass viewing screen when the lens is stopped down to the taking aperture. A rangefinder camera shows you the scene through a viewfinder, a small window in the camera body through which all objects look equally sharp. Use a depth-of-field scale on the lens barrel or a printed table to estimate depth of field with a rangefinder camera.

Zone focusing for action. Knowing the depth of field in advance is useful when you want to preset the lens to be ready for an action shot without last-minute focusing. Zone focusing uses the depth-of-field scale on the lens to preset the focus and aperture so that the action will be photographed well within the depth of field (see below).

Lou Jones. Giant Slalom, Winter Olympics, Japan, 1998. **With zone focusing** *you can be ready for an action shot by focusing in advance, if you know approximately where the action will take place. Suppose you are on a ski slope and you want to photograph a skier coming down the hill. The nearest point at which you might want to take the picture is 15 ft. (4.5 m) from the action; the farthest is 30 ft. (9 m).*

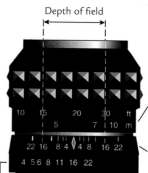

Depth of field

Distance scale lines up opposite the pointer to show the distance from the camera to the most sharply focused object.

Depth-of-field scale lines up opposite the distance scale to show the range of distances that will be sharp at various apertures.

Aperture ring lines up opposite the pointer to show the aperture to which the lens is set.

Line up the distance scale so that these two distances are opposite a pair of f-stop indicators on the depth-of-field scale (with the lens shown at left, the two distances fall opposite the f/16 indicators). Now, if your aperture is set to f/16, everything from 15–30 ft. (4.5–9 m) will be within the depth of field and in focus. It doesn't matter exactly where the subject is when you make the photograph, as long as it is somewhere within these distances.

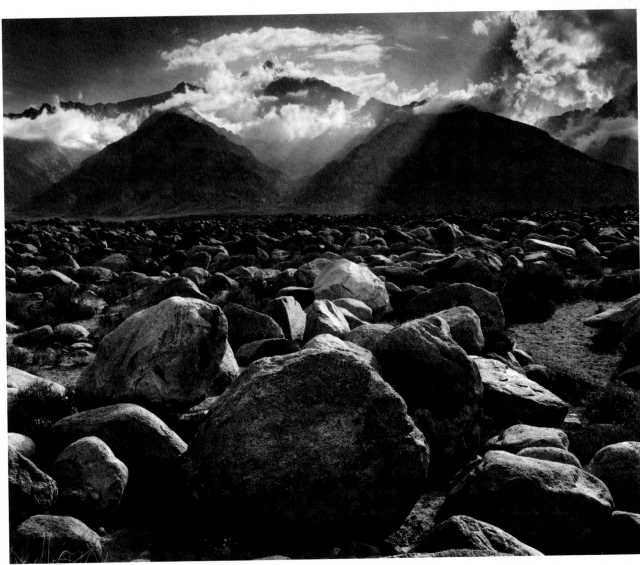

Ansel Adams. Mt. Williamson from Manzanar, California, 1944. **The smaller the aperture the greater the depth of field.** *Everything in the picture above is sharp. Adams usually used a view camera (pages 12–13), which offers additional control over focus, and he preferred its large-format film for making prints of greater clarity.*

View cameras are always used on a tripod. Even if you are using a 35mm camera, a tripod is a good idea to avoid motion blur when the aperture is small and the shutter speed is correspondingly slow.

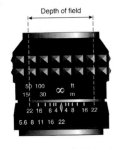

When the lens is focused at infinity *(∞ on the lens distance scale), everything at some distance away and farther will be sharp: with this lens at f/22 everything will be sharp from 50 ft. (16 m) to infinity (as far as the eye can see).*

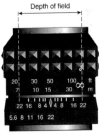

You can increase the depth of field *even more if, instead of focusing on infinity, you set the infinity mark (∞) opposite the point on the depth-of-field scale (22) that shows the f-stop you are using (f/22). You are now focused on a distance (50 ft., 16 m) slightly closer than infinity (technically called the* hyperfocal *distance). Now everything from 23 ft. (7 m) to the far background is within the depth of field and will be sharp in the image.*

Focusing for the greatest depth of field.

When you are shooting a scene that includes important objects at a distance as well as close up, you will want maximum depth of field. Shown above is a way of setting the lens to per-mit as much as possible of the scene to be sharp. You'll need a lens that has a depth-of-field scale. If you are using depth of field tables, it will be in a special column for *hyperfocal distance.*

Perspective

HOW A PHOTOGRAPH SHOWS DEPTH

Perspective: the impression of depth. Few lenses (except the fisheye) noticeably distort the scene they show. The perspective in a photograph—the apparent size and shape of objects and the impression of depth—is what you would see if you were standing at the camera position. Why then do some photographs seem to have an exaggerated depth, with the subject appearing stretched and expanded (this page, top), whereas other photographs seem to show a compressed space, with objects crowded very close together (this page, bottom)? The brain judges depth in a photograph mostly by comparing objects in the foreground with those in the background; the greater the size differences perceived, the greater the impression of depth. When viewing an actual scene, the brain has other clues to the distances. But, when looking at a photograph, the brain relies primarily on relative sizes.

Perspective can be controlled in a photograph. Any lens very close to the foreground of a scene increases the impression of depth by increasing the size of foreground objects relative to objects in the background. As shown opposite, perspective is not affected by changing the focal length of the lens if the camera remains in the same position. However, it does change if the distance from lens to subject is changed.

Perspective can be exaggerated if you change both focal length and lens-to-subject distance. A short-focal-length lens used close to the subject increases differences in size because it is much closer to foreground objects than to those in the background. This increases the impression of depth. Distances appear expanded and sizes and shapes may appear distorted.

The opposite effect occurs with a long-focal-length lens used far from the subject. Differences in sizes are decreased because the lens is relatively far from all objects. This decreases the apparent depth and sometimes seems to squeeze objects into a smaller space than they could occupy in reality.

Walter Iooss. *Ali vs. Terrell, Houston, 1967.* **Expanded perspective** *seems to result from the very wide lens. But using any lens this close to a subject stretches distances because it magnifies objects near the lens in relation to those that are far from the lens.*

Walter Iooss. *100 m start, Los Angeles, 1983.* **Compressed perspective** *is usually associated with a long-focal-length lens. It is because the lens is relatively far from both foreground and background that size differences between near and far parts of the scene are minimized, as is the impression of depth.*

Alan Oransky

Changing focal length alone does not change perspective—*the apparent size or shape of objects or their apparent position in depth. In the photographs above, the camera was not moved, but the lens focal length was increased. As a result, the size of all the objects increased at a comparable rate. Notice that the size of the fountain and the size of the windows in the background both change the same amount. The impression of depth remains the same.*

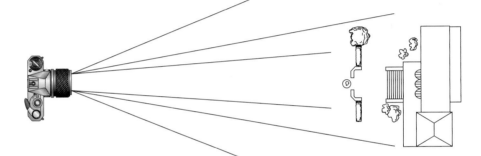

Lens-to-subject distance controls perspective. *Perspective is changed when the distance from the lens to objects in the scene is changed. Notice how the size of the fountain gets much bigger while the size of the windows remains about the same. The depth seems to increase because the camera was brought closer to the nearest part of the subject.*

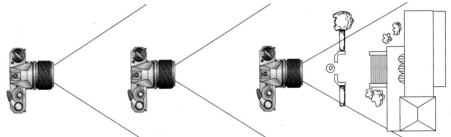

Lens Attachments

MAKING CLOSE-UPS

Close-up equipment. Shown on the right are different types of close-up equipment you can use to produce a larger-than-normal image on your negatives if you don't have a macro lens. All of them do the same thing: they let you move in very close to a subject.

Close-up terms. The closer your camera is to a subject, the larger the image on the film. It is a *close-up* when the image on the film ranges from about $\frac{1}{10}$ life size (1:10) to as big as life size (1:1). *Macro-photography* generally refers to an image on film that is anywhere from life size (1:1) to as big as ten times life size (10:1). *Photo-micrography*, photographing through a microscope, is usually used to get a film image larger than 10:1.

Depth of field is shallow in close-ups. At very close focusing distances, perhaps an inch or less of the depth in the scene may be sharp, even at your smallest aperture. The closer the lens comes to the subject, the narrower the depth of field (the more the background and foreground go out of focus). Accurate focusing is essential or the subject may be out of focus altogether. Moving the camera slightly forward or back may help to get precise focusing. Smaller apertures, as they will at any other distance, increase the depth of field, but stopping down also increases the exposure time. It may be necessary to use a tripod and, if you are photographing outdoors, to shield your subject from the wind to prevent its moving during the exposure.

*A **macro lens** is your best choice for sharp close-ups. If you don't have one, there are several other ways to get close to your subject.*

*A **close-up lens** attaches to the front of a camera lens. They come in different strengths (measured in diopters); the higher the diopter number, the closer you can focus. Close-up lenses are relatively inexpensive and small, but image quality will not be as good as with other close-up methods.*

Bellows (and similar extension tubes) fit between the lens and the camera to increase the distance from the lens to the film; the greater this distance, the closer you can bring the lens to the subject. Extension tubes come in fixed sizes; a bellows is more adaptable because it can be expanded to any length. Using either extension tubes or bellows requires increasing the exposure; see the text opposite.

*Stanley Rowin. Acupuncture, 1995. **The therapist's hands were shot with a macro lens.** The background was purposefully rendered dark and featureless to avoid distracting from the subject.*

Martin Parr. Budapest, 1997. **In a close-up photograph,** *the image on film is ¹/₁₀ life size or larger. In an 8 × 10-inch print, the fingers would be a little larger than life size. A standard camera lens doesn't let you get close enough to a subject to make it that big, so you will need a macro lens or other close-up equipment (see opposite page). Parr used a flash mounted close to the lens to avoid an unintentional shadow of the camera on the subject.*

smaller apertures. Exposures, then, risk motion blur because they are often longer than normal. A tripod will prevent camera motion during exposure. To make sure your long exposures on film are correct, read about reciprocity failure, page 80.

Making the subject stand out from the background. Because a close-up is usually one small object or part of an object, rather than an entire scene, it is important to have some way of making the object you are photographing stand out clearly from its background. Move your camera around to view the subject from several different angles; you may find that from some positions the subject will blend into the background, whereas from others it becomes much more dominant. Shallow depth of field can be an asset in composing your picture. You can use it to make a sharp subject stand out distinctly from an out-of-focus background as in the photograph on page 40. Tonal contrast of light against dark, the contrast of one color against another, or the contrast of a coarse or dull surface against a smooth or shiny one can also make your close-up subject more distinct.

Increased exposures are always needed for close-ups. Regardless of the method—a macro lens, extension tubes, or a bellows— you must move the lens farther from the film or the sensor to focus closer to a subject. But the farther the lens is extended, the dimmer the light that reaches the light-sensitive surface, and the more you must increase the exposure so the result will not be underexposed.

A camera that meters through the lens will increase the exposure automatically. But if the close-up attachment breaks the automatic coupling between lens and camera or if you are using a hand-held meter, you must increase the exposure manually; follow the recommendations given by the manufacturer of the tubes or bellows.

Use a tripod whenever you can. Because depth of field is limited in close-ups (see the page opposite), you will often want to use

Lighting close-ups. Indoors or out, direct light shining on a subject can let you use smaller apertures for greater depth of field. If you want to bring out texture, light angling across the subject from the side will pick out every ridge, fold, and crease. Direct light can be very contrasty, though, with bright highlights and too-dark shadows. If this is the case, fill light can help lighten the shadows (pages 136–137). Close-up subjects are small, so using even a letter-sized piece of white paper as a reflector can lighten shadows significantly.

To copy a flat subject, such as a page from a book, lighting should be even. Two lights of equal intensity, one on each side of the subject, and at the same distance and angle, will illuminate it uniformly.

Lens Attachments

USING FILTERS

Filters for black-and-white film photography. Most black-and-white films are *panchromatic*—sensitive to all colors to about the same extent that the human eye is. Blue colors, however, tend to record somewhat lighter than we expect them to in black-and-white photographs, and one of the most frequent uses of filters is to darken a blue sky so that clouds stand out more distinctly (shown opposite). A colored filter with black-and-white film will lighten objects of its own color and darken objects that are opposite in color. The chart opposite, top, lists some of the filters commonly used in black-and-white pictures.

Filters for color film photography. If you want a natural color rendition with color film, you need to match the color balance of the light source to the color balance of the film (see pages 60–61). You can't change the response of the film, but you can change the color of the light that reaches the film by using a filter. Using an FL (fluorescent) filter on the lens, for example, decreases the greenish cast of pictures taken under fluorescent light. Various filters for color photography are listed in the chart opposite, bottom. Digital pictures can be adjusted the same way with the camera or during editing.

Increasing exposures when filters are used. Filters work by removing some of the light that passes through them. To compensate for the resulting loss of light, the exposure must be increased to prevent underexposure. If you are using a handheld meter, increase the exposure by the number of stops shown in these charts or as recommended by the filter manufacturer. To review changing exposure by stops, see page 22.

Instead of giving the number of stops you need to increase the exposure, some sources do the same thing by giving you a filter factor. The factor tells how many times the exposure should be increased. A factor of 2 means the exposure should be doubled (a one-stop change). A factor of 4 means the exposure

should be increased four times (a two-stop change). See chart this page.

Increasing exposures with a through-the-lens meter. If you are using a camera with a through-the-lens meter, you may not get a good exposure if you meter the scene with a filter on the lens. The sensor in the camera that reads the amount of light may not respond to the color of light in the same way film does. Generally, the sensor will give an accurate exposure reading with lighter filters but not always with darker ones that require several stops of exposure change. A red filter, for example, requires three stops extra exposure when used in daylight with black-and-white film, but some cameras give only two stops more exposure if they meter through that filter. The result: one stop underexposure and a thin, difficult-to-print negative.

Here's how to check your camera's response if you plan to use one of the darker filters. Meter a scene without the filter and note the shutter speed and/or f-stop. Now put the filter on the lens and meter the same scene. Compare the number of stops the camera's settings change with the number of stops they should have changed. Adjust the settings manually, if needed, when using that filter.

Gelatin filters come in 2-in. and larger squares that can be cut to various sizes. They can be taped onto the front of the lens or fit into a filter holder. They are less expensive than glass filters and come in many colors, but they can be scratched or damaged relatively easily. Handle them by their edges only.

Glass filters attach to the front of the lens and are made in sizes to fit various lens diameters. To find the diameter of your lens, look on the ring engraved around the front of the lens. The diameter (in mm) usually follows the symbol Ø. They are convenient, sturdier, and they will protect your lens better than gelatin filters, but they are usually more expensive.

If filter has a factor of...	Increase exposure this many stops
1	0
1.2	1/3
1.5	2/3
2	1
2.5	1 1/3
3	1 2/3
4	2
5	2 1/3
6	2 2/3
8	3
10	3 1/3

Filter factors. *You need to increase the exposure when using most filters. Sometimes this increase is given as a filter factor. If so, see chart for how many stops the exposure should be increased.*

Filters for Black-and-White Film

		Type of Filter	Exposure Increase Needed	
			In daylight	In tungsten light
To darken blue objects, make clouds stand out against blue sky, reduce bluish haze in distant landscapes, or make blue water darker in marine scenes.	Darkens blue objects for a natural effect	8 (yellow)	1 stop	⅔ stop
	Makes blue objects darker than normal	15 (deep yellow)	1⅓ stops	⅔ stop
	Makes blue objects very dark	25 (red)	3 stops	2⅓ stops
To lighten blues to show detail, as in flowers. To increase haze for atmospheric effects in landscapes.		47 (blue)	2⅔ stops	3⅔ stops
To lighten reds to show detail, as in flowers.		25 (red)	3 stops	2⅓ stops
To lighten greens to show detail, as in foliage.		11 (yellow-green)	2 stops	2 stops
To make the range of tones on panchromatic black-and-white film appear more like the range of brightness seen by the eye.		In daylight, 8 (yellow)	1 stop	
		In tungsten, 11 (yellow-green)		2 stops

A blue sky may appear very light in a black-and-white photograph *because film is very sensitive to the blue and ultraviolet light present in the sky.*

Filters for Color Film

	Type of Filter	Exposure Increase Needed
To reduce the bluishness of light on overcast days or in the shade. To penetrate haze. Used by some photographers to protect lens.	1A (skylight) or UV (ultraviolet)	No increase
To decrease bluishness more than 1A or UV.	81A (yellow)	⅓ stop
To get a natural color balance with fluorescent light.	Use FL-B with tungsten-balanced film; FL-D with daylight-balanced film	1 stop
To get a natural color balance with daylight-balanced film exposed in tungsten light.	Use 80A (blue) with ordinary tungsten bulbs or 3200K photolamps; 80B (blue) with 3400K photofloods	2 stops (80A) 1⅔ stops (80B)
To get a natural color balance with indoor film exposed in daylight.	Use 85B (amber) with tungsten-balanced film	⅔ stop
To balance film precisely as recommended by film manufacturer.	CC (color compensating): R (red), G (green), B (blue), Y (yellow), M (magenta), C (cyan)	Varies
To experiment with color changes.	Any color	Varies

A yellow filter *darkened the blue sky and made the clouds and steam stand out. It will also darken shadow areas, which are bluish in tone because they are lit by skylight.*

Lens Attachments

POLARIZATION AND OTHER EFFECTS

A **polarizing filter can remove reflections.** If you have ever tried to photograph through a store window, but wound up with more of the reflections from the street than whatever you wanted to photograph inside the store, you know how distracting unwanted reflections can be. Using a polarizing filter is a way to eliminate some of these reflections (see photographs opposite). The filter eliminates or decreases reflections from glass, water, or any smooth non-metallic surface.

Landscapes can be sharper and clearer with a polarizing filter. Light reflected from particles of water vapor or dust in the atmosphere can make a landscape look hazy and obscured. A polarizing filter will decrease these minute reflections and allow you to see more distant details. It may also help to make colors purer and more vivid by diminishing unwanted coloring such as reflections of blue light from the sky. And using a polarizer is the only way to darken the sky with color film, see the photographs below.

A polarizing filter works best at certain angles. The screen attaches to the front of the camera lens and can be rotated to increase or decrease the polarization. Changing the angle to the subject also affects the polarization (see diagrams, below). With a single-lens reflex or other camera that views through the lens, you can see in the viewfinder the effect of the filter and adjust your position or the filter until you get the results you want. An exposure increase of about $1\frac{1}{3}$ stops is required. A through-the-lens meter will adjust the exposure correctly if you meter with the filter on the lens.

Neutral-density (ND) filters remove a fixed quantity of light from all wavelengths, consequently reducing the overall amount of light that reaches the lens. These filters make it possible to

Best Positions for a Polarizing Filter

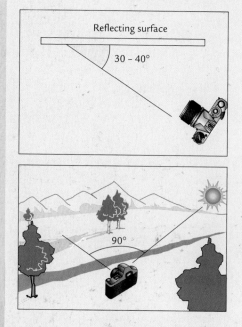

Reflecting surface

30 – 40°

90°

A polarizing filter removes reflections from surfaces such as glass (see photographs opposite). The filter works best at a 30°–40° angle to the reflecting surface.

When shooting landscapes, using a polarizing filter makes distant objects clearer and the sky darker, as in the example at right. The effect is strongest when you are shooting at a 90° angle to the sun.

Without polarizing filter.

With polarizing filter.

use a slower shutter speed or larger aperture than you otherwise could. For example, if you want to blur action but can't use a slower shutter speed because you are already set to your smallest aperture, an ND filter over the lens has the effect of dimming the light, letting you then set a slower shutter speed. Similarly, if you want to decrease depth of field but are already set to your fastest shutter speed, an ND filter would let you open the aperture wider.

Special effects with lens attachments. In addition to the filters that change tone or color, other lens attachments manipulate or change the image itself. A soft-focus attachment blurs details slightly to make them appear hazy, as if seen through a filmy screen. A cross-screen attachment (star filter) causes streamers of light to radiate from bright light sources, such as light bulbs, reflections, or the sun. Other lens attachments produce multiple images, vignette the image, or create other special effects. All of these special effects and more can also be achieved by using digital imaging (see Chapter 8).

Reflections are a distracting element in the top photograph if the goal is to show the hippo and his friend on display inside the museum case. A polarizing filter on the camera lens removed most of the reflections in the bottom photograph so that they can be seen clearly. (The diagram on the opposite page, top, shows the best position to stand when using a polarizing filter to remove reflections.)

Karl Baden

ELAINE O'NEIL
Sonora Desert Museum,
Tucson, Arizona, 1973.

The **light sensitivity of film.** The most important characteristic of film (or a digital camera's recording sensor) is that it is light sensitive; a change occurs when it is exposed to light. Light is energy, the visible part of the electromagnetic energy that exists in a continuum from radio waves through visible light to cosmic rays. These forms of energy differ only in their wavelength, the distance from the crest of one wave to the crest of the next. The visible part of this spectrum, the light that we see, ranges between 400 and 700 nanometers (billionths of a meter) in wavelength.

Not all films respond the same way to light. Silver halides (compounds of silver with chlorine, iodine, bromine, or fluorine) are the light-sensitive part of film. They respond primarily to blue and ultraviolet wavelengths, but dyes in the gelatin emulsion that hold the halides increase the film's range of sensitivity. General-purpose black-and-white films are panchromatic (pan); they are designed to be sensitive to the wavelengths in the visible spectrum, so the image they record is similar to that perceived by the human eye. Some special-purpose films are designed to be sensitive to selected parts of the spectrum. Orthochromatic (ortho) black-and-white films are sensitive to blue and green wavelengths, but not to red. Infrared films are sensitive to all visible light, and also to infrared wavelengths that are invisible to the human eye (see pages 58–59).

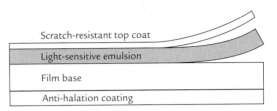

Film cross section. *Film is made up of layers of different materials. On top is a tough coating that helps protect the film from scratches during ordinary handling. Next is the emulsion, a layer of gelatin that contains the light-sensitive part of the film, silver halide crystals—usually a combination of silver chloride, silver bromide, and silver iodide. (Color film has three layers of halides, each made sensitive to a different part of the spectrum.) An adhesive bonds the emulsion to the base, a flexible plastic support. Below the base is an opaque anti-halation dye that absorbs light rays so they don't bounce back through the film and add unwanted exposure to the emulsion.*

Light. *When certain wavelengths of energy strike the human eye, they are perceived as light. Film is manufactured so that it undergoes changes when struck by this part of the electromagnetic energy spectrum. Film also can respond to additional wavelengths that the eye cannot see, such as ultraviolet and infrared light.*

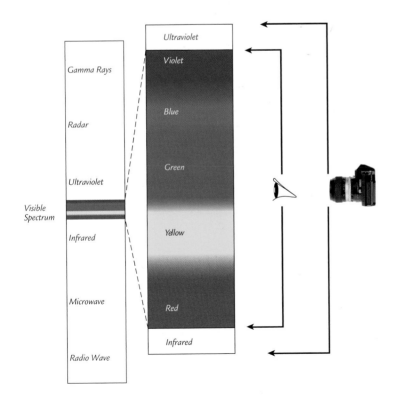

Selecting and Using Film

When you buy film, you'll be confronted by a wide variety, but which one you select depends on only a few basic choices.

Do you want black and white or color? Choose a black-and-white film by its speed, or ISO; see below. With color film, choose a color balance. Daylight-balanced color films are made for the relatively bluish light of daylight or electronic flash. Tungsten films are better for the relatively reddish light from incandescent light bulbs and for longer exposures (see page 80).

Do you want a print? If so, choose a negative film. It will produce an image on the film in which the tones are the opposite of the original scene: light areas in the scene are dark in the negative, dark areas are light. The negative is then used to make a positive print in which the tones are similar to those in the original scene. A print can be also be digitally made from either a negative or a transparency (see Chapter 8, Digital Photography, pages 146–177).

Do you want a transparency? Choose a color reversal film if you want a transparency, a positive image on film, but first read about latitude on page 62. A slide is a 35mm transparency mounted in a small frame of cardboard or plastic so that it can be inserted into a projector. A *chrome* is the professionals' slang for any color transparency, but usually ones larger than 35mm.

During reversal processing, the film tones are chemically reversed so that a positive image appears on the film. If you want a black-and-white transparency, process Kodak T-Max 100 in the T-Max 100 Direct Positive Film Developing Outfit.

What film speed do you want? The higher the ISO, the more sensitive a film is to light and so the less light needed for a correct exposure. A slow film has a speed of about ISO 50 or less; a medium-speed film is about ISO 100. Fast films are about ISO 400 and ultrafast films are rated at ISO 1000 or more. See pages 56–57 for more about film speed.

What size film and number of exposures do you want? The size depends on your camera. 35mm film is packaged in cassettes, with 12, 24, or 36 exposures per roll, labeled 135-12, 135-24, or 135-36. Some 35mm films can be purchased in 50- or 100-foot rolls and hand-loaded into cassettes. This reduces your cost per roll.

Roll film is wrapped around a spool and backed with a strip of opaque paper to protect it from light. (The term roll is also used in a general sense to refer to any film that is rolled, as compared to a flat sheet film.) 120 roll film makes 12 2¼-inch (6cm) square negatives or, in some cameras, 8, 10, or 16 rectangular negatives, depending on the dimensions of the format. Some cameras accept longer 220 roll film, which gives twice as many exposures per roll.

Sheet film or cut film, made in 4 × 5 inch and larger sizes, is used in view cameras. It must be loaded into film holders before use, and it produces one picture per sheet.

Do you want a film for a special purpose? Infrared film responds to infrared wavelengths that the human eye cannot see; chromogenic black-and-white films can be processed by a one-hour color lab (see pages 58–59).

*Linda Connor. Entwined Buddha, Ayuthaya, Thailand, 1988. **A medium-speed film**, ISO 100, was chosen for this photograph. The fine grain and excellent sharpness of the film recorded every detail and delicate shading in the dark tones in the shadows as well as the light tones of the face and exposed roots. With a slow- or medium-speed film, you can make large prints without the image showing significant graininess (see page 56).*

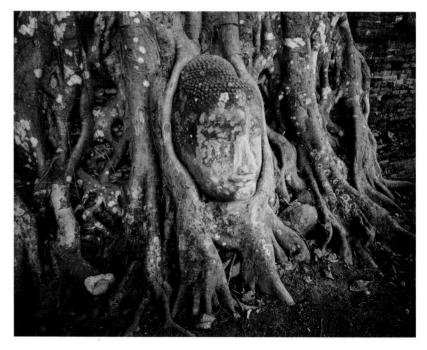

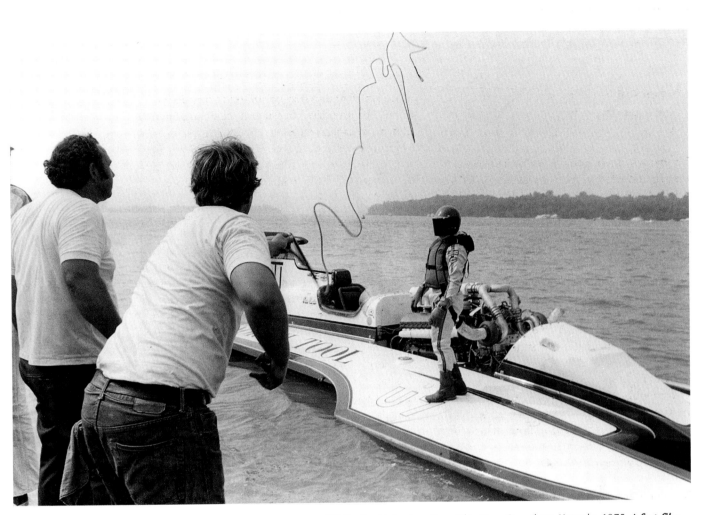

Bill Burke. *Hydroplane Race, Ohio River, Owensboro, Kentucky, 1975. A **fast film**, such as one rated at ISO 400, is good not only for those times when the light is relatively dim but for any situation in which you want to work with a fast shutter speed, a small aperture, or—as in this case—both.*

Take Care with Film

An expiration date is printed on the film package; check it before you make your purchase. The film is usable beyond that date but steadily deteriorates. Color film changes slightly each time the manufacturer makes a batch, so many professionals buy a quantity with the same emulsion number, which identifies the batch. That way they can test one roll and know the others will behave the same way.

Store film in a cool place. Heat accelerates the deterioration of film, so avoid storing it in a warm place such as the inside of a glove compartment on a hot day or the top of a radiator on a cold one. Room temperature is fine for short-term storage, but for longer storage a refrigerator or freezer is better. (Don't freeze Polaroid instant-picture film.) Be sure that the film to be chilled is in a moisture-proof wrapping, and, when you remove the film from refrigeration, avoid condensation of moisture on the film surface by giving it several hours to come to room temperature before opening.

Load film in the shade. Light exposes film, and you want only the light that comes through the lens to strike the film. So load and unload your camera away from strong light to avoid the possibility of stray light leaking into the film cassette and causing streaks of unwanted exposure. When loading film into your camera outdoors, find shade, or at least block direct sun by shading the camera with your body.

Airport security X-ray devices used in the United States for carry-on baggage are generally safe for film. Testing equipment for checked baggage can ruin film, as can some devices in foreign airports. They will fog undeveloped film when the machines are not adjusted correctly or when the operator singles out something in a bag for closer inspection. This will be more of a problem with higher-speed films, but you should always ask to have film (and camera, if it is loaded) inspected by hand to reduce the possibility of X-ray damage.

Film Speed and Grain

THE TWO GO TOGETHER

Film speed ratings. How sensitive a film is to light, that is, how much it reacts to a given quantity of light, is indicated by its film speed. The more sensitive—or faster—the film, the higher its number in the rating system. (See opposite page: Film Speed Ratings.)

A high film speed is often useful: the faster the film, the less exposure it needs to produce an image. Fast films are often used for photographing in dim light or when a fast shutter speed is important. But along with fast film speed go some other characteristics: most important, an increase in graininess plus some decrease in contrast and loss of sharpness. With color films, there is also a loss of color accuracy and saturation. As the photographs on this page show, the most detailed image was produced by the slow ISO 25 film. The very fast ISO 3200 film, by comparison, gave a relatively mottled, grainy effect.

Graininess occurs when the bits of silver that form the image clump together. It is more likely to occur with fast films, which have large and small silver halide crystals, than it is with slower films, which have only small crystals. The effect is more noticeable in big enlargements, if the film is overexposed, if it is not processed at a consistent temperature, or if it is "pushed" to increase its film speed by extended development.

What film speed should you use? Ideally, for maximum sharpness you should choose the slowest film usable in a given situation. For practical purposes, however, most photographers load a medium-speed (ISO 100) film for general use. A higher-speed (ISO 400) film will be their choice for dimly lit subjects or those requiring high shutter speeds.

There is nothing necessarily wrong with grain. Some photographers even try to increase the graininess of their pictures because they like the textured look it can give, especially in

ISO 25 ISO 400 ISO 3200

Slower film speed — Smaller grain / Finer detail / More contrast

Karl Baden

extreme enlargements. Films such as Ilford HP-5 Plus and Kodak Tri-X, which both have a film speed of ISO 400, are relatively fine grained when exposed and developed normally, but increase considerably in graininess when pushed. See Push Processing, page 98.

Certain films have reduced graininess, such as Kodak T-Max or Ilford Delta films. The shape of their silver crystals makes them more sensitive to light, but without a corresponding increase in grain. A caution: follow processing instructions carefully. Even a slight increase in time, temperature, or agitation during development may cause a distinct increase in film contrast. Although, for example, Kodak Tri-X (ISO 400) is grainier than T-Max 400 (same film speed), Tri-X and other standard ISO 400 films continue to be used because they are easier to control with ordinary darkroom processing and because they record tones differently, in a way that some photographers prefer. Black-and-white films based on color technology (see page 58) also offer reduced graininess.

Film speed and grain.
Generally speaking, the slower the film (the lower the ISO number), the finer the grain structure of the film and the more detailed the image the film records. Compare these extreme enlargements. Film speed also affects color film; for example, slower films have more accurate color reproduction.

*Josef Koudelka. Spain, 1971. **A fast film** let the photographer use a shutter speed of ¹⁄₅₀₀ sec. This shutter speed was fast enough to guarantee that action would be sharp in the picture and fast enough to let the photographer shoot freely, hand-holding the camera without fear that camera motion would blur the picture overall.*

Film Speed Ratings

Although there are different rating systems for film speeds, the most important point to remember is that the higher the number in a given system, the faster the film, and, so, the less light needed for a correct exposure.

The most common ratings found in English-speaking countries are **ISO** (International Organization for Standardization) and **EI** (exposure index). **ASA** is an older rating system that is still sometimes mentioned. All use the same numerical progression: each time the light sensitivity of the film doubles, the film speed rating doubles. An ISO (or EI or ASA) 200 film is twice as fast as an ISO 100 film, half as fast as an ISO 400 film. For a correct exposure, the ISO 200 film needs half as much light as the ISO 100 film, twice as much

light as the ISO 400 film—each time a one-stop change.

Digital cameras use the same ISO scale of light sensitivity. The setting can be adjusted for each photograph. Higher settings bring more image noise.

Sometimes the ISO rating includes the European **DIN** (Deutsche Industrie Norm) rating; for example, ISO 200/24°. In the DIN system, the rating increases by 3 each time the film speed doubles. DIN 24 (equivalent to ISO 200) is twice as fast as DIN 21, half as fast as DIN 27. Except for the unlikely case of using a piece of equipment marked only with DIN numbers, you can ignore the DIN part of an ISO rating.

Special-Purpose Films

INFRARED AND CHROMOGENIC

Two films that depart from the norm are worth considering. You may find yourself in a situation that requires one, or you may just enjoy exploring a slightly different way of seeing.

Chromogenic black-and-white film lets you use one-hour processing labs to make black-and-white negatives and prints. Designed to be developed in color-negative processing chemicals (called C-41), these films have a smooth tonality and fine grain. Because the film is based on color technology, your negatives will be somewhat less permanent than conventional black-and-white negatives. Ilford XP2 Super is optimized for printing on conventional black-and-white paper, as you would use in your own darkroom. Kodak BW400CN is intended to give consistent image color and good results when printed on the color paper used in one-hour labs. Although prints made from both these films are always monochromatic, a consistent neutral gray tone is diffi-

cult to achieve on the color paper used by a processing lab. If you intend to scan from negatives, those on chromogenic film often produce better results than those on conventional film.

Infrared black-and-white film is sensitized to wavelengths that are invisible to the human eye, the infrared waves that lie beyond visible red light, as well as to the visible spectrum. Because the film responds to wavelengths that are not visible to the eye, it can be used to photograph in places that appear dark. The sun is a strong source of infrared radiation; tungsten filament lamps, flash bulbs, and electronic flash can also be used. Unusual and strangely beautiful images are possible because many materials reflect infrared radiation differently from visible light (see opposite page). Grass and other vegetation reflects infrared wavelengths very strongly and thus appear very bright, even white. Clouds too are highly reflective of infrared wavelengths, but

Neal Rantoul. *Two Trees, Botswana, 1999.* **Chromogenic film** *is often Rantoul's choice, as it was for this two-frame photograph, for black-and-white negatives with smooth tones, easy contrast control, and rapid processing by a lab.*

Minor White. *Tool Shed in Cemetery, from* Sequence 10, 1955. **Infrared film** *records leaves and grass as very light. The result can be a strangely dreamlike landscape. White said he used the film because he "wanted to give contrast to the landscape," but he also appreciated its surreal qualities.*

because the atmosphere does not scatter infrared the way it does blue wavelengths, the sky appears dark, even black, in a print.

Because infrared wavelengths are invisible, you cannot fully visualize in advance just what the print will look like; this is sometimes a frustration but often it is an unexpected pleasure. The correct exposure is also something of a guess; conventional meters do not measure infrared radiation accurately.

Ilford's SFX 200 film produces some of the effects of true infrared film without the necessity of loading the camera in darkness and, for most lenses, refocusing (see below).

Infrared color film is available for reversal processing. Useful for aerial mapping as well as for expressive photography, it shows infrared reflection using an assigned—and therefore artificial—palette of colors.

Using Infrared Film

Storage and loading. Infrared film can be fogged by exposure to heat or even slight exposure to infrared radiation. Buy infrared film only if it has been refrigerated, and once you have it, store it under refrigeration when possible. Load and unload the camera in total darkness, either in a darkroom or in a changing bag (a light-tight bag into which you put your hands, camera, and film).

Focusing. Lenses focus infrared wavelengths at a slightly different distance than they do visible light from the same object, so a focus adjustment may be required. With black-and-white infrared film, after focusing as usual, rotate the lens barrel forward very slightly as if you were focusing on an object closer to you. Some lenses have a red indexing mark on the lens barrel to show the adjustment needed. The difference is very slight, so, unless depth of field is very shallow (as when you are photographing close up or at a large aperture), you can usually make do without any correction. No correction is needed for infrared color film.

Filtration. Kodak recommends a No. 25 red filter for general use with black-and-white infrared film to enhance the infrared effect by absorbing the blue light to which the film is also sensitive. They also recommend a No. 12 minus-blue filter for general use with color infrared film.

Exposure. An exposure meter, whether built into the camera or hand held, cannot reliably measure infrared radiation. Kodak recommends the following trial exposures for its films in daylight. High Speed Infrared black-and-white film used with No. 25 filter: distant scenes—1/125 sec. at f/11; nearby scenes—1/30 sec. at f/11. Ektachrome Infrared color film with a No. 12 filter—1/125 sec. at f/16. Overexposure is safer than underexposure; after making the trial exposure, make additional exposures of 1/2 stop and 1 stop more and 1/2 stop less (see Bracketing, pages 70–71).

Digital Infrared. Most digital cameras have an infrared-blocking filter over the chip and must be modified to make IR pictures.

Color in Film and Digital

All colors can be created by mixing three primary colors—either the additive primaries (red, green, and blue) or the subtractive primaries (cyan, magenta, and yellow). Most colors we see in nature consist of a blend, or spectrum, of all possible colors, but any visual sensation or perception of color can be matched with the right quantites of three specifically chosen primaries.

The additive process (right, center) mixes red, green, and blue light in varying proportions to match any color. Television sets and computer monitors use additive color. Equal quantities of the three colors appear neutral gray or, if they are bright enough, white.

The subtractive process uses cyan (a bluish green), magenta (a purplish pink), and yellow (right, bottom). Each color absorbs (or subtracts) one of the additive primaries. If you put cyan paint or pigment on paper, for example, it removes red from white light that shines on it, and allows green and blue to be reflected. Your eye perceives that mix of green and blue light to be cyan.

Color films use three emulsion layers, each one sensitive to only one color, to separate a full-color spectrum into primaries. In a similar way, digital color separates full color into primaries saved in three channels of information. When working in color digitally, you have your choice of two color modes, RGB or CMYK. RGB (for Red, Blue, Green) is additive, and it is preferable for most photographic work. CMYK is a standard used in commercial publishing and printing. This mode adds black (abbreviated K instead of B to avoid confusion with Blue) to the three subtractive primaries to suit the needs of the printing industry. Black ink is added to the darkest shadow areas in pictures and used to print text because it is less expensive and easier to keep neutral than a heavy overprinting of the other three colors.

Your light source makes a big difference when you shoot in color. We see a wide variety of light as "white," that is, having no color of its own. Despite our perception that daylight is "white" or "neutral" light, its color is constantly changing all day long. Midday light is more blue (cooler); early morning and late afternoon light is more red (warmer). Other light sources, like light bulbs, also emit white light of a specific *color balance*—the mixture of wavelengths of different colors that it contains. This quality of white light sources is also called its *color temperature*, and it is measured on a scale in degrees Kelvin (°K or just K).

Light from an ordinary bulb, with a color temperature of about 2800°K, has proportionately less blue and more yellow and red than does daylight at 5000°K. You can see this difference if you turn on an indoor lamp in a daylit room: the light from the lamp looks quite yellow (see the photograph opposite). At night, with no daylight for comparison, you see the same lamplight not as yellow but as white. Our brains ignore color balance when we look at a scene, perceiving either daylight or lamplight as "white" if there is only one kind of light present. Color film, however, can't adjust itself and so is made to match the color temperatures of specific light sources.

Color films are balanced for either daylight or tungsten light. If the color balance of your film doesn't match that of your light source, a color shift will appear in your photographs unless you use a special filter to correct it.

Daylight-balanced films yield natural-looking colors when shot in daylight. Electronic flash units produce light of the same color, so you should also use daylight films with flash. In the more reddish light from incandescent bulbs, you will get better results from *tungsten-balanced films* (sometimes called indoor films). These films are designed to reproduce color accurately

A color wheel shows the relationship of the subtractive and additive primary colors.

The additive primaries produce white light when all three are mixed. Combining two at a time can make each of the subtractive primaries.

The subtractive primaries each remove one of the additive primaries.

only in light of 3200°K color temperature that comes from specific bulbs. Tungsten films give acceptable results for most purposes, however, when used with any type of incandescent light.

Fluorescent light presents a special problem because the color balance does not match either daylight or tungsten films and varies depending on the type of fluorescent tube and its age. The light often gives an unpleasant greenish cast to pictures. Film manufacturers provide filtration data for different tubes, but, practically speaking, you usually won't know which tube is installed, and there may be several different kinds of tubes in one room. Try an FL-D (fluorescent) filter with a one stop increase in exposure using daylight film. Daylight film will give a better balance than tungsten film if you use no filter.

Digital cameras adjust themselves for color temperature. Built into each digital camera is the ability to measure the color temperature (with digital cameras it is called *white balance*) of whatever light is on the scene, and to adjust for it for each photograph. You can choose one of the camera's presets for several kinds of light, measure and set the white balance manually before each shot, set the camera to adjust itself automatically, or capture photographs in camera raw format and adjust the white balance later.

Lucinda Devlin. Fürstenbad, Palais Thermal, Bad Wildbad, 1999. **Light from bulbs appears warm** when compared to daylight in the same photograph. Daylight enters this room from above, and through the doorway at the center. By comparison, the space illuminated by the three visible incandescent lights appears quite yellow. The photograph is one of a series made by the artist to document curing baths in Germany.

Color Films

Many color films are available, all of them belonging to one of two categories: negative films and reversal films. A negative film (often with "-color" in its name, such as Fujicolor or Ektacolor) produces a negative in which the tones and colors are the opposite of those in the original scene. The negative (which appears orange because of a built-in color correcting mask) is then printed to make a positive image. A reversal film (usually with "-chrome" in its name, such as Kodachrome or Fujichrome) is given special reversal processing to produce a film positive. 35mm color positives are called slides. Color positives from larger film are called transparencies or chromes.

Prints from either color negatives or color slides can be made in a darkroom; both can be scanned for digital printing. Color negatives are relatively easily and inexpensively processed and printed commercially. If you are comfortable developing and printing black-and-white film and want to try color, you can find the chemicals and master the processes for color negatives without significant difficulty. But the materials for making prints from slides are expensive and the chemicals are quite toxic; it is best to scan and print them digitally or have darkroom prints made by a custom lab. Commercially-made prints from slides are more expensive than prints from negatives but have brilliant color saturation and are somewhat sharper and less grainy in larger sizes.

Latitude is the range of subject brightness a film can hold, and it is another important difference between transparency and negative films. If you use a transparency film to shoot a scene with highlights and shadows more than about five stops apart, you will lose some detail (see the photograph below). Depending

Project:

COLOR BALANCE DURING THE DAY

YOU WILL NEED
Roll of daylight-balanced color film. Use slide film so that color balance changes are not altered during printing.

PROCEDURE
On a sunny day, find a location that you think will make a good landscape or cityscape. Photograph from that location at midday, in the late afternoon, and at dusk. Try to shoot from the same point each time. Identify the resulting slides so that you know when each was shot. In between, make some photographs on the same roll in other color conditions: open shade, indoors with incandescent light, and indoors under fluorescent bulbs.

HOW DID YOU DO?
How are the colors rendered in your pictures? Compare the ones shot in the same place; did one or more look cooler (more bluish) overall, compared to the others? Were one or more warmer (more reddish)? What time or times of day created these changes? Do you prefer the look of certain times of day? How do these color shifts compare to those under the other light sources?

Alex Webb. Port-au-Prince, Haiti, 1979. **Color reversal (slide) film has little exposure latitude.** *Most scenes in full sun, like this one, exceed the range of the film. Webb makes a virtue of its limitations by using solid shadows as graphic elements.*

Color film consists of three light-sensitive layers, each of which responds to about one-third of the colors in the light spectrum. Each layer becomes a negative that records the amount of its spectrum reflected from the subject. At right, the image of the blue airplane is darkest in the blue-sensitive layer's negative (top).

Color negative film (above) first develops into three black-and-white negative layers, but the developer contains dye couplers that color each layer in the complement of the color to which it is sensitive (right). When printed on color negative paper, each color is reversed into a positive. An orange mask corrects for distortions in the process.

Color reversal film is similar, but needs some extra steps in the developing process. After the negative is developed, the silver in each layer is removed by bleaching. The remaining silver halides become one of the dye layers shown above—each a negative of a negative—that make the final positive color image.

on exposure, your highlights will be undetailed white or your shadows lost in black, possibly both. Negative films extend this range a stop or two, so they are better for shooting in sunny daylight. Professionals shooting reversal film in the studio can set their lighting so the scene doesn't exceed a five-stop range; outdoors they will usually try to shoot in the early morning or late afternoon, in cloud-softened sunlight, or use fill light (pages 136–137).

Most commercial photography that is not shot digitally is done with transparency films. As a result, the scanners for digitizing film (see page 157) are better set up to accept chromes. If you expect to use digital imaging after shooting on film, you will probably find it more difficult—although not impossible—to get good results from color negatives.

Color balance is very important with reversal films. Color slides are made directly from the film that was in the camera, so color balance cannot be corrected unless the slides are remade. Reversal film should be shot either in the light for which it was intended or with a filter over the lens to adjust the color balance. If this is not done, the resulting slides will have a distinct color cast. Slight color shifts in color negatives can be adjusted during conventional color printing. If you are expecting to scan your color film into a digital system, exact color balance is less important because some color corrections can be made with image-editing software. Nevertheless, matching the film to the light source is always preferable.

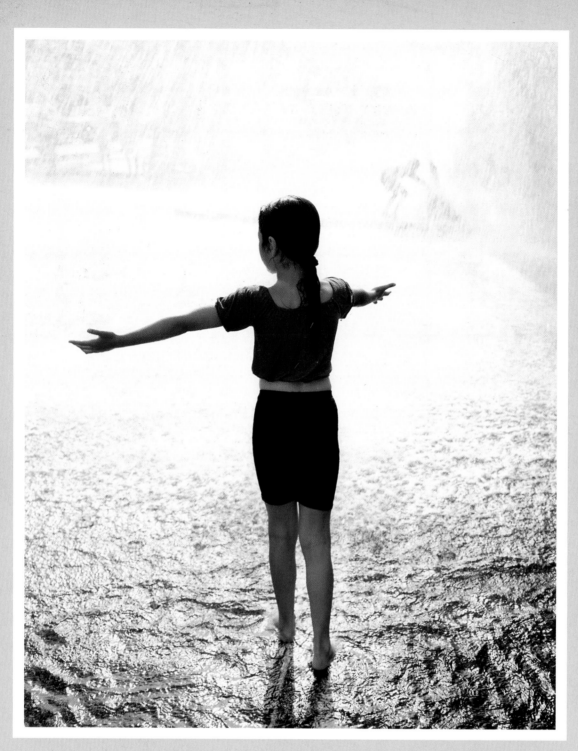

PAUL D'AMATO
Isela, Chicago, 1993.

Exposure 4

Exposing your film correctly (that is, setting the shutter speed and aperture so they let in the correct amount of light for a given film and scene) makes a big difference if you want a rich image with realistic tones, dark but detailed shadows, and bright, delicate highlights, instead of a too dark, murky picture or a picture that is barely visible because it is too light. The same exposure guidelines for getting good results on film will also help you make better pictures with your digital camera.

At the simplest level, you can let your automatic camera set the shutter speed and aperture for you. If your camera has manual settings, you can calculate them by using a hand-held or built-in exposure meter to make an overall reading of the scene. You can even use the chart of general exposure recommendations that film manufacturers provide with each roll of film. In many cases, these standardized procedures will give you a satisfactory exposure. But standard procedures don't work in all situations. If the light source is behind the subject, for example, an overall reading will silhouette the subject against the brighter background. This may not be what you want.

You will have more control over your pictures—and be happier with the results—if you know how to interpret the information your camera or meter provides and how to adjust the recommended exposure to get any variation you choose. You will then be able to select what you want to do in a specific situation rather than exposing at random and hoping for the best.

Making a correct exposure, letting the right amount of light into the camera, involves understanding just three things:

1. How the shutter speed and the size of the lens opening (the aperture) work together to control light (pages 18–23).

2. The sensitivity of your film or digital sensor to light. Film speed (pages 56–57) is usually expressed as an ISO rating. With a digital camera you choose an ISO rating to set into the camera.

3. How to measure the amount of light and then set the exposure, either automatically or manually (pages 68–79).

Normal Exposure, Underexposure, and Overexposure

A negative is the image produced when film is exposed to light and then developed. The tones of a negative are the reverse of the original scene: the brightest areas in the scene are the darkest in the negative. How does this happen? When light strikes film, the energy of the light changes light-sensitive silver halide crystals in the film's emulsion. The energy rearranges the structure of the crystals so that during development they convert to dark, metallic silver.

The more light that strikes a particular area, the more the light-sensitive crystals are activated and so the denser with silver (and the darker) that part of the negative will be. As a result, a white ship, for example, will be very dark in the negative. If film is exposed to light long enough, it darkens simply by the action of light, but ordinarily it is exposed only long enough to produce a *latent* or invisible image that is then made visible by chemical development.

A positive print can be made from the negative by shining light through the negative onto a piece of light-sensitive paper. Where the original scene was bright (the white ship), the negative is very dark and dense with many particles of silver. Dense areas in the negative block light from reaching the paper; few particles of silver form in those parts of the print, so those areas are bright in the final positive image.

The opposite happens with dark areas such as the shadows in the original scene: dark areas reflect little light, so only a little silver (or sometimes none) is produced in the negative. When the positive print is made, these thin or clear areas in the negative pass much light to the paper and form dark deposits of silver corresponding to the dark areas in the original scene. When a positive transparency such as a color slide is made, the tones in the negative itself are chemically reversed into a positive image.

Exposure determines the lightness or darkness of the image. The exposure you give a negative (the combination of f-stop and shutter speed) determines how much light from a scene will reach the film and how dense or dark the negative will be: the more light, the denser the negative, and, in general, the lighter the final image. The "correct" exposure for a given situation depends on how you want the photograph to look. The following pages tell how to adjust the exposure to get the effect you want.

Film and paper have exposure latitude; that is, you can often make a good print from a less-than-perfect negative. Color slides have the least latitude (page 62); for best results, do not overexpose or underexpose them more than ½ stop (one stop is acceptable for some scenes). Black-and-white or color prints can be made from negatives that vary somewhat more: from about one stop underexposure to two stops overexposure is usually acceptable. (More about stops and exposure on page 70.)

With too much variation from the correct exposure, prints and slides begin to look bad. Too much light overexposes a negative; it will be much too dense with silver to pass enough light to the printing paper, resulting in a final print that will be too pale (see photographs, opposite bottom). Conversely, too little exposure produces a negative that is underexposed and too thin, resulting in a print that is too dark (see photographs, opposite top). The results are similar with color slides. Too much exposure produces slides that are too light and that have pale, washed-out colors. Too little exposure produces dark, murky slides with little texture or detail.

Digital cameras produce no negative but the results of over- and underexposure are the same—prints that are too light or too dark and a loss of texture and detail in the highlights or shadows.

Underexposed, Thin Negative

Dark Positive

Normal Negative

Normal Positive

Overexposed, Dense Negative

Light Positive

Bethlehem Steel Corporation

Exposure Meters

WHAT DIFFERENT TYPES DO

Exposure meters vary in design, but they all perform the same basic function. They measure the amount of light; then, for a given film speed (ISO), they calculate f-stop and shutter-speed combinations that will produce a correct exposure for a scene that has an average distribution of light and dark tones.

Meters built into cameras measure reflected light (see opposite page, top center). The light-sensitive part of the meter is a photoelectric cell. When the metering system is turned on and the lens of the camera is pointed at a subject, the cell measures the light reflected from that subject. With automatic exposure operation, you set either the aperture or the shutter speed and the camera adjusts the other to let in a given amount of light. Some cameras set both the aperture and the shutter speed for you. In manual exposure operation, you adjust the aperture and the shutter speed based on the meter's viewfinder readout.

Hand-held meters measure reflected light or incident light (see opposite page, top left and right). When the cell of a hand-held meter (one that is not built into a camera) is exposed to light, it moves a needle across a scale of numbers or activates a digital display. The brighter the light, the higher the reading. The meter then calculates and displays recommended f-stop and shutter-speed combinations.

Meters are designed to measure middle gray. A reflected-light meter measures only one thing—the amount of light—and it calculates for only one result—an exposure that will reproduce that overall level of light as a medium-gray tone in the final photograph. The assumption is that most scenes, which consist of a variety of tones including very dark, medium gray, and very light, average out to a medium gray tone. Most, in fact, do. Pages 74–79 tell how to use a meter to measure an average scene and what to do for scenes that are not average.

A hand-held meter is separate from the camera. After measuring the amount of light, the meter's calculator dial or display panel shows the recommended f-stop for your selected shutter-speed. This type of meter can read either incident or reflected light depending on the position of the small dome on the meter.

The scene visible in the viewfinder

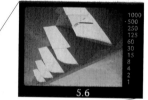

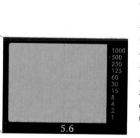

What the camera's metering system "sees"

A through-the-lens (TTL) meter, built into a camera, shows in the camera's viewfinder the area that the meter is reading. You can see the details of the scene, but the camera's metering system does not. Many "see" simply the overall light level. Whether the scene is very light or very dark, the meter always calculates a shutter speed and aperture combination to render that light level as middle gray on the negative. Some meters (as shown opposite, bottom) are more sophisticated and favor the exposure of certain parts of the image.

A TTL meter is usually coupled to the camera to set the exposure automatically. In some older cameras it may simply show an f-stop and shutter-speed combination for you to set manually. This viewfinder displays the aperture (below) and shutter speed (at side) to which the camera is set. It also signals under- or overexposure when you choose an aperture or shutter speed for which there is no corresponding setting within the range of those available on your camera.

Reading Reflected Light

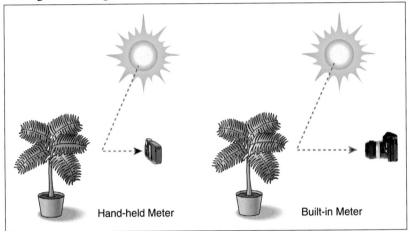

Hand-held Meter Built-in Meter

A reflected-light meter measures the amount of light reflected from an object. It can be hand held (left) or built into a camera (right). To make a reading, point the meter at the entire scene or at a specific part of it.

Reading Incident Light

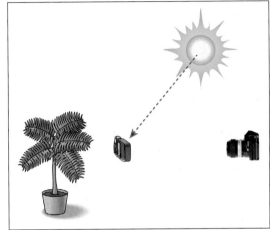

An incident-light meter measures the amount of light falling on it—and so, the amount of light falling on a subject in similar light. To make a reading, point the meter away from the subject, toward the camera.

Meter Weighting *What part of a scene does a reflected-light meter measure?*

An averaging or overall meter reads most of the image area and computes an exposure that is the average of all the tones in the scene. A hand-held meter, like the one shown opposite, typically makes an overall reading.

Averaging Meter

Center-weighted Meter

A center-weighted meter favors the light level of the central area of an image, which is often the most important one to meter. Cameras with built-in meters usually use some form of center weighting.

A spot meter reads only a small part of the image. Very accurate exposures can be calculated with a spot meter, but it is important to select with care the areas to be read. Hand-held spot meters are popular with photographers who want exact measurement and control of individual areas. Some cameras with built-in meters have a spot metering option.

Spot Meter

Multi-segment Meter

A multi-segment meter is the most sophisticated of the meters built into a camera. It divides the scene into areas that are metered individually, then analyzed against a series of patterns stored in the camera's memory. The resulting exposure is more likely to avoid problems such as underexposure of a subject against a very bright sky.

Exposure Meters

HOW TO CALCULATE AND ADJUST AN EXPOSURE MANUALLY

How do you calculate and adjust an exposure manually? Even if you have an automatic exposure camera, it will help you to know how to do so. Many automatic cameras do not expose correctly for backlit scenes or other situations where the overall illumination is not "average," and you will need to know how much and in what direction to change the camera's settings to get the results you want.

This page shows the way a hand-held meter works. Once you understand its operation, you will know how any meter functions, whether built into a camera or separate and hand held. Pages 74–79 tell how to use a meter for different types of scenes.

Exposure = Intensity × Time. Exposure is a combination of the intensity of light that reaches the film or digital sensor (controlled by the size of the aperture) and the length of time the light strikes it (controlled by the shutter speed). You can adjust the exposure by changing the shutter speed, aperture, or both.

Exposure changes are measured in stops, a doubling (or halving) of the exposure. A change from one aperture (f-stop) to the next larger aperture opening, such as from f/5.6 to f/4, doubles the light reaching the film and results in one stop more exposure. A change from one shutter speed to the next slower speed, such as from 1/250 sec. to 1/125 sec., also results in one stop more exposure. A change to the next smaller aperture or the next faster shutter speed halves the light and produces one stop less exposure.

It is worth your effort to memorize the f-stop and shutter-speed sequences, so you know which way to move the controls when you are faced with an exposure you want to bracket or otherwise adjust.

Bracketing helps if you are not sure about the exposure. To bracket, you make several photographs of the same scene, increasing and

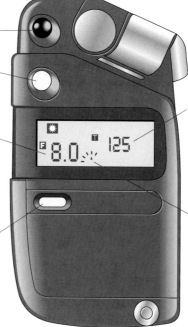

Power Switch

Mode Switch Changes from continuous light (like daylight) to electronic flash.

The f-stop settings are one stop apart. f/8 lets in half as much light as f/5.6. Remember that the lower the f-number, the larger the lens aperture, and so the more light let into the camera.

ISO button; film speed ratings double each time the sensitivity of the film doubles. An ISO 400 film is one stop faster than an ISO 200 film. It needs only half as much light as does the ISO 200 film. ISO settings on digital cameras relate to each other in the same way.

Shutter speeds are one stop apart. A shutter speed of 1/125 sec. lets in twice as much light as a shutter speed of 1/250 sec.

Reads fractions in between the whole f-stop settings

decreasing the exposure by adjusting the aperture or shutter speed. Among several different exposures, there is likely to be at least one that is correct. It's not just beginners who bracket exposures. Professional photographers often do it as protection against having to repeat a whole shooting session because none of their exposures was quite right.

To bracket, first make an exposure with the aperture and shutter speed set by the automatic system or manually set by you at the combination you think is the right one. Then make a second shot with one stop more exposure and a third shot with one stop less exposure. This is easy to do if you set the exposure manually: for one stop more exposure, either set the shutter to the next slower speed or the aperture to the next larger opening (the next smaller f-number); for one stop less exposure, either set the shutter to the next faster speed or the aperture to the next smaller opening (the next larger f-number).

A hand-held exposure meter. Light striking this meter's light-sensitive photoelectric cell results in the display of an f-stop and a shutter speed on its electronic display window. You set the film speed and shutter speed, and it calculates the correct aperture for a normal exposure in light of that intensity. An automatic exposure camera performs the same calculation for you, using a light meter built into the camera.

Most electronic hand-held meters will also calculate exposures when you are using electronic flash (see page 137) or mixing flash with daylight.

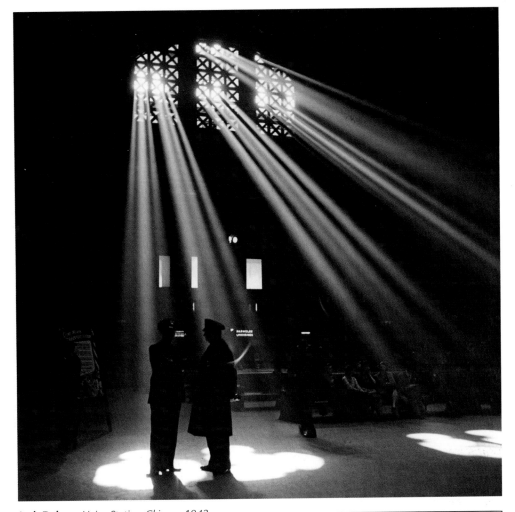

Jack Delano. Union Station, Chicago, 1943.
Bracketing your exposures *is useful when you are not sure if an exposure is correct or if you want to see the results from different exposures of the same scene. Judging the exposure for this extremely contrasty scene is very difficult; bracketed exposures give the photographer a choice. With more exposure, more detail in the interior would have been visible but the beams of sunlight would lose their drama. Less exposure would darken everything so the people on benches would disappear.*

How do you bracket with an automatic exposure camera? In automatic operation, if you change to the next larger aperture, the camera may simply shift to the next faster shutter speed, resulting in the same overall exposure. Instead, you have to override the camera's automatic system. See page 72 for how to do so. Some cameras can be set to make three bracketed exposures in succession when you press the shutter once.

Bracketing produces lighter and darker versions of the same scene. Suppose an exposure for a scene is 1/60 sec. shutter speed at f/5.6 aperture.

Original exposure

1/8	1/15	1/30	1/60	1/125	1/250	1/500 sec.
f/16	f/11	f/8	f/5.6	f/4	f/2.8	f/2

To bracket for one stop less exposure, which would darken the scene, keep the shutter speed at 1/60 sec. while changing to the next smaller aperture, f/8. (Or keep the original f/5.6 aperture while changing to the next faster shutter speed, 1/125 sec.)

Bracketed for one stop less exposure

1/8	1/15	1/30	1/60	1/125	1/250	1/500 sec.
f/16	f/11	f/8	f/5.6	f/4	f/2.8	f/2

To bracket for one stop more exposure, which would lighten the scene, keep the shutter speed at 1/60 sec. while changing to the next larger aperture, f/4. (Or keep the original f/5.6 aperture while changing to the next slower shutter speed, 1/30 sec.)

Bracketed for one stop more exposure

1/8	1/15	1/30	1/60	1/125	1/250	1/500 sec.
f/16	f/11	f/8	f/5.6	f/4	f/2.8	f/2

Overriding an Automatic Exposure Camera

Many cameras with automatic exposure have some means of overriding the automatic system when you want to increase the exposure to lighten a picture or decrease the exposure to darken it. The change in exposure is measured in stops. A one-stop change in exposure will double (or halve) the amount of light reaching the film. Each aperture or shutter-speed setting is one stop from the next setting.

Exposure lock. An exposure lock or memory switch temporarily locks in an exposure, so you can move up close or point the camera in a different direction to take a reading of a particular area, lock in the desired setting, step back, and then photograph the entire scene.

Exposure compensation dial. Moving this dial to +1 or +2 increases the exposure by one or two stops and lightens the picture. Moving the dial to –1 or –2 decreases the exposure and darkens the picture.

Backlight button. If a camera does not have an exposure compensation dial, it may have a backlight button. Depressing the button adds a fixed amount of exposure, 1 to 1½ stops, and lightens the picture. It cannot be used to decrease exposure.

Film speed setting. With a film camera, you can change the exposure by manually changing the film speed setting. The camera then responds as if the film were slower or faster than it really is. Doubling the film speed (for example, from ISO 100 to ISO 200) darkens the picture by decreasing the exposure one stop. Halving the film speed (say from ISO 400 to ISO 200) lightens the picture by increasing the exposure one stop.

If you can't manually change a film speed dial or other camera mechanism, you can buy foil stickers that let you change the DX coding on a film cassette. Doing so rearranges the black and silver squares that tell the camera's electronics the film speed. You must then, however, expose the entire roll at the altered ISO. Neither of these methods will work on a digital camera; changing the ISO setting will change either aperture or shutter speed but will not make the picture lighter or darker.

Manual mode. In manual mode, you adjust the shutter speed and aperture yourself. You can increase or decrease the exposure as you wish.

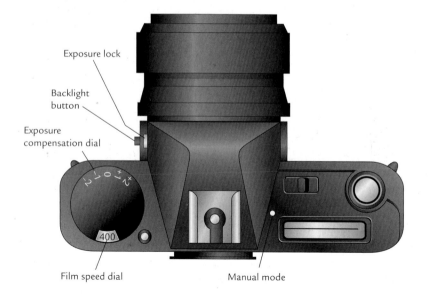

Exposure lock

Backlight button

Exposure compensation dial

Film speed dial

Manual mode

One or more means of changing the exposure are found on most cameras. These features let you override automatic exposure when you want to do so. Don't forget to reset the camera to its normal mode of operation after the picture is made.

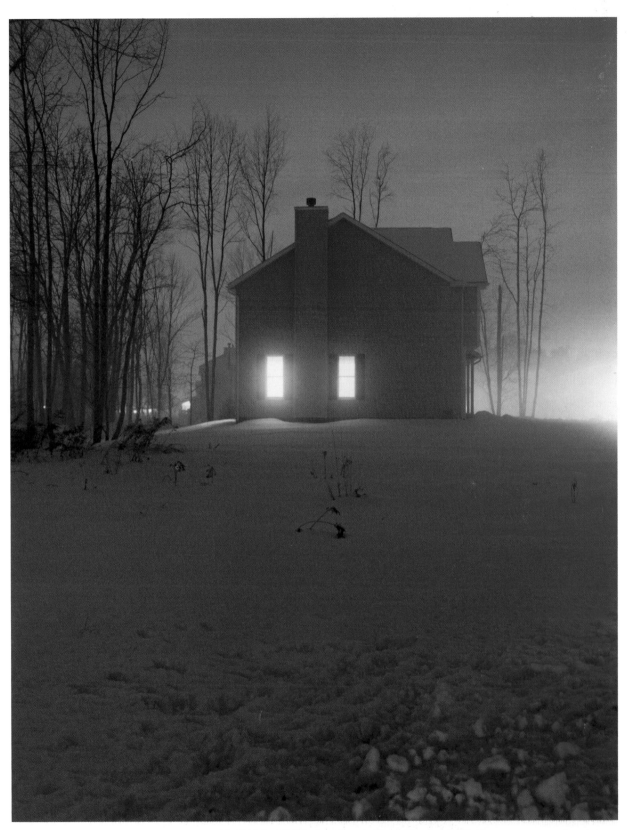

Todd Hido. #2423a from the series House Hunting, *1999.* **You can use manual mode** to set the shutter speed and aperture for photographs at night, like this winter scene from Hido's series of homes at night. More about exposures for unusual lighting situations on pages 76–81.

Making an Exposure of an Average Scene

An overall meter reading works well when most of a directly lit scene is evenly illuminated as seen from camera position. *When light is shining directly on a subject, even illumination occurs when the main source of light is more or less behind you as you face the subject. Shadows may be dark but probably will not obscure important parts of the scene.*

Karl Baden

A scene in diffused light photographs well with an overall reading, *for example, outdoors in the shade or on an overcast day, or indoors when the light is coming from several light sources. Diffused light is indirect and soft. Shadows are not as dark as they would be in direct light.*

What exactly do you need to do to produce a good exposure, one that lets just enough light into the camera so that the image is neither underexposed, making the picture too dark, nor overexposed, making the picture too light? All meters built into cameras (and most hand-held meters) measure reflected light, the lightness or darkness of objects. In many cases, you can simply point the camera at a scene, activate the meter, and set the exposure (or let the camera set it) accordingly.

A reflected-light meter averages the light entering its angle of view. The meter is calibrated on the assumption that in an average scene all the tones—dark, medium, and light—will add up to an average medium gray. So the meter and its accompanying circuitry set, or recommend, an exposure that will record all of the light that it is reading as a middle gray in the photograph.

This works well if you are photographing an "average" scene, one that has an average distribution of light and dark areas, and if the scene is evenly illuminated as viewed from camera position, that is, when the light is coming more or less from behind you or when the light is evenly diffused over the entire scene (see photographs this page). See opposite for how to meter this type of average or low-contrast scene.

A meter can be fooled, however, if your subject is surrounded by a much lighter area, such as a bright sky, or by a much darker area, such as a large dark shadow. See pages 76–78 for what to do in such cases.

Using a meter built into a camera for exposure of an average scene

1 Set the film speed (ISO rating) into the camera. Some film cameras do this automatically when you load the film.

2 Select the exposure mode: automatic (aperture priority, shutter priority, or programmed) or manual. Activate the meter as you look at the subject in the viewfinder.

3 *In aperture-priority mode,* you select an aperture. The camera will select a shutter speed; make sure that it is fast enough to prevent blurring of the image caused by camera or subject motion. In shutter-priority mode, you select a shutter speed. The camera will select an aperture; make sure it gives the desired depth of field. In programmed (fully automatic) mode, the camera selects both aperture and shutter speed. In manual mode, you set both aperture and shutter speed based on the readout in the viewfinder.

Calculating exposure of an average scene with a hand-held reflected-light meter

1 Set the film speed (ISO rating) into the meter.

2 Point the meter's photoelectric cell at the subject at the same angle seen by the camera. Activate the meter to measure the amount of light reflected by the subject.

3 Line up the number registered by the indicator needle with the arrow on the meter's calculator dial. (Some meters do this automatically.)

4 Set the camera to one of the combinations of f-stops and shutter speeds shown on the meter. Any combination shown lets the same quantity of light into the camera and produces the same exposure.

Calculating exposure of an average scene with an incident-light meter

1 Set the film speed (ISO rating) into the meter.

2 Position the meter so that the same light is falling on the meter's photoelectric cell as is falling on the part of the subject seen by the camera. To do this, point the meter's photoelectric cell away from the subject, in the opposite direction from the camera lens. Activate the meter to measure the amount of light falling on the subject. Make sure the same light that is falling on the subject is falling on the meter. For example, take care not to shade the meter if the subject is brightly lit. Proceed as in steps 3 and 4 for reflected-light meter.

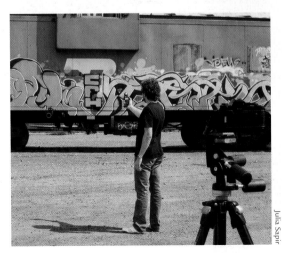

Julia Sapir

Exposing Scenes that are Lighter or Darker than Average

"It came out too dark." Sometimes even experienced photographers complain that they metered a scene carefully, but the picture still wasn't properly exposed. All a meter does is measure light. It doesn't know what part of a scene you are interested in or whether a particular object should be light or dark. You have to think for the meter and sometimes change the exposure it recommends.

Scenes that are light overall, such as a snow scene, can look too dark in the final photograph if you make just an overall reading or let an automatic camera make one for you. The reason is that the meter will make its usual assumption that it is pointed at a scene consisting of light, medium, and dark tones (one that averages out to middle gray), and it will set the exposure accordingly. But this will underexpose a scene that consists mostly of light tones, resulting in a too-dark final photograph. Try giving one or two stops extra exposure to such scenes.

Scenes that are dark overall are less common, but do occur. When the meter assumes that the entire scene is very dark, it lets in more light. If your main subject is not as dark as the background, it will be rendered too light. Try reducing the exposure one or two stops.

You can make some adjustments in tone when you make a print from a negative or from a digital image. But good results and the effect you want are easier to get if you first use the camera to capture the correct exposure. Bracket your exposures if you are not sure, especially if you notice that the scene is not average—equally light and dark. If you are shooting transparencies, the film in the camera is the final product. You can't easily make adjustments after the fact and must later add extra steps by scanning and working with the image using digital imaging software or by making a negative or duplicate transparency from the original.

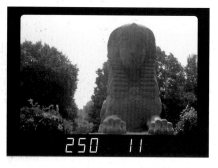

An underexposed (too dark) photograph can result when the light is coming from behind the subject or when the subject is against a much brighter background, such as the sky. The problem is that a meter averages all the tonal values that strike its light-sensitive cell. Here the photographer pointed the meter so that it included the much lighter tone of the sky as well as the monument. The resulting exposure of 1/250 sec. shutter speed at f/11 aperture produced a correct exposure for an average scene but not a correct exposure for this scene.

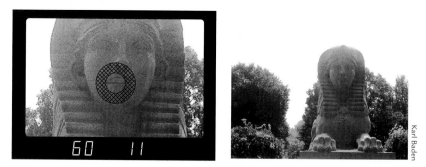

Karl Baden

A better exposure for contrasty scenes results from moving up close to meter only the main subject, as shown above. This way you take your meter reading from the most important part of the scene—here, the sphinx's face. The resulting exposure of 1/60 sec. at f/11 let in two more stops of exposure and made the final picture (right) lighter, especially the important part of it, the front of the monument.

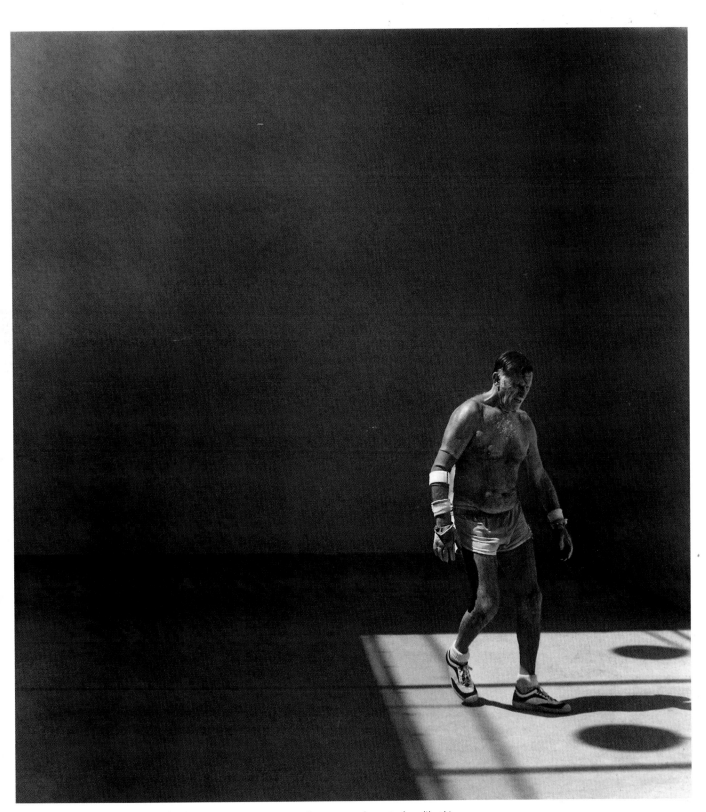

Jerome Liebling. *Miami Beach, Florida, 1977.* **Some scenes need more care in metering,** *like this handball player in a shaft of sunlight. An average meter reading would see mostly the dark court and suggest an exposure that would make the sunstruck areas too light.*

Backlighting

The most common exposure problem is a backlit subject, one that is against a much lighter background, such as a sunny sky. Because the meter averages all the tonal values—light, medium, and dark—in the scene, it assumes the entire scene is very bright. Consequently, it sets an exposure that lets in less light, which makes the entire picture darker and your main subject too dark.

Backlight can make an effective silhouette, but you shouldn't render your subject in blackness unless you want that. To show your main subject with detail, like the illustration, right, make sure to meter the part of your subject facing the camera without letting the backlight shine into the meter, as shown below. When you want a silhouette against a bright background, try giving a stop or two less exposure than the meter recommends for the main subject.

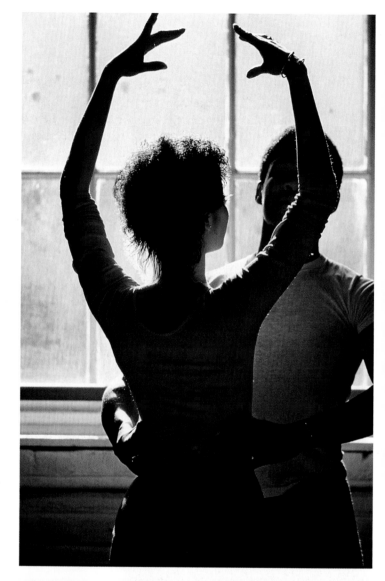

Lou Jones. *Dancers Rehearsing, Boston, 1985.* **Careful exposure is required** *in backlit scenes like this one if you want to retain detail in the shadowed side of the subject.*

Move in close to meter a high-contrast scene. *With a built-in meter, move in (without blocking the light) until the important area just fills the viewfinder. Set the shutter speed and aperture and move back to your original position to take the picture.*

With a hand-held, reflected-light meter, *move in close enough to read the subject but not so close as to block the light. A spot meter, which reads light from a very narrow angle of view, is particularly useful for metering high-contrast scenes.*

Exposing Scenes with High Contrast

High-contrast scenes are difficult to expose correctly because the range of tones in the scene can meet or even exceed the latitude of the film (see page 62 and the photograph on page 71). Even a small exposure error will leave you with detail missing in your highlights or shadows. As always, it is safest to bracket.

Try not to underexpose negative film. The shadow areas suffer most from exposure error; most films have more latitude in the highlights. With black-and-white film, you may get good results in hard sun by setting the film speed to half the film's ISO or by leaving your exposure compensation dial on +1. See page 62 for more about color films. Digital cameras typically capture a tonal range similar to negative films, but with less latitude in the highlights. With any recording system, precise metering is more important in contrasty light.

To expose the main subject correctly in a contrasty scene, measure the light level for that part of the scene only. If you are photographing a person or some other subject against a much darker or lighter background, move in close enough so you exclude the background from the reading but not so close that you meter your own shadow. If your main subject is a landscape or other scene that includes a very bright sky, tilt the meter or camera down slightly so you exclude most of the sky from the reading. But suppose a bright sky with interesting clouds is the area in which you want to see detail and there are much darker land elements silhouetted against it (see the small photograph on page 9, bottom center). In that case, the sky is your main subject, the one you should meter to determine your camera settings.

A substitution reading is possible if you can't move in close enough to the important part of a contrasty scene. Look for an object of about the same tone in a similar light and read it instead. For exact exposures, you can meter the light reflected from a *gray card*, a card that is a standard middle gray of 18 percent reflectance (meters are designed to calculate exposures for subjects of this tone). You can also meter the light reflected by the palm of your hand (see below). Make sure you hold the card or your hand in the same light that is falling on the subject.

How do you set your camera after you have metered a high-contrast scene? If your camera has a manual exposure mode, set the shutter speed and aperture to expose the main subject correctly, using the settings from a reading made up close or from a substitution reading. In automatic operation, you must override the automatic circuitry (see page 72). Don't be afraid to do this; only you know the picture you want.

A substitution reading, such as one taken from the palm of your hand or a gray card, will give you an accurate reading if you can't get close enough to a subject or—as in this scene—you can't easily find an area of average reflectance. Make sure you are metering just the palm (or the card) and not the sky or other background of a different tone. A hand-held reflected-light meter is shown, but you can also use a meter built into a camera.

If you meter from the palm of your hand, try the exposure recommended by the meter if you have very dark skin, but give one stop more exposure if you have light skin, as here. If you make a substitution reading from a photographic gray card, use the exposure recommended by the meter.

Low Light and Reciprocity

Film needs extra exposure when the exposure time is long. At exposures of one second or longer, most films do not respond the way they do at shorter exposure times. Generally, light intensity and exposure time are *reciprocal*: a decrease in one will be balanced by an increase in the other. But for long exposure times, usually one second or longer, you need to increase the metered exposure, either by adding exposure time or by opening the aperture. If you don't, your film will be underexposed and your photograph will be too dark.

If your meter tells you to use a one-second exposure, the film probably needs about one extra stop of exposure: you can double the exposure time to two seconds or open the aperture one stop. If your meter calls for a ten-second exposure, you might need to increase that by two stops: either open the aperture two stops or multiply the exposure time by four. Some films are less prone to reciprocity failure than others, but it happens to all of them.

The film manufacturers help you by providing tables for reciprocity compensation for each of their films. These tables include a development adjustment to control the increased contrast that is a by-product of long exposures. Check each film maker's technical literature and Web site, or call their telephone hotline for information. Charts of suggested exposures for hard-to-meter scenes, like the one on the right, generally include this extra exposure.

Color films have a particularly awkward problem with reciprocity. Color films are actually made of three black-and-white emulsion layers; usually the three layers respond differently from each other to very long exposures, skewing the rendering of color in ways that are very difficult to remove in printing. Because of this, most professional tungsten-balanced color films are made specifically for long exposures; they have a color shift when used with very short exposures.

Digital cameras do not exhibit reciprocity failure, although some do not allow extremely long exposures. Longer exposures with digital cameras do, however, produce more noise in shadow areas. Take some test shots with your camera at long exposures to see.

Exposures in Hard-to-Meter Situations/ISO 400 Film

Outdoor scenes at night

Brightly lit downtown streets	¹⁄₆₀ sec.	f/2.8
Brightly lit nightclub or theater districts, e.g., Las Vegas	¹⁄₆₀ sec.	f/4
Neon signs and other lit signs	¹⁄₁₂₅ sec.	f/4
Store windows	¹⁄₆₀ sec.	f/2
Holiday lighting, Christmas trees	¹⁄₁₅ sec.	f/2
Subjects lit by streetlights	¹⁄₁₅ sec.	f/2
Floodlit buildings, fountains	¹⁄₁₅ sec.	f/2
Skyline—distant view of lit buildings	1 sec.	f/2.8
Skyline—10 min. after sunset	¹⁄₆₀ sec.	f/5.6
Fairs, amusement parks	¹⁄₃₀ sec.	f/2.8
Amusement-park rides—light patterns	1 sec.	f/16
Fireworks—aerial displays (Keep shutter open for several bursts.)		f/16
Lightning (Keep shutter open for one or two streaks.)		f/11
Burning buildings, campfires, bonfires	¹⁄₆₀ sec.	f/4
Subjects by campfires, bonfires	¹⁄₃₀ sec.	f/2
Night football, baseball, racetracks*	¹⁄₁₂₅ sec.	f/2.8
Moonlit landscapes	8 sec.	f/2
Moonlit snow scenes	4 sec.	f/2

Indoor scenes*

Home interiors at night—average light	¹⁄₃₀ sec.	f/2
Candlelit close-ups	¹⁄₁₅ sec.	f/2
Indoor holiday lighting, Christmas trees	¹⁄₁₅ sec.	f/2
Basketball, hockey, bowling	¹⁄₁₂₅ sec.	f/2
Boxing, wrestling	¹⁄₂₅₀ sec.	f/2
Stage shows—average	¹⁄₆₀ sec.	f/2.8
Circuses—floodlit acts	¹⁄₆₀ sec.	f/2.8
Ice shows—floodlit acts	¹⁄₁₂₅ sec.	f/2.8
Interiors with bright fluorescent light †	¹⁄₆₀ sec.	f/4
School—stage, auditorium	¹⁄₃₀ sec.	f/2
Hospital nurseries	¹⁄₆₀ sec.	f/2
Church interiors—tungsten light	¹⁄₃₀ sec.	f/2

* Use indoor (tungsten-balanced) film for color pictures
† Use daylight-balanced film for color pictures
© Eastman Kodak Company. 1978

In hard-to-meter situations like the photograph on the opposite page, try these manually set exposures for films rated at ISO 400. Give four times as much exposure (two stops more) for films rated at ISO 100, and half as much exposure for films rated from ISO 1000 to 3200.

Exposures in Hard-to-Meter Situations

Bruce Cratsley. *Centennial Fireworks, Brooklyn Bridge, New York City, 1983.*

What do you do when you can't make a meter reading—photographing a city skyline at night, for instance, or a display of fireworks? The meter in your camera can't tell you how to expose your film in most very low-light situations. But using a chart, like the one opposite, or simply guessing and making a couple of experimental tries may produce an image you'll like very much. If you keep a record of the scene and your exposures, you will have at least an idea about how to expose such a scene the next time.

Bracketing is a good idea: make at least three shots—one at the suggested exposure, a second with 1 or 1½ stops more exposure, and a third with 1 or 1½ stops less exposure. Not only will you probably make one exposure that is acceptable, but each different exposure may be best for a different part of the scene. For instance, at night on downtown city streets a longer exposure may show people best, whereas a shorter exposure will be good for brightly lit shop windows.

BEN SCHNALL
Film Reels, c. 1940.

This chapter describes how to process black-and-white film. The film is immersed in chemicals that transform the invisible image on the film to a permanent, visible one. After you have developed a roll or two of film, you'll find that the procedure is relatively easy, and the principles are the same if you want to try developing your own color film.

Familiarize yourself with the steps involved before you develop your first roll because the process begins in the dark and then proceeds at a brisk pace. Read through the step-by-step instructions on pages 87–92, check the manufacturer's instructions, and make sure you have ready all the materials you'll need. Sacrifice a roll of unexposed film to practice loading the developing reel (steps 4–8); you'll be glad you did when you step into the darkroom to load your first roll and you turn out the lights.

Consistency and cleanliness pay off. If you want to avoid hard-to-print negatives, mysterious stains, and general aggravation, be sure to follow directions carefully; adjust temperatures exactly; and keep your hands, equipment, and the film clean. Darkrooms generally have a dry side where film is loaded and printing paper is exposed, and a wet side with sinks where chemicals are mixed and handled. Always keep chemicals and moisture away from the dry side and off your hands when you are loading film. (See Avoid Contamination, page 86.)

You get your first chance to see the results of your shooting when you unwind the washed film from the developing reel. But when film is wet, the emulsion is soft and relatively fragile; dust can easily stick to the film, become embedded in the emulsion, and then appear in your print as white specks on the image. Resist the temptation to spend much time looking at the film until it is dry.

Imogen Cunningham. Snake, 1929. **Sometimes a negative image is more beautiful than the positive.** *Cunningham liked the reversed tones in this negative so much when she saw it that she went through several extra printing steps to keep it that way.*

Processing Film

EQUIPMENT AND CHEMICALS YOU'LL NEED

EQUIPMENT TO LOAD FILM

Developing reel holds and separates the film so that chemicals can reach all parts of the emulsion. Choose a reel to match the size of your film, for example 35mm or the larger 120 roll-film size. Some plastic reels can be adjusted to different sizes. Stainless steel reels are not adjustable and are somewhat more difficult to learn to load than are plastic reels. However, they are the choice of many photographers because they are durable and easy to clean of residual chemicals.

Developing tank with light-trap cover accepts the reel loaded with film. Loading has to be done in the dark, but once the film is inside and the cover in place, processing can continue in room light. A light-tight opening in the center of the cover lets you pour chemicals rapidly into and out of the tank without removing the cover. Larger tanks are made that hold two or more reels, if you want to process more than one roll at a time.

Bottle cap opener pries off the top of a 35mm film cassette. Special cassette openers are also available.

Scissors trim the front end of 35mm film square and cut off the spool on which the film was wound.

Optional: **Practice roll of film** lets you get used to loading the developing reel in daylight before trying to load an actual roll of film in the dark. A trial run is important before developing your first roll of film or when loading a different size of film for the first time.

A completely dark room is essential for loading the film on the reel. Even a small amount of light can fog film. If you can see objects in a room after 5 min. with lights out, the room is not dark enough. If you can't find a dark enough room, use a changing bag, a light-tight bag into which fit your hands, the film, reel, tank, cover, opener, and scissors. After the film is in the tank with the cover on, you can take the tank out of the bag into room light.

EQUIPMENT TO MIX AND STORE CHEMICALS

Source of water is needed for mixing solutions, washing film, and cleaning up. A hose on a faucet splashes less than water straight from the faucet. A particle filter may be necessary in some locations.

Photographic thermometer measures the temperature of solutions. An accurate and easy-to-read thermometer is essential because temperatures must be checked often and adjusted carefully. You will need a temperature range from about 50° to 120°F (10° to 50°C).

Graduated containers measure liquid solutions. Two useful sizes are 1 liter (or 32 oz) and 250 ml (8 oz). Graduates can be used for mixing and for holding the working solutions you will need during processing.

Mixing and storage containers hold solutions while you mix them and save them between processing sessions. You can use a graduated container to mix smaller quantities; for more, use a storage container with a wide mouth. Storage containers should be of dark glass or opaque plastic to keep out light and have caps that close tightly to minimize contact with air, which causes oxidation and deterioration of the chemicals.

Some plastic bottles can be squeezed and capped when partially full to expel excess air. Be sure all containers are labeled.

Stirring rod mixes chemicals into solution. The rod should be made of an inert and nonabsorbent material such as hard plastic, glass, or stainless steel that will not react with or retain chemicals.

Optional: **Funnel** simplifies pouring chemicals into narrow-mouthed storage bottles.

Optional: **Rubber gloves** (right). Gardening, dishwashing, or surgical gloves protect your hands from potential allergic reactions to processing chemicals.

EQUIPMENT TO PROCESS FILM

Tri-X film	65°F min.	68°F min.
HC-110 (Dilution B)	8½	7½
D-76	9	8
D-76 (1:1)	11	10
Microdol-X	11	10
DK-50 (1:1)	7	6

Manufacturer's instructions included with film or developer give recommended combinations of development time and developer temperature.

Containers for working solutions must be large enough to hold the quantity of solution needed. Graduates are convenient to use. Have three for the main solutions—developer, stop bath, and fixer. It is a good idea to reserve a container for developers only; even a small residue of stop bath or fixer can keep the developer from working properly.

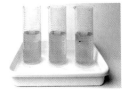

Optional: **Tray** or pan can be used as a water bath for the containers of working solutions to keep them at the correct temperature.

Timer with a bell or buzzer to signal the end of a given period is preferable to a watch or clock that you must remember to consult. An interval timer can be set from 1 sec. to 60 min. and counts down to zero, showing you the amount of time remaining.

Film clips attach washed film to a length of string or wire to hang to dry. Spring-loaded clothespins will do the job. A dust-free place to hang the wet film is essential. A school darkroom usually has a special drying cabinet; at home, a bathroom shower is good.

Optional: **Photo sponge** wipes down wet negatives so that they dry evenly.

Negative storage pages protect the dry film.

CHEMICALS

You'll need three essential and two optional (but recommended) solutions to process black-and-white film. For more information, see Mixing and Handling Chemicals (page 86) and manufacturer's instructions.

Developer converts the latent (still invisible) image in exposed film to a visible image. Choose a developer designed for use with film, not for prints. For general use and for your first rolls of film, choose an all-purpose developer such as Kodak D-76 (T-Max developer if you use T-Max films), Ilford ID-11, or Edwal FG7.

The length of time you can store a developer depends on the developer and on storage conditions. A stock solution of Kodak D-76, for example, lasts about six months in a full container, two months in a half-full container. Some developers are reusable. See Replenishing-Type Developers and One-Shot Developers, page 86.

Stop bath stops the action of the developer. Some photographers use a plain water rinse.

Others prefer a mildly acid bath prepared from about 1 oz of 28 percent acetic acid per quart of water.

If you are using plain water as a stop bath, simply discard it after processing. An acetic acid stop bath is reusable. Working solution lasts about a month if stored in a full, tightly closed bottle, and treats about 20 rolls of film per quart. An indicator stop bath changes color when it is exhausted.

Fixer (also called hypo) makes film no longer sensitive to light, so that when fixing is complete the negative can be viewed in ordinary light. A fixer that contains a hardener makes film more resistant to scratching and surface damage. Regular fixer takes 5–10 min. to fix film; rapid fixer takes 2–4 min.

Fixer treats about twenty-five rolls of film per quart of working-strength solution and lasts a month or more in a full container. The best test of fixer strength is to use an inexpensive testing solution called hypo check or fixer check. A few drops of the test solution placed in fresh fixer will stay clear; the drops will turn milky white in exhausted fixer.

Optional: **Clearing bath** (also called a washing aid, fixer remover, or hypo neutralizer), such as Heico Perma Wash or Kodak Hypo Clearing Agent, followed by washing in running water, clears film of fixer more completely and faster than washing alone. The shortened wash time also reduces swelling and softening of the emulsion and makes the wet film less likely to be damaged.

Different brands vary in capacity and storage; see manufacturer's instructions.

Optional but highly recommended: **Wetting agent,** such as Kodak Photo-Flo, reduces the tendency of water to cling to the surface of the film and helps prevent water spots during drying, especially if you have hard water.

A very small amount of wetting agent treats many rolls of film. Discard the diluted solution periodically.

Always wear safety gear to protect your skin and eyes.

Mixing and Handling Chemicals

Mixing dry chemicals. Transfer dry chemicals carefully from package to mixing container so you do not create a cloud of chemical dust that can contaminate nearby surfaces or be inhaled. Mix chemicals with water that is at the temperature suggested by the manufacturer; at a lower temperature, they may not dissolve. Stir gently until the chemical dissolves.

Stock and working solutions. Chemicals are often sold or stored as concentrated solutions. Before use, dilute the more concentrated stock solution to its working strength.

Instructions are often given as a ratio, such as 1:4. The concentrated chemical is listed first, followed by the diluting liquid, usually water. A developer to be diluted 1:4 means add 1 part concentrated stock solution to 4 parts water.

Replenishing-type developers can be reused if you add replenisher chemicals after each developing session to bring the solution back to working strength. For consistency, keep a record of the number of rolls processed, the replenishment, and the date the developer was mixed. Discard any

solution stored longer than recommended; if in doubt about the age or strength of any solution—throw it out.

One-shot developers are used once, then discarded. They are often used in school darkrooms so there is no question about developer replenishment, age, or strength. They are usually supplied in a highly concentrated form, and so are a good choice if your developing sessions are infrequent. Stored developer deteriorates more rapidly if it is dilute.

Raising or lowering temperatures will take less time if the solution is in a metal container rather than a glass or plastic one. To heat a solution, run hot water over the sides of the container. To cool a solution, place the container for a short time in a tray of ice water. Stir the solution occasionally to mix the heated (or cooled) solution near the outside of the container into the solution at the middle.

Avoid unnecessary oxidation. Contact with oxygen speeds the deterioration of most chemicals, as does prolonged exposure to light or heat. Stir solutions

gently to mix them rather than shaking them. Don't let chemicals sit for long periods of time in open tanks or trays. Store in tightly covered dark-colored containers of the right size. Chemicals last longer in full or nearly full containers.

Avoid contamination. Getting chemicals where they don't belong is a common cause of darkroom problems and an easy one to prevent.

Keep work areas clean and dry. Wipe up spilled chemicals and rinse the area thoroughly with water.

Keep chemicals away from the dry side of the darkroom, where you load film and make prints. Measure and mix chemicals and do all your processing on the wet side of the darkroom.

Chemicals on your fingers, even in small amounts, can cause spots and stains on film or paper. Rinse your hands well when you get chemicals on them, then dry them on a clean towel.

Rinse tanks, trays, and other equipment well. The remains of one chemical in a tank can affect the next chemical that comes in contact with it. Be particularly careful to keep

stop bath and fixer out of the developer.

Wear old clothes or a work apron in the darkroom. Developer splashed on your clothes will darken to a stain that is all but impossible to remove, and fixer can bleach colors.

Handle chemicals safely. Photographic chemicals, like any chemical, should be handled with care.

Read manufacturer's instructions before using a new chemical. Consult each chemical's Materials Safety Data Sheet (MSDS) to be certain of any hazards. The U.S. government requires each chemical manufacturer to provide an MSDS on request; ask your retailer, call the manufacturer's hotline, or check their Web site.

Mix and handle chemicals only in areas where there is adequate ventilation and a source of running water. Do not inhale chemical dust or vapors or get chemicals in your mouth or eyes. Wash hands carefully before eating.

Some people are allergic to certain chemicals and can develop skin rashes or other symptoms, especially with repeated exposure. See a doctor if you suspect this is

happening to you. Using surgical or rubber gloves and tongs will minimize chemical contact.

Special safety cautions with acids. Follow the basic rule when diluting concentrated acids: always add acid to water, not water to acid. Stop bath is an acid.

Concentrated acids that come in contact with your skin can cause serious burns. Immediately flush well with cold water. Do not scrub. Do not use ointments or other preparations. Cover with dry, sterile cloth until you can get medical help.

If you get chemicals in your eye, immediately flush the eye with running water for at least 15 min. Then get to a doctor immediately.

If you swallow any chemicals, do not induce vomiting. Drink a neutralizing agent such as milk or milk of magnesia. See a doctor immediately.

Dispose of chemicals properly. Used fixer especially is an environmental hazard and its disposal is regulated. If you are working at home, arrange to drop off your used fixer at a school or professional lab that adheres to EPA guidelines.

Processing Film Step by Step

SETTING OUT MATERIALS NEEDED

1 Determine the developer time and temperature. The warmer the developer, the faster it works, so the less time needed to develop the film. Manufacturers provide charts recommending time-and-temperature combinations in the instructions that come with developers and films. Darker, **boldface** type usually indicates the optimum combination. If the chart lists different times for large tanks and small tanks (sometimes called reel-type tanks), use the small-tank times. Select a time-and-temperature combination for your film and developer. If you don't have a data sheet, check the manufacturer's home page on the Internet.

KODAK T-MAX 400 Professional Film

Kodak Developer	Small-Tank Development Time in Minutes (Use vigorous agitation at 30-second intervals)					EI
	65°F (18°C)	68°F (20°C)	70°F (21°C)	72°F (22°C)	75°F (24°C)	
T-Max RS Developer and Replenisher	—	7	6	6	**5**	400/27°
T-Max	—	7	6½	6½	**6**	400/27°
D-76	9	**8**	7	6½	5½	400/27°
D-76 (1:1)	14½	**12½**	11	10	9	400/27°
HC-110 (Dil B)	6½	**6**	5½	5	4½	320/26°
Microdol-X	12	**10½**	9	8½	7½	200/24°
Microdol-X (1:3)	—		20	18½	**16**	320/26°

The development times in **bold type** are the primary recommendations.

The developer you use determines the exposure index (EI). Set your camera or meter (marked for ISO or ASA speeds) at the speed shown for your developer.

2 Mix the solutions and adjust their temperatures. Dilute the developer, stop bath, and fixer to the working strength recommended by the manufacturer. Make at least enough solution to cover the reel (or reels, if you are developing more than one) completely in the tank; it's better to have too much solution than too little. Check temperatures (rinse the thermometer between solutions). Adjust the developer temperature exactly, and the stop bath and fixer within 3°F of the developer temperature. In a cold darkroom, put the containers of solutions into a tray of water at the developing temperature; this will prevent them from cooling down before you are ready to use them. Or, you can mix the chemicals after loading the film.

3 Arrange materials for loading film. In a dry, clean, light-tight place, set out your exposed roll of black-and-white film, the developing tank and its cover, a reel, a pair of scissors, and a bottle cap opener. Make sure the tank, its cover, and, particularly, the reel are clean and dry.

If this is your first roll of film, practice steps 4–8 (shown on pages 88–89). Film has to be loaded onto the reel and put into the tank in complete darkness, so if you are developing your first roll of film, practice locating things with your eyes shut. Use an out-of-date or scrap roll of film to practice loading the reel.

Each coil of film must be wound into a separate groove. If two or more coils wind onto the same groove or part of a coil jumps its track, different sections of film can come in contact with each other and prevent development at those points.

When you practice, particularly if you are using a stainless-steel reel, see how much of the reel the film fills. A 36-exposure roll of 35mm film will fill a reel completely: a 12- or 24-exposure roll will fill it partway. Knowing how full the reel should be will help you check that it is correctly loaded when you are in the dark.

Processing Film Step by Step

PREPARING THE FILM

Before opening the film cassette, make sure your hands and the counter-top are clean and dry, with no residue from any chemicals that you have been handling. Check that everything you will need is in place (see step 3). Lock the door and turn off the lights. Keep lights off until the film is in the tank with the cover on.

In an unfamiliar darkroom, give your eyes a few minutes to adjust to the darkness before opening your film cassette. If you can see your hands, a harmful amount of light is leaking in.

Note: The black tone behind the illustrations of steps 4–9 means the room must be completely dark.

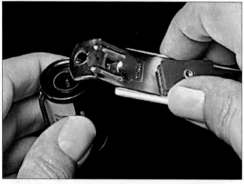

4 **Open a 35mm film cassette.** Use the rounded end of the bottle cap opener to pry off the flat end of the cassette. From the other end, gently push out the film, together with the spool on which it is wound.

Opening other types of roll film. With larger sizes of roll film, which are wrapped in paper, break the seal and let the film roll up loosely as you unwind it from the paper. When you reach the end of the film, gently pull it loose from the adhesive strip that attaches it to the paper. To open film that is in a plastic cartridge, twist the cartridge apart and remove the spool of film.

5 **Trim 35mm film square.** 35mm film has a tongue of film leader at its front end. Cut off this tongue to make the end of the film square.

Handle film carefully. Hold the film loosely by its edges. This helps prevent oil from your skin getting on the image area of the film and causing uneven development or fingerprints. Do not unroll film too fast or rip off an adhesive strip with a quick snap. Doing so can generate a flash of static electricity that may streak the film with light.

6 **Loading a plastic reel.** To load this type of plastic reel, first run your finger along the squared-off end of the film to make sure you have cut between the sprocket holes, not through them. The film may snag if the end is not smooth. Hold the film in either hand so it unwinds off the top. Hold the reel vertically in your other hand with the entry flanges at the top, evenly aligned and pointing toward the film. Insert the end of the film just under the entry flanges. Push the film forward about half a turn of the reel.

7 **Wind the film on the reel.** Hold the reel in both hands. Turn the two halves of the reel back and forth in opposite directions to draw the film into the reel.

8 **Cut the spool free with the scissors** when all the film is wound. In total darkness, a blunt-end scissors is safer.

8a **Alternate procedure: Loading a stainless-steel reel.** The reel consists of wire spirals running from the core of the reel to the outside. The film loads into the grooves between the spirals.

Hold the reel vertically in your left hand and feel for the blunt ends of the wire on the outermost spirals. Position the reel with the ends on top, pointing toward your right hand. Hold the film in your right hand (in your left hand if you are left-handed) so that the film unwinds from the top, pointing toward the reel.

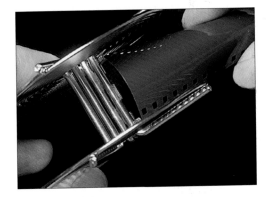

Thread the film into the reel. Unwind 2 or 3 inches of film and bow it slightly by squeezing the sides gently (extreme flexing can crimp the film and cause marks). Insert the end of the film into the core of the reel. Feed the film straight so that it goes squarely into the center of the reel. Attach the film to the clip at the center of the reel.

Rest the reel edgewise on a flat surface. Keeping the film bowed slightly, rotate the top of the reel away from the film to start the film feeding into the innermost spirals. Hold the film loosely and let it be drawn from your fingers, rather than poking or forcing the film into the reel. If the film kinks, unwind past the kink, then rewind. Check that the film is wound correctly by feeling how full the reel is. If you find more—or fewer—empty grooves than should be there, gently unwind the film from the reel, rolling it up as it comes, and begin again.

9 **Put the reel in the tank and cover it.** The cover shields the film from light, so when the loaded reel is in the tank with the cover securely in place you can turn on the room lights or take the tank to the developing area. If you have a two-reel tank, make sure to put two reels in. If one is empty, put it on top.

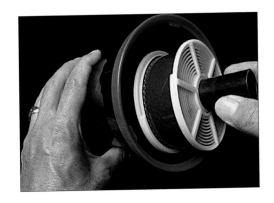

Important: Remove the correct cover to add or pour out solutions. The tank shown here has a pouring opening at the center and a cover that is removed to add or pour out solutions. The cover is replaced during agitation so that chemicals do not spill out.

Processing Film Step by Step

DEVELOPMENT

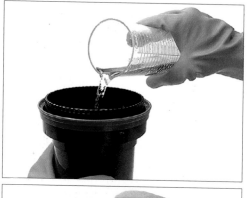

10 **Before pouring the developer into the tank,** check the developer temperature. If the temperature has changed, readjust it and the other solution temperatures, or select the corresponding development time from the time-and-temperature chart. Set the timer.

Start the timer and pour the developer into the tank. To fill a stainless-steel tank, remove only the small cap at the center of the lid, not the entire lid. Tilt a stainless-steel or plastic tank slightly to help it accept the liquid quickly, and pour in developer until the tank is completely full.

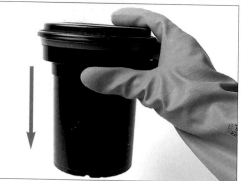

11 **Begin agitation immediately** as described in step 12. Quickly cover the tank and hold the tank so its cover or cap won't fall off.

Rap the bottom of the tank once or twice sharply against a solid surface to dislodge any air bubbles that might be clinging to the film surface. Do this only at the end of your first agitation cycle.

12 **Agitate the developer** in the tank by turning the tank upside down and right side up again. Each complete movement should take about 1 sec. Provide an initial agitation of 30 sec., then repeat the agitation for 5 sec. out of every 30 sec. during the development time. (Check instructions for the developer you are using. Follow manufacturer's recommendations if they differ from these.) Put the tank down and don't handle it between agitation periods so that your hands don't warm or further agitate the solution within.

Some plastic tanks have a crank in the lid that rotates the reel to agitate it.

13 **Pour out the developer.** About 10–15 sec. before the end of the development time, remove the correct cap or cover from the pouring opening.

Hold the tank so the cover won't come off (see the photo at step 11). Pour the developer out of the tank, draining it completely. Discard the solution if you are using a one-shot developer; save it if it can be replenished and used again (see page 86).

14 **Pour the stop bath into the tank.** Immediately pour the stop bath through the pouring opening in the tank. As before, tilt the tank to help it accept the liquid quickly and fill the tank completely. Replace the cover or cap over the pouring opening.

Agitate the stop bath. Agitate continuously for about 30 sec. by gently swirling and inverting the tank, holding the tank cover so it won't fall off.

15 **Pour out the stop bath.** Remove only the correct cap or cover from the pouring opening. Hold the tank so that the cover won't come off and pour out the stop bath, draining the tank completely. Discard a plain water stop bath; save an acetic acid stop bath, which can be reused.

16 **Pour the fixer into the tank.** Pour the fixer through the pouring opening in the tank until the tank is full. Replace the cover over the pouring opening.

Agitate the fixer. Agitate continuously for the first 30 sec. of the fixing time recommended by the manufacturer, then at 30-sec. intervals. Fixing time will be about 5–10 min. with regular fixer, 2–4 min. with rapid fixer.

17 **Check that the film is clearing.** Halfway through the fixing time, you can lift the entire tank cover and take a quick look at the film. Film should be fixed for about twice the time it takes to clear of any milky appearance. If the film still has a milky look after fixing for more than half the maximum time recommended by the manufacturer, the fixer is exhausted and should be discarded properly (see page 86). Keep the tank covered and refix the film in fresh fixer.

Pour out the fixer, saving it for future use. Once the film has been fixed, it is no longer sensitive to light, and the tank cover can be removed.

Processing Film Step by Step

WASHING AND DRYING

18 **Treating the film with a clearing bath** is an optional but recommended step that will greatly reduce the washing time. With Kodak Hypo Clearing Agent, first rinse the film in running water for 30 sec. Immerse in the working solution of clearing bath, agitating first for 30 sec., then at 30-sec. intervals for 1½ min. more. (Check manufacturer's instructions if you are using a different brand.)

19 **Wash the film** in running water at about the development temperature. Leave the film on the reel in the tank and, after adjusting the water temperature, insert the hose from the faucet into the core of the reel. Run the wash water at least fast enough to completely change the water in the tank several times in 5 min. Also dump the water completely several times. Wash for 5 min. if you have used a hypo clearing bath, 30 min. if you have not.

Treat the film with a wetting agent like Kodak Photo-Flo to help prevent spotting as the film dries. Immerse film in diluted solution for 30 sec., agitating gently for about 5 sec. If you still get drying spots, mix the wetting agent with distilled water.

20 **Hang the film to dry** in a dust-free place. Hang a clip or clothespin on the bottom end to keep the film from curling. Handle the film as little as possible and very carefully at this stage; the wet emulsion is soft and easily damaged.

Wiping down the film gently can speed drying and discourage spotting or streaking if that is a problem even though you use a wetting agent. Use only a clean sponge made for photo purposes and dampened with diluted wetting agent. Keep the sponge in good condition by squeezing (not wringing or twisting) out excess moisture. The risk of wiping the film is that you may scratch it; don't wipe it if it dries well without wiping.

21 **Clean up.** Discard a one-shot developer or save and replenish a developer that can be reused (see page 86). Store solutions that you want to save in tightly closed containers. Rinse well your hands, the reel, tank, containers, and any other equipment that came in contact with chemicals.

When the film is completely dry it will curl slightly toward its emulsion, the less shiny side. Cut the film into strips of five or six frames, depending on the size of the storage pages you have. Insert individual strips gently into the page's sections, handling the film by its edges. Store in a dust-free place, away from extremes of temperature or humidity.

Summary of Film Processing

STEP	TIME	PROCEDURE
Prepare chemicals	–	Mix the developer, stop bath, and fixer, plus optional clearing bath and wetting agent and dilute to working strength. Select a developer time and temperature from the film or developer manufacturer's instructions. Adjust the temperature of all the solutions accordingly.
Load film	–	IN TOTAL DARKNESS, load the film onto the developing reel. Put the loaded reel into the tank and put on the tank's cover. Lights can be turned on when tank is covered.
Development	Varies with film, developer, and temperature	Check the solution temperatures and adjust if necessary. Start timer. Pour developer into the tank through the pouring opening in the tank. DO NOT REMOVE ENTIRE COVER. Agitate by inverting and righting the tank continuously for the first 30 sec. Rap tank bottom once or twice on a solid surface. Then agitate for an additional 5 sec. out of every 30 sec. of development time. About 10–15 sec. before the development time is over, pour out developer through the pouring opening in the tank. DO NOT REMOVE ENTIRE COVER.
Stop bath	30 sec.	Immediately fill tank through pouring opening with stop bath. Agitate for the entire time. Pour out through pouring opening. DO NOT REMOVE ENTIRE COVER.
Fixer	5–10 min. with regular fixer; 2–4 min. with rapid fixer	Fill tank through pouring opening with fixer. Agitate for 30 sec., then at 30-sec. intervals. Pour out fixer.
Clearing bath (recommended)	30 sec. rinse in running water. Then 2 min. in clearing bath.	Agitate in the clearing bath for 30 sec., then at 30-sec. intervals for another 1½ min. (Check manufacturer's instructions.) Cover may be removed.
Wash	5 min. if you used a hypo clearing bath; 30 min. if you did not.	Wash water should flow fast enough to fill tank several times in 5 min. Dump water out of the tank several times during wash period.
Wetting agent (recommended)	30 sec.	Immerse the film in the wetting agent, agitating gently for about 5 sec. Mix the wetting agent with distilled water, if you live in a hard-water area.
Dry	1 or more hours. Less in a heated film drying cabinet.	Remove film from reel and hang to dry in a dust-free place. When completely dry, cut into convenient lengths and store strips in storage pages.

How Chemicals Affect Film

What **developer does.** Even after film has been exposed to light, the image is *latent*, not yet visible. Developer chemicals take the film to its next step by converting the exposed crystals of silver halide in the film emulsion to visible metallic silver. The developer you use is not a single chemical but a blend of several. The active ingredient in the developer is the *reducing agent*. Metol and hydroquinone, usually used in combination, are two common reducers.

Other chemicals enhance the action of the reducer. Most reducers work only in an alkaline solution. This is provided by the *accelerator*, an alkaline salt such as borax or sodium carbonate. Some reducers are so active that they can develop the unexposed as well as the exposed parts of the film, fogging the film with unwanted silver. To prevent this, a *restrainer*, usually potassium bromide, is added to some developers. A *preservative*, such as sodium sulfite, prevents oxidation and premature deterioration of the developer solution.

Developer time and temperature are critical. The longer the film is in the developer at a given temperature or the higher the temperature of the developer for a given time, the more of the silver halide crystals that will be converted to metallic silver and the denser and darker the negative will be. As little as 30 sec. or a few degrees temperature change can make a significant difference in the resulting image. Charts (such as the one on page 87) show the combinations of time and temperature for various films and developers.

The stop bath is a simple acid solution (sometimes plain water is used) that neutralizes and partially removes the alkaline developer. Fixer is also acidic, so use of an acid stop bath helps extend the life of the fixer.

Fixer makes the image permanent by dissolving out of the emulsion any undeveloped crystals of silver halide. These are still sensitive to light and, if exposed, would darken the negative overall. This is why the cover must stay on the developing tank until well into the fixing stage of development (step 17, page 91). Once the fixing is complete, a permanent image of metallic silver remains. Fixer time is not as critical as developer time, but the film should not be underfixed or overfixed (of the two, overfixing is less damaging), so follow the time limits set by the manufacturer.

The active chemical in fixer sold dry is sodium thiosulfate. An early name for this chemical was sodium hyposulfite, which is why fixer is still often referred to as *hypo*. Ammonium thiosulfate, sold as a liquid concentrate, is a similar but faster-acting chemical called rapid fixer. A hardener is an optional part of the fixer formula. It prevents the emulsion from softening and swelling during the washing that follows fixing.

Washing removes chemicals left in the film after fixing, such as sulfur compounds that can damage the image if allowed to remain. Simple immersion in running water will wash the film, but treatment with a clearing bath speeds up the process and does a better job than using water alone, leaving the film as permanent as possible.

Fresh solutions are vital. Chemicals gradually deteriorate, particularly once they are diluted to working strength with water and exposed to air. Processing film in exhausted chemicals can produce stains, fading images, uneven development, or no image at all. When you store chemical solutions for future use, keep a written record of the date you mixed the solution and how many rolls of film you processed with it. Don't store chemicals longer than the manufacturer recommends or try to use them to process more rolls of film than recommended.

As development begins, the developer solution goes to work first on exposed crystals of silver halides near the surface of the film.

As development continues, the developer solution soaks deeper into the emulsion and the film becomes denser with developed silver.

With even more development, bright highlight areas, which received the most exposure to light in the camera, continue to increase in density at a more rapid rate than dark shadow areas that were exposed to less light.

Developer time and temperature affect how dense a deposit of silver will be created in the film emulsion. The image gradually increases in density during development.

Evaluating Your Negatives

You can make a print from a negative that is less than perfect, such as one that is overexposed or overdeveloped and so has too much density in the highlights (see the negatives opposite, far right). But if a negative is correctly exposed and developed, it will be easier to print and you will almost always get a better print from it.

Negatives are affected by both exposure and development. Remember this old photographic rule: Expose for the shadows, develop for the highlights. You can change the density of bright highlights during development, but you must give adequate exposure in the camera to dark shadow areas if you want them to show texture and detail in the print. In photographic terms, shadows are the darkest parts of a scene, even if they are not actually in the shade. Highlights are the lightest-toned areas.

Development controls highlight density. The longer the development time (at a given temperature), the denser and darker a negative will be, but that density does not increase uniformly over the entire negative. During extended development, the density of highlights, such as a sunlit white wall, increases quickly. The density of medium tones, such as a gray rock, increases at a moderate rate. The darkest tones, such as a deeply shaded area, change very slowly. Increasing the development time increases the *contrast*, the difference between the densities of bright highlight areas and dark shadow areas.

Exposure controls shadow density. Because development time has relatively little effect on the thinner areas in a negative (the darker parts of the original scene), they must be adequately exposed to begin with if you want them to show texture and detail. If you frequently have trouble getting enough detail in darker parts of your prints, try giving your negatives more exposure by resetting the film speed dial to a speed lower than that recommended by the film manufacturer or by bracketing to give the film extra exposure. (If you have an automatic camera, you'll need to override its automatic settings. Page 72 gives general information on how to do this, or see your camera's instruction manual.)

Follow recommended development times exactly at first. Ordinarily, you should use the recommended times, but you can change them if you find that roll after roll of your negatives are difficult to print. If your negatives are often high in contrast, so that you print most negatives on a low-contrast paper, try decreasing the development time 20 to 30 percent (more about paper contrast grades in Chapter 6, Printing). If your negatives are often low in contrast, so that you have to print most of your negatives on a high-contrast paper, try increasing the time 25 to 40 percent.

You can change the development for individual scenes. Just as you can adjust the exposure for different scenes, you can change the development time for a scene as well. In a very contrasty scene, for example, in a forest on a sunny day, sunlit foliage can measure six or more stops brighter than dark shadows. Given normal exposure and development, such a scene will produce very contrasty, hard-to-print negatives. You can decrease the density of highlights and so decrease the contrast by decreasing the negative development to about three-quarters the normal time.

In a scene with little contrast, perhaps at dusk or on an overcast day, the difference between highlights and shadows may be only two or three stops. If you think such a scene will be too flat, with too little contrast, try increasing the negative development time by 50 percent.

With roll film, changing the development affects the entire roll, so it's best to shoot the whole roll under the same conditions.

How do you tell the difference between an underexposed negative and an underdeveloped one? Or between an overexposed negative and an overdeveloped one? It's useful to be able to recognize which is which in order to prevent problems with future negatives.

Underexposed. *If your negatives are consistently too thin and lack detail in shadow areas, increase future exposures. One way to do this is by setting the camera to a lower film speed. For one stop more exposure, divide the normal film speed by two.*

Overexposed. *If many of your negatives are too dense overall with more than adequate detail in shadow areas, decrease future exposures, such as by setting the camera to a higher film speed. For one stop less exposure, multiply the film speed by two.*

A normally exposed, normally developed negative
(made of a scene with a normal range of contrast) should have good separation in highlights, midtones, and shadows. The negative will make a good print on a normal contrast grade of paper.

Underdeveloped. *If many negatives seem flat, with good shadow detail but not enough brilliance in highlights, increase the development time for future rolls. Try developing for 50 percent more than the normal time.*

Overdeveloped. *If negatives are often too contrasty, with good shadow detail but highlights that are overly dense (particularly if you make prints on a condenser enlarger), decrease the development time for future rolls. Try developing for three-quarters the normal time.*

Push Processing

Push processing can help you shoot in very dim light. Sometimes the light on a scene is so dim that you cannot use a fast enough shutter speed even at the widest lens aperture. Pushing the film lets you shoot at a film speed higher than the normal rating by, in effect, underexposing the film. For example, if you are using an ISO 400 film, you can reset your film speed dial to ISO 800 or even ISO 1600. This underexposes the film, but lets you shoot at a faster shutter speed. To compensate for the underexposure, you overdevelop the film, either by increasing the development time or by using a special high-energy developer, such as Acufine, Diafine, or Microphen.

To double the film speed, such as from ISO 400 to ISO 800, try increasing your normal development time by about 50 percent. Kodak T-Max films need less increase in development time. See chart at right for manufacturer's instructions. The times of the other processing steps (stop bath, fixer, and wash) stay the same.

Push processing does not actually increase the film speed. It does, however, increase the density of highlight areas enough to produce a usable image, which you might not have if you exposed and developed the film normally. Dark tones, such as shadowed areas, will be darker and less detailed than in a normally exposed scene because they will be underexposed and the increased development time will not have much effect on them. With push processing, you deliberately sacrifice shadow detail to get a usable highlight image.

Push processing has some side effects. The more you push the film by increasing the working film speed and subsequently overdeveloping, the more that graininess and contrast increase, and sharpness and shadow detail decrease. Similarly, digital pictures have more noise at higher working speeds.

Pushing Black-and-White Films

Film (normal speed ISO 400)	Developer	To push film one stop to 800	To push film two stops to 1600
Kodak T-Max 400	Kodak T-Max 68°F (20°C)	7 min. (normal development)	10 min.
	Kodak D-76 68°F (20°C)	8 min. (normal development)	10½ min.
Kodak Tri-X	Kodak T-Max 68°F (20°C)	6 min.	10 min.
	Kodak D-76 68°F (20°C)	7 min.	13 min.
Ilford Delta 400	Kodak D-76 68°F (20°C)	9 min.	12½ min.
Ilford HP5 Plus	Ilford Microphen 68°F (20°C)	8 min.	11 min.
Fuji Neopan 400	Kodak T-Max 75°F (24°C)	5¼ min.	8 min.

Film (normal speed ISO 800)	Developer	To push film speed to 3200	To push film speed to 6400
Kodak T-Max 3200 (actual speed 1000)	Kodak T-Max 70°F (21°C)	11 min.	13 min.

Film (normal speed ISO 1600)	Developer	To push film speed to 3200	
Fuji Neopan 1600	Kodak D-76 72°F (22°C)	8 min.	

Pushing film speed. The chart shows some manufacturers' development recommendations for pushing film. The development times shown are a starting point from which you should experiment to determine your own combinations.

Sometimes you don't need to change the development time: you can push film one stop by underexposing it and developing normally. Kodak recommends this for a one stop push of its T-Max 400 film. Simply expose at ISO 800, instead of the standard ISO 400. Kodak suggests this film has enough exposure latitude to accept one stop of underexposure without the need for extra development.

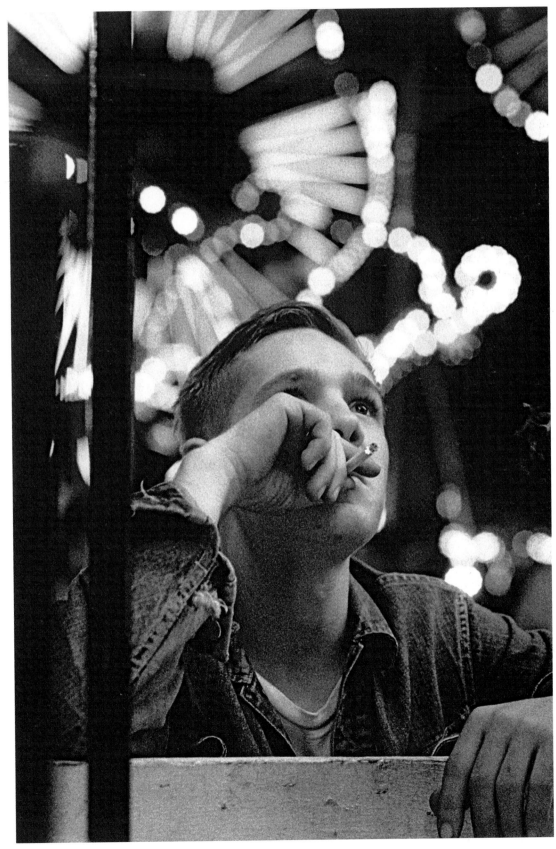

Susan Meiselas. *Young Gawker, Essex Junction, Vermont, 1974.* **Pushing film,** *underexposing the film then giving it greater-than-normal development, lets you expose film at a higher-than-normal film speed. It can save the day when the ambient light isn't bright enough for you to use as fast a shutter speed as you want.*

Meiselas rated Kodak Tri-X film at ISO 1600 instead of the standard ISO 400 and gave the film special development. This gave her two extra stops of film speed and let her shoot in available light indoors and at night—where flash would have been intrusive—for the project Carnival Strippers.

Pushing increases graininess and contrast in a photograph, but it is valuable when you must have more film speed than normal processing can provide.

Printing 6

Negative

Now comes the fun. Developed negatives in hand, you finally get to examine your pictures closely, first in a contact print that is the same size as the negative, then in enlarged prints. This chapter describes how to print black-and-white film. Many of the procedures are the same if you make color prints. See pages 174–175 for printing digital images.

The negative has the opposite tones of the original scene. Where the scene was bright, such as white clouds, that part of the film received a great deal of exposure and produced an area in the negative that is dense and dark with silver. Where the scene was dark, such as in a shadowed area, the film received little exposure, resulting in a less-dense or even clear area in the negative.

When you make a positive print, the tones are reversed again, back to those of the original scene. The densest and darkest parts of the negative will hold back the most light from the paper, producing a light area in the print. Less-dense parts of the negative will pass the most light, producing the darkest parts of the print.

Avoid chemical contamination to avoid printing problems. Think of your printing darkroom as having a dry side and a wet side; you will be moving repeatedly from one side to the other. On the dry side, you handle negatives, adjust the enlarger, and expose paper. On the wet side, you mix chemicals and process prints. It is vital to prevent wet-side procedures from contaminating the dry side. Even a small amount of a chemical straying over to the dry side on your fingertips—even if you wiped them—can leave fingerprints on your next print, permanently damage negatives, and more. See page 86 for how to avoid contamination, mix chemicals, and handle them safely.

Positive

Printing

EQUIPMENT AND MATERIALS YOU'LL NEED

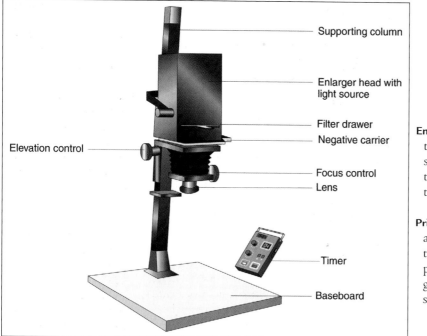

Supporting column

Enlarger head with
light source

Filter drawer

Negative carrier

Elevation control

Focus control

Lens

Timer

Baseboard

**Dodging and burning-in
tools** let you selectively
lighten or darken
parts of a print (see
pages 118–119).

Miscellaneous: marking
pen, scissors. For clean-
ing negatives, use a
clean soft brush or a
compressed gas such as
Dust-Off Plus.

Enlarger timer activates
the enlarger light
source, turning it on,
then off when the set
time has expired.

Printing frame holds neg-
atives and paper tightly
together for contact
prints. A sheet of plain
glass can be used as a
substitute.

PRINTING PAPER

Printing paper (for
conventional black-
and-white or color
prints) is coated with a
light-sensitive emulsion
onto which the image
is exposed.

DRY-SIDE EQUIPMENT

Enlarger (shown
above) projects light
through a negative
onto photographic
paper.

Supporting column
holds the enlarger
head out over the
baseboard.

Enlarger head contains
the light source, nega-
tive carrier, lens, and
other components.

Light source spreads light
from a lamp over the
negative. A condenser
source concentrates
light on the negative
through a pair of lens-
es. A diffusion source
scatters light onto the
negative, producing

less contrast. Some
designs combine char-
acteristics of these two
systems.

Filter drawer holds
filters that affect the
color of the light
source for variable-
contrast black-and-
white paper or for
color printing. A
dichroic enlarger
head has built-in fil-
ters; you simply dial
in different colors.

Negative carrier holds
the negative flat and in
place.

Lens focuses the image
from the negative onto
the baseboard. The lens
aperture is adjustable
to control the bright-
ness of the light pass-
ing through the lens.

The focal length of the
lens must match the
size of the negative: a
50mm lens is normally
used with a 35mm
negative, 80mm lens
with 6 × 6 cm
(2¼-inch) square or
6 × 7 cm negative,
150mm lens with
4 × 5-inch negative.

Focus control focuses the
image projected by the
enlarger by adjusting
the distance from nega-
tive to lens.

Elevation control adjusts
the image size by
moving the enlarger
head up or down a
track on the support-
ing column.

Baseboard supports
enlarger and printing
frame or easel.

Easel holds printing
paper flat on the
enlarger's baseboard
for enlargements. Most
have adjustable blades
for cropping the image
and creating white
borders.

Focusing magnifier
enlarges the projected
image when setting up
an enlargement so you
can focus sharply.

Fiber base or resin coated?
Resin-coated (RC)
papers have a water-
proof coating that lets
processing chemicals
reach the paper's emul-
sion but not the paper
fibers in its base. RC
paper does not become
saturated with liquid,
so less processing time
is required for fixing,
washing, and drying.
Nevertheless, many
photographers still pre-
fer fiber-base papers,
which are available in a
wider range of surface
finishes, are more per-
manent, and have what
many feel is a better
finish.

Graded contrast or variable contrast? To change the contrast of your print, you change the contrast grade of the printing paper. Each grade of a graded-contrast paper produces a single level of contrast. A variable-contrast paper produces different levels of contrast depending on the color (controlled by filtration) of the enlarger's light. See pages 116–117.

Surface finish and image tone. Characteristics vary widely, from smooth to rough finishes, glossy to matte (dull) surface sheen, cool blue-black to warm brown-black image color.

Size. Readily available sizes include 8 × 10, 11 × 14, and 16 × 20 inches; some papers are available in additional sheet sizes and wide rolls.

Weight refers to the thickness of the paper base. Fiber-base papers come in single weight (suitable for contact prints or small-size prints) and double weight (sturdier and easier to mount). RC papers come only in a medium weight that is between single and double weight.

WET-SIDE EQUIPMENT

Trays hold solutions during processing. For 8 × 10-inch prints, you'll need three trays of that size, plus one larger tray for washing.

Tongs lift prints into and out of solutions, keeping your hands clean so that you don't need to wash and dry them so often. At minimum, you'll need one for developer, another for stop bath and fixer.

Safelight provides dim, colored light that lets you see well enough to work without fogging the printing paper with unwanted exposure.

Timer or clock with sweep second hand times the processing.

Washing siphon clamps onto a tray. It pumps water into the top of a tray and removes it from the bottom so that fresh water circulates around the washing prints. Special print washers are also available.

Photo squeegee or sponge wipes down wet prints to remove excess water before drying.

Drying racks or other devices dry prints after processing (see page 108).

Mixing and storing equipment is similar to that used for film chemicals (page 84): mixing container, thermometer, stirring rod, storage bottles.

CHEMICALS

Most of the chemical solutions used in paper processing, including stop bath, fixer, and clearing bath, are the same as those used in film processing. Only the developer is different. Average storage times and capacities are given here; see manufacturer's directions for specifics.

Developer converts into visible metallic silver those crystals in the paper's emulsion that are exposed to light. Choose a developer specifically made for use with paper, not film.

Stock solution lasts from 6 weeks to 6 months, depending on the developer and how full the storage container is; the more air in the container, the faster the solution deteriorates. Discard working solution after developing fifteen to twenty 8 × 10 prints per quart (liter), or at the end of one working day.

Stop bath halts the action of the developer. A simple stop bath can be prepared from about 1½ oz (46 ml) 28 percent acetic acid to 1 quart (1 liter) of water. Stop bath stock solution lasts indefinitely. Discard working solution after about a month or after treating twenty prints per quart. An indicator stop bath changes color when exhausted.

Fixer removes undeveloped silver halides from the emulsion. A fixer with hardener prevents softening and possible damage to the emulsion during washing.

Fixer stock solution lasts 2 months or more. Working solution lasts about a month in a full container and will process about twenty-five 8 × 10-inch prints before it should be discarded properly (page 86). A testing solution called hypo check (or fixer check) is the best test of fixer exhaustion.

Optional: **Clearing bath** (also called washing aid, fixer remover, or hypo neutralizer) is highly recommended when you are using fiber-base papers. It removes fixer better and faster than washing alone. Capacity and storage time vary depending on the product; see manufacturer's instructions.

Making a Contact Print Step by Step

A **contact print** is made with the negative in contact with the printing paper; the print is the same size as the negative. A contact sheet of all the negatives on a roll makes it possible to examine and compare different frames so you can choose the ones to enlarge. Then you can store the contact for later reference.

It is useful to have a contact sheet for each roll (or negative storage page). Store them separately so that handling your contact sheets doesn't pose the risk of damage to your negatives. Contact prints of 35mm negatives are too small for you to evaluate each image critically, but they do give you a first look at sharpness, exposure, lighting, and other factors. In addition, the back of the contact print gives you a convenient place to keep dates, places, names, and other notes about the photographs.

The following method uses an enlarger as the light source and a sheet of glass or a contact printing frame to hold the negatives in good contact with the printing paper. See Equipment and Materials You'll Need, pages 102–103, and Processing a Print Step by Step, pages 106–108. A 36-exposure roll of 35mm film (or a roll of 2¼-inch 120 film) will just fit on an 8 × 10-inch sheet of printing paper. Use a grade 2 or normal contrast paper. (Contrast grades are explained on page 117.)

1 **Position the enlarger.** Insert an empty negative carrier in the enlarger head and close the slot where it is inserted so that light will shine only on the baseboard and is not coming out of the slot. This is particularly important in a school's group darkroom because stray light can fog other people's prints. Using an empty carrier ensures even illumination. Switch on the enlarger lamp. Place the negatives and the glass or printing frame on the enlarger baseboard. Raise the enlarger head until the light covers the entire glass.

Note: The dark background and yellow tone in this chapter's illustrations means that the room lights should be off, darkroom safelights on.

2 **Set the lens aperture and the enlarger timer.** As a trial exposure, set the enlarger lens aperture to f/8 and the timer to 5 sec. You may want to change these settings after developing and evaluating the print (see step 6, opposite). You can, if you wish, make a test print, using a range of different exposures as described on page 112.

3 Identify the emulsion sides of the negatives and paper. The negative emulsion must face the paper emulsion or prints will be reversed left-to-right. Film tends to curl toward its emulsion side, which is usually duller than the backing side. You are looking at the emulsion if the frame numbers on the edge of the film read backward.

Turn on the darkroom safelights and TURN OFF THE ROOM LIGHTS AND ENLARGER LAMP before opening the package of paper. The emulsion side of the paper is shinier and, with glossy papers, smoother than the back side. Fiber-base paper curls toward the emulsion side; RC paper curls much less and may curl in either direction, but may have a visible manufacturer's imprint on the back side.

4 Insert the negatives and one sheet of paper under the glass. The paper goes emulsion side up. The negatives go above the paper, emulsion side down. The glass sandwiches the negatives and paper together tightly. The easel shown here helps locate the glass exactly, but you can simply put the paper on the enlarger baseboard with the negatives on top, then cover them with a plain sheet of glass.

To make contact prints, you can leave negatives in their plastic storage pages or remove them. The contact print through the plastic will not be quite as sharp, but leaving them in the page minimizes handling and protects them from accidental damage. Unfortunately, an entire 36-exposure roll won't fit on an 8 × 10 sheet if the film is in a storage page.

5 Expose and process the print. With the printing frame in place under the enlarger head, push the timer button to turn the enlarger light on and expose the print.

Process the paper as shown on pages 106–108. After fixing, evaluate the print in room light. If you are the only person using the darkroom, you can simply turn on the lights there. BEFORE YOU TURN ON ROOM LIGHTS, make sure the package of unexposed printing paper is closed. If you are in a school darkroom used by others at the same time, bring the print into another room for evaluation. Carry it in an extra tray so fixer doesn't drip on other surfaces.

6 Evaluate the print. Some of the frames will be lighter, others darker, depending on the exposure each received in the camera. To judge print exposure overall, examine the film edges in the print. They should be black but with the edge numbers legible and, with 35mm film, a very slight difference between the edges and the darker sprocket holes. If the edges of the film look gray, many frames will probably be very light; make another print with the enlarger lens opened to the next larger aperture. If the edges of the film are so dark that you can't see edge numbers or sprocket holes, many frames will probably be very dark; close the enlarger lens to the next smaller aperture for the next print.

Processing a Print Step by Step

DEVELOPMENT

Processing a print is not unlike processing film: the exposed print is immersed and agitated in developer, stop bath, and fixer, then washed and dried. Until the print is fixed, don't expose it to ordinary room light, only to darkroom safelights. They are bright enough so that you can see what you are doing and see the image as it emerges—one of the real pleasures of printing.

See Equipment and Materials You'll Need, pages 102–103. Notice that resin-coated (RC) paper needs less time in the stop bath and fixer, no clearing bath, and less washing than fiber-base paper does.

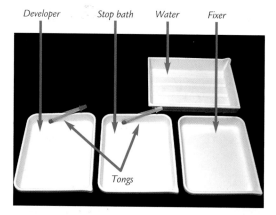

Developer Stop bath Water Fixer

Tongs

1 **Set up the wet-side materials.** Set up the processing solutions in four trays (one each for developer, stop bath, and fixer, plus one filled with water to hold prints after fixing until washing).

If you use tongs to lift the paper out of the solutions, reserve one set exclusively for the developer, another for stop bath and fixer. Label them so you do not accidentally interchange them.

Temperatures are not as critical as for film, but the recommended print developer temperature is often 68°F (20°C). Have other solutions close to the same as much as possible, but at least between 65° and 75°F (18°–24°C).

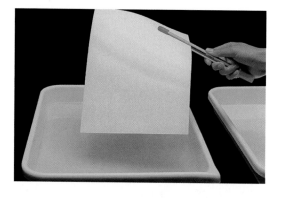

2 **Immerse the print in the developer.** Slip the exposed paper quickly into the solution, emulsion side up, so the developer covers the entire surface of the print.

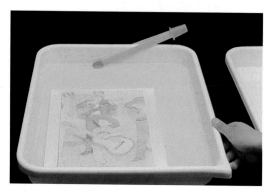

3 **Agitate the print in the developer.** Agitate continuously for the time recommended by the manufacturer for the particular paper you are using, typically 1–3 min. Time the development from the moment you slip the print into the developer until you slip it into the stop bath.

Agitate by rocking the tray gently, doing so in different directions, so you don't set up a constant flow pattern of developer. In an oversize tray, as is sometimes used in school darkrooms, you may have to use tongs to agitate the print. If so, touch the surface of the print as little as possible; the tongs can leave marks.

4 **Remove the print from the developer.** Let it drain for a few seconds into the developer tray so you don't carry too much developer into the stop-bath tray.

5 **Immerse the print in the stop bath.** Agitate continuously for at least 15 sec. (at least 10 sec. for RC paper). Use only the stop-bath/fixer tongs in this solution, not the developer tongs. If you accidentally get stop bath on the developer tongs, rinse them well before putting them back into the developer.

Remove the print from the stop bath. Let the print drain for a few seconds into the stop-bath tray. Don't let stop-bath solution splash into the developer.

6 **Immerse the print in the fixer.** Agitate the print frequently for 5 min. (2 min. for RC paper). If several prints are in the fixer, rotate individual prints from the bottom to the top of the tray. You can look at the print in ordinary room light after about 2 min., but be sure to return the print to the fixer to complete the fixing time. If you need to take the print to another room for viewing, make sure to carry it in a clean dry tray.

7 **Remove the print from the fixer** at the end of the recommended time and drain briefly. Transfer fiber-base paper to a large tray filled with water until the end of your printing session, when you can wash all the prints at once. In the meantime, run water gently into the tray, or dump and refill from time to time.

 Wash RC paper promptly for best results; ideally, total wet time should not exceed 10 min. to prevent solutions from penetrating the paper at the edges of the print. See Washing and Drying, next page.

Processing a Print Step by Step

WASHING AND DRYING

8 **Inspect your print in the light.** Your viewing light should be the same as the light in which the print will be viewed. If it is brighter or dimmer, you will make prints that are too dark or too light. If you want to keep a print that is on fiber-base paper, treat it in a clearing bath. (RC paper should not be treated with a clearing bath; go directly to step 9.)

Rinse fiber-base paper in running water with continuous agitation for 1 min. Then agitate in the clearing bath continuously for 15–30 sec., then occasionally for 2–3 min. more, or as directed by the manufacturer. When processing several prints at a time, rotate individual prints from the bottom of the tray to the top during agitation.

9 **Wash prints in running water.** If fiber-base paper has been treated with a hypo clearing bath, wash single-weight paper for 10 min., double-weight paper for 20 min.; if untreated, wash for 1 hour. Wash RC paper for 4 min. A wash water temperature of 50°–85°F (10°–30°C) is acceptable; 75°F (24°C) is optimum.

A dedicated print washer like the one shown is best. If you wash prints in a tray, run the wash water fast enough to fill the tray several times in 5 min., or dump and refill the tray several times. Rotate individual prints from top to bottom, and keep prints separated so they circulate freely. If necessary, move them frequently by hand. Prints won't wash if they just sit in a tray.

10 **Wipe off excess water.** Put one print at a time on the back of a tray or a clean sheet of plastic or glass. If you use a tray, clean it well and make sure the tray bottom is not ridged. Use a clean photo sponge or squeegee (an automobile windshield-wiper blade works well) to gently wipe down first the back of the print, then the front.

11 **Dry prints.** You can dry fiber-base prints face down on racks of plastic window screens, in a heated dryer, or between photo blotters. RC prints dry well face up on a rack or clean towel, or hung from a line with a clothespin. Do not dry them in a heated dryer unless it is designed specifically for drying RC prints. You can also use a hair dryer to dry RC prints; use it carefully at a low-heat setting.

An improperly washed print will contaminate its drying surface with fixer and cause stains on the next prints dried there. If blotters or cloths from heat dryers become tinged with yellow, they are contaminated with fixer. Blotters should be discarded and replaced with new ones; heat dryer cloths can be washed. Wash drying-rack screens occasionally.

Summary of Print Processing

STEP	TIME	PROCEDURE
Prepare chemicals	–	Mix developer, stop bath, and fixer to working strength. Pour each into a tray; fill a fourth tray with water. Temperatures are not as critical as for film, but try to keep the solutions as close to the recommended developer temperatures of 68°F (20°C) or 70°F (21°C) as you can. Keep the dry side of the darkroom free of chemical contamination. If your hands get wet, rinse and dry them well before handling items on the dry side, especially film or paper.
Expose the print	–	Expose a piece of printing paper to make a contact print (page 104), test print (page 112), or final print (page 113). Open printing paper package only under darkroom safelight. Do not turn on room lights until print has been fixed.
Development	1–3 min. (see manufacturer's instructions)	Agitate continuously for the time recommended by the manufacturer. Drain print for 10–15 seconds before transferring it to the stop bath.
Stop bath	At least 15 sec. with fiber-base paper, at least 10 sec. with RC paper	Agitate continuously. Drain print before transferring it to the fixer.
Fixer	5 min. with fiber-base paper, 2 min. with RC paper	Agitate frequently. If more than one print is in tray, rotate each from bottom to top of stack.
Holding until wash	As needed with fiber-base paper	If you have additional prints to make, transfer fiber-base prints into a tray of water until all are ready to wash. Run water gently into tray, or dump and refill occasionally. Don't let the water temperature rise above 80°F (27°C). Wash RC paper promptly (total wet time ideally should be not more than 10 min.).
Clearing bath (recommended for fiber-base paper only)	Water rinse: 1 min.	Agitate continuously in running water.
	Clearing bath: 2–5 min. (Check manufacturer's instructions.)	Agitate continuously for the first 15–30 sec., occasionally thereafter. Do not use with RC paper.
Wash	If hypo clearing bath was used with fiber-base paper: 10 min. with single-weight paper, 20 min. with double-weight paper If no clearing bath was used with fiber-base paper: 60 min. 4 min. with RC paper	Wash in running water at a temperature between 50° and 85°F (10°–30°C). Best is around 75°F (24°C). Keep prints separated. Rotate prints; dump and refill tray several times, or use a specially designed print washer.
Dry	1 or more hours	Wipe down front and back of print with clean squeegee or photo sponge. Dry fiber-base paper on racks, in heated print dryer, or in photo blotters. Dry RC prints on racks, on a line, or on any clean surface, but not in a heated dryer unless you are sure it is safe for RC prints. Make sure drying surface is free of fixer or other chemical residues.

Making an Enlarged Print Step by Step

SETTING UP THE ENLARGER

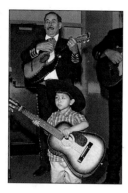

An enlarged print finally gives you a good look at your photograph and the chance to show it to others. Making an enlargement is shown here in three steps: Setting Up the Enlarger (on this page and the one opposite), Exposing a Test Print, and Exposing a Final Print, pages 112–113.

See Equipment and Materials You'll Need, pages 102–103, and Processing a Print Step by Step, pages 106–108.

Some photographers think enlargers with a diffusion light source produce superior print tones to those with a condenser. Dust and scratches on your negatives and graininess will certainly show less on prints from a diffusion enlarger, and printing contrast is lower. If you use one, start with a grade 2½ or 3 paper or filter in step 8.

1 **Select a negative for printing.** Examine the contact sheet with a magnifying glass or loupe. If you have several shots of the same scene, which has the best light, or action, or expressions? Evaluate the images technically as well. Is the scene sharp or is it slightly blurred because the camera or subject moved during the exposure? Maybe you have another frame that is sharper. Is the scene overexposed and very light or underexposed and very dark? Check the negatives to make sure this isn't just a problem with the contact sheet. You can correct minor exposure variations during printing, but massive exposure faults will make the negative difficult, if not impossible, to print. Use a white grease pencil to mark the frames on the contact sheet that you want to enlarge.

2 **Insert the negative in the negative carrier and dust it.** Use an antistatic brush or compressed air to dust the negative and the enlarger's negative carrier (usually two metal pieces that hold the negative between them). Look for dust by holding the carrier and negative at an angle under the enlarger lens with the lamp on; it is often easier to see dust with room lights off. Dusting is important because enlargement can make even a tiny speck of dust on the negative big enough in the final print to be visible.

Position the negative in the carrier window so that the (duller) emulsion side faces the easel. Insert the carrier into the enlarger.

3 **Open the enlarger's lens** to its largest opening to produce the brightest image for focusing. Make sure the room lights are off, then turn the enlarger lamp on using a switch on the timer.

4 **Adjust the easel.** Position the easel under the projected image. Insert a piece of plain white paper or the back of an old print in the easel so you can see the projected image clearly. Adjust the movable sides of the easel to hold the size of paper being used and to provide the desired white border.

5 **Adjust the enlarger head.** Loosen the carriage lock and raise or lower the enlarger head to get the amount of image enlargement that you want. Lock the carriage in place again and readjust the position of the easel or the easel blades to crop the image exactly as you want. (More about cropping on page 120.)

6 **Focus the image.** Focus by turning the knob that raises or lowers the enlarger lens. A focusing magnifier will help you make the final adjustments of focus. The best focusing magnifiers enlarge the image enough for you to focus on the grain in the negative. If you can't keep both sides of the image in focus at the same time, the enlarger may be out of alignment. See the enlarger's instruction manual.

7 **Set the enlarger aperture and timer.** Stop down the aperture to a setting (you can try f/11 as a start) that is at least two stops from the widest aperture. This gives good lens performance plus enough depth of focus to minimize slight errors in focusing the projected image.

Set the enlarger timer to 5 sec. The first print will be a test that receives several different exposures (see next page).

Making an Enlarged Print Step by Step

EXPOSING A TEST PRINT

Total Exposure

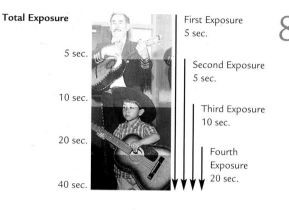

First Exposure
5 sec.

5 sec.

Second Exposure
5 sec.

10 sec.

Third Exposure
10 sec.

20 sec.

Fourth
Exposure
20 sec.

40 sec.

8 **A test print** has several exposures of the same negative on one piece of paper so that you can determine the best exposure for the final print. The print shown here received four exposures to produce a test with 5-, 10-, 20-, and 40-sec. exposures, one stop apart. Turn on the enlarger and estimate where you will place the strip. It should go across the most important parts of the image, ideally showing both highlight and shadow areas.

Make the test on a medium-contrast grade 2 paper or on a variable-contrast paper with a number 2 filter in the enlarger. TURN OFF THE ROOM LIGHTS AND ENLARGER before opening the package of paper. Cut a sheet of 8 × 10-inch paper into quarters or four equal strips. Put all but one of the strips back in the paper package and close it.

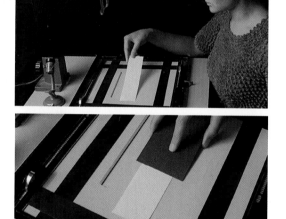

9 **Make the first exposure.** Put one strip, emulsion side up, on the easel. If you can, secure at least one end of the strip under the easel blades so that the strip will stay in place. Have an opaque piece of cardboard at hand, but don't cover any of the test strip yet. For this test strip, the timer is set for 5 sec. and the enlarger lens aperture is set to f/11. Push the timer button.

Make the second exposure. Use the cardboard to cover one-quarter of the test strip. Push the timer button again for another 5-sec. exposure. Try not to move the test strip when you move the cardboard; holding the cardboard slightly above the paper will help.

10 **Make the third exposure.** Reset the timer to 10 sec. Cover one half of the test strip. Push the timer button.

Make the fourth exposure. Reset the timer to 20 sec. Cover all but one quarter of the test strip. Push the timer button.

Tip: Use black or very dark cardboard to avoid reflecting unwanted light.

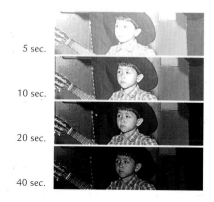

5 sec.

10 sec.

20 sec.

40 sec.

11 **An alternate way to test.** Instead of one strip with four exposures on it, use four strips, each one exposed in the same position for a single exposure time. This uses more paper but lets you see the same areas in each exposure. It also makes it easier to position the strips to show both highlight and shadow areas.

Remove one strip of paper from the package and expose it for 5 sec. Place each exposed strip in a covered place, so it doesn't get exposed to additional light or mixed up with unexposed strips. You can identify the exposure of each strip by writing on the back with pencil. Expose the second strip for 10 sec., the third strip for 20 sec., and the fourth strip for 40 sec.

12 **Process the test.** Develop the strip (or strips) for the full time. Do not remove a print from the developer early if it looks too dark or leave it in longer than the recommended time if it is too light. After fixing, evaluate the test.

Evaluating the test. Always judge prints under room light because they will look much darker under darkroom safelight. If you turn on room lights in the darkroom, make sure the package of unexposed paper is closed. In a school darkroom used by others at the same time, bring the test into another room. If you do so, carry the wet paper in an extra tray so that you don't drip fixer onto other surfaces.

Judging exposure. If all the test segments are too light, retest using longer times or a larger aperture. One stop wider aperture darkens the print the same as doubling the time. If the segments are all too dark, use shorter times or a smaller aperture. One stop smaller aperture lightens the same as halving the time.

Judging contrast. Is the test too contrasty, with inky black shadows and overly light highlights? If so, retest using a lower contrast grade of paper or a lower numbered filter. Is the test too flat, with dull gray shadows and muddy highlights? If so, retest with a higher contrast grade of paper or a higher numbered filter. See pages 114–115 for how to evaluate a print.

13 **Expose and process the final print.** Open the lens, recheck the focus, then reclose the aperture. Set the timer to the best exposure time shown on the test (often a midpoint between two of the exposures). Insert a full sheet of paper in the enlarger easel and expose.

Develop for the full time. After fixing for about 2 min., you can evaluate the print under room lights. Make sure to continue fixing for the full time if you wish to keep the print.

14 **Evaluate the final print.** Don't be disappointed if this print is not really final because it often takes several trials to get a good print. Are exposure and contrast about right? You can't always tell from a test print how the full print will look. Also, most prints require some dodging, holding back light from part of the image during the initial exposure, or burning in, exposing an area for extra time. See pages 118–119 for more about these local controls.

When you are satisfied with a print, complete the fixing, washing, and drying. Make a note of the final aperture and exposure time for reprints.

Evaluating Your Print
for Density and Contrast

Now that you have a print, how good is it technically? The goal in most cases is a full-scale print, one that has a full range of tones: rich blacks, brilliant, textured highlights, and good separation in middle tones. Look at your print under room light; safelight makes prints seem darker than they really are. You'll be evaluating two elements: density and contrast.

Density is the lightness or darkness of a print. It is controlled by the print exposure—the size of the enlarger lens aperture and the length of the exposure time. More exposure makes a print darker, less exposure makes it lighter. A test strip with a series of exposures on it (like the one on page 112) helps you evaluate density and determine the basic exposure for a print, although you may not be able to evaluate density completely until you see an entire print at one exposure.

Contrast is the difference in darkness between light and dark parts of the same print. Contrast is controlled by the contrast grade of the paper or, with variable-contrast paper, by the printing filter used (see pages 116–117).

Adjust density first, then contrast. The photographic rule of thumb for *negative* exposure and development is: Expose for the shadows, develop for the highlights. The rule for *prints* is: Expose for the highlights, adjust paper contrast for the shadows.

First, examine the highlights in your print, particularly large areas that should be light but still show texture and detail, such as skin or light clothing. (For the moment, ignore areas that should be white or extremely light, such as light sources or their reflections, sunlit snow, or very bright sky.) If light areas seem too dark, make another print giving less exposure; if they are too light, make another print with more exposure. Prints tend to "dry down" slightly in tone, so that

a dry print will appear slightly darker overall than a wet one.

When highlight density in the print seems about right, examine the shadow areas. Again, look at larger areas that should have some sense of texture and detail, such as dark clothing or leaves, but not those that should be completely black. If shadows are weak and gray rather than substantial and dark, make another print on the next higher contrast grade of paper. If shadows are extremely dark, so that details that appeared in the negative are obscured in the print, make another print at the next lower contrast grade.

Different contrast grades of paper usually have different printing speeds, so if you change to another contrast grade of paper, make another test strip to find the best exposure time. Find the exposure that produces correct highlights, then examine the shadows. When one exposure gives you good tones both in highlights and shadows, you are printing on the correct contrast grade of paper.

Last adjustments. When the print looks about right overall, examine it for individual areas that you might want to lighten by dodging or darken by burning in. For example, you can lighten a person's face slightly by dodging it during part of the basic exposure. Sky areas often benefit from burning in because they are often so much brighter than the rest of the scene. (More about dodging and burning on pages 118–119.)

If a photograph is important to you, don't be satisfied with a print that only more or less shows the scene. For example, skin tones are important in a portrait, and they should not be pale and washed out or murky dark. Many beginners tend to print too light, with too little contrast, a combination that produces poor texture and detail. You will find a big difference in satisfaction between a barely acceptable print and one that conveys a real sense of substance. Keep trying.

Normal Density, Normal Contrast

A full-scale print with normal density and contrast shows good texture and detail in important light highlights and dark areas.

Barbara London

Density: Too Light **Too Dark**

Evaluate density first by looking at the important lighter parts of the print. If they look too light, make another print with more exposure (longer exposure time or wider aperture). If they look too dark, make another print with less exposure (shorter time or smaller aperture).

Contrast: Too Flat **Too Contrasty**

Evaluate contrast (after the density of the highlights is about right) by looking at the important darker parts of the print. If they look muddy gray, the print is too low in contrast or flat; to correct, use a higher contrast grade of paper. If they look too black, the print is too contrasty; use a lower contrast grade.

More about Contrast

HOW TO CONTROL IT IN A PRINT

Contrast is the relative lightness and dark-ness of different parts of a scene. It is different from density, which is the darkness of the print overall. Most often, you will want a normal range of contrast: deep blacks, brilliant whites, plus a full range of gray tones. But how much contrast is best depends on the scene and how you want to print it. Too little contrast makes most prints look muddy and dull. However, in a scene such as a foggy landscape, low contrast can enhance the impression of soft, luminous fog. Too much con-trast, for example in a portrait, can make the photograph—and your subject—look gritty and harsh. However, high contrast with dense blacks, bright whites, and few or no middle-gray tones might convey just the feeling you want in certain scenes.

You can change contrast during printing. The contrast of your negative is set by the con-trast of the scene, the film type, exposure, and processing. But you can change the contrast of a print made from that negative to a considerable extent by changing the contrast of the paper used during printing. You can lower the contrast of a print by using a low-contrast paper. You can increase the contrast by using a high-contrast paper (see opposite).

Other factors also affect print contrast. A con-denser enlarger produces about one grade more contrast than a diffusion enlarger with the same negative. A highly textured paper surface reduces contrast, as do some paper developers, such as Kodak Selectol-Soft. However, the contrast grade of the paper is the main method of control.

Aaron Siskind. Martha's Vineyard, 1954. **High contrast** *dominates these seacoast rocks. Printing on a lower contrast grade of paper would have made both the lightest and darkest areas less intense, but that is not necessarily the best choice. Choosing a higher-than-normal grade of paper, Siskind increased the harshness of midday light, which abstracted the image so that both the rocks and the shapes of the spaces between them are important.*

Graded-contrast papers are manufactured and packaged in fixed degrees of contrast: grades 0 and 1 (soft or low contrast), grade 2 (medium or normal contrast), grade 3 (sometimes the normal contrast grade for 35mm negatives), and grades 4 and 5 (hard or high contrast). Every paper is not manufactured in every grade. Some photographers prefer to use graded-contrast papers even though it is necessary to purchase each contrast grade separately.

Variable-contrast papers can change contrast grade, so you have to purchase only one type of paper. Each sheet of paper is coated with two emulsions. One is sensitive to yellow-green light and produces low contrast; the other is sensitive to blue-violet light and produces high contrast. You control the contrast by inserting appropriately colored filters in the enlarger, or, with certain enlargers, by dialing in the correct filtration. The filters affect the color of the light reaching the paper and so the contrast of the print.

Variable-contrast filters are numbered with the contrast grade they produce: a number 0 or 1 filter produces low contrast, 2 and 3 medium contrast, and 4 and 5 high contrast. Numbers ½, 1½, 2½, and 3½ filters produce intermediate contrast grades. During printing, if you change from one filter to another, you may also need to adjust the exposure because some filters pass less light to the print overall. See manufacturer's instructions.

Using digital-imaging software is another way to adjust contrast, as well as the lightness or darkness of a print. Changes can be made either in the print overall or in selected areas. See pages 158–165.

To change the contrast in a print, change the contrast grade of the printing paper or, with variable-contrast paper, change the filter. Here, the same negative was printed with different levels of contrast.

Grade 2 Paper (or Filter) Produces Moderate or Normal Contrast

Grade 4 Paper (or Filter) Produces High Contrast

Barbara London

Local Controls

BURNING IN AND DODGING

Once the overall density (the lightness or darkness) of a print is right, you will often find smaller areas that could be a little lighter or darker. For example, a face might be too dark or the sky too light, even though most of the scene looks good. Dodging (shown below) lightens an area that prints too dark. Burning in (shown opposite) darkens an area.

Dodging lightens part of a print by holding back light from that area during some of the basic exposure. You can use a dodging tool like the one shown at right, your hands, a piece of cardboard, or any other object that casts a shadow of the appropriate size. The longer you hold back the light, the lighter that part of the print will be. However, the amount of dodging you

can do is limited. Too much dodging will make a dodged area look murky gray rather than realistically lighter.

Burning in darkens part of a print by adding light to an area after the basic exposure. The edge of a piece of cardboard, a piece of cardboard with a hole in the center, your hands, or any opaque object can be used as long as it shields light from the rest of the print while you are adding exposure to the part you want darker.

Many prints are both dodged and burned. Whatever manipulation you do, keep it subtle so that the scene looks natural. An obviously dodged or burned-in area is more of a distraction than an improvement.

Before Dodging

Dodging lightens an area that is too dark. *Here the face was dodged just enough to make features visible.*

After Dodging

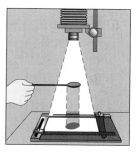

Dodge a print to make part of it lighter. *Hold an object (here, a piece of cardboard attached to a stiff wire) underneath the enlarger lens during some of the basic exposure time to block light from the part of the print you want to lighten. The closer the dodging tool is to the enlarger lens, the larger and more diffuse the shadow it casts.*

Burn in a print to make part of it darker. After the basic exposure is complete, give more light to the part of the print you want to darken while shielding the rest of the print from additional exposure.

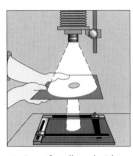

A piece of cardboard with a hole cut in the center is a useful tool. The closer you bring the cardboard to the lens, the larger the circle of light that will be cast and the more diffuse its edges.

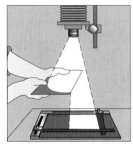

For large areas, such as the sky in a landscape, try using the edge of a piece of cardboard.

Darkening a too-light sky is the most common use of burning in. In nature, the sky is often much brighter than any other part of a scene. Its blue color can also make the sky appear too light in a black-and-white photograph because most black-and-white films are somewhat more sensitive to blue than to other colors. In this example, the atmospheric haze also adds blue. The effect of haze, mist, and

fog increases with distance; objects farther away will appear lighter. If you are shooting in black and white, a yellow filter over the lens (pages 48–49) darkens the sky, but often you will still want to improve the appearance of a sky in a photograph by burning it in slightly when you make the print. Here, after the basic overall exposure, the top of the print was burned in for an additional 50 percent of the basic time.

Tips for Burning In and Dodging

Blend in the edges of the dodged or burned-in area. Keep your dodging or burning tool in smooth, steady motion during the exposure so that the dodged or burned-in area blends into the rest of the print. If you don't move the tool enough, you are likely to print its outline onto the paper. You don't need to shake the tool back and forth quickly; a slow, steady movement will make your adjustments more precise.

Make your dodging and burning-in tools black on one side, white on the other. Light reflects up from the surface of printing paper during exposure. The black surface of the tool facing the paper will absorb that light so it doesn't bounce back down to the printing paper and fog or gray the print overall. The white upper surface of the tool lets you see the part of the image that the card is blocking from the printing paper, and so lets you judge better how to move the card in order to blend the edge.

Learn to judge your burning and dodging times as a percentage of the primary exposure. Dodging an area for 20 percent of the exposure time will result in the same change, whether your primary exposure was 5 seconds or 60 seconds. When you look at the test print for which you have the overall exposure and contrast correct, try to estimate whether you want, for example, the sky 30 percent darker or the face 10 percent lighter. Learning to do this is more efficient than making changes by trial and error.

Digital imaging makes dodging and burning more precise and repeatable (see pages 164–165). Image-editing software lets you select even very small areas to be lightened or darkened. Once you save the computer file containing the changes, you have those changes permanently recorded and exactly repeatable every time you make a print.

Cropping

Is there something sticking into the corner of an image that you didn't notice when you shot the picture? Is the horizon tilted when you want it straight? You can often improve a print by cropping it, cutting into the image at the edges to remove distracting elements or to focus attention on the most important part of the picture.

The best time to crop is when you take the picture, by composing the viewfinder image until it is the way you want it. You have another chance to crop when you make the print, by adjusting the blades of the printing easel. Be aware, though, that enlarging a very small part of an image during printing can result in a loss of sharpness. When you mount the print, you have a chance to trim it and fine-tune the cropping again.

Keep horizon lines straight unless you deliberately want to call attention to the tilt. Even if a horizon line is not visible, an image can look off balance if it is tilted even slightly.

Cropping shouldn't be used to perform major surgery. In this example, very slight but precise cropping emphasizes the similarity of hands and their gestures.

Marc PoKempner

◀ *A more common use for cropping is to eliminate distracting elements from the edges of the image, leaving the picture you thought you were making at the time. For example, how would you crop the photograph at left? Would you cut out the reflection of the photographer and flash?*

Cropping L's, two L-shaped pieces of cardboard, laid over a print will let you try out possible croppings.

Spotting

Spotting is almost always needed to finish a print. No matter how careful you have been during film development and printing, there are likely to be a few specks on a print that shouldn't be there. Spotting is the repair of defects in the photographic process; changing the picture (smoothing a wrinkle on someone's face, for example) is called *retouching*.

Spotting is done after the print is dry. Practice before you work on a good print; it takes some experience to learn how to blend a tone into the surrounding area. Do the minimum amount of spotting needed to make the blemish inconspicuous; too much spotting can look worse than not enough.

Use dyes to remove white spots. Liquid photographic dyes, such as Spotone, soak into the emulsion and match the surface gloss of the print. They are available in colors to match paper tones: usually neutral black, brown, blue, and olive. In addition to the dye, you will need a very fine brush, such as an artist's watercolor brush of size 000 or smaller. Place a drop of neutral black dye on a small dish. Test the color of the dye on the margin of a scrap print. Add a bit of brown, blue, or olive dye if needed to match the image color of your print. You need only a very small amount of color in the neutral dye to match the color of most papers.

Spot the darkest areas first. Pick up a bit of undiluted dye on the tip of the brush and spot out any specks visible in the darkest parts of the print. Use a dotting or stippling motion with an almost-dry brush; too much liquid on the brush will make an unsightly blob.

Then mix water into part of the dye on the dish to dilute it for lighter areas. The dye makes a permanent change in the print, so start with a lighter tone than you think you need and darken it if necessary. Always test the darkness of the dye on the margin of a scrap print.

Small black specks or scratches can be etched off. Use the tip of a new mat knife blade (such as an X-acto blade) or single-edge razor blade to stroke the spot gently until enough of the emulsion density has been etched away to match the surrounding area. Etching is easier to do with fiber-base papers than with resin-coated (RC) papers, and with matte papers than with glossy papers.

Other spotting techniques. Local reduction or bleaching, with products such as Farmer's Reducer or Spot Off, is a chemical treatment that bleaches out larger areas than can be etched with a knife blade.

Digital-imaging software gives you tools for the computer equivalent of spotting. Once you spot or retouch a photograph during editing, you can make a permanent record of the change, so that all future prints are automatically corrected.

Spotting

Etching

Spotting corrects small imperfections in a print by adding dyes to cover up white specks, near right, or by etching off dark ones, far right. Keep your hands very clean or wear cotton gloves while you work.

Rick Steadry

Mounting a Print

Why mount a print? Besides the fact that mounting protects a print from creases, dents, and tears, you'll find that you (and your viewers) are likely to give more serious attention to and spend more time looking at a finished and mounted final print than at an unmounted workprint.

There are several ways to mount a print. Dry mounting is the most common. A sheet of dry-mount tissue bonds the print firmly to a piece of mount board when the sandwich of board, tissue, and print is heated in a mounting press. You can dry mount a print with a border or without one (pages 124–126).

Overmatting (pages 126–127) provides a raised border that helps protect the surface of the print. If you frame a print, the overmat will keep the print surface from touching and possibly sticking to the glass.

If you are mounting prints from digital-imaging output, overmat rather than use heat with dye-sublimation or thermal-wax prints. Heat mounting will not physically damage an ink-jet print, but the heat may shorten the display life of its colors.

You have quality choices in the materials you use. Archival mounting stock (also called *museum board*) is the most expensive. It is made of rag fiber, instead of wood pulp. Free of the acids that in time can cause paper to deteriorate, it is preferred by museums, collectors, and others concerned with long-term preservation. Most prints, however, can be mounted on less expensive but good-quality *conservation board* available in most art supply stores. If you want a print to last for even a few years, avoid long-term contact with materials such as brown paper, ordinary cardboard, most cheap papers, and glassine. Don't use brown paper tape, rubber cement, animal glues, spray adhesives, or any kind of pressure-sensitive tape, such as masking tape or cellophane tape.

Jo Whaley. *Cerambycidae, Selected Writings, 2003.* **What should you photograph?** *The answer is—anything you like. Photographs can be made rather than found, so don't limit your pictures to landscapes, portraits, or other existing subject matter. Here, a dried bug is combined with a book by Helen Keller found at the local shooting range.*

EQUIPMENT AND MATERIALS YOU'LL NEED

MOUNTING EQUIPMENT

Utility knife with sharp blade trims the mounting stock and other materials to size. A paper cutter can be used for lightweight materials, but make sure the blade is aligned squarely and cuts smoothly.

Mat cutter holds a knife blade that can be rotated to cut either a perpendicular edge or a beveled (angled) one. It can be easier to use than an ordinary knife, especially for cutting windows in overmats. Some models include a straightedge that clamps the board in place.

Metal ruler measures the print and board and acts as a guide for the knife or mat cutter. A wooden or plastic ruler is not as good because the knife can cut into it.

Miscellaneous: pencil, soft eraser. *Optional:* fine sandpaper or an emery board for smoothing

inside edges of overmat window, T-square to make it easier to get square corners. For archival or other purposes where extra care is required, cotton gloves protect mat or print during handling.

Mounting press heats and applies pressure to the print, dry-mount tissue, and mounting board to bond the print to the board. It can also flatten unmounted fiber-base prints, which tend to curl. You can use an ordinary household iron to mount prints if no press is available, but the press does a much better job.

Tacking iron bonds a small area of the dry-mount tissue to the back of the print and the front of the mounting board to keep the print in position until it is put in the press. Again, you can use a household iron, but the tacking iron works better.

MOUNTING MATERIALS

Mount board (also called *mat board*) is available in numerous colors, thicknesses, and surface finishes.

Color. The most frequent choice is a neutral white because it does not distract attention away from the print. However, some photographers prefer an off-white, gray, or black mount.

Thickness. The thickness or weight of the board is stated as its ply: 2-ply (single weight) board is lightweight and good for smaller prints; more expensive, 4-ply (double weight) board is better for larger prints.

Surface finish. Finishes range from glossy to highly textured. A matte, not overly textured surface is neutral and unobtrusive.

Size. Boards are available precut in standard sizes or an art supply store can cut them for you, but it is often less expensive to buy a large piece of board and cut

it down yourself. A full sheet is usually 32 × 40 inches.

Quality. See information opposite about quality choices in mounting materials. Archival quality is best but not a necessity for most prints.

Dry-mount tissue is a thin sheet of paper coated on both sides with a waxy adhesive that becomes sticky when heated. Placed between the print and the mount board, the tissue bonds the print firmly to the board.

Several types are available, including one for fiber-base papers and one used at lower temperatures for either RC or fiber-base papers. Some are removable, which lets you readjust the position of a print; others make a permanent bond.

Cold-mount tissues do not require a heated mounting press. Some adhere on contact; others do not adhere until pressure is applied, so that, if necessary, they can be repositioned.

A cover sheet protects the print or mount from surface damage. Use a lightweight piece of paper as a cover sheet between each print in a stack of mounted prints to prevent sur-

face abrasion if one print slides across another. Use a heavy piece of paper or piece of mount board as a cover sheet over the surface of the print when in the mounting press.

Release paper can be useful, for example, between the cover sheet and a print in the mounting press. It will not bond to hot dry-mount tissue in case a bit of tissue protrudes beyond the edge of the print.

Tape hinges a print or an overmat to a backing board. Gummed linen tape and other archival tapes are available from specialty shops and catalog retailers. Archival tape should always be used for hinge mounting a print. Ideally, use linen tape to hinge an overmat to a backing board, but less expensive tape is also usable.

Dry Mounting a Print Step by Step

Mounting board
Dry-mount tissue
Print

Dry mounting provides a good-looking, stable support for a print. Shown here is a mount with a wide border around the print. Bleed mounting, a borderless mounting, is shown on page 126. The mounting materials, the print, and the inner surfaces of the press should be clean; even a small particle of dirt can create a bump or dent when the print is put under pressure in the press.

Wearing cotton gloves when handling the print will keep smudges and fingerprints off the surface. When cutting, use a piece of cardboard underneath to protect the work surface. Several light cuts often work better than just one cut, especially with thick mounting board. The blade must be sharp, so be careful of your fingers.

1 **Cut the mounting board to size** using the knife or mat cutter and the metal ruler as a guide. Press firmly on the ruler to keep it from slipping. A T-square can help you get corners square.

Standardizing the size of your mount boards makes a stack of mounted prints somewhat neater to handle, and makes it easier to switch prints in a frame. Often 8 × 10-inch prints are mounted on 11 × 14-inch or 14 × 17-inch boards. Generally, the board is positioned vertically for a vertical print, horizontally for a horizontal print. Some photographers like the same size border all around; others prefer the same size border on sides and top, with a slightly larger border on the bottom.

2 **Heat the press and dry the materials.** If you are mounting a fiber-base print, heat the dry-mount press to 180°–210°F (82°–99°C) or to the temperature recommended by the dry-mount tissue manufacturer. Put the board, with a protective cover sheet on top, in the heated press for a minute to drive out any moisture. Repeat with the print. The heating will also take any curl out of the print, making it easier to handle.

For a resin-coated (RC) print, use low-temperature dry-mount tissue made for RC papers. The press must be no hotter than 210°F (99°C) or the print may melt. Temperature control is inaccurate on many presses, so 200°F (93°C) is safer. There is no need to preheat an RC print, just the board and cover sheet.

3 **Tack the dry-mounting tissue to the print.** Heat the tacking iron (be sure to use a low setting for RC prints). Put the print face down on a clean smooth surface, such as another piece of mounting board. Cover the back of the print with a piece of dry-mount tissue. Tack the tissue to the print by pressing down the hot iron and sliding it smoothly from the center of the tissue about an inch or toward one side. Do not tack at the corners. Do not wrinkle the tissue or it will show as a crease on the front of the mounted print.

4 **Trim the print and dry-mount tissue.** Turn the print and dry-mount tissue face up. Use the knife or mat cutter to trim off the white print borders, along with the tissue underneath them. Cut straight down on top of a piece of scrap cardboard so that the edges of the print and tissue are even. Press firmly on the ruler when making the cut, and watch your fingers.

5 **Position the print on the mount board.** First, position the print so that the side margins of the board are equal. Then adjust the print top to bottom. Finally, remeasure the side margins to make sure they are even. Measure each side two times, from each corner of the print to the edge of the board. If the print is slightly tilted, it will be noticeable at the corners even though the print measures evenly at the middle.

To keep the print from slipping out of place, hold the print down gently with one hand or put a piece of paper on the print and a weight on top of that.

6 **Tack the dry-mount tissue and print to the board.** Slightly raise one corner of the print and tack that corner of the tissue to the board by making a short stroke toward the corner with the hot tacking iron. Keep the tissue flat against the board to prevent wrinkles, and be careful not to move the print out of place on the board. Repeat at the diagonally opposite corner.

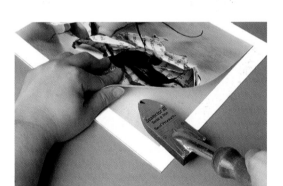

7 **Mount the print.** Put the sandwich of board, tissue, and print in the heated press with the protective cover sheet on top. If you have release paper, put it between the print and the cover sheet. Clamp the press shut for about 30 sec. or until the print is bonded firmly to the board. You can test the bond by flexing the board slightly after it has cooled.

Both time and temperature in the press affect the bonding. If the print does not bond, first try more time in the press. If the print still does not bond, increase the press temperature slightly.

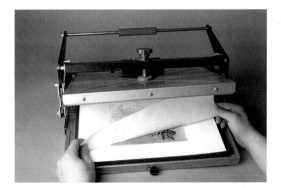

 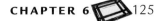

Bleed Mounting/Overmatting

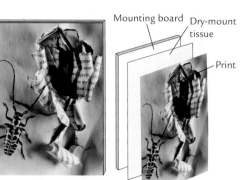

Mounting board Dry-mount tissue

Print

A bleed-mounted print is even with the edges of the mount.

1 **Prepare the print and mount board.** Cut the mount board, dry the materials, and tack the mounting tissue to the print (steps 1, 2, and 3 on page 124). In step 1, the board can be the same size or slightly larger than the print.

 Trim off any excess dry-mount tissue so that the edges of the tissue are even with the edges of the print. Then tack the dry-mount tissue and print to the board, and heat in the press (steps 6 and 7, page 125).

2 **Trim the mounted print.** Place the mounted print face up and trim off the white print borders, along with the mount board underneath, using the ruler as a guide. A T-square can help you get the corners square. Hold the knife blade vertically so that it makes an edge perpendicular to the surface of the print. Press firmly on the ruler, and watch your fingers.

 Because the edges of a bleed-mounted print come right up to the edges of the mount board, be careful when handling the mounted print so you don't accidentally chip or otherwise damage the edges.

Overmat Window

Tape hinge Photo corner

Backing board

An overmatted print has a raised border around the print. It consists of an overmat (a piece of mount board with a hole cut in it) placed over a print that is attached to another piece of mount board (the backing board). The overmat helps protect the print and can be easily replaced if it becomes soiled or damaged. After overmatting, the print can be framed or displayed as is.

 Overmatting is the preferred means of mounting a print if you are interested in archival preservation or if a print will be framed behind glass. A photograph pressed directly against glass can in time stick permanently to the glass.

1 **Mark the window on the mount board.** Cut two pieces of mount board. For easier shopping, framing, and storage, stick to standard graphic arts sizes: 11 × 14, 14 × 17, 16 × 20. Subtract the width of your print from the width of the board. For a 7 × 9-inch vertical window in an 11 × 14-inch board, the board is 4 inches wider than the print. Divide that by two to find the width of the border on each side: two inches. Do the same for the height to find the top and bottom border. Most artists prefer a print mounted slightly higher than center, so subtract 1/4 inch from the top border and add it to the bottom one.

 Mark the back of the board lightly in pencil for the window cut. Be sure the window aligns squarely to the edges of the board. A T-square, if you have one, will help.

2 **Cut the window.** Don't even attempt to cut a window freehand with a mat knife. A mat cutter such as the one shown here and on page 123 is an inexpensive way to make your matting job look professional. Make sure to adjust the blade angle and depth so it penetrates the mat only enough to go through the board. Use a sharp blade. Push the blade tip through the mat at one corner and slide a metal ruler against the cutter's edge. Hold the ruler firmly, parallel to your edge mark, and push the cutter against it and away from you until it reaches the next corner.

Cut each side just to the corner, not past it. If the cut edges are a bit rough, you can smooth them with very fine sandpaper or an emery board.

3 **Hinge the two boards together** by running a strip of tape along a back edge of the overmat and a front edge of the backing board (see illustration on opposite page, second from bottom). You may not need to hinge the boards together if you intend to frame the print.

Position and attach the print. Slip the print between the backing board and the overmat. Align the print with the window. The print can be dry-mounted to the backing board or attached with photo corners or hinges (see below).

4 **Photo corners,** like the ones used to mount pictures in photo albums, are an easy way to attach a print to a backing board. The print can be taken out of the corners and off the mount at any time. The corners are hidden by the overmat. You can buy corners or make your own from archival or acid-free paper (right) and attach them to the board with a piece of tape.

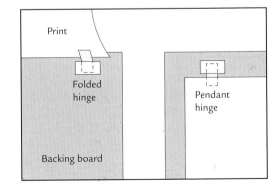

Fold

5 **Hinges** hold the print in place with strips of tape attached to the upper back edge of the print and to the backing board.

A folded hinge (left) is hidden when the print is in place. Use a piece of tape to reinforce the part of the hinge that attaches to the mounting board.

A pendant hinge (right) is hidden by the overmat.

Print

Folded hinge

Pendant hinge

Backing board

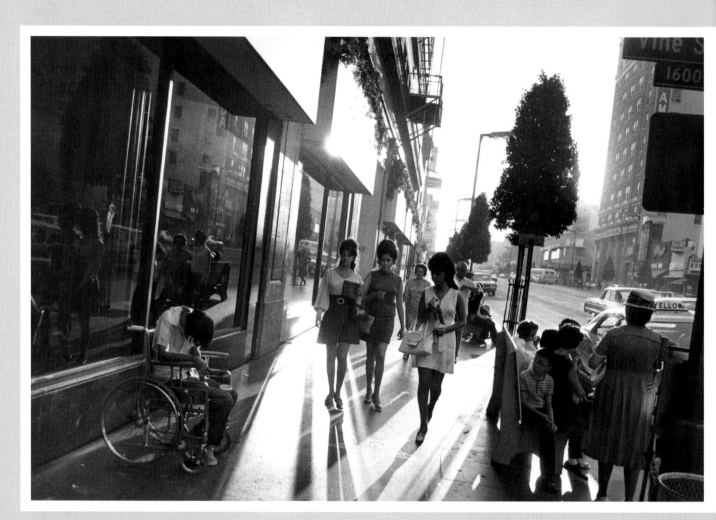

GARRY WINOGRAND
Los Angeles, 1969. **Look at the light on your**
subject. *Garry Winogrand often photographed*
complex interactions that we all see every day
but seldom notice. Here, in addition to the mix
of people on the street, a reflection from a store
window makes it appear there are two suns.
Winogrand said, "I photograph to see what the
photograph will look like."

Lighting 7

Changes in lighting will change your picture. Outdoors, if clouds darken the sky, or you change position so your subject is lit from behind, or you move from a bright area to the shade, your pictures will change as a result. Light changes indoors, too: your subject may move closer to a sunny window, or you may turn on overhead lights or decide to use flash lighting.

Light can affect the feeling of the photograph so that a subject appears, for example, brilliant and crisp, hazy and soft, stark or romantic. If you make a point of observing the light on your subject, you will soon learn to predict how it will look in your photographs, and you will find it easier to use existing light or to arrange the lighting yourself to get just the effect you want.

Kenneth Josephson. *Chicago, 1961.* **Light itself can sometimes be the subject** *of the picture. Here, a bright pattern of light pierces the darkness under Chicago's elevated transit tracks.*

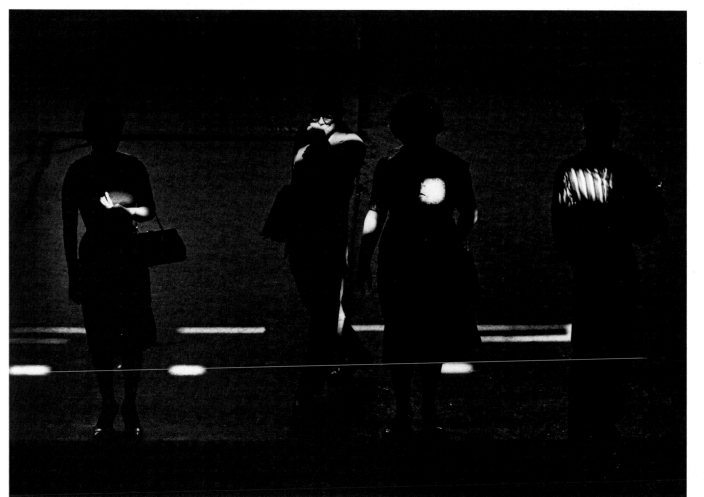

Qualities of Light

FROM DIRECT TO DIFFUSED

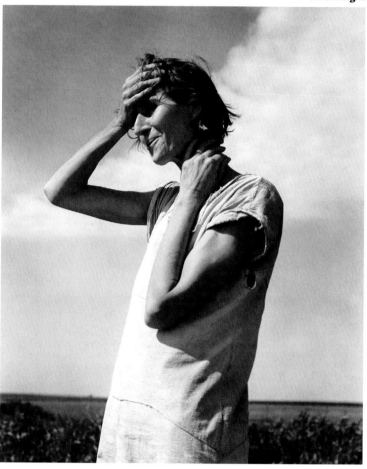

Dorothea Lange. *Woman of the High Plains, Texas Panhandle, 1938.*

Compare the qualities of light in these pictures and the effect it has on the subjects. Direct light—contrasty, with hard-edged shadows. Directional/diffused light—some shadows, but softer edged than in direct light. Diffused light—indirect and soft.

Whether indoors or out, light can range from direct and contrasty to diffused and soft. Here's how to identify these different qualities of light and predict how they will look in your photograph.

Direct light is high in contrast. It creates bright highlights and dark shadows with sharp edges. Photographic materials, particularly color slides, cannot record details in very light and very dark areas at the same time, so directly lit areas may appear brilliant and bold, with shadowed ones almost entirely black. If you are photographing in direct light, you may want to add fill light (pages 136–137) to lighten shadows. Because direct light is often quite bright, you can use a small aperture to give plenty of depth of field, a fast shutter speed to stop motion, or both, if the light is bright enough.

The sun on a clear day is a common source of direct light. Indoors, a flash or photo lamp pointed directly at your subject (that is, not bounced off another surface) also provides direct light.

Diffused light is low in contrast. It bathes subjects in light from all sides so that shadows are weak or even absent. Colors are less brilliant than they are in direct light and are likely to be

Project: THE SAME SUBJECT IN DIFFERENT LIGHT

PROCEDURE Photograph the same person in several different lighting situations. For example, on a sunny day begin by photographing outdoors in the sun. Try not to work at noon when the sun is directly overhead. Light usually appears more interesting in the morning or afternoon when the sun is at an angle to the subject. Make several exposures in each situation.

Work relatively close: head-and-shoulders rather than full-length views.

First, have the sun behind your back, so it shines directly into the person's face. Then move your subject so the sun is shining on him or her from the side. Then have the sun behind the person, so he or she is backlit. (Page 78 tells how to meter backlit scenes.)

Make several photographs in diffused natural light, for example, under a tree or in the shade of a building. Make some indoors, with the person illuminated by light coming from a window.

As a comparison to sunlight in the morning or afternoon, you could also make some photographs at noon with the subject lit by the sun overhead to see why it is not recommended.

Select the best portrait in each type of light.

HOW DID YOU DO? What do you see that is different among the various photographs? Is there more texture visible in some shots? Do the shadows seem too dark in some? (Pages 136–137 tell how to use fill light to make shadows lighter.) How does the light affect the modeling (the appearance of volume) of the face? Light not only changes the way subjects appear in a photograph, it can change the way we perceive or feel about them. Do some of the portraits appear softer? Harsher? More dramatic?

Directional/Diffused Light

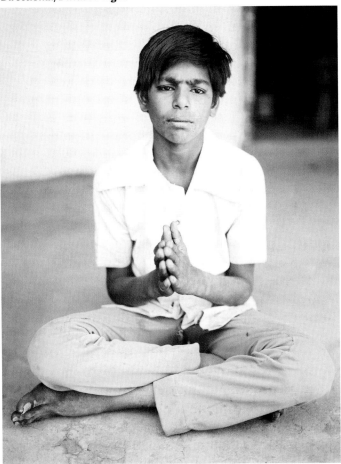

Wendy Ewald. Hasmukh. Vichya, Gujerat, India, 1994.

Diffused Light

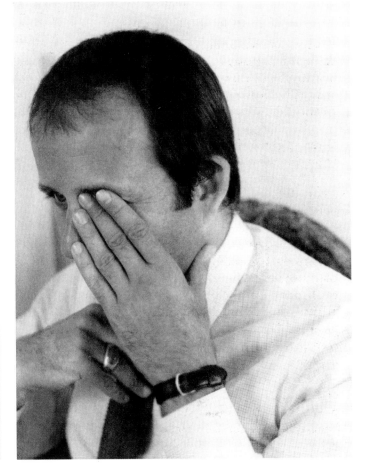

Jan Groover. P. W., 1978.

pastel or muted in tone. Because diffused light is likely to be dimmer than direct light, you might not be able to use a small aperture with a fast shutter speed.

A heavily overcast day creates diffused light because the light is cast evenly by the whole dome of the sky rather than, as it is on a sunny day, mostly by the small disk of the sun. Indoors, diffused light can be created with a very broad source of light used close to the subject (such as light bounced into a large umbrella reflector) plus additional fill light. (Page 137 top shows a *soft box*—another broad source—used in a lighting setup.)

Directional/diffused light is intermediate in contrast. It is partly direct and partly diffused.

Shadows are present, but they are softer and not as dark as those cast by direct light.

You will encounter directional/diffused light on a hazy day when the sun's rays are somewhat scattered so light comes from the surrounding sky as well as from the sun. A shaded area, such as under trees or along the shady side of a building, can have directional/diffused light if the light is bouncing onto the scene primarily from one direction. Indoors, a skylight or other large window can give this type of light if the sun is not shining directly on the subject. Light from a flash or photo lamp can also be directional/diffused if it is softened by a translucent diffusing material placed in front of the light or if it is bounced off another surface such as a wall or an umbrella reflector.

Existing Light

USE WHAT'S AVAILABLE

Don't wait for a sunny day to go photographing. You can take pictures even if the light is dim: indoors, in the rain or snow, at dawn or dusk. If you see a scene that appeals to you, you can find a way to photograph it.

A high ISO is useful when light is dim. It will help you shoot at a fast enough shutter speed to stop motion or at a small enough aperture to give adequate depth of field. A tripod can steady a camera for long exposures.

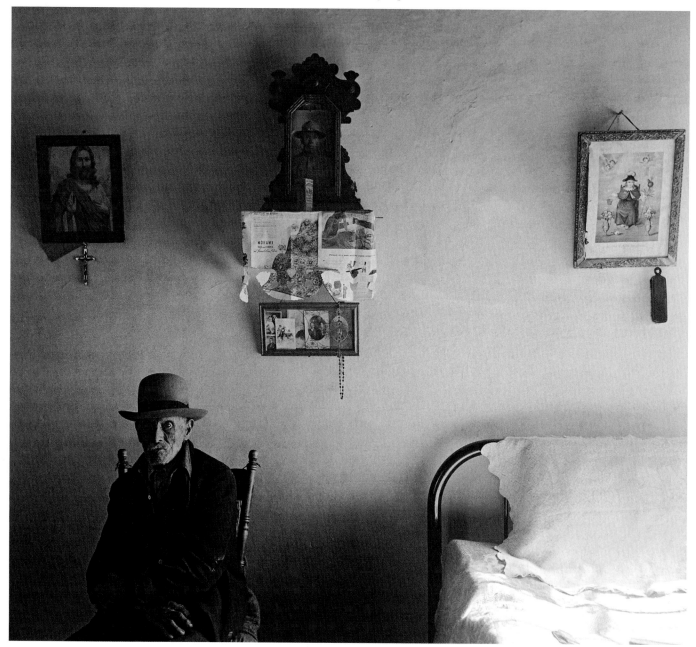

John Collier. *Grandfather Romero, 99 years old, Trampas, New Mexico, 1943.* **Use the light you find** *if you can; it usually looks the most believable. Try to make something out of what is already there before thinking of changing anything. The light in this room from one small window is simple and effective.*

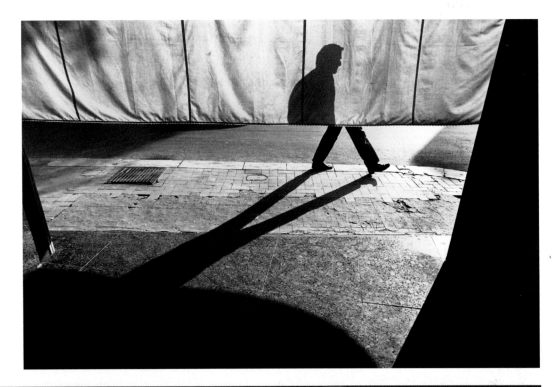

Lars Tunbjörk. *Sicily, 1983.* **Available light** *can also mean available shadow. Often, the play of light and shadow alone can be enough to make a great picture. As a subject, the figure here is not as important as the arrangement of shapes made by the late afternoon sun and captured at the right moment.*

Karl Baden. *Amelia, 1998. In extremely dim light, here a few small candles, try an ultrafast film like Kodak T-Max P3200 or Fuji Neopan 1600. Bracketing is always a good idea in marginal lighting situations. Make several extra shots, increasing the exposure, then decreasing it. Sometimes though, as in this shot, you may only get one chance.*

The Main Light

THE STRONGEST SOURCE OF LIGHT

The most realistic and usually the most pleasing lighting resembles daylight, the light we see most often: one main source of light from above creating a single set of shadows. Lighting seems unrealistic (although there may be times when you will want that) if it comes from below or if it comes from two or more equally strong sources that produce shadows going in different directions.

Shadows create the lighting. Although photographers talk about the quality of light coming from a particular source, it is actually the shadows created by the light that can make an image harsh or soft, menacing or appealing. To a great extent, the shadows determine the solidity or volume that shapes appear to have, the degree to which texture is shown, and sometimes the mood or emotion of the picture.

The main light, the brightest light shining on a subject, creates the strongest shadows. If you are trying to set up a lighting arrangement, look at the subject from camera position. Notice the way the shadows shape or model the subject as you move the main light around or as you change the position of the subject in relation to a fixed main light.

Direct light from a 500-watt photo lamp in a bowl-shaped metal reflector was used for these photographs, producing shadows that are hard edged and dark. Direct sunlight or direct flash will produce similar effects. The light would be softer if it was bounced onto the subject from another surface, such as an umbrella reflector (shown on page 139), or if it was diffused. Fill light (see pages 136–137) would lighten the shadows.

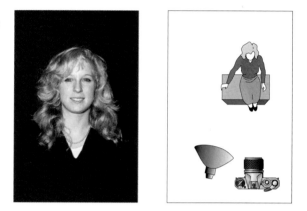

Frontlighting. *Here the main light is placed close to the lens, as when a flash unit attached to the camera is pointed directly at the subject. Fewer shadows are visible from camera position with this type of lighting than with others, and, as a result, forms seem flattened and textures less pronounced. Many news photos and snapshots are frontlit because it is simple and quick to shoot with the flash on the camera.*

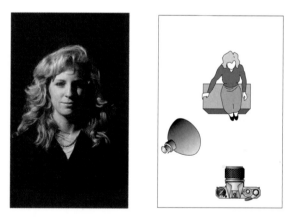

High 45° lighting. *If the main light is moved high and to the side of the camera, not precisely at 45° but somewhere in that vicinity, shadows model the face to a rounded shape and emphasize textures more than with front lighting. This is often the main light position used in commercial portrait studios; fill light would then be added to lighten the shadows.*

Side lighting. *A main light at about a 90° angle to the camera will light the subject brightly on one side and cast shadows across the other side. When the sun is low on the horizon at sunset or sunrise, it can create side lighting that adds interest to landscapes and other outdoor scenes. Side lighting is sometimes used to dramatize a portrait.*

Top lighting. *With the light directly overhead, long dark shadows are cast into eye sockets and under nose and chin, producing an effect that is seldom appealing for portraits. Unfortunately, top lighting is not uncommon—outdoors at noon when the sun is overhead or indoors when the main light is coming from ceiling fixtures. Fill light added to lighten the shadows can help (see next page).*

Fredrik D. Bodin

Backlighting. *Here the light is moved around farther to the back of the subject than it is for side lighting. If the light was directly behind the subject, the entire face would be in shadow with just the hair outlined by a rim of light. Backlighting, also called edge or rim lighting, is used in multiple-light setups to bring out texture or to separate the subject from the background.*

Bottom lighting. *Lighting that comes from below looks distinctly odd in a portrait. This is because light on people outdoors or indoors almost never comes from below. This type of light casts unnatural shadows that often create a menacing effect. Some products, however—glassware, for example—are effectively lit from below; such lighting is often seen in advertising photographs.*

Fill Light

TO LIGHTEN SHADOWS

Fill light makes shadows less dark by adding light to them. Photographic materials can record detail and texture in either brightly lit areas or deeply shadowed ones but generally not in both at the same time. So if important shadow areas are much darker than lit areas—for example, the shaded side of a person's face in a sunlit portrait—consider whether adding fill light will improve your picture. The fill light should not overpower the main light but simply raise the light level of shadow areas so you can see clear detail in the final print.

When do you need fill light? Color transparencies and digital cameras need fill light more than prints do. With either, as little as two stops difference between lit and shaded areas can make shadows very dark, even black. Color and black-and-white negative films are also sensitive to contrast, although somewhat less so.

Conventional black-and-white prints can handle more contrast between highlights and shadows than color materials can. In a black-and-white portrait of a partly shaded subject, shadows that are two stops darker than the lit side of the face will be dark but still show full texture and detail. But when shadows get to be three or more stops darker than lit areas, fill light becomes useful. You can control contrast between highlights and shadows in black-and-white prints by, for example, printing on a paper of a lower contrast grade (see pages 116–117). Digital imaging software gives you similar control over contrast. However, results are often better if you control the contrast by adding fill light, rather than trying to lighten a too-dark shadow when printing.

Fill light outdoors. It is easier to get a pleasant expression on a person's face in a sunlit outdoor portrait if the subject is lit from the side or from behind and not squinting into the sun. These positions, however, can make the shadowed side of the face too dark. In such cases, you can add fill light to decrease the contrast between the lit and shadowed sides of the face (see right). You can also use fill light outdoors for close-ups of flowers or other relatively small objects in which the shadows would otherwise be too dark.

Fill light indoors. A single photoflood or flash often produces a very contrasty light in which the shaded side of the face will be very dark if the lit side of the face is exposed and printed normally. Such light is likely to appear more contrasty than in a similar photograph lit by sunlight because light from the sky acts as fill light outdoors. Notice how dark the shaded areas are in the single-light portraits on pages 134–135. You might want such contrasty lighting for certain photographs, but ordinarily fill light should be added to make the shadows lighter.

Sources of fill light. A reflector, such as a white card or cloth, is a good way to add fill light indoors or out. An aluminized "space blanket" from a camping-supply store is easy to carry and highly reflective. Holding the reflector at the correct angle, usually on the opposite side of the subject from the main light, will reflect some of the main light into the shadows.

A flash can be used for fill light indoors or outdoors. A unit in which the brightness of the flash can be adjusted is much easier to use than one with a fixed output. Some flash units designed for use with automatic cameras can be set to provide fill flash automatically.

In indoor setups, light from another photoflood can be used for fill light. To keep the fill light from overpowering the main light, the fill can be farther from the subject than the main light, of lesser intensity, bounced, or diffused. See photographs opposite.

Frontlight. *The man's face is lit by sunlight shining directly on it. Facing into the sun caused an awkward squint against the bright light.*

Backlight. *Here he faces away from the sun and has a more relaxed expression. Increasing the exposure would lighten the shadowed side of his face but make the lit side very light.*

Backlight plus fill light. *Here he still faces away from the sun, but fill light has been added to lighten the shaded side of the face.*

Tom Wolfe

Using a reflector for fill light. *A large white cloth or card can lighten shadows in backlit or sidelit portraits by reflecting onto the shaded side of the subject some of the illumination from the main light. Sometimes nearby objects will act as natural reflectors, such as sand, snow, water, or a light-colored wall. The reflector can be clamped to a stand, held by an assistant, or simply be propped up. The closer the reflector is to the subject, the more light it will reflect into the shadows. Be careful to keep it out of the picture.*

In the example on the right, the main light is on your left— the sitter's right. The light is inside a soft box, used to soften shadow edges. Clamped to a stand on the opposite side of the subject is the reflector, sometimes called a bounce card.

For a portrait, try to angle the reflector to add enough fill light so the shadowed side of the face is one to two stops darker than the sunlit side. Here's how to count the number of stops' difference. Meter only the lit side and note the shutter-speed and aperture settings. Meter only the shadowed side and note the shutter speed and aperture. The number of f-stops (or shutter-speed settings) between the two exposures equals the number of stops' difference.

Satnley Rowin

Using a photoflood for fill light. *The photographer placed the main light at about a 45° angle to the left, then positioned a second photoflood on the right side of the camera so it increased the brightness of the shadows. This fill light was placed close to the camera's lens so it did not create secondary shadows that would be visible from camera position. The main light was placed closer to the subject so it would be stronger than the fill light.*

Meter the lit side of the scene and the shaded side; then adjust the lights until the shaded side is one to two stops darker than the lit side. To get an accurate reading, you must meter each area separately without including the background or other areas of different brightness. If you are photographing very small objects, you can use a spot meter or make substitution readings from a photographic gray card positioned first on the lit side, then on the shadowed side.

Alan Oransky

Using flash for fill light. *To lighten the shadows on the man's face, the photographer attached a flash unit to her camera. If the flash light is too bright, it can overpower the main light and create an unnatural effect. To prevent this, the photographer set the flash for manual operation and draped a handkerchief over the flash head to decrease the intensity of the light. She could also have stepped back from the subject (although this would have changed the framing of the scene), or, with some flash units, decreased the light output of the flash.*

The handkerchief also changes the quality of the light. Like a small version of the soft box pictured above, it slightly softens the harshness that usually results from small camera-mounted flash units.

See your owner's manual for instructions on how to set your camera and flash for fill lighting. In general, for a subject that is partly lit and partly shaded, decrease the brightness of the flash on the subject until it is one to two stops less than the basic exposure from the sun.

Tom Wolfe

Simple Portrait Lighting

Many fine portraits have been made using simple lighting setups. You don't need a complicated arrangement of lights to make a good portrait. In fact, the simpler the setup, the more comfortable and relaxed your subject is likely to be. (See pages 192–195 for more about photographing people.)

Outdoors, open shade or an overcast sky surrounds a subject in soft, even lighting (photograph this page). In open shade, the person is out of direct sunlight, perhaps under a tree or in the shade of a building. Illumination comes from light reflected from the ground, a nearby wall, or other surfaces. If the sun is hidden by an overcast or cloudy sky, light is scattered over the subject from the entire sky. Indirect sunlight is relatively bluish, compared with direct sunlight. If you are shooting color film, a 1A (skylight) or 81A (yellowish) filter on the camera will help remove excess blue.

Indoors, window light is a convenient source of light during the day (see opposite, bottom). The closer your subject is to the window, the brighter the light will be. If direct sunlight is shining through the window and falls on the subject, contrast will be very high: lit areas very light, unlit areas very dark. Unless you want extreme contrast, it's best to have the subject lit by indirect light bouncing off other surfaces first. A reflector opposite the window can lighten shadows by adding fill light to the side of the person facing away from the window.

A main light—photoflood or flash—plus reflector fill is a simple setup when available light is inadequate (see opposite top). Bouncing the light into an umbrella reflector provides a softer light than shining it directly onto the subject.

John Weiss. *Garry Templeton, San Diego Padres, 1984.* **In open shade** *outdoors, a building, tree, or other object blocks the direct rays of the sun. Softer indirect light bounces onto the subject. Here, the ballplayer was shaded by the dugout roof. The photographer hung a black cloth on the dugout wall to provide a plain background.*

Martin Benjamin. George Gilder, Technology Guru, Housatonic, Massachusetts, 2000. **A main light plus reflector fill** *is the simplest setup when you want to arrange the lighting yourself. The main source of light is from a photoflood or flash pointed into an umbrella reflector that is then pointed at the subject. A reflector on the other side of the subject bounces some of the light back to lighten the shadows.*

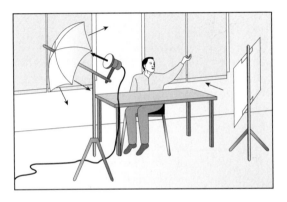

Judy Dater. Joyce Goldstein, 1969. **Window light** *is bright on the parts of the scene that face the window but is usually dark in areas that face away from the window. Here light from more distant windows on the right bounced into the room to soften the result. Contrast between light and dark tones would have been much greater if direct rays of light from the sun had been shining through the window.*

If contrast seems too strong between the lit and shaded sides of the face, use a reflector card to bounce some of the window light onto the shaded side (see the card used for fill in the portrait above).

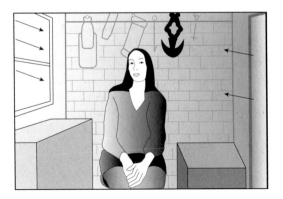

Using Artificial Light

PHOTOLAMP OR FLASH

Artificial light sources let you bring your own light with you when the sun goes down, when you photograph in a relatively dark room, or when you need just a little more light than is available naturally. Artificial sources are consistent and never go behind a cloud just when you're ready to take a picture. You can manipulate them to produce any effect you want—from light that looks like natural sunlight to underlighting effects that are seldom found in nature. Different sources produce light of different color balances, an important factor if you are using color films.

Continuously burning (incandescent) lamps such as photo lamps and quartz (or halogen) lamps plug into an electrical outlet. Because they let you see how the light affects the subject, they are excellent for portraits, still lifes, and other stationary subjects that give you time to adjust the light exactly. Determining the exposure is easy: you meter the brightness of the light just as you do outdoors.

Flashbulbs are conveniently portable, powered by small battery units. Each bulb puts out one powerful, brief flash and then must be replaced. Not so many years ago, press photographers could be followed by the trail of spent flashbulbs they left as they threw away a bulb after each shot. Today, flashbulbs are still used for some special purposes but mainly with older snapshot cameras that accept flashcube or flip-flash units.

Electronic flash or *strobe* is the most popular source of portable light. Power can come from either batteries or an electrical outlet. Some units are built into cameras, but the more powerful ones, which can light objects at a greater distance, are a separate accessory. Because electronic flash is fast enough to freeze most motion, it is a good choice when you need to light unposed shots or moving subjects.

Flash must be synchronized with the camera's shutter so the flash of light occurs when the shutter is fully open. With a 35mm single-lens reflex or other camera that has a focal-plane shutter, shutter speeds of $\frac{1}{60}$ sec. or slower will synchronize with electronic flash; some models have shutters that synchronize at speeds up to $\frac{1}{300}$ sec. At shutter speeds faster than that, the camera's shutter curtains are open only part of the way at any time so only part of the film would be exposed. Cameras with leaf shutters synchronize with flash at any shutter speed. See your owner's manual for details on how to set the camera and connect the flash to it.

Automatic flash units have a sensor that measures the amount of light reflected by the subject during the flash; the unit terminates the flash when the exposure is adequate. Even if you have an automatic unit, sometimes you will want to calculate and set the flash exposure manually, such as when the subject is very close to the flash or very far from it and not within the automatic flash range. Like automatic focus, automatic flash units may give less accurate results when your subject is not centered in the frame.

Determining your own exposure with flash is different from doing so with other light sources because the flash of light is too brief to measure with an ordinary light meter. Professionals use a hand-held light meter that can measure the brief burst of a flash, but you can calculate your own flash exposure without one. The farther the subject is from a given flash unit, the dimmer the light that it receives and so the more you need to open the lens aperture.

Automatic electronic flash is a standard accessory for an automatic exposure camera. The flash has a light-sensitive cell and electronic circuitry that sets the duration of the flash by metering the amount of light reflected by the subject during the exposure.

Nikon, Inc.

The inverse square law *is the basis for flash exposure calculations. The farther that light travels, the more the light rays spread out and the dimmer the resulting illumination. The law states that at twice a given distance, an object receives only one-fourth the light (intensity of illumination is inversely proportional to the square of the distance from light to subject). In the illustration here, only one-fourth the amount of light falls on an object at 10 ft. from a light source as on an object at 5 ft. from the source.*

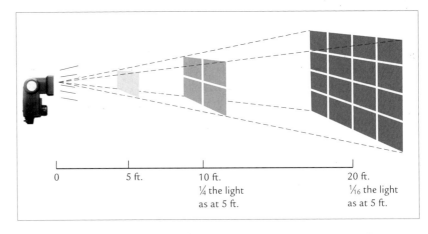

0	5 ft.	10 ft.	20 ft.
		¼ the light as at 5 ft.	¹⁄₁₆ the light as at 5 ft.

To calculate your own flash exposure, *you need to know two things: the distance the light travels to the subject and the guide number (a rating given by the manufacturer for the flash when used with a specific film speed). Divide the distance that the light travels from flash unit to subject into the guide number. The result is the lens f-stop you should use.*

Some flash units have a calculator dial that will do the division for you. Dial in the film speed and the flash-to-subject distance, and the dial will show the correct f-stop.

Manually Calculating a Direct Flash Exposure

Guide number is 80 with this flash unit used with ISO 100 film.

0	5 ft.	10 ft.	20 ft.

$$\frac{\text{Guide number}}{\text{Distance from flash to subject}} = \text{f-stop} \qquad \frac{80}{5} = 16 \qquad \frac{80}{10} = 8 \qquad \frac{80}{20} = 4$$

f/16	f/8	f/4

Bounce flash travels an extra distance. *If you are calculating a bounce flash exposure, measure the distance not from flash to subject but from flash to reflecting surface to subject. In addition, open the lens aperture an extra one-half stop or full stop to allow for light absorbed by the reflecting surface. Open even more if the reflecting surface is not white or very light in tone.*

Some automatic flash units have a head that can be swiveled up or to the side for bounce flash while the flash sensor remains pointed at the subject. This type of unit can automatically calculate a bounce flash exposure because no matter where the head is pointed, the sensor will read the light reflected from the subject toward the camera. Some cameras can measure flash light through the lens: these also can be used automatically with bounce flash.

Manually Calculating a Bounce Flash Exposure

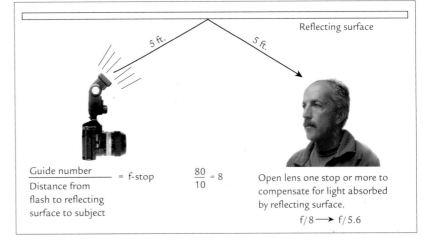

Reflecting surface

5 ft. 5 ft.

$$\frac{\text{Guide number}}{\text{Distance from flash to reflecting surface to subject}} = \text{f-stop} \qquad \frac{80}{10} = 8$$

Open lens one stop or more to compensate for light absorbed by reflecting surface.

f/8 ⟶ f/5.6

Changing the shutter speed does not affect a flash exposure, as long as it is within the acceptable range for synchronization.

You determine the amount of light falling on the subject by dividing the distance to the subject into the flash unit's output (its *guide number*). Then you set the aperture accordingly (see illustrations above). Some manufacturers overrate guide numbers a bit (in order to make their products sound more powerful than they actually are), so it's a good idea to try out a new flash unit with a roll of test film or a professional flash meter before you use it for anything important.

More about Flash

HOW TO POSITION IT

Light gets dimmer the farther it travels. Light from any source—a window, a continuously burning lamp, a flash—follows the same general rule: the light falls off (gets dimmer) the farther the light source is from an object. You can see and measure that effect if, for example, you meter objects that are near a bright lamp compared to those that are farther away. But light from a flash comes and goes so fast that you can't see the effect of the flash on a scene at the time you are taking the picture. Special exposure meters are designed for use with flash; you can't use an ordinary exposure meter to measure the flash.

A flash-lit scene may not be evenly illuminated. Because light from a flash gets dimmer the farther it travels, you have to use a smaller lens aperture for subjects close to the flash, a wider aperture for subjects farther away. But what do you do if different parts of the same scene are at different distances from the flash?

Sometimes you can rearrange the subject, such as the people in a group portrait, so all are more or less at the same distance from the flash. Sometimes you can change your own position so the flash more evenly reaches various parts of the scene, such as by bouncing the light onto the subject or by using more than one flash unit. If this is not possible, you simply have to work with the fact that those parts of the scene that are farther from the flash will be darker than those that are closer. If you know the light falls off and gets dimmer the farther it travels, you can at least predict how the flash will illuminate a scene.

Flash portraits. In one way, flash is easy to use for portraits: the flash of light is so fast that you don't have to worry about the subject blurring because it moved during the exposure. But the light from the flash is so quick ($\frac{1}{1000}$ sec. or shorter) that you can't really see what the subject looks like when lit. However, with some practice you can predict the qualities of light that are typical of different flash positions. Shown on the opposite page are some simple lighting setups for portraiture.

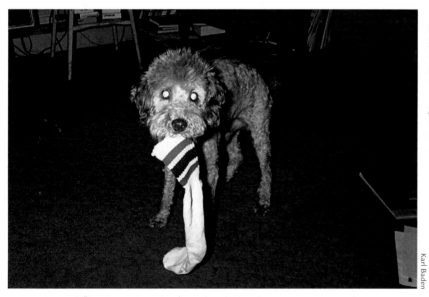

When objects are at different distances from a flash, those that are closer will be lighter than those that are farther away. Notice how dark the back of the room is; even the dog's tail is darker than his head. Try to position the most important parts of a scene (or position the flash) so they are more or less the same distance from the flash.

Notice the dog's unusually bright eyes. In a color photograph they would appear red. Red-eye is a reflection of the eye's retina through its lens and occurs when the flash is mounted too close to the camera's lens. The retina's surface is covered with blood vessels that make the reflected light red.

Karl Baden

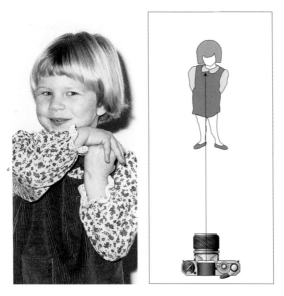

Direct flash on camera is simple and easy to use because the flash is attached to the camera. The light shining straight at the subject from camera position, however, tends to flatten out roundness and gives a rather harsh look.

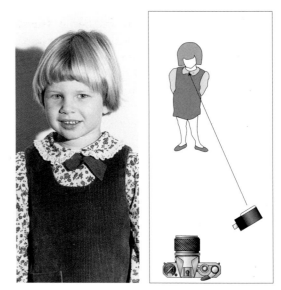

Direct flash off camera—usually raised and to one side— gives more roundness and modeling than does flash on camera. A synchronization (or sync) cord lets you move the flash away from the camera. To avoid a shadow on the wall, move the subject away from it or raise the flash more.

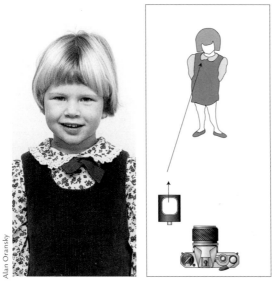

Alan Oransky

Flash bounced from above onto the subject gives a softer, more natural light than direct flash. Light can also be directed into a large piece of white cardboard or an umbrella reflector and then bounced onto the subject. Bouncing the flash cuts the amount of light that reaches the subject. Some flash units automatically compensate for this, or you can make the exposure adjustment yourself (see page 141).

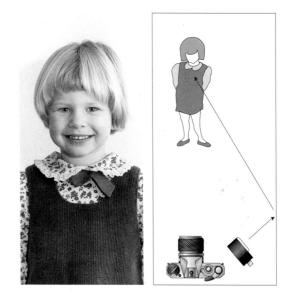

Flash bounced from the side onto the subject gives a soft, flattering light. You can use a light-colored wall, a large piece of white cardboard, or an umbrella reflector. The closer the subject is to the reflector, the more distinct the shadows will be. To avoid a shadow on the back wall, move the subject away from it.

Using Flash

Paul D'Amato. *Groom Toss, Chicago, 1993.* **Flash stops motion.** *Suspended animation is easy with flash photography. The duration of an electronic flash is so short, $\frac{1}{1000}$ sec. or less, that most moving objects will be sharp.*

Notice that the figures in the background, more distant from the light source, are darker. The light fixtures, themselves emitting light, blurred a little with camera movement because the shutter was set to a relatively low speed to synchronize with flash (page 140).

Carl De Keyzer. *Gl. K. 6. Krasnoyarsk, 2002.* **Flash fills the shadows.** *Without the flash, shooting into the light like this would put the subject in silhouette; the position of the sun is revealed by the shadows of the man and the building coming toward the photographer. The blur of movement around the birds' wings is like the blur around the light fixtures on the opposite page, the result of movement during the exposure. It is more noticeable here because the daylight provides more of the overall exposure than the flash.*

This photograph is from a self-assigned project investigating Siberian prison camps, former gulags, that was published as the book Zona.

Digital Photography 8

Digital capture, processing, and printing have replaced film and paper for most professional photographers. Most photographs made by professionals are intended to appear on a printed page—newspapers, magazines, brochures, reports—and need to be in digital form before publishing. But beyond that simple requirement there are many other advantages to digital images. The processes are fast and instantly visible, and images can be transmitted by Internet around the world. Digital cameras can record hundreds of photographs on one reusable memory card. Software lets you separately and precisely control tones and colors for individual areas of an image, save each successive stage of the process, and send it to a desktop printer to make exactly repeatable prints.

Some photographers make valid arguments for staying with film (or *analog*) photography, just as there are those who are completely satisfied with the electronic version. But anyone who understands both sides of the medium is better off. Computers alter photographs by manipulating the binary world of ones and zeroes; there is no rectangle of film emulsion or liter of developer. Nevertheless, software programs for editing photographs contain commands that are inherited from—and tools that are modeled after—the traditional processes of photography. You apply "filters" or use "burning and dodging" tools. Experience with film exposure, chemical processing, and darkroom enlarging will make you a better digital photographer, too.

Equipment and Materials You'll Need

CAPTURE

First, your image must be digitized, that is, converted into a numerical form so your computer can display, edit, store, or transmit it.

Digital camera does not use film. It electronically records an image that can be sent to the computer directly as digital information. See pages 10–11.

Scanner reads and converts a conventional negative, slide, or print into digital form. See page 157.

EDITING

Computer is the heart of a digital-imaging system. It processes the image and drives the monitor, printer, and other devices to which it is attached. You'll need a recent Apple or IBM-compatible computer. The more powerful and faster models are preferable; editing photographs is among the more demanding uses for a computer. Adding more memory (RAM) will make any computer perform image editing faster.

Computer monitor displays the image you are working on and shows various software tools and other options.
 Your monitor

should be *calibrated*, or set to display colors and tones in a standardized way. For casual picturemaking it is enough to use the calibration utility that is part of your computer's operating system.
 For more accurate results, use a third-party calibrating program with a hardware "puck" (a *spectrophotometer* or *colorimeter*) that rests on your screen and reads directly from it. The software generates a measured set of colors, compares the sensor's reading of what is displayed, and generates a *monitor profile* (see page 150) that—once it is installed in the operating system—corrects your monitor's unique characteristics so it matches the standard. Because the monitor's brightness and color changes with time, this

process should be repeated regularly—once a month is a good interval. If the software gives you options, choose those best for photographic printing, a gamma of 2.2 and a D65 white point.

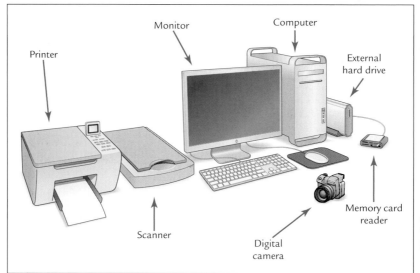

Printer — Monitor — Computer — External hard drive — Scanner — Digital camera — Memory card reader

Image-editing software lets you select editing commands that change the image. *Adobe Photoshop* is the dominant product but you may choose an integrated workflow application like Adobe Photoshop Lightroom or Apple Aperture (see page 155).

 Editing software uses on-screen *menus* to list commands and to call for *dialog boxes* that open on the monitor. Most dialog boxes and other illustrations on the pages of this book were made with Photoshop CS3 run-

ning on an Apple Macintosh computer; the Windows version looks nearly identical.
 This book tells you a lot about photography but won't replace the owner's manuals for your camera or software. You will need a separate reference book for Photoshop, either the one that comes with the software or one of the many good publications that cover in depth all its tools and controls.

STORAGE AND TRANSMISSION

Hard disk (or *hard drive*) stores image files within the computer. External drives can be added simply by connecting with a wire. Picture files occupy a great deal of memory,

so only a limited number of pictures can be stored internally on a single drive. See box, About File Sizes, opposite page.

Optical storage medium such as a CD or DVD lets you expand your storage or take files to another location.

Modem, wireless, or ethernet connection to another computer or a network of them lets you send digitally encoded image files. Connecting to the Internet lets you transmit images worldwide.

OUTPUT

Printer transfers the image to paper. Print quality, cost, and permanence vary widely. Printers may be the inkjet, laser, or dye-sublimation type.

Web site lets others see your photographs displayed on their monitors.

You don't need to own these items yourself. Many schools and libraries provide access to computers, scanners, and printers. Computer services bureaus (often in shops that do copying and offset printing) rent time on computers, scan and print images, and offer help with how to use their services.

Pixels Make the Picture

Increasing resolution

For the same image size, the higher the resolution (the more pixels per inch), the finer the detail of the image, but the more pixels required. The photographs above show increased detail with smaller—therefore more—pixels. You need to know how large you want your image to be (image size) and how much detail you need (resolution and bit depth) in order to determine how many pixels will be required. See box below.

Increasing bit depth

For the same image size, higher bit depth reproduces more tones but requires more pixels. A bit depth of one (left) can reproduce only black or white. A bit depth of two (center) adds two gray shades. An 8-bit image (right) reproduces all the grays we perceive between black and white.

About File Sizes

Your computer stores each picture as a *file* that consists of a binary number (a quantity of ones and zeroes) for each pixel. The greater the resolution (the number of pixels per inch—ppi or dpi) and the greater the bit depth (the amount of information per pixel), the better the sharpness, color quality, and tonal range of the image—and the bigger the size of the computer file that the picture will occupy.

Larger files make your computer take more time to execute each command you give it, require more computer memory, and take more room to store. You may have to balance the quality and size of the picture you want against the practicality of the file size for your particular computer. You can find out more from your instructor at school or an image-editing software manual.

File sizes are measured in *bytes* (8 bits). A 6-megapixel camera's recording chip captures a 2000 × 3000 grid of pixels—that's 6 million pixels. If each pixel uses 8 bits (one byte or 256 possible values) for each color (red, green, and blue), each image will produce an 18-megabyte file.

Bit. Smallest unit of digital information
Byte. 8 bits
Kilobyte (1K or KB). 1,000 bytes
Megabyte (1M or MB). 1,000,000 bytes
Gigabyte (1G or GB). 1,000,000,000 bytes
(The numbers have been rounded off. A kilobyte actually contains 1,024 bytes.)

A small file for a color photograph on the Internet might be 90K, a medium-size file for an 8 × 10-inch print 18MB, a large file for a poster 200MB or more.

Pixels **are the basis of a digital image.** Pictures are represented digitally as a grid of squares, like a page of graph paper. Each square is called a *pixel*, for **pic**ture **el**ement. One pixel is a square of a uniform color or, in a black-and-white photograph, a shade of gray. For an individual picture, the pixels are all the same size, and they can only be captured or displayed in a set number of colors or shades.

Resolution is a measure of the fineness of an image; a large number of very small squares can make a picture with more detail than a smaller number of larger squares (see the photographs left, top). Normally measured in pixels per inch (ppi), resolution and picture quality are also affected by the size of an image. If your digital camera captures a photograph that is 2000 pixels across, the resolution of your print will be 200 ppi if you choose to make it 10 inches wide, but only 100 ppi if you enlarge it to 20 inches wide.

Bit depth tells you how smooth the tones will be. Computers operate on bits, or numbers that can only be a one or a zero. An image with a bit depth of one can only have two different colored pixels, usually black and white. A bit depth of two means you can have four colors—adding a dark and a light gray for example. The pixels in an 8-bit picture or file can have 256 different values: black, white, and 254 shades of gray in between.

The human eye can distinguish only about two hundred different shades between black and white. An 8-bit photograph (with 256 tones of black, white, and gray) is fine for a black-and-white picture (see the photographs left, bottom). But to match a traditional color print or slide, three times that much is needed—256 different values for each of the three component colors, red, green, and blue (see page 60). Each pixel in a full-color photograph is usually stored as a 24-bit number.

High bit files let you make more adjustments. Some cameras and scanners can capture up to 16 bits per pixel. You can't see or print such fine distinctions but having more data lets you make extreme adjustments without loss.

Digital Color

MODES, GAMUTS, SPACES, AND PROFILES

Color in digital imaging is a visible system, more visible to the user and more systematic than in traditional color photography. Understanding how digital imaging deals with color will give you better control of tools that can help you get the final image you want.

Every digital image has a color mode, a means of defining the colors in an image. Black-and-white photographs are usually stored in a mode called *grayscale*, which saves only light or dark tones, not color. The value (lightness or darkness) of a grayscale pixel is described by one number, between 0 and 255.

When an image has color information that needs to be stored for each pixel along with its value (or lightness), several options are available. The most common in digital photography is the *RGB* mode in which all colors are made by combining the primary colors red, green, and blue (more about primary colors on page 60). *CMYK* mode (cyan, magenta, yellow, and K for black), used by graphic artists, combines the ink colors used in commercial printing.

Three numbers are used to describe the color of each pixel in a color image. In RGB mode, for example, one number (between 0 and 255) is used for the amount of red in that pixel, one for the amount of green, and one for the amount of blue. A pixel that is part of the image of a slightly warm-toned concrete building in afternoon sunlight might be described as 202, 186, 144. That pixel contains some red, somewhat less green, and even less blue. (If all three numbers were the same, the color would be a neutral gray.)

You can't print all the colors you can see. All digital capture or display devices—cameras, scanners, monitors, and printers—are slightly limited. The color *gamut* (a *color space*) of a device is the total of all the colors it can accept or produce. Knowing the extent of this gamut is useful because it is always smaller than the gamut of human vision; it tells us what colors we can see but can't reproduce. And more importantly, the gamuts of various devices and materials are different from each other. For example, a monitor can't display some of the colors you can capture on slide film. And a printing press (or your ink-jet printer) can't reproduce some of the colors you can see on your screen.

Each image carries with it a working space, a gamut that should be slightly larger than all the other gamuts (monitor, printer, etc.) to allow for translations from one to another. Software (in its *Color Settings* or *Preferences* dialog box) assigns or lets you assign each document a color space—use *Adobe RGB* (*1998*) if you expect to print.

Profiles translate one gamut into another. No two printers, for example, have the same gamut—they can't reproduce exactly the same range of colors. In order to be able to print the same photograph on two different printers and make the two prints look as much alike as possible, you need a profile that describes each gamut. An output profile accompanies each file you send to a printer and adjusts that photograph to the individual color characteristics of that printer. A monitor profile standardizes what you see on your screen so your picture looks the same (or close to the same) on any monitor.

A gamut is all the colors a device can render. This three-dimensional graph represents the gamut of a monitor, white at the top and black at the bottom. Colors farthest out from the vertical axis are the most saturated. This monitor can display the most saturated colors in the upper-middle values.

Three channels contain the information in a color photograph. The record of brightness (or luminance) in each primary color channel (here, red, green, and blue) lets you see the image in full color (above), each color separately (right), or each individual color image converted to black and white (below).

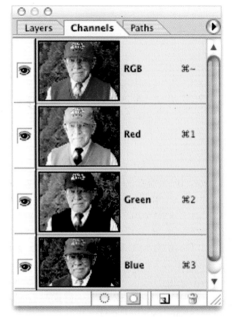

Three channels produce three different black-and-white photographs and give you more choices when you want to convert color to black and white. The red channel (right) is the smoothest and most flattering rendering of the man's face. Green (right center) and blue (right bottom) have more contrast and give the face more texture.

CHANNELS

A digital color image is made up of several black-and-white ones. When you make a photograph on traditional color film or a color print in a darkroom, the image is recorded on three superimposed layers (see page 63). Each layer is actually a black-and-white photograph rendered in one primary color by a dye. Image-editing software makes this separation process easy to understand (and use) by letting you see and work with each layer separately.

Your RGB photograph has three *channels*; each can be seen as a monochromatic photograph displayed by Photoshop in the *channels palette* (see left top), which gives you the option of seeing the red channel, for example, in shades of red or in black and white. In addition to seeing each channel separately, you can perform most of Photoshop's image adjustments on any one channel independently. Lightroom and Aperture show the channels in a histogram (page 152) but do not let you adjust them separately.

Converting a color photograph to black and white is easy. You might want to do this if, for example, a photograph is to be printed in black and white, or sometimes for a more dramatic effect. The best way in Photoshop is Image>Adjustments>Black & White, which lets you choose the amount of each color channel that it blends together to make one black-and-white one. Aperture has a similar command called Monochrome Mixer, and Lightroom calls it Grayscale Mix. The resulting file can be saved in the Grayscale mode and will be one-third the size of the same image in RGB.

Using Histograms and the Info Palette

A histogram shows the brightness values (tones) of all the pixels in an image. The height of each bar in the chart represents the number of pixels of a particular brightness level that occurs anywhere in the image. The histogram shows each of the 256 tones available for the picture. Black is 0, middle gray 128, white 255.

For most scenes, a rich print uses most of the 256 tones, from the subtle tones of a white cloud to the deep shadows on the side of an old barn. Empty space on either end of a histogram usually means a digital image has no bright highlights or no dark shadows; it can be a sign of a careless scan or a poorly exposed image from a digital camera.

Digital cameras display a histogram as a kind of digital light meter. An image in a camera's monitor is often too small or too dim to see clearly. The histogram of an image you have just taken will tell you if your picture was over- or underexposed so you can immediately adjust your shooting strategy.

In scanning software and photo editing programs, a histogram can guide your lightness and contrast adjustments. The software displays a histogram (for example, see Curves, pages 162–163), and you redistribute the tones in the image according to the information it presents.

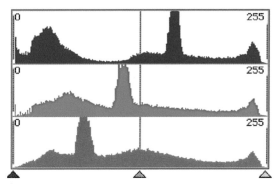

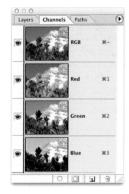

Christine Chin. *Indian Paintbrushes, Colorado, 2004.* **A color photograph has one histogram for each channel,** *plus a combined one that merges them. In the R, G, and B histograms for this photograph, shown above, you can see tall bumps from a lot of light blue pixels from the sky, medium-toned green pixels from the foliage, and darker red pixels from the flowers. At the right end of the histogram, the nearly identical bumps in the very bright highlights for all three channels are from the neutral-colored snow.*

The three channels are shown below as displayed simultaneously by Lightroom. Where the additive primaries overlap it shows the resulting subtractive primary (page 60). A digital camera might display a single histogram (left).

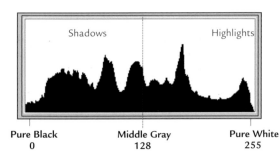

Pure Black 0 — Middle Gray 128 — Pure White 255

Histogram: A graph of a digital image. *A histogram shows the brightness values of all the pixels in an image. The height of each section represents the total number of pixels of a given brightness in the whole photo.*

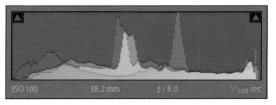

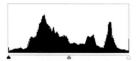

The histogram for this normal-contrast image *has dark shadows, bright highlights, and a wide range of tones in between.*

Normal contrast

High contrast

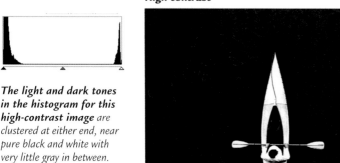

The light and dark tones in the histogram for this high-contrast image *are clustered at either end, near pure black and white with very little gray in between.*

Low contrast

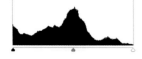

The tones in this low-contrast image *are clustered in the middle of the histogram with fewer pixels in the highlights and shadows.*

Photoshop's Info Palette will become very useful to you as you get more experience with digital imaging. Click on Window>Info to see numbers that describe colors, sizes, and locations, whenever you want more precision than you can get from guessing at what might make an image look better. Aperture and Lightroom also display color values, pixel dimensions, and output sizes in numerical form.

Information displayed on the screen comes from your cursor's location on the image and changes as the cursor moves. You can display color values in RGB or CMYK for one pixel at a time or as an average for a spot several pixels across.

Whenever you need precise measurements, Photoshop's Info also gives the cursor position and distances spanned by the Ruler Tool. You can set it to measure on several scales including pixels, inches, and millimeters.

The Info Palette shows the color values for both before and after an adjustment when you are adjusting an image but haven't yet committed to the change. This is especially useful when something in the image should be neutral gray; you can watch as you adjust the image to bring the numbers closer to the same value, therefore closer to neutral gray.

Setting up a Workflow

STAY ORGANIZED

A **workflow is an organized series of steps** leading to a desired result. The image-editing workflow on page 172 is an example of the adjustment steps in Photoshop that lead from a raw scan or camera file to an image with the desired colors and tones. Follow the more comprehensive series steps below to ensure that you get through the entire process of digital photography with the results you want.

Capture your photographs: expose the film or image sensor. Whether it is on film or with a digital camera, capture is what most people think photography is all about—shooting and camera work—but there's more to it than that.

Download (or *import*) your captured images from the memory card of your camera (or from a scanner) into a computer so you can complete the rest of the steps. The computer is the command center for all the operations of your workflow. Downloading the images to your computer's hard drive also frees the camera's memory card to be reused. Scanned images are sent directly from the scanner to the computer.

Organize your images, keeping in mind that you may soon have thousands of them. Page 176 discusses ways to make sure you can find the needles in your haystack. Essential information can slip from your memory if there are long delays between shooting and organizing; try to make time to put your image files in order at the end of every shooting day.

Edit. Editing has two different meanings in a photographer's workflow. The traditional version of editing, letting the "good" pictures rise to the top, is actually part of organizing. Workflow applications (opposite) let you code the keepers by assigning a rating or sorting similar photos into stacks with the "select" on top.

Digital image editing, or post-processing, encompasses a wide range of alterations to a photograph that can go well beyond the choices that could be made when printing an image in a darkroom. Workflow software can perform most of the standard image adjustments—cropping and rotating, changing size, modifying hue, value, and saturation. Adobe Photoshop can do much more.

Image editing is used to prepare an image for the next step, output. Since you may have several different uses for the same image, you may use image editing to prepare several different versions. Editing has its own workflow, see an image editing workflow on pages 172 and 173.

Output is not limited to printing, although that may now be your primary focus. Later you may want to show a prospective client your work on a laptop or email images to a gallery. Your output may be destined for a billboard and a Web site, as well as a wall. To create the best file for each use will require several different editing strategies.

Archive your work in an organized way. In other words, make sure all your original and *derivative* files (the altered or edited versions) are not only preserved against change, damage, and loss, but also that individual items may be found and retrieved when necessary.

Digital files present unique challenges for long-term storage (see page 176) but have a big advantage over most materials; they can be identically copied. A copy of a file (or of an entire drive) is called a backup. All the media on which files can be kept are vulnerable to well-understood threats like theft, fire, and flood, and each has its own set of weaknesses to things like dust, magnetism, heat, and shock. Your best defense is to make multiple copies of everything you do, as early in the process as possible, and to create two or more identical archives stored in different locations. A digital file can vanish in an instant; once it is gone—if you don't have a copy—it is gone forever.

Capture

Download

Organize

Edit

Output

Archive

Two similar programs integrate most of the tools a digital photographer needs. Adobe Photoshop Lightroom and Apple's Aperture are called workflow applications. Both allow you to perform *non-destructive* editing—they save your files in their original camera raw format along with your decisions about tone, color balance, cropping, and other characteristics for each picture. The saved adjustments are only applied (pixels are changed) when you print or otherwise export the file, uploading it to your Web page, for example, or opening it in Photoshop. You can change and alter your editing decisions at any time or save multiple versions of the same image, and never make any permanent changes to the underlying, original file. Since the programs only save your editing commands, rather than an altered version of the entire file, your archive doesn't take up much more disk space than the raw files alone.

These programs include a complete workflow. Each will download files from your memory card after a shoot, automatically organizing them into folders. You can rename your files in a group as they download and tag each file with its own rating, keywords and other metadata (see page 176). You can search by keyword and/or rating through all the pictures you have downloaded into the program. You can edit each image for color and tone, retouch, apply sharpening, and then print, upload your photos to a Web site, or make a slide show.

With a workflow application you may not need Photoshop, unless you want to adjust a selected part of an image (page 164), make a composite photograph (page 170), or you need to work in the CMYK mode.

Lightroom (above) lets you customize your workspace, showing, moving, or hiding tools, commands, and previews in each of its five work modules.

Aperture (right), if you have two monitors, will display a full-screen preview of the file you are editing on one, along with editing tools and other previews on the other.

Importing an Image

Your photographs are saved on a memory card when you use a digital camera. Your camera will accept only one kind of card (see some of the styles below) but you will still have choices to make when you want to buy one.

Bigger isn't necessarily better. Cards are made in a variety of capacities. To choose one, know your needs as well as the size file your camera makes. A 12 megapixel camera produces a camera raw file of about 12 megabytes. If you have the camera set to save JPEGs, they will be less than half that size. A 4GB card will let you take over 250 photographs as 12MB raw files.

If you are shooting underwater or photographing a wedding or sporting event, for example, you might want to avoid interruptions by using the largest capacity card you can find. If you work at a slower pace, having several smaller cards might be a better idea.

Cards are rated by their speed too; the ratings refer to how fast the card can read or write data. The write speed usually matters most, because it affects your ability to shoot several photographs in rapid succession. A card's speed might be rated at 133x, which is a transfer rate of about 20MB per second. The speed of some cards is stated directly in MB/s (megabytes/second).

Don't leave your pictures on a card any longer than you have to. Cards and cameras are vulnerable to shock, heat, and magnetic fields; they are susceptible to damage and theft. Once your photographs are transferred to a computer you can make backups to protect against loss. After your files are duplicated and stored in at least two places, you can reformat the card for further use.

Connect your camera and computer with a cord or remove the memory card and insert it into the appropriate card reader (see below). Some universal readers can accept as many as 12 different card styles, others are small enough for a keychain. Since your computer can write any kind of file directly on a card, you can use a spare card like a portable hard drive to transfer files to a service bureau or between home and school.

Transferring from a card to a computer is called downloading, or importing, and it is the best time to rename your files rather than leaving them the way the camera named them (like IMG_0237.CR2). At the same time you can add standard metadata (page 176) like your copyright, name, and address, and convert proprietary camera raw files into the more universal DNG format (page 158). Lightroom and Bridge (a utility program that comes with Photoshop) will rename, write metadata, and convert each file to DNG simultaneously as they download. If you use Aperture, get Adobe's free DNG converter from their Web site for the last step.

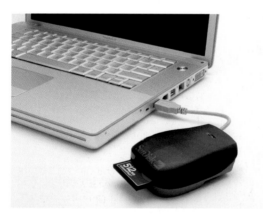

A card reader lets you transfer pictures into your computer. Most cameras can be connected directly with a wire but the reader won't drain the camera's battery. Make sure you get a reader that is compatible with your camera's memory card. Some different kinds of cards are shown below and left.

| CF card | SD card | Memory Stick | xD-Picture card |
| (Compact Flash) | (Secure Digital) | | |

Scanners are the link between film and the digital darkroom. When you use a digital camera, it captures what you see directly as pixels that can be edited on the computer. But photographs that were made on film need to be digitized first. Scanning is the process that reads color and tonal values from a negative, slide, or print and converts it into a pixel grid just as though the picture had been taken with a digital camera.

Scanning software controls the process, offering you choices about how your image will be scanned. Photoshop gives you many more tools for editing than scanning software does and allows more precise adjustments, but you should choose a resolution based on your final use for the image and make as many color and tone corrections as possible in the scan. In the same way that making the right choices when exposing and developing film is better than trying to fix everything when you make a print, making good exposure, contrast, and color balance decisions when you scan can improve your results considerably. Most photographers make basic corrections when scanning but still edit later.

Flatbed scanners are primarily intended for opaque, reflective originals, like photographic prints. The scanner's bed is a rectangular sheet of glass—inexpensive scanners are letter (8½ × 11 inches) or legal (8½ × 14 inches) size; professional models may be tabloid (11 × 17 inches) size or larger. A flatbed scanner will digitize anything placed on the glass: a photograph, drawing, magazine page, or even your hand or face. Some flatbed scanners can accept film by using an illuminated cover or a separate drawer.

Scanner Features That Affect Quality

Optical resolution or hardware resolution refers to the number of pixels per inch the scanner is capable of capturing and is often described by two numbers, such as 3200 × 9600 ppi (pixels per inch), for flatbed scanners. The first number is the resolution across the width of the scanning area; the second is along its length. The smaller number represents the scanner's maximum optical resolution. Scanning film at a higher resolution than 4000 ppi may have little benefit.

Dynamic range is the brightness range of an image, the difference between the darkest shadows and lighest highlights. A scanner should capture a dynamic range of at least 3.5. Slides usually have a wider dynamic range than negatives. A scanner with a dynamic range of 4.2 will gather virtually anything on film and will get the most out of difficult originals.

Bit depth measures how many different tones can be distinguished between black and white (see page 149). A minimum of 24 bits per pixel (8 bits each of red, green, and blue) are needed for a continuous-tone print. To maintain quality during later adjustments, 36 or 48 bits are better.

Interpolated resolution uses software to guess what the pixels might look like in between the ones the scanner can actually measure. No real information is generated, so it is best to scan no higher than the optical resolution.

Focusing may be automatic or manual and can be used, for example, to adjust for warped or buckled film frames.

Sharpening is usually an option in scanning software. Photoshop's sharpening tools are usually better, so turn off sharpening during scanning and leave it for later editing.

Multiscanning allows scanning one frame multiple times (typically 4 or 16 times). It is an important noise-reduction technique used with slides to reduce the specks (or noise) that can appear in darker areas. Multiscan is not an advantage for scanning negatives because their dark tones become highlights in which noise is harder to see.

Dust removal is provided in some scanners by an extra infrared channel that can be used to detect and remove dust, fingerprints, scratches, and other surface damage from the scanned image. This does not work with conventional black-and-white film or Kodachrome, but it does with most dye-based slides, color negatives, and chromogenic black-and-white films.

Scanning software may be an independent program that operates the scanner and produces a TIFF file to be opened in an image-editing program. Some exist as a Photoshop plug-in that permits scanning directly into Photoshop for further manipulation. Most scanners come with dedicated software. Third-party vendors like SilverFast and VueScan sell scanning software that may be more sophisticated and provide more control.

Film scanners are made specifically for transparencies or negatives and cannot scan anything opaque. The one shown above, left, will scan only 35mm film in strips or individual slide mounts. Others have a batch feeder that holds a stack of mounted slides. Film scanners that accept medium- and large-format film are considerably more expensive than those made only for 35mm.

Professional-level film scanners (above, right) offer higher resolution, more bit depth, and greater dynamic range, and produce less image noise. They are too expensive for most school labs or desktop darkrooms, but you may find access to one at a very well-equipped school or service bureau.

Getting Started Editing an Image

Open your image-editing software so it is running, or active, on your computer. With Adobe Photoshop CS use File>Open to call up your photograph; you will see a screen that looks like the one on the page opposite. You can also start by opening an image file directly (an image is a *data file*; your software is an *application file*). The computer will usually recognize the file type (see box below) and open the appropriate application automatically. With Aperture and Lightroom, open the application then navigate to the photograph you want in its library.

Tools and commands are used to manipulate your photograph in image-editing software. Tools appear on screen as small symbols called *icons*, displayed in the toolbox (the series of small boxes shown at the left side of the screen, opposite). Word commands, such as Transform, Sharpen, and Print, can be reached from pull-down menus across the top of the screen. Palettes, like the Layers palette or Info palette shown on the right of the screen, provide information in addition to more tools and word commands.

Photoshop's menu commands often require navigating through several levels. Click on a menu heading, then on each level in turn; or hold the mouse down as you drag the screen cursor to the command you want. The common abbreviation for such a sequence is, for example, Image>Adjustments>Curves.

Save a copy of your file before you make any changes to it. In Photoshop, use File>Save As and give the working file a slightly different name. Then you can experiment and still have the original to go back to in case you change your mind.

Learn to navigate around the image. You can see the entire picture at once or zoom in to any magnification. The window in which the picture is displayed can fill the monitor's screen or be any size smaller, and you can display or hide palettes and tools.

Your first edit should make the image the right shape. Rotate the photograph if it needs it (Select>All, then Edit>Transform>Rotate). Then select the Crop tool from the toolbar to crop the edges, if needed.

One of the most important commands is called Undo (not shown here). Choose Edit>Undo to cancel your last action, returning the image to its previous state. This lets you try an effect, then undo it to see how it looked before. Edit>Redo reinstates the command.

You can always start over. There are usually several different ways to effect any change with image-editing software. Along with reading or taking a class, you can learn by simply opening an image file and experimenting with various tools and commands.

File Formats

You have a choice of file formats when you create or save a digital image. Some computers need the three-letter suffix (file extension) to identify the type. Here are the important ones.

.psd is Adobe's proprietary format for documents that can only be opened and edited in Photoshop. If you are using Photoshop to edit a file, there are few reasons to use any other format until your editing is complete and you save the file for a specific purpose.

.jpg (or JPEG) compresses photos into a smaller file. You can choose one of several quality levels for progressively smaller files; a low quality may allow an image saved as a JPEG to be reduced to as little as one-twentieth its original size. This kind of compression, which discards information, is called *lossy*. Every time you open and resave a JPEG its quality deteriorates; choose another format for editing. JPEGs, with smaller file sizes making faster transmission times, are common for displaying photographs on the Web or sending snapshots over the Internet. Digital cameras offer this format as a file option to fit more photographs on a memory card.

.tif (written TIFF) is a nearly universal format that allows a photograph to be opened on any computer by nearly every program that works with photographs. Saving a file as a TIFF makes no changes to it (it is called *lossless*), nor does its optional compression (LZW).

Camera Raw (.CR2, .NEF, .PEF, etc.) files do not conform to a single set of standards like JPEGs or TIFFs. Raw is a generic term for the individual and proprietary way that a digital camera produces unprocessed data, before settings like white balance are applied. Starting with a raw file allows more precise editing control and lets you keep your pictures in the high-bit (16 bits per pixel) format that good digital cameras capture. Open Raw files with software from the camera manufacturer, Photoshop, Aperture, or Lightroom.

.dng (Digital Negative) is an open-source (publicly available) format developed by Adobe in the hope that camera makers would standardize their now-proprietary formats. Adobe's software, or their free utility, will let you convert any Camera Raw file into a .dng, which is likely to be the future standard.

Tool Options Bar *lets you define the characteristics of the tool that is highlighted in the Toolbox (see below). Here, the options for the Polygonal Lasso tool are shown.*

Menu headings *open to reveal commands. Here, the Window menu is open; it lets you display different palettes on the screen. Click on a checked (open) item to close it if your screen seems cluttered.*

Palettes *provide information as well as various ways to modify images. Click on the black arrow at the top right to reveal other commands and options.*

Image file size

Toolbox, *where commonly used editing tools reside on screen. Select a tool by clicking on it. You can then define its characteristics in the Tool Options Bar at the top of the screen.*

Tools with arrows to the right *provide access to related tools. Click on the tool shown and hold the mouse button down to see and select other versions.*

Plug-ins offer more options. *Plug-ins are add-on software modules that expand editing capabilities—they create borders, add special effects, operate scanners and cameras, and more. Plug-ins are available from several software companies; many are listed on the Photoshop Web site at adobe.com.*

Adjusting an Image

LEVELS

Using **Levels to adjust the tones in an image** is not as complex as using Curves (page 162). Sliders let you adjust the brightness separately for dark, middle-value, or light pixels (shadows, midtones, or highlights). After setting the exact tones that will become black and white (while preserving shadow and highlight detail), you can lighten or darken the middle tones without changing the extreme highlights or deepest shadows. This page shows images in black and white, but you can set Levels separately for each channel to make rapid color balance adjustments in color photographs. Moving the red channel's midtone slider to the left, for example, will make the image more red.

Choose Image>Adjustments>Levels to generate a histogram that lets you make Levels adjustments. If you open Levels instead as an Adjustment Layer (see page 166), you can later alter or discard whatever change you make in the image.

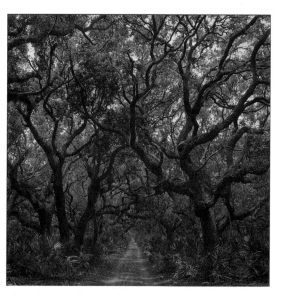

The photographer wanted more contrast in this scanned image of a road through a forest. He used Levels to adjust the dynamic range exactly by setting white and black points (see opposite page) that were just right for the printer he used.

Setting and using the eyedroppers

Photoshop lets you define specific white and black points so you can keep detail easily in highlights and shadows. The settings remain in place as the default setting for any file you open until you change them; these values apply to most ink-jet printers.

Open the Levels dialog box (shown opposite, top) for any image.

 Double-click on the black-point eyedropper at the bottom right of the dialog box. This will open the Color Picker box (right). Set the Red, Green, and Blue values at 10 to define the darkest black with some detail. (Zero in each color would produce a black with no detail.) Click OK.

 Double-click on the white-point eyedropper to reopen the Color Picker box. Set the Red, Green, and Blue values at 244 to define the brightest white with detail. Click OK.

Once these values are set, you can quickly adjust highlight and shadow values (and simultaneously neutralize their color) in any image. Open Levels, select the shadow eyedropper, and click it on the spot in your image you want to be the darkest black with detail (see box, right). Repeat for the highlights using the highlight eyedropper.

Black point **White point**

Seeing the white and black points

Photoshop lets you see your white and black points so you can choose where to use the eyedroppers.

Open the image and then the Levels dialog box. Hold the Option key and move the highlight slider (opposite, top). The lightest pixels are the first to appear. At any position, the pixels to the right of the slider will be displayed as white, the others black (left, center). Holding the Option key and moving the shadow slider reveals the black point (left, bottom).

At each slider position, you can see exactly which pixels will be set to white or black if you leave the slider in that position. See opposite, top center.

The histogram from the scanned negative shows that the tones of the image are not distributed throughout the available tonal range, represented by the numbers from 0 to 255. Empty space at the ends of the histogram suggest that, if left uncorrected, the shadow areas will be too light and the highlights too dark, making the flat image on the opposite page.

The Levels dialog box shows the histogram but also gives you tools to adjust the image. The left-hand slider (black triangle) sets the black point, the right-hand slider the white point. Moving them to the ends of the captured information sets the shadow and highlight areas of the image closer to white and black. The middle slider changes the gamma—it makes the middle tones darker or lighter. Pressing OK applies the change.

A histogram of the final image (below), after the change has been applied, shows a good distribution of pixels between the pure white and pure black endpoints. With a color image you can separately set the black, white, and middle points for each component channel. Separate adjustment of the middle sliders alters overall color balance.

Tom Tarnowski.
Cumberland Island, Georgia, 2001.

Adjusting an Image

CURVES

Curves is the power user's tool for image editing, a kind of digital Swiss Army Knife for making a photograph look exactly the way you want. With Curves you can adjust—independently and with great precision—the tones, contrast, and colors of your image as well as its black and white points.

Image>Adjustments>Curves opens a dialog box like that shown opposite, right; its main features are a square graph with a corner-to-corner diagonal line and a histogram overlay of the image. The graph plots *input* (existing brightness values) on the horizontal axis, against *output* (those same values in your picture after the adjustment) on the vertical axis. Shadows are at the bottom and left, highlights at the top and right. The exact center of the graph is 128/128: middle gray input, middle gray output. The starting 45° diagonal line means that all values are the same before and after.

You can put an adjustment point anywhere on the line and move it. The line becomes a smooth curve that passes through that point. If you click on the middle (128/128) and move that point straight up to 128/140, the "after" (output) value of anything that was a middle value increases (gets lighter) and so do all the other tones along the curve. See the top photograph on this page. The middle values have moved the farthest from the original diagonal; darker and lighter tones will change proportionately less.

The shape of the curve (or any section of it) indicates contrast. A steeper slope is higher contrast; more horizontal is lower contrast. When you increase contrast in one part of the curve, you have to lose it somewhere else. As many as sixteen points can determine how the tones are altered. If you want to remove a point, just pull it off the side of the graph.

Like Levels, Curves can be applied as a separate and changeable Adjustment Layer (see page 166). Lightroom also offers a version of Curves that is always changeable.

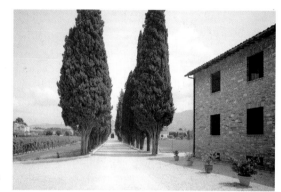

Move the curve up to lighten all the tones in the image. Middle tones are displaced the most.

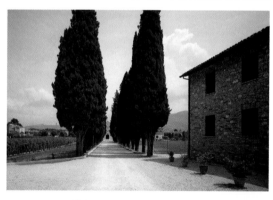

Move the curve down to darken all the tones in the image. Very dark areas don't change much.

This S-curve makes light tones lighter and dark tones darker, raising the contrast.

This S-curve makes light tones darker and dark tones lighter, lowering the contrast.

Several points can be added to the curve to adjust the tones very precisely.

Channel: Blue

The curves for each channel can be adjusted independently. Here the blue channel is lightened in the highlights—visible in the road—and darkened in the shadows; the red and green channels remain unchanged.

Reducing blue (darkening) is the same as adding its complement, yellow. In the shadow areas this is most noticeable in the green of the trees.

In practice, very small adjustments of this sort are the most useful.

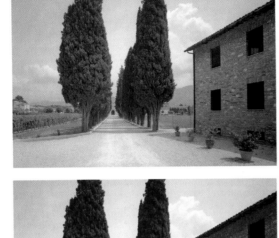

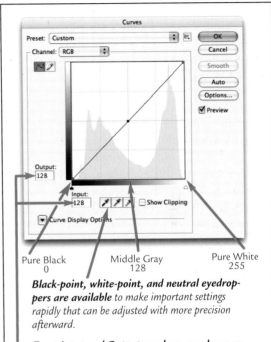

Pure Black
0

Middle Gray
128

Pure White
255

Black-point, white-point, and neutral eyedroppers are available to make important settings rapidly that can be adjusted with more precision afterward.

Exact Input and Output numbers are shown as you add or move points on the curve.

Lawrence McFarland.
Farm entrance near Assisi, Italy, 2002.

Adjusting Part of an Image

SELECTIONS

Selecting **an area lets you edit or adjust part of an image** instead of all of it. All the pixels in a subject may be selected or just one. You may choose to select pixels in a geometric shape like a square or to follow an outline to select all the pixels that form a particular image, for example, of a bird. Your selection may encircle one shape or be formed of several separate pieces. And importantly, pixels can be partially selected, in addition to entirely or not at all selected. Only Photoshop allows the adjustment of a selected area; Aperture and Lightroom can only adjust the entire picture.

A selected area is like a separate picture. It can be made darker or lighter, like burning or dodging in a conventional darkroom. In addition, its color or contrast can be changed, which is extremely difficult to do to part of a picture in a darkroom. A selected area can be made bigger or smaller, it can be rotated or distorted, or it can be moved to another part of the picture or to another picture entirely. Selecting is the first step toward compositing—assembling an image from separate pieces (see pages 170–171).

The selection itself can be edited. You can add to and subtract from a selection, expand or shrink it, or feather its edges. *Inverting* a selection changes the selected pixels to unselected and vice versa. Selections can be saved with the document, to be brought back, or *loaded*, later. Photoshop provides many different tools for making and altering selections (opposite) because it is such an important part of the digital-imaging process.

Adjustments will be made only to the selected area. For example, if you select an area, then apply a Levels adjustment, it will only affect the selected pixels. Partially selected pixels (such as those made by feathering an edge) will be partially adjusted. Making an adjustment layer (see page 166) when pixels are selected makes changes only to those selected pixels and lets you later adjust those changes.

Selecting the object makes it possible to adjust its tones separately from the background. Once the overall colors and values look good in the photograph at left, the glass butter dish in the middle of the scene is too dark and has a color cast.

Following its outline with the Lasso tool (see opposite page) turns the object into a selection and lets a separate Curves adjustment make it an eyecatching centerpiece.

The selection of an object can be inverted to select the background. Once the background is selected, any of its characteristics, including its color, can be changed, below. It is also possible—and very frequently useful—to eliminate the background entirely, right.

The toolbar displays selection tools and their variations.

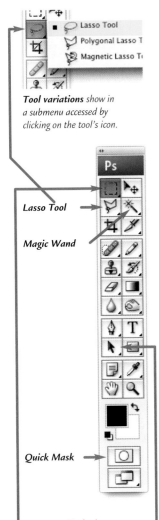

Tool variations show in a submenu accessed by clicking on the tool's icon.

Lasso Tool

Magic Wand

Quick Mask

Marquee Tool selects geometric shapes. Its options include square and rectangle, circle and oval.

Pen Tool makes smooth and precise outlines called Bézier curves that are the mainstay of drawing and illustration software. Its use is less intuitive than other selection tools and takes a bit longer to learn.

Selecting with the Lasso tool is like drawing with a pencil. A computer mouse makes a somewhat clumsy pencil; drawing tablets are available if you do a lot of direct selecting.

Lasso Tool Options:

Make a new selection.

Add to an existing selection.

Subtract from an existing selection.

Select an area that is the intersection of two selections.

Use the Lasso tool to outline the area you want to select. You must go entirely around the area while you hold the mouse button down. If you release it before reaching the point of origin, a straight line will automatically complete the circuit. You can fix it, add other unconnected areas, or smooth any unwanted jiggles using the *add to* or *subtract from* buttons (above) or by switching to Quick Mask mode (bottom) to correct it with drawing tools.

Magic Wand selects pixels by color. It is most useful where a background is relatively uniform or where foreground and background colors or values are strongly contrasting.

Add, subtract, intersect (see above).

Determines how close in value selected pixels will be.

Allows pixels to be partially selected

The Magic Wand tool is much faster in some situations than drawing. A click of the Wand at one spot selects all the pixels of the same color that are contiguous to (touching) that spot. The *Tolerance* setting, in the Tool Options bar shown here, is an essential variable. It sets the range (how far from the sample's color or value) of the pixels that will be selected. The size of the sample can also be adjusted.

Quick Mask mode lets you use drawing tools to make and modify a selection.

Quick Mask changes a selection to a mask, like a sheet of glass covering your photograph on which you can brush opaque paint (the mask is usually displayed in red). You can use drawing tools—pencil, brush, airbrush—to reshape the mask and then change it back to a selection. It is most useful to improve a selection made with another tool. Drawing with white extends (adds to) the selection; black subtracts. Partially selected pixels will result from painting with gray or using a feather-edge tool.

More Techniques

LAYERS

Layers may be Photoshop's greatest feature. Adding a layer to your image is like putting a sheet of clear glass over a print. You can draw on the layer or make alterations that change the image below the layer, but you can still take it away to reveal the unchanged picture. And you can add another layer and another (Photoshop lets you add thousands) that are individually editable, removable, and—except for what you put on them—completely transparent.

Layers make it easier to composite a picture, assembling elements from more than one image. Each part of your picture can sit on an individual layer, which you can then move and change and move and change again, until your final image looks the way you want (see pages 170–171).

Adjustment layers let you make tonal changes, using Curves, Levels, or other tools, without permanently altering the original, underlying image. Use Layers>New Adjustment Layer; then you can revisit your changes and modify them at any time, the way you can in a workflow application like Aperture or Lightroom. When you need to finalize your decisions, to print for example, you *flatten* the file to make the adjustments permanent, but you can—and should—keep a copy of the unflattened file.

When using Levels, Curves, or almost anything else that alters a picture, the software discards some information when it applies the change. If you darken a picture, for example, and later you decide it should be even darker, more information is discarded. Each time, the image is further degraded.

Using an adjustment layer avoids this problem; the settings you choose affect the image that is displayed or printed but they don't change the numbers in the original file until you choose to flatten it. All settings can be changed—or discarded—without loss.

Photoshop CS3 introduced smart filters, which adds filters to the list of non-destructive adjustments. The most important of these is sharpening; you can now change the amount you apply to an image for each different output.

Two layers make all the adjustments this photograph needs. The first layer (shown below and on the Layers palette below left), made some areas lighter and others darker.

Layer>New>Layer was opened. In the dialog box Mode: Overlay was selected, then Fill with Overlay-neutral color was checked. The Overlay layer is not visible unless you turn off the background layer's display by clicking its eye icon. Making the neutral gray—even if you don't see it—lighter or darker with any tool lightens or darkens the underlying image. A gradient darkened the sky gradually in the upper left corner.

The second layer, a Curves adjustment layer, added contrast. Each additional layer affects only those that appear below it in the Layers Palette, below left.

Peter Vanderwarker. *Peter B. Lewis Building, Case Weatherhead School of Management, Cleveland, Ohio, 2003.*

Filters are playful and can lead to the unexpected. The photograph at right was subjected to a sampling of filters, as shown below.

FILTERS

Filters are automatic—and often exotic—image manipulations. They go by self-descriptive names like Colored Pencil, Twirl, and Glowing Edges. If the ones that come with your image-editing program aren't enough for you, independent developers offer hundreds more for sale as plug-ins (see page 159).

Look under the Filter menu for many different options, or choose Filter>Filter Gallery to browse through them at random. Each gives control over several variables. For example, the Stained Glass filter lets you set different values for cell size, border thickness, and light intensity. The variations are endless.

Be careful because filters are like candy; restraint is advised. They are appealing confections but it is easy to overindulge. Remember also that exactly the same zoomy special effects are available to the millions of other users of Photoshop, and their arbitrary use can easily appear to be a cliché. Many filters belong in your toolbox, especially if your task is illustration, but don't assume that because you've never seen the results of the Craquelure filter, no one else has either.

Chrome filter

Glass filter

Craquelure filter

Stamp filter

Watercolor filter

More Techniques

RETOUCHING

Retouching can be tedious with conventional photographs, particularly if you make multiple prints. Spotting darkroom-made prints (page 121) is necessary because dust is virtually unavoidable.

Disguising dustspots and improving complexions are both called retouching; you make changes once and save them. You never need to make the corrections again. For minor (but careful) retouching of small areas, you can work directly on your background layer—assuming you have saved a copy. For major alterations, such as those on the photograph below, make a new duplicate layer to retouch. Go to Layers>Duplicate Layer, and then perform your corrections on the new layer.

To repair damaged photographs or to remove unwanted specks and scratches, various tools are available, such as the clone stamp, healing brush, smudge, focus, toning, and sponge tools, along with the patch tool shown at right. Before you begin, adjust the image for contrast, brightness, and, if working in color, color balance.

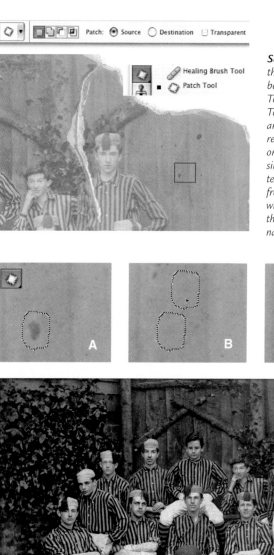

Select the patch tool from the Toolbox (it may be behind the Healing Brush Tool). Select Source in the Tool Options Bar. Draw around the area needing repair (A). Drag the selection onto an undamaged area similar in value, color, and texture (B). The pixels from the undamaged area will combine with those in the selection to make a natural-looking repair (C).

For best results, build up a repair slowly. Work in Layers to protect the original image. This torn and faded old photograph found at a flea market was scanned, then retouched just enough to restore the original appearance of the image. Adjustment with Curves brought the tones back to an approximation of its unfaded state. Some drawing skill can help in replacing a large damaged area, but the key is to borrow bits from other, similar areas in the picture.

All scans and digital captures need some sharpening. The Unsharp Mask filter increases the differences between adjacent pixels to make the image appear sharper.

The right amount of sharpening makes details and edges crisp without sacrificing smooth tones. Different pictures need different amounts.

SHARPENING

Select Filter>Sharpen> Unsharp Mask. In the dialog box, experiment with the filter's three variables, Amount, Radius, and Threshold, to see how they affect the image.

Too much sharpening is as bad as not enough. When you see halos around fine details in your image, you have gone too far. Use the preview option on screen to compare before and after, viewing at 100%.

Sharpening improves most digital images but won't save a photograph that was made out of focus. It is an important adjustment that should be applied to almost any digital photograph, usually just before printing. It is necessary for digitally-captured photographs. The amount of sharpening for best results depends on both the resolution of the file and the size of the print. If you are using a workflow application or Photoshop CS3 (or later), sharpening can be changed for different output. If not, save an unsharpened version of your file.

Michael Schäfer. Aufzug (HGB), 2002. *Retouching can work miracles.* Here, the photographer removed every trace of himself and his camera from an elevator mirror to achieve a hauntingly surreal image that suggests a voyage—up or down—into the existential.

More Techniques

COMPOSITING

Digital imaging was invented for com-positing, or so it might seem. The kinds of images that have become most closely associated with Photoshop are the invented spaces and impossible situations that we see everywhere in advertising. It is not that such *composited* (com-bined from several sources) images aren't possi-ble with conventional photographic techniques (see photos below), but it is very difficult and often prohibitively time consuming to do so without using digital imaging. Aperture and Lightroom do not provide tools for compositing.

Mastering the composite takes some effort even with the advantage of a computer. Learning the tools takes some time but is not the real chal-lenge. Learning to think ahead and to create and assemble parts that fit together visually—that still requires practice, clear thinking, and atten-tion to detail.

Consistent illumination is most important to make everything in your image believable. If you take people from a photograph made in the sun and drop them into an overcast landscape, it won't look right no matter what you do. Few viewers will be able to tell exactly what the prob-lem is, but everyone will find viewing the image a little uncomfortable.

Display several images at once when you com-bine elements from multiple pictures. A large (or second) monitor helps when you want to have sev-eral files open and still see your tools and palettes. The Info palette provides useful measurements to maintain consistency among disparate elements, as do the rulers that appear on two borders of each window. Keep each element on a separate layer. You can make an adjustment layer (see page 166) that is *linked* (attached) to each and won't affect any other layers.

Francis Frith. *Hascombe, Surrey, c.1880.* **The composite photograph is not new.** *To "improve" this nineteenth-century English landscape, Frith cut a horse and cart—along with their convincing shadow—from another photograph and pasted it onto the original photograph.*

Dan Burkholder. *Turtle in Church, Alice, Texas, 1994.* **To create this image of a flying turtle,** *Burkholder combined three separate photographs that he made on film with a conventional 35mm camera on a trip in south Texas.*

He photographed a sea turtle at an aquarium. The doorway was the exterior door of a mission building. The crumbling altar was part of an old church that was being torn down.

Beginning with the background image of the church altar, *Burkholder increased the contrast slightly to add depth to the shadows.*

He drew a selection around the turtle to isolate it from its background.

He moved the turtle onto a separate layer and feathered (softened) its edges for a smooth blend. The visible checkerboard pattern indicates a transparent background.

He copied the selection itself, a simple outline without contents, onto another transparent layer. He filled the selection with pure black, flipped, rotated, stretched, and blurred it, then reduced the layer's tranparency so the altar could be seen through it, making it appear to be a shadow.

The door was selected, feathered, and placed on a separate layer below the layers containing the turtle and its shadow.

Making a Digital Image Step by Step

Here is an outline of the steps to a finished digital image using Photoshop.

1 **Open the file and save a duplicate.** Use File>Save As and give a new name to the version you'll be working with.

2 **Rotate and crop the image** so the edges of the frame are exactly where you want them to be.

3 **Resize if necessary.** It helps to know how you'll be using a picture—on a magazine page, in a Web display, or making it into a poster—to know how big a file and how much resolution you need.

4 **Retouch** (page 168) to remove dust, scratches, or spots. Scans generally require much more retouching than photographs made with a digital camera.

5 **Add a Levels or Curves adjustment layer.** Use it to set the black and white points and overall color balance (pages 160–163). Remember that with adjustment layers you can make more changes later. Make general adjustments first, then fine-tune them after your other adjustments have been made.

6 **Make other overall adjustments.** A Curves adjustment layer in the Luminosity mode lets you adjust tones and contrast without affecting color. A Hue/Saturation adjustment layer is often useful to reduce the color bias of some scanners and digital cameras or to increase the vibrancy of selected colors.

7 **Make local adjustments.** When the overall image has been improved but certain areas need individual attention, make a selection and add an adjustment layer with the selection in place (pages 164–165). Both the selection (automatically saved as a *layer mask*) and the adjustment can be later edited. Add as many individual adjustments as you need,

but keep in mind each one adds to the file size, makes each successive step take a little longer, and fills your storage space faster.

8 **Sharpen the background layer.** If you expect to use the photograph for different applications or print it at different sizes, save the unsharpened file with all its layers and sharpen a copy before each use.

9 **Soft proof and print your photograph** (see pages 174–175). Think of your first print as a test. Are there changes to make?

10 **Make final adjustments,** make a final print, and save the final version of the file.

The original scan from Mark Klett's large-format color negative looks good but it needs some work before it will make the beautiful print shown on the opposite page.

A Curves layer makes the first and most significant changes to both tone and color. It sets the black and white points and the overall color balance.

Luminosity is adjusted with another Curves layer, but with the layer mode set to Luminosity instead of Normal. This layer is used to make small adjustments to the tones and contrast without changing the color balance.

The mode can be set when the layer is created or later using a menu on the Layers palette (this page, top right).

The Layers palette shows each layer with its name, an icon for the type of layer, and a small image of its layer mask.

Selected areas are made lighter with another Curves layer. The selected areas are turned into a layer mask that is saved as a channel in the Channels palette (see page 151).

Klett lightened the right side of the tent and parts of its floor. A burning and dodging layer in Overlay mode can be used to give similar results (see caption, page 166).

Mark Klett. View from the tent at Pyramid Lake, 7:45 AM, Nevada, 9/16/00. **The final adjustment layer is Hue/Saturation,** applied through a layer mask to affect just the land, water, and sky outside the tent. Color saturation is increased in the yellows and blues to deepen the sky and accentuate the early morning sunlight.

Soft Proofing

The easiest way to print an image is to just hit the Print button. This is something like using an automatic camera; it lets the software and printer make the final decisions. You can do much better by taking control.

Ideally, your print should look like what you see on the screen, but it won't unless you *soft proof* while you are editing. A soft proof is an on-screen preview of how the image will look once it is printed. It simulates how your printer will translate the image, which is very useful because every combination of printer, paper, and ink will make a somewhat different version of the same file.

Soft proofing uses profiles (page 150) that take into account the characteristics of printer, ink, and paper. Standard profiles are supplied with desktop printers; special software makes custom profiles. Accurate monitor calibration (page 148) and consistent ambient light at your workstation are helpful.

Following are some basic steps to proof and print in Photoshop. Lightroom's Print module lets you make the most of these same output choices but as of this writing (version 1.2) it has no option for soft proofing. In Aperture, enter your output profile (View>Proofing Profile), select View>Onscreen Proofing, then you can do all your editing while in the soft proof mode.

1 In Photoshop, open the file you want to work on.

2 Choose View>Proof Setup>Custom and select a profile for your printer and paper from the displayed list. Set Intent: Perceptual and check *Use Black Point Compensation.*

3 Edit your image as needed. Turn on the printer and load the paper of your choice.

4 Choose File>Print, then select your output settings. The *Source* (or *Document*) Space, such as Adobe RGB (1998), is your working space (page 150). In *Print Space* and *Intent* make the same selections you used for your Proof Setup (step 2).

5 Choose Page Setup to select the printer, paper size, and orientation. Photoshop uses icons to help you choose an orientation; sometimes words describe the orientation—*Landscape* for horizontal, *Portrait* for vertical.

6 Choose Print. Set *No Color Adjustment* under *Color Management.* This tells the printer to accept your file and output settings without alteration. Otherwise, your printer will make color and contrast changes based on an average. Choose a printer resolution; higher resolutions yield finer-looking prints but longer printing times. When everything is set, select *Print* again, and enjoy.

Holding a newly printed photo is a rewarding moment. The digital darkroom lets you view your images through every step of preparing them, but seeing the photo on paper remains a high point. The quality of your results depends not only on your abilities but also on your choice of printers, papers, and inks.

Printers affect the way your prints look and how large you can make them. Each printer limits the size of a print by the maximum width of the paper it will accept.

Ink jet printers are universal and inexpensive; they can print on a wide variety of surfaces. Newer models make sharp, colorful, long-lasting prints at a reasonable price.

Desktop Ink Jet Printer

Wide-format ink-jet printers that print on two-, four- or six-foot-wide paper are available but are fairly expensive. You may be able to use one in your school or have large prints made for you at a service bureau.

Dye-sublimation printers produce smooth tones and subtle colors but the prints do not resist fading, and your choices of printers, paper, and ink are limited.

Photographic laser printers make digital prints on traditional photographic paper. Laser light exposes photo paper (usually 50-inch-wide color paper) that is then fed directly into a roller-transport color processor. The result is an extremely high-quality digital print with the smooth tones and predictable archival qualities of a traditional color photograph. Large and very expensive, these machines (LightJet and Lambda are the best known) can be found only in professional color labs and service bureaus.

Paper makers offer choices. Makers of ink-jet printers, the kind you are most likely to use at home or school, supply their own brand (called OEM) of papers that are convenient and work well. But you can also experiment with a wide variety of alternates that may better suit your vision or budget. On their Web sites most non-OEM papermakers provide profiles for using each of their papers with most popular printers.

Ink cartridges can be a major expense. To save money you can buy ink in larger quantities and refill them, although the practice can be tedious and messy. Alternate ink sets may be available for your printer to give your prints a wider gamut or more longevity.

If you are interested only in black and white, you can replace your color inks with a special set that includes a black and several grays. These often require a special *driver* or software but may result in smoother, more neutral and more permanent images than you would get by printing black-and-white photographs with color inks.

Paper is available in an incredibly wide variety of sizes, surfaces, colors, textures, and weights. Papers made for ink-jet printing should take and hold the ink without smearing or blotting. Many other papers can be used, but test your choices for suitability. You can also print on self-stick labels, iron-on transfers, metallic paper, or even refrigerator magnets.

Storage, Archiving, Retrieval

A **digital image is not an object** until you print it. The file is your original. If you lose a scan, you can return to a negative or print, assuming that you have been careful with processing and storage. But if you shoot with a digital camera or make complex composite images, it is crucial to archive your files carefully.

Make copies. Disk drives can fail without warning. A spike in your electricity, a stray magnet, or a piece of airborne dust can cause years of work to vanish. Your first task after making a scan or downloading a card full of digital pictures should be to make an extra copy on something other than your main hard drive.

A second, external hard drive is an inexpensive form of insurance; copying files onto one takes little time. Although somewhat slower, recordable optical disks—both CDs and DVDs—are a more stable and permanent medium for storage. If you use optical disks, you'll want at least two copies of each, just in case. Files can become corrupted, and disks can be scratched, broken, or lost. At the first sign of a problem, make a new copy from your backup. If you can, store two full copies of your archive in different locations.

How do you keep track? After only a few years of taking digital pictures, you'll have thousands of images to file. Not only will you want to save the raw scan or original camera file, but you will probably also have several versions with different layers and adjustments. As your archive grows, locating something can become difficult if you don't plan ahead.

Fortunately, the computer that edits your images can help track them. Aperture, Lightroom, and Bridge (an application that ships with Photoshop: File>Browse) allow you to display an entire folder's image files in *thumbnails* (small versions) so you can find images visually instead of by name or number. They let you rename your files, organize them into groups and—perhaps

most important—tag your files with information called *metadata*.

Metadata is information about information, kept in several categories. The date of an image file is metadata that is normally displayed in a directory or folder by your computer's operating system. Digital cameras automatically record *Exif* metadata with each picture: time and date, aperture and shutter speed, ISO, etc. With Photoshop, Bridge (which is called a *browser*) or a workflow application you can add other metadata called *IPTC* that may be as simple as a title, or may include your copyright and telephone number, a lengthy description and location of the subject, and keywords for later searching.

An *image* (or *asset*) *management* database, shown below, lets you keep track of files stored on your computer's hard drive as well as *offline* (not connected). You can search by keywords or any other metadata to find, for example, all the photographs you ever made in Texas, or just the ones of Tommy you took at Texas Tech in 2002. This software and a simple numbering system in the name of each disk (Photos 2007-026, for example) will keep all your image files organized.

Extensis Portfolio.
This image database program helps you find exactly the photograph or photographs you are looking for among thousands.

Ethics and Digital Imaging

Just because you can alter an image, should you? Digital methods haven't changed much about the laws or ethics of photography, it has simply become much easier to violate them. Now that almost anyone can make extensive changes in a photograph that are sometimes impossible to detect, the limits of acceptability are constantly tested and debated.

Has photography lost its reputation for accurate representation of reality? For a 1982 *National Geographic* cover, digital imaging was used to move one of the Great Pyramids a little for the cover photograph so it would better fit the magazine's vertical format. When some readers objected, the change was defended as being merely "retroactive repositioning," the same as if the photographer had simply changed position before taking the shot. Was it different? The magazine has since eliminated this practice.

Photojournalists usually follow fairly strict rules concerning photographic alterations. Generally, they agree that it's acceptable to lighten or darken parts of an image. However, many newspapers don't allow the use of digital imaging to, say, remove a distracting telephone pole or, worse, to insert something new.

One of these photojournalists is not really there. This photograph of all the members of the photo agency VII was originally commissioned for a magazine. By the time it was selected for the camera company's ad, one of the members had been replaced. The new member, at the far right, was shot in the same New York café in the same position as the man he replaced, then added to the picture digitally.

Advertisers often take considerable leeway with illustrations. We have come to expect exaggeration in advertising, as long as the products are not misrepresented. Few people would object to the altered photograph below, even when the advertiser doesn't mention a change. But would the same image be acceptable without explanation if it ran with a news story?

Digital imaging raises ethical questions in the fine arts area as well. It is easy to scan a photograph from a magazine or download one from the Internet and to incorporate all or part of it in your own work. Perhaps you intend to criticize or comment on consumerism by "quoting" recognizable pieces of advertising in a montage. Artists' *appropriation* of copyrighted material—incorporating an image as a form of critique—has been a widely debated topic and the subject of a number of legal battles.

Copyright laws have certain built-in exceptions called *fair use*; among them is education. What you make for a class project may be protected, but if you try to sell it in a gallery or distribute it on your Web site you may be infringing on someone's copyright.

Working photographers are concerned about financial matters. When your efforts result in something you can sell, you probably think it is stealing if someone uses it without asking. How can you protect your rights when images are easily accessible electronically? How can you collect fees for use of your work when images, after they leave your hands, can be scanned, altered, and then incorporated in a publication? When, if ever, is it acceptable for someone to appropriate your image and use it without permission or payment? The law is continually redefined by court cases. Each new copyright infringement lawsuit makes the line a little more clear but there are still more questions than answers.

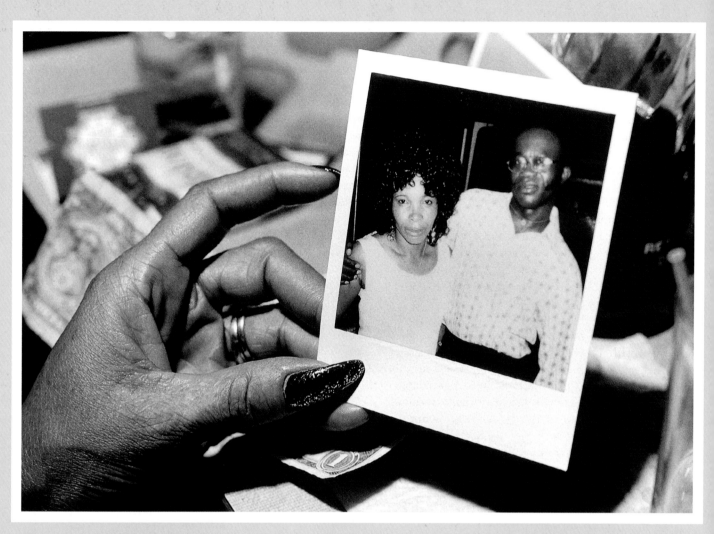

MARC POKEMPNER
Down at Theresa's, 1974.

Seeing Like a Camera 9

Pictures translate the world you see. Your black-and-white photographs leave the colors of the world behind, make it flatter and, usually, much smaller. Even in color, a photograph is not the same thing as what you photographed; it refers somehow to the original scene but has its own life and meaning. The only way to understand and master this translation is to continue the work cycle: make a photograph, look at it, think about it, make another.

Photographs can tell a story, arouse an emotion, or evoke a mood. They can convey a political, sociological, or theological insight, or they can merely be a reminder of an event. The weight and import of your photographs will depend on your own aspirations and the effort you devote to the medium.

There is a literature to photography—in two ways. First, any time that you spend with the work of recognized masters will reward your own work with insight and inspiration; a good library is as important as a good lens. Second, a photograph can affect another that is next to it, so photographs can be assembled like sentences to carry a larger meaning. For example, the two photographs on pages 198–199 show a romantic and a gritty side of city life, and say more than either one of them says by itself.

This chapter's illustrations should be a jumping-off point, but there is no better way to become a good photographer than to keep making photographs. Every time before you shoot, ask yourself what you want in the photograph. Once you have taken the photograph you think you want, stop for a moment to consider some other options. How would it look if you framed the scene vertically instead of horizontally? What if you moved to a very low point of view? What would a slow shutter speed do to the motion of the scene? Try some of the variations, even if you are not sure how they will look in a print, in fact, especially if you are not sure, because that is the way to learn how the camera and film will translate them. More about your choices, and how to make them, on the following pages.

Santiago Harker. *Norte de Santander, Colombia, 1985.*
Choices. *To begin with, what do you choose to photograph? The whole person, head to toe? Their face? Or just a part of them that reveals something about their life?*

Opposite, the photographer moved in close to concentrate on the hand holding the snapshot. Depth of field is shallow when the camera is close to the subject, so it is important to select and focus on the part of the scene you want to be sharp.

Above, a different photographer made many different choices. He chose color film, natural light, a more distant vantage point, more depth of field, and a vertical format. More important, he chose a different balance between form and content (see page 190), choosing to emphasize bold colors and strong graphics over a clear description of an event.

What's in the Picture

THE EDGES OR FRAME

One of the first choices to make with a photograph is what to include and what to leave out. The image frame, the rectangle you see when you look through the viewfinder, shows only a section of the much wider scene that is in front of you. The frame crops the scene—or, rather, you crop it—when you decide where to point the camera, how close to get to your subject, and from what angle to shoot.

Decide before you shoot whether you want to show the whole scene (or as much of it as you can) or whether you want to move in close (or zoom in with a zoom lens) for a detail. You can focus attention on something by framing it tightly or you can step back and have it be just another element in a larger scene.

Where is your subject positioned in the frame? We naturally look at the middle of things to get the clearest view, and most of us have a similar tendency to place a subject squarely in the middle of the frame. Usually it's better not to, although there are exceptions to this and to any other rule.

When you look through the viewfinder, imagine you are viewing the final print or slide. This will help you frame the subject better. The tendency is to "see" only the main subject and ignore its surroundings. In the final print, however, the surroundings and the framing are immediately noticeable.

You can also change framing later by cropping the edges of a picture when it is printed. Many photographs can be improved by cropping out distracting elements at the edges of the frame. But it is best to crop when you take the picture, especially with slide film. Although you can duplicate a slide and change its cropping then, it's easier to frame the scene the way you want it when you shoot.

How much of the subject should you include? What you put in the picture and what you leave out are among the most important decisions you have to make when photographing. Do you need to include the entire subject, or will a detail better represent your ideas?

Karl Baden

Terry E. Eiler. *Old Fiddler's Convention, Galax, Virginia, 1978.* **You can frame the central subject of a picture with other parts of the scene.** *Showing the instruments surrounding the fiddler at center, while cropping out most of the other musicians themselves, focuses attention on the fiddler.*

Project: THE CUTTING EDGE

PROCEDURE Expose a roll of film—or a few dozen digital pictures—using the edges of the picture, the frame, in various ways. As you look through the viewfinder, use the frame to surround and shape the image in different ways. Make a viewing aid by cutting a small rectangle in an 8 × 10-inch piece of black cardboard. It will be easier to move it around and look through than a camera and can help you visualize your choices.

Put the main subject off to one side or one corner of the frame. Can you balance the image so that the scene doesn't feel lopsided?

Put the horizon line at the very top or very bottom of a photograph, or try tilting it intentionally.

Have "nothing" at the center of the frame. Keep the viewer's interest directed toward the edges.

Make a portrait of someone without their head in the picture. Try to have the image express something of the subject's personality.

Have someone looking at or reaching for something outside the frame. Have them close to the side of the frame they are looking or reaching toward. Then have them far from that side, at the other side of the frame.

Photograph something in its entirety: a person, a shopfront, an animal, an overstuffed chair—whatever gets your attention. Move in a little closer. How will you use the frame to cut into the object? Do you crop the object evenly all around? More on one side than the other? Move in even closer. Closer. Photojournalist Robert Capa said, "If your pictures aren't good enough, you aren't close enough." Do you agree?

HOW DID YOU DO? What worked best? What wouldn't you ordinarily have done?

What's in the Picture

THE BACKGROUND

Seeing the background. When you view a scene, you see most sharply whatever you are looking at directly, and you see less clearly objects in the background or at the periphery of your vision. If you are concentrating on something of interest, you may not even notice other things nearby. But the camera's lens does see them, and it shows unselectively everything within its angle of view. Unwanted or distracting details can be ignored by the eye looking at a scene, but in a picture those details are much more conspicuous. To reduce the effect of a distracting background, you can shoot so that the background is out of focus or change your angle of view as shown in the photographs below. There is no rule that says you shouldn't have a distracting background; sometimes that can be exactly the point, as in the picture opposite. Just be aware of the different way the camera sees.

Where's the subject?
The clutter of objects in the background attracts the eye at least as much as do the man and bird in the foreground. If the picture is about the location, then the building can make a useful contribution. But if the photograph is supposed to be about the man and his bird, then the background seems an unnecessary element.

A less-intrusive background *resulted when the photographer simply moved to a lower vantage point and changed the angle from which she shot. The plain sky doesn't distract from the subject.*

Polly Brown

Lee Friedlander. New York City, 1974. **Make sure you look at the background of a scene** *as well as the main subject of interest. If you aren't paying attention, you may lose your subject entirely. Confusion of the background and foreground, however, may itself be the subject. Here, Friedlander uses* chiaroscuro, *as artists call patterns of light and dark, to suggest the intensity of life—even for a statue—*

in New York. The picture is visually chaotic and ambiguous, but intentionally so.

Remember that the camera records everything within its angle of view with equal importance, even if you are looking only at one subject. A photograph can render the relation between a foreground object and a background very differently than you perceive it.

Project: USING THE BACKGROUND

PROCEDURE Make photographs in which the background either complements or contrasts with the subject. For example, someone drinking coffee in front of a large ornate espresso maker; an arguing couple in front of a smiling-face poster; a child by a "Library Closed" sign; a shopkeeper standing in front of a store.

Look through the viewfinder (or a viewing aid, like the one described in the Project box on page 181) as you try different positions from which to photograph.

HOW DID YOU DO? Compare several of your most successful prints. Could the background be seen as clearly as the subject? What did the background contribute?

Depth of Field

WHICH PARTS ARE SHARP

When **you look at a scene** you actually focus your eyes on only one distance at a time; objects at all other distances are not as sharp. Your eyes automatically adjust their focus as you look from one object to another. If you were at the scene shown opposite, bottom, you might look at the wire rack and not notice you were seeing the sailors much less sharply. But in a photograph, differences in the sharpness of objects at different distances are immediately evident. Such differences can be distracting or they can add interest to the photograph, depending on how you use them.

Controlling the depth of field. In some photographs you have no choice about depth of field (the area from near to far within which all objects appear acceptably sharp). For example, in dim light or with slow film or under other conditions, the depth of field may have to be very shallow. But usually you can control the depth of field to some extent, as shown on pages 42–43. It is not necessarily better to have everything sharp or the background out of focus or to follow any other rules, but it is important to remember that in the photograph you will notice what is sharp and what isn't.

Eliot Porter. *Gravel and Mud, San Juan Canyon, Utah, 1962.* **Landscapes are often photographed so that everything is sharp** *from foreground to background. The entire image is more important than any single part of it. If you had been standing next to the camera when this picture was taken, each part of the scene would have looked sharp to you. Instead of simply enhancing the realism of the picture, this kind of all-over sharpness can also call attention to its two-dimensional graphic qualities. Porter hoped in vain that his photographs of scenic splendor in the Glen Canyon area of Arizona and Utah could stop the construction of a dam that eventually submerged everything he photographed under Lake Powell.*

Project:

USING DEPTH OF FIELD

PROCEDURE As you look at various subjects, try to anticipate how much depth of field you want, and how you can increase (or decrease) the depth of field to get more (or less) of the photograph to appear sharp. Page 41 shows how to use aperture size, focal length, and/or distance to do this.

Make several photographs of each scene, using depth of field in different ways. See for example, the landscape on page 43. You might have the entire scene sharp, as shown, or for the same scene, the boulders in front sharp and the background out of focus. How about just the mountains in the distance in focus? Is there some object you can call attention to using shallow depth of field that might be overlooked with everything in focus?

Keep notes of your aperture size, focal length, distance, and why you chose them, to remind you later what you did.

HOW DID YOU DO?

Compare your results. Were you able to get everything sharp when you wanted it that way? When you wanted something out of focus, was it out of focus enough? Now that you look at the prints, do you see anything you might try next time?

Elliott Erwitt. *Metropolitan Museum of Art, New York City, 1949.* **The illusion of depth** *is enhanced when the foreground is in sharp focus and the background becomes gradually softer. The gentle transition from near to middle distance to background in this photograph emphasizes its realism.*

Ray K. Metzker. *The Loop: Chicago, 1958.* **Here the background is out of focus**—*but the photographer wanted the out-of-focus figures to become the most important element. We naturally give more attention to what is in focus and what is close but there are always exceptions. This photograph pushes its subject toward the edge of recognizability. Even further toward that edge is the photograph on page 189, top. It reverses our expectations, putting the foreground out of focus and leaving the background sharp.*

Time and Motion in a Photograph

A photograph is a slice of time. Just as you select the section that you want to photograph out of a larger scene, you can also choose the section of time you want to record. You can think of a photograph as carving through time, taking a wide slice at a slow shutter speed or a narrow slice at a fast shutter speed. In that slice of time, things are moving, and, depending on the shutter speed, direction of the motion, and other factors discussed earlier (pages 18–19), you can show objects frozen in mid-movement, blurred until they are almost unrecognizable, or blurred to any extent in between.

Blur part of a picture for emphasis. If the subject moves a little during the exposure (or if by panning, you keep the subject still and move the background) you create visual interest with the comparison. Use a tripod to keep the background very sharp while your subject moves. Rarely is it effective to have the entire image blurred by motion, the way it would be if you used too slow a shutter speed or didn't hold the camera steadily. But even a photograph that is everywhere out of focus can be a visual treat; it is up to you to make it work.

Jim Stone. Country and Samm Running the Swings at the Puerto Rican Festival, Rochester, New York, 1985. **Control your shutter speed to suggest motion.** *A ¼-second shutter speed is enough for the spinning ride to blur while everything else—including the ride's operators—remains sharp. The blur reminds us how a photograph, by incorporating the element of time, differs from the other graphic arts.*

Project:

SHOWING MOTION

YOU WILL NEED

A tripod, when you want to keep the camera steady during long exposures.

PROCEDURE Make a series of photographs that depict motion in different ways. Select a scene that will let you photograph the same action several times, such as people moving on a crowded street, children on swings, or moving water or leaves. Or have someone perform the same action for you several times, such as a skateboarder, a runner, or a dancer.

How can you make a photograph that makes a viewer feel the subject is moving? Try showing the subject sharp. Try showing it blurred. Try panning the camera with the subject, so that the subject appears sharp against a blurred background. Page 19 shows some of the ways you can control the representation of motion.

Try photographing from a different angle, such as very low to the ground. If you move closer to your subject's feet or skateboard, or whatever is moving, you'll get more of a blur than if you stay farther away.

Keep notes of the shutter speed, distance, and relative subject speed so later you can reconstruct what you did.

HOW DID YOU DO?

What worked well? What didn't, but might have worked for another type of subject? Did some exposures produce too much blur? Did the subject disappear entirely in any frame?

Russell Lee. *Soda Jerk, Corpus Christi, Texas, 1939.* **Time is frozen by a flash.** *The rapid motion of the flying ice cream has been halted in midair by the quick burst of light from an on-camera flash. Stopping time this abruptly can be unflattering, for example by catching faces in between expressions, but it can also produce magical visions the eye could never have seen.*

Lou Jones. *Boston, 1998.* **Move the camera along with your subject to keep it in focus.** *Here, the photographer was positioned on the carnival ride itself so his relatively-long shutter speed held nearby passengers in focus but allowed the parts of the scene not moving with him to blur. Panning, or moving the camera during exposure to follow a moving subject, often makes your photograph appear this way: a subject in focus against a streaking background.*

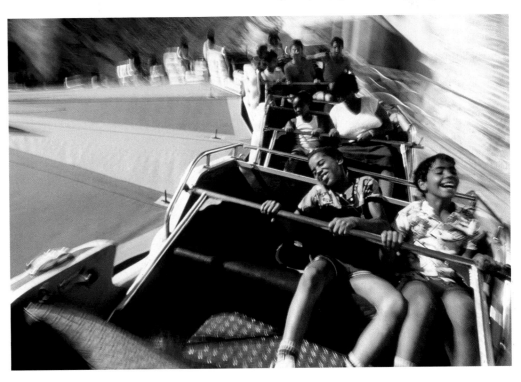

Depth in a Picture

THREE DIMENSIONS BECOME TWO

Photographs can seem to change the depth in a scene. When you photograph, you translate the three dimensions of a scene that has real depth into the two dimensions of a visual image. In doing so, you can expand space so objects seem very far apart or you can compress space so objects appear to be flattened and crowded close together. For example, compare these two photographs of buildings in a city. One shows us flat planes that look almost as if they were pasted one on top of the other and the other gives the scene volume and depth.

Your choices make a difference. The top photograph was made with a long-focal-length lens. Its narrow angle of view and close cropping, combined with the straight-on vantage point, helped the photographer reduce what we can see to a simple geometry. The bottom photo was made with a normal focal-length lens but from an elevated position. This wider angle of view includes more buildings, and more of the bottom and top of each building. There was probably a limited selection of possible vantage points, but this one was still carefully chosen. Pages 44–45 explain more about how to use your lens and position to control the way a photograph shows depth.

All of your choices affect the viewer's impression of your subject's depth, something the photograph itself—being two dimensional—doesn't have at all. Showing only part of an object or a narrow view of a scene, for example, may contribute to reducing a viewer's impression of volume in a photograph. This may be easy to do by choosing a longer-focal-length lens, but framing, focus, vantage point, and lighting are all important factors as well.

Every time you take a picture, the three dimensions of the real world are translated automatically into the two dimensions of a photograph. But, like taking control of automatic focus and automatic exposure, it is usually best to make your own decisions.

Dan McCoy. *Midtown Manhattan, 1973.*

Two perspectives of the city. *Buildings (top) seen from the side seem to lie on top of each other. A bird's-eye night view (bottom) gives the buildings volume. All your choices, especially focal lengh, lighting, vantage point, and focus, can contribute to enhancing or suppressing the sense of a third dimension in your photographs.*

Berenice Abbott. *New York at Night, 1934.*

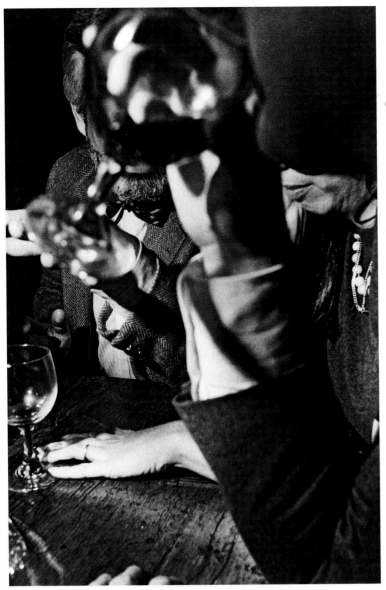

CHAOS BECOMES ORDER

Your choices of timing, vantage point, focus, and lens are a complex mix. You are *making* photographs, not just taking them, and must keep in mind that viewing them will be a different experience from seeing the world from which they were made. What kind of experience do you want to communicate?

Consider the two photographs on this page. The one below is carefully ordered and organized to create a mood of calm and serenity. We imagine the place—because of the way it is shown to us—to have a storybook quality that we can't credit to a simple choice of lens or depth of field. At left is a photograph so chaotic it is difficult at first to sort out. It is jangled and energetic, with no clear subject.

In both cases the photographer has imposed a personal sensibility on what was in front of the lens and so directed our experience in viewing them. The ability to create a unique sensibility, and to do so consistently, is often called *style*. Style takes time to develop, and it hinges on both an understanding of the available tools and a sense of what it is important to use them for.

Larry Fink. *Man Drinking, Alan Turner Party, 1982.* **The eye and brain hesitate** *when an image is too complex to be quickly deciphered. Creating that kind of hesitation is a goal of some photographers (see page 183).*

Pete Turner. *Ibiza Woman, 1961.* **You can simplify your subject** *with choices of where, when, and how to take the picture.*

Photographing
for Meaning

Good composition and technical quality are not the only goals you could keep in mind as you photograph. For some it is enough to make a competent, well-designed photograph of the subject of your choosing. In fact, many photographers make a good living doing just that. All photographs have both form—the way a picture looks, including its composition—and content—what a picture is about, including its subject. And there is a balance between form and content that the photographer can control. If you'd like an additional challenge, however, consider the way you can use form and content together to create meaning in a photograph.

Meaning can be reinforced, as in the photographs on these two pages, by arranging the way you represent your subject to be a comment on it. New meaning can be created using a metaphor based on appearance, like the pepper on this page and the supermarket opposite. To expand a picture's possibilities, think not only about what something looks like, but what else it looks like. Your pictures can be more than a reminder of your subject's existence.

Consider the physical qualities of your photograph. The slightly brown color of some enlarging papers is called *warm tone* because it imparts an emotional warmth to photographs printed on it. The wide panoramic shape of the landscape below suggests an endless horizon, a topography so vast it can't be contained in an ordinary rectangle. Scale changes the impact of an image: a tiny print often exudes intimacy; a very large one can project power. A thoughtful presentation of your work will make a big difference in its impact.

Edward Weston. Pepper #30, 1930. **Common shapes can be suggestive** *when photographically isolated. About this image Weston said "It is classic, completely satisfying—a pepper—but more than a pepper; abstract, in that it is completely outside subject matter."*

Warren Padula. Mouth, 1996. **Your subject can be a metaphor** for something else. Here, the dairy aisle in a supermarket becomes an open mouth in an amusing study of consumer culture. Made by using the bottom rack of a supermarket cart as a tripod to hold a home-made pinhole camera—a simple lensless box—it reminds us that the success or failure of a photograph is not the result of expensive equipment, but of the efforts and ability of the user.

Art Sinsabaugh. Midwest Landscape #24, 1961. **A photograph's shape can affect its meaning.** The extreme panoramic format used for this image was the photographer's response to the relentlessly horizontal and often featureless landscape of the American Midwest.

Portraits

INFORMAL: FINDING THEM

A good portrait shows more than merely what someone looks like. It captures an expression, reveals a mood, or tells something about a person. Props, clothing, or a view into the subject's environment are not essential, but they can help show what a person does or what kind of a person he or she is (see photographs at right on both pages).

Put your subject at ease. To do this, you have to be relaxed yourself, or at least look that way. You'll feel better if you are familiar with your equipment and how it works so you don't have to worry about how to set the exposure or make other adjustments.

Don't skimp on film with portraits. Taking three, four, or a dozen shots to warm up can get your subject past the nervousness that many people have at first when being photographed.

Try to use a fast enough shutter speed, $\frac{1}{60}$ sec. or faster, if possible, so you can shoot when your subject looks good, rather than your having to say, "Hold it," which is only likely to produce a wooden expression. Don't automatically ask your subject to smile, either. A quietly pleasant, relaxed expression looks better than a pasted-on big smile.

Lighting. See what it is doing to the subject. Soft, relatively diffused light is the easiest to use; it is kind to most faces and won't change much even if you change your position.

Side lighting, like in the photographs on these two pages, adds roundness and a three-dimensional modeling. The more to the side the main light is, particularly if it is not diffused, the more it emphasizes facial texture, including wrinkles and lines. That's fine for many subjects, but bad, for instance, for your Uncle Pete if he still wants to see himself as the young adult he used to be. Front lighting produces less modeling than does side lighting (see pages 134–135), but it minimizes minor imperfections. Three simple portrait lighting setups are shown on pages 138–139.

Judith Joy Ross. *Maria I. Leon, U. S. Army Reserve, On Red Alert, Gulf War, 1990.* **Soft light from the side** *highlights the strength and attentiveness of this off-duty soldier. The environment is out of focus so we are left only with the figure and pose to imagine her situation and the interaction with a photographer.*

Project:

A PORTRAIT

PROCEDURE There are at least as many different ways to make a portrait of someone as there are people in the world to photograph. Use at least one roll of film to photograph the same person in as many different ways as you can. Two or three rolls of the same person are even better. It may take a number of exposures before both you and your subject feel relaxed and comfortable. Here are some possibilities, but you can think up even more.

As a baseline, consider the conventional head-and-shoulders graduation-type portrait. Where can you go from there?

Try different sites and backgrounds, such as in a park, at home, at work. Does the background have to look pleasant? How about in front of a row of beat-up school lockers?

Try different angles: from above or below, as well as from eye level. Try moving in very close, so the camera exaggerates facial features. Does the person always have to be sitting or standing?

If the person feels relaxed enough or can role-play, have him or her express different emotions, such as anger, sadness, silly good humor.

Vary the lighting: front, side, top, bottom, back (see pages 134–135). In direct sun, by a window, in the shade (see pages 130–131).

Do you have to see their face? Can you make a revealing portrait from the back? As a silhouette?

You'll know you have shot enough when both you and your subject are worn out.

HOW DID YOU DO?

Which are your favorite photographs? Why? Which are your subject's favorites? Why? How did the background, props, or other elements contribute to the picture? What would someone who didn't know this person think about them, based simply on seeing the photographs?

August Sander. *Pastry Cook, Cologne, 1928.*
Having someone look into the camera lens *creates eye contact with the viewer of a portrait and often conveys a more intimate feeling than you get when* the person is looking away. Sander made this and thousands of similar portraits in the 1920s and 1930s in what he wanted to be a photographic index of the German population.

Portraits

FORMAL: SETTING THEM UP

Control more of the situation when you want your portraits to look a certain way. You may want your portrait to look spontaneous, like you just stumbled on your subject. A photograph can feel casual even if you've made an appointment in advance, asked your subject to wear your choice of clothes, or made them hold a given posture. Like the photographs on pages 192–193 show, there is a power in presenting someone in a believable setting.

Some portraits should look more formal. A political leader or business executive may want a photograph that suggests the traditions of a studio portrait, like the one on this page. A magazine may want someone photographed in a more flamboyant way, but one (like on the opposite page) that appears just as deliberate. These styles require an understanding of lighting (see Chapter 7) and are usually made in artificial illumination supplied by the photographer.

A model release protects you if you sell a photograph of someone for commercial use. It is a contract with your subject that gives you the right to sell or publish his or her image. You can find sample releases online with a simple Internet search. The ASMP (American Society of Media Photographers, asmp.org) provides them, along with other legal and business information, to its members.

Yousuf Karsh. *Sir Winston Churchill, 1941.* **The photographer was given only two minutes** *of this world leader's precious time. Lighting was arranged using a stand-in. Churchill arrived with his trademark cigar clenched in his teeth; Karsh instinctively reached out and removed it, capturing the angry and belligerent response that, for him, represented England's wartime defiance.*

Annie Leibovitz. *Steve Martin, 1981.* **Theatricality is appropriate for a subject who is an actor.** *Martin, an avid collector of contemporary art, affects a pose that* references the gestural style of a Franz Kline painting in his collection. The result clearly reflects a situation invented and staged purely to be photographed.

Photographing the Landscape

How do you photograph a place? There are as many different ways to view a scene as there are photographers. Most important for you: what do you want to remember? What is the best part of the place for you? Is it the landscape as a whole that is interesting or some particular part of it? How does a place speak to you?

Look at a scene from different angles, walking around to view it from different positions. Your location can profoundly affect the relation between foreground and background; the closer you are to an object, the more a slight change of position will alter its relationship to the background. Change your point of view and a subject may reveal itself in a new way.

Eric Rorer. *Flock of starlings near Bakersfield, California, 2002.* **A landscape can also be an event.** *A sort of alien invasion, a million or so starlings circle over a fallow field in central California. Not native to the Americas, these birds are a small portion of the millions of descendants of sixty starlings let loose in Central Park in 1890. The converging lines of the plowed furrows in the field draw your eye directly to the birds.*

196 **SEEING LIKE A CAMERA**

Stuart Rome. *Horsetail Falls, Oregon, 1996.*
**Landscapes are often sharp from foreground to
background.** *Depth of field increases with smaller
apertures, but you must compensate with longer
exposures. Here, the longer exposure allowed the motion
of the waterfall to blur into a soft, surreal presence—in
marked contrast to the hardness and sharpness of the
surrounding rock.*

*Rome photographed from inside a cave to frame the
waterfall in rock and show it against a background of
forest. Your location can profoundly affect the relation
between foreground and background; the closer you are to
an object, the more a slight change of position will alter its
relationship to the background.*

Barbara London. *Point Lobos, California, 1972.*
A landscape dosn't have to be a wide view.
*This photograph of dried mud taken from up close
and directly overhead is slightly disorienting. Not only
is the subject matter ambiguous, but it isn't clear
which way is up. The top of a picture usually identifies
the top of a scene because we are used to seeing
things—and photographing them—from an upright
position. Change your point of view and a subject may
reveal itself in a new way.*

Photographing the Cityscape

Who do you see the city? Is it a place of comfort or of chaos? Is it the people or the buildings that give it character? Whether you live in the city or you are just visiting, use the camera as your excuse to explore it.

Walking gives you time to photograph. Stop if you see something interesting; don't be in such a hurry that you can't pause to think about how best to frame your subject or wait for a moving presence to enter the scene. A passing pedestrian, dog, or city bus in transit may be just the graphic element to make your cityscape distinctive.

Return to a place when the light is best. The sun will illuminate a different side of a building in the morning than it does in the afternoon. Clouds or an overcast sky impart an entirely different emotional tone than a bright, sunny day.

Don't ignore the possibilities of photographing at night. A tripod will let you make long exposures, but be careful setting one up on a busy sidewalk.

The time of day affects more than just the light. Downtown streets look strangely deserted on Sunday mornings; rush hour is a great opportunity to capture human interaction.

Alfred Stieglitz. The Flatiron Building, New York, 1903.
***Choose your moment carefully.** Soft focus and winter weather combine for a peaceful, contemplative scene. Stieglitz asserted this photograph's role as an art object by emphasizing its picturesque qualities and printing it on an elegant, textured paper.*

Walker Evans. *Graveyard and Steel Mill, Bethlehem, Pennsylvania, 1935.* **Your vantage point creates relationships.** *Evans helps us see parallels here between the rhythmic appearance of apartment house windows, the gravestones, and the smokestacks in the background. All these elements seem purposefully convened before the foreground cross as though for a sermon.*

Photographing Inside

Interior spaces always present multiple challenges for the photographer, but overcoming them will be rewarding. Every indoor space has its own character and can imply meaning, much like a landscape. You may want to capture the personality of the space itself, as in the photograph on the opposite page, or you may use it—like below—to highlight your subject the way a stage set features actors. Interiors reflect the lives of people who live or work in them, and even of those who just pass through them. When photographs of people reveal something of the subjects' surroundings they can find resonance with a much wider audience than can a simple head-and-shoulders portrait.

Vantage points are limited indoors. Often there is an inconveniently-located wall that prevents you from backing up to fit everything into your picture. It is no wonder that architectural photographers, who are often asked to photograph interiors, carry wide angle lenses in several focal lengths. Even for the professional who is allowed to move the furniture, finding the right spot for the camera can be a challenge.

*Shelby Lee Adams. The Napiers' Living Room, 1989. **Bring your own light** if necessary. For his extended series on Appalachian families Adams carried a set of studio strobes to provide enough light for dark interiors like this one and to let him illuminate his subjects for the clarity and depth he wanted.*

Pay attention to the light. Most interior spaces are illuminated by several sources; there may be windows on more than one wall, and window light is often supplemented by artificial lighting during the day. Watch for unwanted shadows that may appear more bothersome in a photograph than in the scene itself, and be on the lookout for excessive contrast from strong side or top light. If you are working in color and can't control the lighting, you may see different color casts in different areas.

Almost invariably there is less light indoors than you'd find outdoors. Stay aware of depth of field; it is especially important to interior photography because you are often close to your subject. Remember that the closer you are to a subject, the less depth of field you'll get with any given focal length and aperture. If you need to close down the aperture to keep most of the space in focus, as did the photographers in the examples on these two pages, you may need a tripod, some extra light, or both.

Catherine Wagner. Defense Foreign Language Institute, Language Laboratory, Monterey, California, 1983. **This interior sits for its own portrait.** *In the series* American Classroom, *Wagner presents unpopulated spaces used for education to highlight our culture's love of order and the value we place on knowledge.*

Responding to Photographs

"It's good." "It's not so good." What else is there to say when you look at a photograph? What is there to see—and to say—when you respond to work in a photography class or workshop? Looking at other people's pictures helps you improve your own, especially if you take some time to examine an image, instead of merely glancing at it and moving on to the next one.

In addition to responding to other people's work, you need to be able to look at and evaluate your own. What did you see when you brought the camera to your eye? How well did what you had in mind translate into a picture? Would you do anything differently next time?

Following are some items to consider when you look at a photograph. You don't have to deal with each one every time, but they can give you a place to start.

Type of photograph. Portrait? Landscape? Advertising photograph? News photo? What do you think the photograph was intended to do or to mean? A caption or title can provide information, but look at the picture first so the caption does not limit your response.

Suppose the picture is a portrait. Is it one

Tom Young. Bicycles, 1995. **What do you respond to in a photograph?** *These bicycles suggest the presence of children. Do you wonder where they are or what they are doing? The foreground is dark but the houses in the distance are bright. Do you see hope in this picture or despair? The appearance of edge damage comes from the Polaroid negative used by the photographer, who chose not to crop it out. How does its presence change your feeling about the image?*

that might have been made at the request of the subject? One made for the personal expression of the photographer? Is the sitter simply a body or does he or she contribute some individuality? Does the environment surrounding the sitter add anything?

Emphasis. Is your eye drawn to some part of the picture? What leads your eye there? For example, is depth of field shallow, so that only the main subject is sharp and everything else out of focus?

Technical considerations. Do they help or hinder? For example, is contrast harsh and gritty? Is it suitable to the subject or not?

Emotional or physical impact. Does the picture make you feel sad, amused, peaceful? Does it make your eyes widen, your muscles tense? What elements might cause these reactions?

What else does the picture tell you besides what is immediately evident? Photographs often have more to say than may appear at first. For example, is a fashion photograph about the design of the clothes, or is it really about the roles of men and women in our culture?

Trust your own responses to a photograph. How do you actually respond to an image and what do you actually notice about it? What do you remember about it the next day?

Visual Elements

Following are some of the terms that can be used to describe the visual or graphic elements of a photograph. See the page cited for an illustration of a particular element.

Focus and Depth of Field
Sharp overall (pages 184, 190 bottom), *soft focus overall* (page 191 top)
Selective focus: One part sharp, others not (page 40). See also Shallow depth of field.
Shallow depth of field: Little distance between nearest and farthest sharp areas (pages 178, 185 bottom)
Extensive depth of field: Considerable distance between nearest and farthest sharp areas (pages 43, 196)

Motion
Frozen sharp even though subject was moving (pages 3, 42)
Blurred: Moving camera or subject blurred, part or all of the image (pages 187 bottom, 197 top)

Light
Front light: Light comes from camera position, shadows not prominent (page 138)
Back light: Light comes toward camera, front of subject is shaded (pages 77, 128)
Side light: Light comes from side, shadows cast to side (pages 2, 132)
Direct light: Hard-edged, often dark shadows (page 130)
Directional diffused light: Distinct, but soft-edged shadows (page 131 left)
Diffused light: No, or almost no, shadows (page 131 right)
Silhouette: Subject very dark against light background (pages 64, 71)
Glowing light: Subject glows with its own or reflected light (pages 73, 133 bottom)

Contrast and Tone
Full scale: Black, white, and many tones of gray (pages 100, 132)

High contrast: Very dark and very light tones, few gray tones (pages 82, 116)
Low contrast: Mostly gray tones (page 198)
High key: Mostly light tones (page 64)
Low key: Mostly dark tones (page 129)

Texture
Emphasized: Usually results from light striking subject from an angle (pages 132, 133 top)
Minimized: Usually results from light coming from camera position or from all sides (page 146)

Viewpoint and Framing
Eye-level viewpoint (pages 55, 186)
High (page 188 bottom), *low* (page 181), or *unusual* viewpoint (page 187 bottom)
Framing: The way the edges of the photograph meet the shapes in it (page 179)

Perspective
Compressed perspective (telephoto effect): Objects seem crowded together, closer than they really are (pages 33, 188 top)
Expanded perspective (wide-angle "distortion"): Parts of the scene seem stretched or positioned unusually far from each other (pages 34, 35 bottom)

Line
Curved (page 189 bottom)
Straight (page 190–191 bottom)
Horizontal (page 100)
Vertical (page 44 top)
Diagonal (pages 57, 196)
Position of horizon line (pages 196, 199)

Balance
An internal, physical response. Does the image feel balanced or does it tilt or feel heavier in one part than another?

How to Learn More

Further information on photography is readily available. Many books and magazines extend technical information; others reproduce great examples—both contemporary and historical—of practical and artistic photography. The bibliography on page 217 and a local library are good places to start.

Camera store personnel can answer questions about the products they sell. Additionally, the staff in most camera stores are often avid photographers themselves, and they may be eager to discuss photography—especially when the store is not crowded.

Advanced classes and workshops are offered almost everywhere, from guided photo tours to professional lighting seminars. Ask about them at a camera store, a local community college or university, or search the Internet (see below).

The Internet can answer almost any question you may have about photography. Like an immense library, the World Wide Web (the most widely used part of the Internet) gives you access to information, opinions, and images. On it you can search for prices and order books, supplies, and equipment. And you can show your own photographs to anyone with an Internet connection, worldwide.

Most universities and public libraries have computers that are always online, meaning they are connected to the Internet. Many cities have *Internet cafés* that charge a modest hourly fee for Internet access. Some coffeehouses and other businesses offer free wireless *(Wi-Fi)* connection to the Internet that you can use if you bring your own appropriately equipped portable laptop computer.

To connect from your home, you need a computer and a contract with an *Internet Service Provider* (or ISP). A local computer retail store can help answer questions, and numerous self-help books are available on the topic.

A Web browser is the software program your computer uses to reach the World Wide Web. Dominating the field are Mozilla Firefox, Apple Safari, and Microsoft Internet Explorer. They are free (but you need to use one to download another), and most computers are supplied with at least one already installed. Your Web browser lets you type in a location or address, called a *URL* (for Uniform Resource Locator), to reach a specific page on the Web. All URL Web addresses begin with *http://*. Most pages contain links that connect you directly to other related pages simply by clicking on them. Your browser lets you save any URL as a *bookmark* so you can easily return to it.

Use a search engine to find pages on a specific topic. Navigator, Safari, and Internet Explorer all have search engines already stored as bookmarks; three useful ones among many are Ask.com, Google, and Yahoo. Type keywords to locate your topic, using several to narrow the search. A recent search on the keyword *photography* turned up over 229 million sites. Narrowing the search to *photography museum* listed 29 million possibilities. Changing the search to *photography museum Rochester* reduces the number to a still-daunting one million entries, but the first on that list is probably the one you'd want—the home page for the George Eastman House.

Portal sites are very useful for many topics. A portal is a compilation of links to other sites of interest on the topic. Fortunately there are several good ones for photography, organizing links into areas of interest such as manufacturers, museums, schools, stores, and online galleries and discussion groups. A very complete portal comes from the Art Library at the University of New Mexico (go to *elibrary.unm. edu/subjects/photog.php* then click on *Additional Web Resources*). Another complete site is The Photography Portal (*www.thephotographyportal .com*). Other photography portals can be found with a general search for *photography portal*.

Product information is plentiful on the Web. Camera makers feature new products and provide listings of lenses and accessories. Film and paper manufacturers give you data sheets and processing information, like Ilford's shown here, as well as complete product listings.

Museums have sites on the Internet. This one is a catalog of landscape photography from an exhibition that was held at the Smithsonian American Art Museum. Information about individual artists is often presented along with images.

Photography organizations have galleries and libraries; many publish newsletters and books and—like this Syracuse, New York, artist's space above—sponsor artists in many ways. Find out about their programs from their Web sites.

Troubleshooting

F rom time to time, every photographer encounters negatives or prints that display unexpected problems. This section can help you identify the cause of some common problems—and how to prevent them in the future.

SOLVING CAMERA AND LENS PROBLEMS

LIGHT STREAKS. Image area flared or foggy looking overall (darkened in a negative, lightened in a print or slide), with film edges unaffected. The image may also show ghosting or geometric spots in the shape of the lens diaphragm.

Cause: The sun, a bright bulb, or other light source was within or close to the image, or bright light struck the lens at an angle.

Prevention: Expect some flare if you can see a light source in your viewfinder. The larger or brighter the light, the more flare you will get; distant or dim lights may not produce any flare at all. To prevent stray light from striking the lens, use the correct size lens shade for your lens focal length (see below right). Even with a lens shade, make sure the sun is not shining directly on your lens.

LIGHT STREAKS on film edges, as well as in image area.

Cause: The camera back was accidentally opened with film inside, light leaked into the film cassette, or light in the darkroom struck the film while it was being loaded or developed. Heat or age can fog film overall.

Prevention: Load and unload your camera in the shade, or at least block direct light with your body. Don't let bright light strike the film cassette or roll: put it back into its protective container or box until ready for development.

PICTURE NOT SHARP. Easier to see in an enlarged print, but may even be visible in the negative.

Cause: Too slow a shutter speed will blur a moving subject or blur the picture overall due to camera motion. Too wide an aperture will make the scene sharp where you focused it but not in front of or behind that part. An extremely dirty lens can sometimes reduce sharpness overall, especially when combined with lens flare.

Prevention: Use a faster shutter speed or smaller aperture, or support the camera more steadily. Keep fingerprints and dirt off the lens.

VIGNETTING. Image obscured at the corners (clear in a negative, dark in a print or slide).

Cause: A lens shade, filter, or both projected too far forward of the lens and partially blocked the image from reaching the lens.

Prevention: Lens shades are shaped to match different focal-length lenses (see right). Use the correct shade for your lens; too long a lens shade can cause vignetting, but one that is too shallow will not provide adequate protection from flare. Using more than one filter or a filter plus a lens shade can cause vignetting, especially with a short lens.

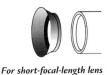

Lens shade for long-focal-length lens

For short-focal-length lens

SOLVING EXPOSURE PROBLEMS

If you are evaluating a color slide (or digital image), remember that it is the reverse of a negative. If your negative is too light or your slide is too dark, the problem is underexposure: too little light reached the film (or image sensor). If your negative is too dark or your slide is too light, the problem is overexposure—too much light on the film (or sensor).

NO PICTURE AT ALL. Image area and negative edges are clear, but film frame numbers are visible.

Cause: If the entire roll is blank, it was not put into the camera. If you are sure that it was, then it did not catch on the film advance sprockets and so did not move through the camera. If only a few frames are blank, the shutter was accidentally released with the lens cap on, the flash failed to fire, the shutter failed to open, or, in a single-lens reflex camera, the mirror failed to move up.

Prevention: To make sure film is advancing, check that the camera's rewind lever (if it has one) rotates when you advance the film. In an automated camera without a rewind lever, check that the frame-number counter advances. Have camera checked if film advance or other problems persist.

NEGATIVE THIN LOOKING, TOO LIGHT OVERALL. With a too-thin negative it is difficult to produce a print that is not too dark.

Cause: Most likely, the negative was underexposed: film speed set too high, shutter speed too fast, aperture too small, or all of the above, resulting in not enough light reaching the film. See Evaluating Your Negatives, page 96. Less likely, a film development problem; film received too little development. If your exposure was longer than 1 sec., reciprocity effect may have caused underexposure (see page 80). Occasionally exposure problems are caused by camera malfunction, such as the shutter or lens diaphragm not working correctly.

Prevention: The best prevention for occasional exposure problems is simply to meter scenes more carefully and to make sure you correctly set all camera controls. Bracket your exposures (one or two with more exposure, one or two with less exposure) if you are not sure of the camera settings.

If your negatives frequently look underexposed, including entire rolls, your meter is probably inaccurate: if your camera lets you adjust the film speed setting (not all cameras do), set it to a number lower than the film's stated speed. For example, with ISO 400 film, set the camera to half that rating, 200, to get one stop more exposure.

NO PICTURE AT ALL. Image area and negative edges are completely clear, no film frame numbers are visible.

Cause: A film development problem; nothing is wrong with the camera. The film was put into fixer before it reached the developer, or it was not developed at all.

Prevention: If you developed the film yourself, review film processing, page 90.

NEGATIVE DENSE LOOKING, TOO DARK OVERALL. With a too-dense negative it is difficult to produce a print that is not too light.

Cause: Most likely, the negative was overexposed: film speed set too low, shutter speed too slow, aperture too wide, or all of the above, resulting in too much light reaching the film. See Evaluating Your Negatives, page 96. Less likely, a film development problem: film received too much development.

Prevention: If your negatives frequently look overexposed, including entire rolls, and your camera lets you adjust the film speed setting, set the camera to a film speed number higher than the film's stated speed. For example, if you are using ISO 400 film, set the film speed to double that rating, 800, to get one stop less exposure.

SNOW SCENE (or other very bright scene) TOO DARK.

Negative appears thin; print or slide too dark.

Cause: The meter averaged all the tones in its angle of view, then computed an exposure for a middle-gray tone. The problem is that the scene was lighter than middle gray, so appears too dark.

Prevention: With scenes that are very light overall, such as in snow or on a sunlit beach, give one or two stops more exposure than the meter recommends. See page 76.

SUBJECT VERY DARK AGAINST LIGHTER BACKGROUND (or very light against dark background).

Cause: If the subject is too dark, your meter was overly influenced by a bright background and underexposed the image. The reverse can happen with a small light subject against a much larger, very dark background; the subject will be overexposed and too light.

Prevention: Don't make an overall reading when a subject is against a much lighter or much darker background. Instead, move in close to meter just the subject, then set your shutter speed and aperture accordingly (see pages 76–78).

DOUBLE EXPOSURES.

Cause: If images overlap on the entire roll, the film was put through the camera twice. If images overlap on one or a few frames, the film did not advance properly between exposures.

Prevention: Rewind 35mm film entirely back into the cassette, including the film leader; if you leave the film leader hanging out, you can mistake an exposed roll of film for an unexposed one and put it through the camera again. Accidentally pushing the film rewind button may let you release the shutter without advancing the film; check the way you grip the camera. If double exposures are a repeated problem, have the film advance mechanism checked.

SOLVING NEGATIVE DEVELOPMENT PROBLEMS

PATCHES OF UNDEVELOPED FILM (usually on more than one frame).

Cause: Two loops of film came in contact with each other during processing, either wound together onto the same loop of the developing reel or squeezed together after reeling. As a result, chemicals did not reach the film emulsion where it was touching. Most often the patches will be unprocessed and opaque (light in print). Less likely, but possible if the film comes unstuck during fixing, are clear patches on film (dark in print).

Prevention: Check the positioning of the film with a fingertip as you wind it onto the reel. If it feels wrong, unwind a few loops and start again (see steps 7 and 8a, page 89).

PARTIAL DEVELOPMENT. A strip along one edge of the entire roll of film is lighter than the rest of the film (darker in print).

Cause: Developer did not entirely cover reel of film.

Prevention: Check the amount of developer needed to cover the reel (or reels) in the developing tank or fill the tank to overflowing.

OVERDEVELOPMENT ON EDGES OF FILM. Streaks on the edge of the film are somewhat darker than the surrounding area (lighter in print). Streaks are coming from sprocket holes of 35mm film.

Cause: Excessive agitation in developer forced solution along spirals of developing reels, overdeveloping the edges of film.

Prevention: Do not agitate film in developer longer than the recommended amount or with excessive vigor (see step 12, page 90). If you develop one reel of film in a two-reel tank, put an empty reel on top so the loaded one doesn't bounce back and forth.

UNEVEN, STREAKY DEVELOPMENT, NOT JUST AT EDGES.

Cause: Too little agitation in developer let exhausted chemicals accumulate and slide across the surface of the film, retarding development in those areas.

Prevention: Agitate regularly, as directed.

CINCH MARKS.
Small dark marks (light in print), often with the crescent-moon shape and approximate size of a fingernail clipping.

Cause: Film was pinched or squeezed too tightly while it was being loaded onto the reel.

Prevention: Handle film gently during loading, without pinching or crumpling it, especially if you have to unreel and rereel it. Bow film only slightly to feed it onto the reel.

SPECKS, SCRATCHES, FINGERPRINTS.

Cause: Rough handling during processing. Dirt on squeegee or sponge. Dirt on the felt light-trap opening of the film cassette. Chemicals on fingers.

Prevention: Keep hands clean. Handle film gently, and only by the edges. Be particularly careful when emulsion is wet and more sensitive to surface damage. Hang film to dry in as dust free a place as possible, where it will not be jostled or moved around.

PINHOLES. TINY CLEAR SPECKS ON NEGATIVE (DARK IN PRINT).

Cause: Most likely caused by dust on film that keeps light from reaching the film during exposure. Less likely, but possibly due to dust on film keeping developer away from emulsion. Could be due to acetic acid stop bath solution being mixed too strong or undissolved particles in the fixer.

Prevention: Blow or brush dust out of the inside of the camera, and load film onto the developing reel on a dust-free surface. Check that you are mixing stop bath correctly: use a more diluted solution or just plain water instead. Filter any undissolved particles out of the fixer.

AIR BELLS.
Small, round, clear spots on negative (dark in print).

Cause: Small bubbles of air sticking to the surface of the film prevented developer from reaching the emulsion.

Prevention: At the start of the development period, rap tank sharply on a solid surface (step 11, page 90). Presoaking the film in plain water for about a minute with occasional agitation before development might help if you have persistent problems. Although presoaking is a common practice, Kodak warns that it may cause uneven development with some films.

CLOUDY LOOK OVERALL.

Cause: Probably due to inadequate fixing, but possibly caused by using old, light-struck, or X-rayed film.

Prevention: Refixing film in fresh fixer may help if due to inadequate fixing; rewash completely.

FAINT STREAKS ON THE SURFACE OF FILM.

Cause: Uneven drying or water splashed on film during drying. Using tap water in a hard-water area.

Prevention: After washing, immerse film in a wetting agent, such as Kodak Photo-Flo, then wipe film gently with photo sponge (steps 19–20, page 92). If you live in a hard-water area, dilute the Photo-Flo with distilled water instead of tap water. Don't let water from one roll of film drip onto another roll hanging to dry. Rewashing and redrying the film or cleaning it with a film cleaner may remove the marks.

RETICULATION.
Image appears crinkled, cracked, or patterned overall.

Cause: Extreme difference between temperatures of processing solutions; for example, taking film from very warm developer and putting it into very cold stop bath. Less extreme changes can cause an increase of graininess in the image.

Prevention: Keep all solutions, from developer to wash water, within a few degrees of each other.

SOLVING PRINTING PROBLEMS

ENTIRE PRINT OUT OF FOCUS, NEGATIVE IS SHARP.

Cause: Vibration of enlarger during exposure. Enlarger never focused properly. Buckling of negative during exposure due to heat from enlarger lamp can cause all or part of the print to go out of focus. If only one side of a print is out of focus, check the enlarger alignment.

Prevention: Avoid jostling the enlarger, its base, or the easel just before or during the exposure; push the timer button gently. Focus carefully. Avoid extremely long exposures.

UNEVEN, MOTTLED, OR MEALY APPEARANCE.

Cause: Too little time or not enough agitation in developer. Exhausted or contaminated developer.

Prevention: Develop prints with constant agitation in fresh developer for no less than the recommended time. Do not pull a print out of the developer early if it starts to look too dark; finish the development, look at it in the light, and make another test.

FOGGING (gray cast in highlights or paper margins).

Cause: Usually due to exposure of paper to unwanted light before fixing, such as from light leaking into darkroom from outside, light from safelight too strong or too close, paper stored in package that is not light-tight, turning on room light too soon after print is placed in fixer. May be caused by too much time in developer, by old paper, or by paper stored near heat.

Prevention: Check all the above.

YELLOWISH OR BROWNISH STAINS.

Cause: Processing faults of numerous kinds, such as too much time in developer, exhausted developer, exposing developing print to air by lifting it out of the developer for too long to look at it, delay in placing print in stop bath or fixer, exhausted stop bath or fixer, inadequate agitation in fixer, too little fixing, inadequate washing. Inadequate fixing also causes brownish-purple stains.

Prevention: Review and follow processing procedure, pages 106–108.

FINGERPRINTS (on print, not on film).

Cause: Touching paper with chemical-laden or greasy fingers. Fixer is the usual chemical culprit. Contaminated print tongs can make similar marks.

Prevention: Rinse and dry hands before handling film or paper, especially after handling fixer. Handle paper by edges. Don't let tongs touch more than one chemical.

WHITE SPECKS (on print, not on negative).

Cause: Most likely, dust on negative. Possibly, dust on printing paper during exposure. Larger, out-of-focus white spots may be dust on the enlarger's condenser lens.

Prevention: Blow or brush dust off negative and negative carrier before printing. Keep the enlarger area and darkroom as free of dust and dirt as possible.

DARK SPECKS OR SPOTS. See *Pinholes* and *Air bells*, opposite.

PRINTS FADE.

Cause: Prints that fade immediately were bleached by too much time in fixer or an overly strong fixer. Later fading is due to inadequate fixing or washing.

Prevention: Review and follow fixing and washing procedure, pages 107–108.

SOLVING FLASH PROBLEMS

ONLY PART OF SCENE EXPOSED.

Cause: Shooting at too fast a shutter speed with a camera that has a focal plane shutter, such as a single-lens reflex camera. The flash fired when the shutter was not fully open.

Prevention: Check manufacturer's instructions for the correct shutter speed to synchronize with flash, and set the shutter-speed dial accordingly. For most cameras, $1/60$ sec. is safe; faster speeds are usable with some cameras. The flash shutter speed may appear on your camera's shutter-speed dial in a different color from the other shutter speeds, or it may be marked with an X.

SOLVING FLASH PROBLEMS, continued

Flash pointed straight at reflective surface

Same scene shot at an angle

UNWANTED REFLECTION.

Cause: Light bouncing back from reflective surfaces such as glass, mirror, or shiny walls.

Prevention: Position the camera at an angle to highly reflective surfaces or aim the flash at the subject from off camera.

RED EYE. A person's or animal's eyes appear red or amber in a color picture, very light in a black-and-white picture (see page 142).

Cause: Light reflecting from the blood-rich retina inside the eye.

Prevention: Hold the flash away from the camera or have the subject look slightly to one side. Turning the subject's head slightly can also prevent bright reflections from eyeglasses.

ENTIRE SCENE TOO DARK OR ENTIRE SCENE TOO LIGHT.

Cause: Too dark—not enough light reached the film or digital image sensor. Too light—too much light reached the film or sensor. An occasional frame that is too dark or too light probably results from calculating the lens aperture based on the wrong ISO film speed or making an exposure before the flash is fully charged.

Prevention: If flash pictures are consistently too dark, try lowering the ISO setting on the flash unit's film-speed dial. Setting the dial to one-half the speed of the film you are using (or dividing the guide number by 1.4) will give one additional stop of exposure.

If pictures are consistently too light, try increasing the speed set on the ISO dial. Setting the dial to twice the film speed or multiplying the guide number by 1.4 will give one stop less exposure.

PART OF SCENE EXPOSED CORRECTLY, PART TOO LIGHT OR TOO DARK.

Cause: Objects in the scene were at different distances from the flash, so were exposed to different amounts of light.

Prevention: Try to group important parts of the scene at about the same distance from the flash (see page 142).

SOLVING COLOR PROBLEMS

GREENISH LOOK TO SCENE OVERALL.

Cause: Scene shot in fluorescent light, which emits disproportionate amounts of greenish light. See also Unexpected color cast, below.

Prevention: An FL filter on the lens will help (see page 61). Set the white balance of a digital camera to fluorescent (see page 11).

BLUISH OR REDDISH LOOK TO SCENE OVERALL.

Cause: Color film or a digital camera's settings not matched to the type of lighting on the scene. Tungsten film shot in daylight or with flash will give a bluish look to a scene. Daylight film shot in tungsten light will give a reddish look.

Prevention: For a more realistic color balance, use tungsten-balanced film for a scene lit by incandescent light bulbs. Use daylight-balanced film in daylight or with flash. Set the white balance of a digital camera to the type of lighting used (see page 11).

UNEXPECTED COLOR CAST.

Cause: Light reflected from a nearby colored object can give a color cast to the scene. The shade of a tree can add an unexpected look to skin tones because the light was filtered through colored leaves; here, orange fall leaves. Similarly, light bouncing off a strongly colored wall can tint the scene the color of the wall. The effect is most noticeable on skin tones or neutral tones like white or gray.

Prevention: With slides, try a color filter on the lens if color balance is critical. With a color print or a digital image, the color balance can be adjusted later.

SOLVING DIGITAL PROBLEMS

PIXELATION. Edges look stair-stepped. Details are indistinct.

Cause: Image resolution too low for the intended use.

Prevention: 72 dpi is ideal for display on a monitor, but printing from an ink-jet or dye-sublimation printer requires 200–300 dpi. If you scanned the image, rescan it at a higher dpi setting

If the image came from a digital camera, try Photoshop Image>Image Size to resample the image at a higher dpi. Next time you photograph, use a higher resolution.

SOFT IMAGE. Details in the image are not sharp.

Cause: Possibly, poor focus or camera movement (see Picture not sharp, page 205). Extreme file compression (JPEG, page 158). With a digital camera, quality level is too low. At low-quality settings (also called basic or good), the camera compresses the image file. When the image is reopened, details can be lost. The visible results may be negligible when prints are very small, but will be noticeable if they are enlarged.

Prevention: Try to anticipate the final size and reproduction method for your images. Pictures to be used only on the Web can be shot at low quality. Use the camera's highest quality setting if you might ever want to make 8 × 10-inch prints.

DIGITAL NOISE. Colored specks in dark areas.

Cause: Often occurs in shadow areas, in photos taken at night, or in low light with a long exposure.

Prevention: Try shooting at a lower ISO; instead of ISO 800 or 1600, try ISO 100 or 200. Try Photoshop Filter>Noise>Despeckle. This reduces the noise, although it softens the image somewhat.

BANDING. Unexpected bands in areas with no detail.

Cause: With a digital camera, scene may have been shot at too high an ISO.

Prevention: Try shooting the scene with a lower ISO. You might need to use a tripod and a slower shutter speed or add light from a flash or other light source. Sometimes the quality of the available light may be preferable to adding light, even if some banding occurs. In that case, use the higher ISO.

OVERSHARPENING. Details too crisp and contrasty that may show digital noise; colored fringes along edges.

Cause: Oversharpening the print while scanning or while working on the image in an image-editing program. See page 169.

Prevention: Rescan the print, transparency, or negative without sharpening it. With a digital camera image, return to the original digital file, if it has not been sharpened. When you resharpen the image, do so while viewing at 100% magnification.

Glossary

Aberration Optical defect in a lens (sometimes unavoidable) causing distortion or loss of sharpness in the final image.

Adapter ring A ring used to attach one camera item to another; for example, to attach a lens to a camera in reverse position in order to increase image sharpness when focusing very close to the subject.

Agitate To move a solution over the surface of film or paper during the development process so that fresh liquid comes into contact with the surface.

Angle of view The amount of a scene that can be recorded by a particular lens from a given position; determined by the focal length of the lens.

Aperture The lens opening formed by the iris diaphragm inside the lens. The size is variable and adjusted by the aperture control.

Aperture control The ring on the camera lens (a push button on some models) that, when turned, adjusts the size of the opening in the iris diaphragm and changes the amount of light that reaches the film.

Aperture-priority mode An automatic exposure system in which the photographer sets the aperture (f-stop) and the camera selects a shutter speed for normal exposure.

ASA A film speed rating similar to an ISO rating.

Automatic exposure A mode of camera operation in which the camera automatically adjusts either the aperture, the shutter speed, or both for normal exposure.

Automatic flash An electronic flash unit with a light-sensitive cell that determines the duration of the flash for normal exposure by measuring the light reflected back from the subject.

Auto winder See Motor drive unit.

Available light A general term implying relatively dim light that already exists where a photograph is to be made.

Averaging meter An exposure meter with a wide angle of view. The indicated exposure is based on an average of all the light values in the scene.

B See Bulb.

Base The supporting material that holds a photographic emulsion. For film, it is plastic or acetate. For prints, it is paper.

Bellows An accordion-like section inserted between the lens and the camera body. In close-up photography the bellows allows closer-than-normal focusing, resulting in a larger image.

Bleed mount To mount a print so there is no border between the edges of the print and the edges of the mounting surface.

Blotters Sheets of absorbent paper made expressly for photographic use. Wet prints dry when placed between blotters.

Body The light-tight box that contains the camera mechanisms and protects the film from light until you are ready to make an exposure.

Bounce light Indirect light produced by pointing the light source at a ceiling or other surface to reflect the light back toward the subject. Softer and less harsh than direct light.

Bracketing Taking several photographs of the same scene at different exposure settings, some greater than and some less than the setting indicated by the meter, to ensure a well-exposed photograph.

Built-in meter An exposure meter in the camera that takes a light reading (usually through the camera lens) and relays exposure information to the electronic controls in an automatic camera or to the photographer if the camera is being operated manually.

Bulb A shutter-speed setting (marked B) at which the shutter stays open as long as the shutter release is held down.

Burn in To darken a specific area of a print by giving it additional printing exposure.

Byte A unit of digital data used, for example, to measure the size of a computer file. See also Kilobyte, Megabyte.

Cable release An encased wire that attaches at one end to the shutter release on the camera and has a plunger on the other end that the photographer depresses to activate the shutter. Used to avoid camera movement or to activate the shutter from a distance.

Carrier A frame that holds a negative flat in an enlarger.

Cassette A light-tight metal or plastic container in which 35mm film is packaged.

Center-weighted meter A through-the-lens exposure meter that measures light values from the entire scene but gives greater emphasis to those in the center of the image area.

Changing bag A light-tight bag into which a photographer can insert his or her hands to handle film safely when a darkroom is not available.

Close-up A larger-than-normal image obtained by using a lens closer than normal to the subject.

Close-up lens A lens attached to the front of an ordinary lens to allow focusing at a shorter distance in order to increase image size.

Color balance 1. A film's response to the colors in a scene. Color films are balanced for use with specific light sources. 2. The reproduction of colors in a photograph.

Color temperature Description of the color of a light source. Measured on a scale of degrees Kelvin.

Compound lens A lens made up of several lens elements.

Condenser enlarger An enlarger that illuminates the negative with light that has been concentrated and directed by condenser lenses placed between the light source and the negative.

Contact printing The process of placing a negative in contact with sensitized material, usually paper, and then passing light through the negative onto the material. The resulting image is the same size as the image on the negative.

Contamination Traces of chemicals that are present where they don't belong, causing loss of chemical activity, staining, or other problems.

Contrast The difference between the light and dark parts of a scene or photograph.

Contrast grade The contrast that a printing paper produces. Systems of grading contrast are not uniform, but in general grades 0 and 1 have low or soft contrast; grades 2 and 3 have normal or medium contrast; grades 4 and 5 have high or hard contrast.

Contrasty Having greater-than-normal differences between light and dark areas. The opposite of flat.

Crop To trim the edges of an image, often to improve the composition. Cropping can be done by moving the camera position while viewing a scene, by adjusting the enlarger or easel during printing, or by trimming the finished print.

Darkroom A room where photographs are developed and printed, sufficiently dark to handle light-sensitive materials without causing unwanted exposure.

Daylight film Color film that has been balanced to produce natural-looking color when exposed in daylight.

Dense Describes a negative or an area of a negative in which a large amount of silver has been deposited. A dense negative transmits relatively little light. The opposite of thin.

Density The relative amount of silver present in various areas of film or paper after exposure and development. Therefore, the darkness of a photographic print or the light-stopping ability of a negative or transparency.

Depth of field The distance between the nearest and farthest points that appear in acceptably sharp focus in a photograph. Depth of field varies with lens aperture, focal length, and camera-to-subject distance.

Developer A chemical solution that changes the invisible latent image produced during exposure into a visible one.

Development 1. The entire process by which exposed film or paper is treated with various chemicals to make an image that is visible and permanent. 2. Specifically, the step in which film or paper is immersed in developer.

Diaphragm (iris diaphragm) The mechanism controlling the size of the lens opening and therefore the amount of light that reaches the film. It consists of overlapping metal leaves inside the lens that form a circular opening of variable sizes. (You can see it as you look into the front of the lens.) The size of the opening is referred to as the f-stop or aperture.

Dichroic head An enlarger head that contains yellow, magenta, and cyan filters that can be moved in calibrated stages into or out of the light beam to change the color balance of the enlarging light.

Diffused light Light that has been scattered by reflection or by passing through a translucent material. An even, often shadowless, light.

Diffusion enlarger An enlarger that illuminates the negative with light that has been diffused by passing it through a piece of translucent material above the negative.

Digital camera A camera that records an image directly in digital form, instead of on conventional silver film.

Digital imaging A means by which a photograph is recorded as a digital image that can be read and manipulated by a computer, and subsequently reformed as a visible image.

DIN A numerical rating used in Europe that indicates the speed of a film. The rating increases by three each time the sensitivity of the film doubles.

Diopter Unit of measurement that indicates the magnifying power of a close-up lens.

Directional/diffused light Light that is partly direct and partly scattered. Softer and less harsh than direct light.

Direct light Light shining directly on the subject and producing strong highlights and deep shadows.

Dodge To lighten an area of a print by shading it during part of the printing exposure.

Dry down To become very slightly darker and less contrasty, as most photographic printing papers do when they dry after processing.

Dry mount To attach a print to another surface, usually a heavier mat board, by placing a sheet of adhesive dry-mount tissue between the print and the mounting surface. Generally, this sandwich is placed in a heated mounting press to melt the adhesive in the tissue. Some tissues are pressure sensitive and do not need to be heated.

Easel A holder to keep sensitized material, normally paper, flat and in position on the baseboard of an enlarger during projection printing. It may have adjustable borders to frame the image to various sizes.

EI See Exposure index.

Electronic camera A camera that records an image by using electronic circuitry instead of film. See also Digital camera.

Electronic flash (strobe) A camera accessory that provides a brief but powerful flash of light. A battery-powered unit requires occasional recharging or battery replacement but, unlike a flashbulb, can be used repeatedly.

Emulsion A thin coating of gelatin, containing a light-sensitive material such as silver-halide crystals plus other chemicals, coated on film or paper to record an image.

Enlargement An image, usually a print, that is larger than the negative. Made by projecting an enlarged image of the negative onto sensitized paper.

Enlarger An optical instrument ordinarily used to project an image of a negative onto sensitized paper. More accurately called a projection printer because it can project an image that is either larger or smaller than the negative.

Environmental portrait A photograph in which the subject's surroundings are important to the portrait.

Etch To remove a small dark imperfection in a print or negative by scraping away part of the emulsion.

Exposure 1. The act of allowing light to strike a light-sensitive surface. 2. The amount of light reaching the film, controlled by the combination of aperture and shutter speed.

Exposure index A film speed rating similar to an ISO rating. Abbreviated EI.

Exposure meter (light meter) An instrument that measures the amount of light and provides aperture and shutter-speed combinations for correct exposure. Exposure meters may be built into the camera or they may be separate instruments.

Exposure mode The type of camera operation (such as manual, shutter-priority, aperture-priority) that determines which controls you set and which ones the camera sets automatically. Some cameras operate in only one mode. Others may be used in a variety of modes.

Extension tubes Metal rings attached between the camera lens and the body to allow closer-than-normal focusing in order to increase the image size.

Fast 1. Describes a film or paper that is very sensitive to light. 2. Describes a lens that opens to a very wide aperture. 3. Describes a short shutter speed. The opposite of slow.

Fiber-base paper Formerly the standard type of paper available; now being replaced to a certain extent by resin-coated papers.

File A quantity of data storage on a computer. Each photograph is saved as a single file.

Fill light A light source or reflector used to lighten shadow areas so that contrast is decreased.

Film A roll or sheet of a flexible material coated on one side with a light-sensitive emulsion and used in the camera to record an image.

Film advance lever A device, usually on the top of the camera, that winds the film forward a measured distance so an unexposed segment moves into place behind the shutter.

Film plane See Focal plane.

Film speed The relative sensitivity to light of photographic film. Measured by ISO (or ASA or DIN) rating. Faster film (higher number) is more sensitive to light and requires less exposure than slower film. See also Speed.

Filter 1. A piece of colored glass or plastic placed in a camera's or enlarger's light path to alter the quality of the light reaching the film. 2. To use a filter.

Filter factor A number, provided by the filter manufacturer, that tells you how much to increase exposure to compensate for the light absorbed by the filter.

Fisheye lens An extreme wide-angle lens covering a 180° angle of view. Straight lines appear curved at the edge of the photograph, and the image itself may be circular.

Fixer A chemical solution (sodium thiosulfate or ammonium thiosulfate) that makes a photographic image insensitive to light. It dissolves unexposed silver halide crystals while leaving the developed silver image. Also called hypo.

Flare Non-image-forming light that reaches the film, resulting in a loss of contrast or an overall grayness in the final image. Caused by stray light reflecting between the surfaces of the lens.

Flash 1. A short burst of light emitted by a flashbulb or electronic flash unit to illuminate the scene being photographed. 2. The equipment used to produce this light.

Flashbulb A battery-powered bulb that emits one bright flash of light and then must be replaced.

Flat Having less-than-normal differences between light and dark areas. The opposite of contrasty.

Focal length The distance from an internal part of a lens (the rear nodal plane) to the film plane when the lens is focused on infinity. The focal length is usually expressed in millimeters (mm) and determines the angle of view (how much of the scene can be included in the picture) and the size of objects in the image. A 100mm lens, for example, has a narrower angle of view and magnifies objects more than a lens of shorter focal length.

Focal plane The surface inside the camera on which a focused lens forms a sharp image.

Focal-plane shutter A camera mechanism that admits light to expose film by opening a slit just in front of the film (focal) plane.

Focus 1. The point at which the rays of light coming through the lens converge to form a sharp image. The picture is "in focus" or sharpest when this point coincides with the film plane. 2. To change the lens-to-film distance (or the camera-to-subject distance) until the image is sharp.

Focusing ring The band on the camera lens that, when turned, moves the lens in relation to the film plane, focusing the camera for specific distances.

Focusing screen See Viewing screen.

Fog An overall density in the photographic image caused by unintentional exposure to light, unwanted chemical activity, or excess heat or age.

Frame 1. A single image in a roll of film. 2. The edges of an image.

Fresnel An optical surface with concentric circular ridges. Used in a viewing screen to equalize the brightness of the image.

F-stop (f-number) A numerical designation (f/2, f/2.8, etc.) indicating the size of the aperture (lens opening).

Full-scale Describes a print having a wide range of tonal values from deep, rich black through many shades of gray to brilliant white.

Ghosting 1. A kind of flare caused by reflections between lens surfaces. It appears as bright spots the same shape as the aperture (lens opening). 2. A combined blurred and sharp image that occurs when flash is used with bright existing light. The flash creates a sharp image; the existing light adds a blurred image if the subject is moving.

Glossy Describes a printing paper with a great deal of surface sheen. The opposite of matte.

Graded-contrast paper A printing paper that produces a single level of contrast. To produce less or more contrast, a change has to be made to another grade of paper. See Variable-contrast paper.

Grain The particles of silver that make up a photographic image.

Grainy Describes an image that has a speckled look due to particles of silver clumping together.

Gray card A card that reflects a known percentage of light falling on it. Often has a gray side reflecting 18 percent and a white side reflecting 90 percent of the light. Used to take accurate exposure meter readings (meters base their exposures on a gray tone of 18 percent reflectance).

Ground glass 1. A piece of glass roughened on one side so that an image focused on it can be seen on the other side. 2. The viewing screen in a reflex or view camera.

Guide number A number rating for a flash unit that can be used to calculate the correct aperture for a particular film speed and flash-to-subject distance.

Handheld meter An exposure meter that is separate from the camera.

Hand-hold To support the camera with your hands rather than with a tripod or other fixed support.

Hard 1. Describes a scene, negative, or print of high contrast. 2. Describes a printing paper emulsion of high contrast such as grades 4 and 5.

High-contrast film Film that records light tones lighter and dark tones darker than normal, thereby increasing the difference between tones.

Highlight A very light area in a scene, print, or transparency; a very dense, dark area in a negative. Also called a high value.

Hot shoe A clip on the top of the camera that attaches a flash unit and provides an electrical link to synchronize the flash with the camera shutter, eliminating the need for a sync cord.

Hyperfocal distance The distance to the nearest object in focus when the lens is focused on infinity. Setting the lens to focus on this distance instead of on infinity will keep the farthest objects in focus as well as extend the depth of field to include objects closer to the camera.

Hypo A common name for any fixer; taken from the abbreviation for sodium hyposulfite, the previous name for sodium thiosulfate (the active ingredient in most fixers).

Hypo clearing bath A chemical solution used between fixing and washing film or paper. It shortens the washing time by converting residues from the fixer into forms more easily dissolved by water. Also called fixer remover or washing aid.

Incident-light meter A handheld exposure meter that measures the amount of light falling on the subject. See also Reflected-light meter.

Indoor film See Tungsten film.

Infinity Designated ∞ The farthest distance marked on the focusing ring of the lens, generally about 50 feet. When the camera is focused on infinity, all objects at that distance or farther away will be sharp.

Infrared film Film that is sensitive to wavelengths slightly longer than those in the visible spectrum as well as to some wavelengths within the visible spectrum.

Interchangeable lens A lens that can be removed from the camera and replaced by another lens.

Iris diaphragm See Diaphragm.

ISO A numerical rating that indicates the speed of a film. The rating doubles each time the sensitivity of the film doubles.

JPEG A format for saving digital photographs (see File) that compresses data to preserve space in the computer's memory.

Kilobyte Approximately one thousand bytes. A measure of computer file size. Abbreviated K or KB.

Latent image An image formed by the changes to the silver halide grains in photographic emulsion upon exposure to light. The image is not visible until chemical development takes place.

Latitude The amount of over- or underexposure possible without a significant change in the quality of the image.

Leaf shutter A camera mechanism that admits light to expose film by opening and shutting a circle of overlapping metal leaves.

LED See Light-emitting diode.

Lens One or more pieces of optical glass used to gather and focus light rays to form an image.

Lens cleaning fluid A liquid made for cleaning lenses.

Lens coating A thin transparent coating on the surface of the lens that reduces light reflections.

Lens element A single piece of optical glass that acts as a lens or as part of a lens.

Lens hood (lens shade) A shield that fits around the lens to prevent unwanted light from entering the lens and causing flare.

Lens tissue A soft lint-free tissue made specifically for cleaning camera lenses. Not the same as eyeglass cleaning tissue.

Light-emitting diode (LED) A display in the viewfinder of some cameras that gives you information about aperture and shutter-speed settings or other exposure data.

Light meter See Exposure meter.

Long-focal-length lens A lens that provides a narrow angle of view of a scene, including less of a scene than a lens of normal focal length and therefore magnifying objects in the image. Often called telephoto lens.

Macro lens A lens specifically designed for close-up photography and capable of good optical performance when used very close to a subject.

Macro-photography Production of images on film that are life size or larger.

Macro-zoom lens A lens that has close-focusing capability plus variable focal length.

Magnification The size of an object as it appears in an image. Magnification of an image on film is determined by the lens focal length. A long-focal-length lens makes an object appear larger (provides greater magnification) than a short-focal-length lens.

Main light The primary source of illumination, casting the dominant shadows.

Manual exposure A nonautomatic mode of camera operation in which the photographer sets both the aperture and the shutter speed.

Manual flash A nonautomatic mode of flash operation in which the photographer controls the exposure by adjusting the size of the camera's lens aperture.

Mat A cardboard rectangle with an opening cut in it that is placed over a print to frame it. Also called an overmat.

Mat cutter A short knife blade (usually replaceable) set in a large easy-to-hold handle. Used for cutting cardboard mounts for prints.

Matte Describes a printing paper with a relatively dull, nonreflective surface. The opposite of glossy.

Megabyte Approximately one million bytes. A measure of computer file size. Abbreviated M or MB.

Metadata Information about information. In digital photography, the camera, exposure, and subject data stored in the image file.

Meter 1. See Exposure meter. 2. To take a light reading with a meter.

Middle gray A standard average gray tone of 18 percent reflectance. See Gray card.

Midtone An area of medium brightness, neither a very dark shadow nor a very bright highlight. A medium gray tone in a print.

Mirror A polished metallic reflector set inside the camera body at a 45° angle to the lens to reflect the image up onto the focusing screen. When a picture is taken, the mirror moves out of the way so that light can reach the film.

Motor drive unit (auto winder) A camera device that automatically advances the film once it has been exposed.

Mottle A mealy gray area of uneven development in a print or negative. Usually caused by too little agitation or too short a time in the developer.

Negative 1. An image with colors or dark and light tones that are the opposite of those in the original scene. 2. Film that was exposed in the camera and processed to form a negative image.

Negative film Photographic film that produces a negative image upon exposure and development.

Neutral-density filter A piece of dark glass or plastic placed in front of the camera lens to decrease the intensity of light entering the lens. It affects exposure but not color.

Noise Pixels of random colors and brightnesses, most often appearing in the dark areas of a digital image.

Normal-focal-length lens (standard lens) A lens that provides about the same angle of view of a scene as the human eye.

One-shot developer A developer used once and then discarded.

Open up To increase the size of the lens aperture. The opposite of stop down.

Orthochromatic film Film that is sensitive to blue and green light but not red light.

Overdevelop To give more than the normal amount of development.

Overexpose To expose film or paper to too much light. Overexposing film produces a negative that is too dark (dense) or a transparency that is too light. Overexposing paper produces a print that is too dark.

Oxidation Loss of chemical activity due to contact with oxygen in the air.

Pan To move the camera during the exposure in the same direction as a moving subject. The effect is that the subject stays relatively sharp and the background becomes blurred.

Panchromatic film Film that is sensitive to all the wavelengths of the visible spectrum.

Parallax The difference in point of view that occurs when the lens (or other device) through which the eye views a scene is separate from the lens that exposes the film.

Pentaprism A five-sided optical device used in an eye-level viewfinder to correct the image from the focusing screen so that it appears right side up and correct left to right.

Perspective The optical illusion in a two-dimensional image of a three-dimensional space suggested primarily by converging lines and the decrease in size of objects farther from the camera.

Photoflood A tungsten lamp designed especially for use in photographic studios. It emits light at 3400 K color temperature.

Photo-micrography Photographing through a microscope.

Pinhole A small clear spot on a negative usually caused by dust on the film during exposure or development.

Pixel Short for picture element. The smallest unit of a digital image that can be displayed or changed.

Plane of critical focus The part of a scene that is most sharply focused.

Polarizing screen (polarizing filter) A filter placed in front of the camera lens to reduce reflections from nonmetallic surfaces like glass or water.

Positive An image with colors or light and dark tones that are similar to those in the original scene.

Print 1. An image (usually a positive one) on photographic paper, made from a negative or a transparency. 2. To produce such an image.

Printing frame A holder designed to keep sensitized material, usually paper, in full contact with a negative during contact printing.

Programmed automatic A mode of automatic exposure in which the camera sets both the shutter speed and the aperture for a normal exposure.

Proof A test print made for the purpose of evaluating density, contrast, color balance, subject composition, and the like.

Push To expose film at a higher film speed rating than normal, then to compensate in part for the resulting underexposure by giving greater development than normal. This permits shooting at a dimmer light level, a faster shutter speed, or a smaller aperture than would otherwise be possible.

Quartz lamp An incandescent lamp that has high intensity, small size, long life, and constant color temperature.

Raw file A digital camera file that contains picture information exactly as it is captured. Most Raw file formats are proprietary, or specific to the camera manufacturer, and must be interpreted before editing.

RC paper See Resin-coated paper.

Reciprocity effect (reciprocity failure) A shift in the color balance or the darkness of an image caused by very long or very short exposures.

Reducing agent The active ingredient in a developer. It changes exposed silver halide crystals into dark metallic silver. Also called the developing agent.

Reel A metal or plastic reel with spiral grooves into which roll film is loaded for development.

Reflected-light meter An exposure meter (hand held or built into the camera) that reads the amount of light reflected from the subject. See also Incident-light meter.

Reflector Any surface—a ceiling, a card, an umbrella, for example—used to bounce light onto a subject.

Reflex camera A camera with a built-in mirror that reflects the scene being photographed onto a ground-glass viewing screen. See Single-lens reflex, Twin-lens reflex.

Replenisher A substance added to some types of developers after use to replace exhausted chemicals so that the developer can be used again.

Resin-coated paper Printing paper with a water-resistant coating that absorbs less moisture than a fiber-base paper, consequently reducing some processing times. Abbreviated RC paper.

Reticulation A crinkling of the gelatin emulsion on film that can be caused by extreme temperature changes during processing.

Reversal film Photographic film that produces a positive image (a transparency) upon exposure and development.

Reversal processing A procedure for producing a positive image on film (a transparency) from the film exposed in the camera or a positive print from a transparency with no negative involved.

Rewind crank A device, usually on the top of the camera, for winding film back into a cassette once it has been exposed.

Roll film Film (2¼ in. wide) that comes in a roll, protected from light by a length of paper wound around it. Loosely applies to any film packaged in a roll rather than in flat sheets.

Safelight A light used in the darkroom during printing to provide general illumination without giving unwanted exposure.

Scanner A device that optically reads a conventional negative, slide, or print, converting it to digital form for use in digital imaging.

Sharp Describes an image or part of an image that shows crisp, precise texture and detail. The opposite of blurred or soft.

Shoe A clip on a camera for attaching a flash unit. See also Hot shoe.

Short-focal-length lens (wide-angle lens) A lens that provides a wide angle of view of a scene, including more of the subject area than a lens of normal focal length.

Shutter A device in the camera that opens and closes to expose the film to light for a measured length of time.

Shutter-priority mode An automatic exposure system in which the photographer sets the shutter speed and the camera selects the aperture (f-stop) for normal exposure.

Shutter release The mechanism, usually a button on the top of the camera, that activates the shutter to expose the film.

Shutter-speed control The camera control that selects the length of time the film is exposed to light.

Silhouette A dark shape with little or no detail appearing against a light background.

Silver halide The light-sensitive part of a photographic emulsion, including the compounds silver chloride, silver bromide, and silver iodide.

Single-lens reflex (SLR) A type of camera with one lens that is used both for viewing and for taking the picture. A mirror inside the camera reflects the image up into the viewfinder. When the picture is taken, this mirror moves out of the way, allowing the light entering the lens to travel directly to the film.

Slide See Transparency.

Slow See Fast.

SLR See Single-lens reflex.

Sodium thiosulfate The active ingredient in most fixers.

Soft 1. Describes an image that is blurred or out of focus. The opposite of sharp. 2. Describes a scene, negative, or print of low contrast. The opposite of hard or high contrast. 3. Describes a printing paper emulsion of low contrast, such as grade 0 or 1.

Software A computer program designed to perform a specific purpose or task, for example image editing or word processing.

Spectrum The range of radiant energy from extremely short wavelengths to extremely long ones. The visible spectrum includes only the wavelengths to which the human eye is sensitive.

Speed 1. The relative ability of a lens to transmit light. Measured by the largest aperture at which the lens can be used. A fast lens has a larger maximum aperture and can transmit more light than a slow one. 2. The relative sensitivity to light of photographic film. See Film speed.

Spot To remove small imperfections in a print caused by dust specks, small scratches, or the like. Specifically, to paint a dye over small white blemishes.

Spot meter An exposure meter with a narrow angle of view, used to measure the amount of light from a small portion of the scene being photographed.

Stock solution A concentrated chemical solution that must be diluted before use.

Stop 1. An aperture setting that indicates the size of the lens opening. 2. A change in exposure by a factor of 2. Changing the aperture from one setting to the next doubles or halves the amount of light reaching the film. Changing the shutter speed from one setting to the next does the same thing. Either changes the exposure one stop.

Stop bath An acid solution used between the developer and the fixer to stop the action of the developer and to preserve the effectiveness of the fixer. Generally a dilute solution of acetic acid; plain water is sometimes used instead of a stop bath for film.

Stop down To decrease the size of the lens aperture. The opposite of open up.

Strobe See Electronic flash.

Substitution reading An exposure meter reading taken from something other than the subject, such as a gray card or the photographer's hand.

Sync (or synchronization) cord A wire that links a flash unit to a camera's shutter-release mechanism.

Synchronize To cause a flash unit to fire while the camera shutter is open.

Tacking iron A small electrically heated tool used to melt the adhesive in dry-mount tissue, attaching it partially to the back of the print and to the mounting surface. This keeps the print in place during the mounting procedure.

Telephoto effect A change in perspective caused by using a long-focal-length lens very far from all parts of a scene. Objects appear closer together than they really are.

Telephoto lens See Long-focal-length lens.

Thin Describes a negative or an area of a negative where relatively little silver has been deposited. A thin negative transmits a large amount of light. The opposite of dense.

Through-the-lens meter (TTL meter) An exposure meter built into the camera that takes light readings through the lens.

TIFF A format for saving digital photographs (see File) that is readable by most graphic software running on most computers.

Transparency (slide) A positive image on a clear film base viewed by passing light through from behind with a projector or light box. Usually in color.

Tripod A three-legged support for the camera.

TTL Abbreviation for through the lens, as in through-the-lens viewing or metering.

Tungsten film Color film that has been balanced to produce colors that look natural when exposed in light from an incandescent bulb, specifically light of 3200 K color temperature.

Twin-lens reflex A camera in which two lenses are mounted above one another. The bottom (taking) lens forms an image to expose the film. The top (viewing) lens forms an image that reflects upward onto a ground-glass viewing screen. Abbreviated TLR.

Umbrella reflector An apparatus constructed like a parasol with a reflective surface on the inside. Used to bounce diffused light onto a subject.

Underdevelop To give less development than normal.

Underexpose To expose film or paper to too little light. Underexposing film produces a negative that is too light (thin) or a transparency that is too dark. Underexposing paper produces a print that is too light.

Variable-contrast paper A printing paper in which varying grades of print contrast can be obtained by changing the color of the enlarging light source, as by the use of filters. See Graded-contrast paper.

View camera A camera in which the taking lens forms an image directly on a ground-glass viewing screen. A film holder is inserted in front of the viewing screen before exposure. The front and back of the camera can be set at various angles to change the plane of focus and the perspective.

Viewfinder eyepiece An opening in the camera through which the photographer can see the scene to be photographed.

Viewing screen The surface on which the image in the camera appears for viewing. This image appears upside down and reversed left to right unless the camera contains a pentaprism to correct it.

Vignette To shade the edges of an image so they are underexposed. A lens hood that is too long for the lens will cut into the angle of view and cause vignetting.

Visible spectrum See Spectrum.

Washing aid See Hypo clearing bath.

Wetting agent A chemical solution, such as Kodak Photo-Flo, used after washing film. By reducing the surface tension of the water remaining on the film, it speeds drying and prevents water spots.

Wide-angle distortion A change in perspective caused by using a wide-angle (short-focal-length) lens very close to a subject. Objects appear stretched out or farther apart than they really are.

Wide-angle lens See Short-focal-length lens.

Working solution A chemical solution diluted to the correct strength for use.

Zone focusing Presetting the focus to photograph action so that the entire area in which the action may take place will be sharp.

Zoom lens A lens with several moving elements that can be used to produce a continuous range of focal lengths.

Photo Credits

Bibliography

A vast number of books on photography are available, whether your interest is in its technique or its history, its use for art or for commerce. Look for them in your local library, bookstore, or camera store.

If you want a broader selection of books than you can find locally, try Photo-Eye, 376 Garcia Street, Santa Fe, NM 87501 (505-988-5152). This photo-only bookstore has an immense selection of new and used photo books sold by mail and through its online bookstore, *photoeye.com*. Printed catalogs are also available.

Light Impressions, P. O. Box 787, Brea, CA 92822 (800-828-6216) is an excellent source of photographic storage, preservation, and display materials, as well as publications. Catalogs are free. You can buy online at *lightimpressionsdirect.com*.

Kodak and Silver Pixel Press sell a range of books on photographic technique. A catalog is online at *sterlingpublishing.com*.

Technical References

Adobe Creative Team. *Adobe Photoshop CS3 Classroom in a Book.* Berkeley: Adobe Press, 2007. Includes a CD-ROM containing tutorial images. A good way to learn the basics of the most popular image-editing software.

Ciaglia, Joseph. *Digital Photography,* 2nd ed. Upper Saddle River, NJ: Prentice Hall, 2005. Extensive information, clearly written.

Hirsch, Robert. *Exploring Color Photography, From the Darkroom to the Digital Studio,* 4th ed. New York: McGraw-Hill, 2005. Profusely illustrated, detailed compendium of color processes and techniques.

Horenstein, Henry. *Beyond Basic Photography: A Technical Manual,* rev. ed. Boston: Little, Brown, 1997. An excellent next step, in black and white, after learning the basics.

Kobré, Kenneth. *Photojournalism: The Professionals' Approach,* 5th ed. Newton, MA: Focal Press, 2004. Complete coverage of equipment, techniques, and approaches used by photojournalists.

London, Barbara, John Upton, Jim Stone. *Photography,* 9th ed. Upper Saddle River, NJ: Prentice Hall, 2008. Widely used as a text. Very comprehensive.

Schaefer, John P. *The Ansel Adams Guide: Basic Techniques of Photography.* Boston: Little, Brown, 1999. The master's techniques, updated.

Stone, Jim, ed. *Darkroom Dynamics: A Guide to Creative Darkroom Techniques.* Newton, MA: Focal Press, 1985. Illustrated instructions on how to expand your imagery with multiple printing, toning, hand coloring, high contrast, and other techniques.

History of Photography, Collections

Frizot, Michael, ed. *A New History of Photography.* Köln, Germany: Könemann, 1999. Massive, beautifully produced, thorough, and relatively inexpensive.

Hirsch, Robert J. *Seizing the Light: A History of Photography.* New York: McGraw-Hill, 1999. Thorough and contemporary survey of the medium's history.

Rosenblum, Naomi. *A World History of Photography,* 4th ed. New York: Abbeville, 2007. Comprehensive and profusely illustrated.

Szarkowski, John. *Looking at Photographs: 100 Pictures from the Collection of the Museum of Modern Art.* Boston: Bulfinch, 1999. Eloquent and concise essays from the medium's most influential curator.

Periodicals

American Photo, 1633 Broadway, New York, NY 10019. Photography in all its forms, including the fashionable and the famous. (*popphoto.com/americanphoto*)

Aperture, 20 East 23rd Street, New York, NY 10011. A superbly printed magazine dealing with photography as an art form. Published at irregular intervals. (*aperture.org*)

DoubleTake, Online contact only. Emphasis on documentary work, including photography. (*doubletakecommunity.org*)

Photo District News, 770 Broadway, New York, NY 10003. Directed toward professionals, particularly in stock and advertising photography. (*pdnonline.com*)

The Photo Review, 140 East Richardson Avenue, Suite 301, Langhorne, PA 19047. Fine-art photography exhibition and book reviews with portfolios. (*photoreview.org*)

The Rangefinder, 1312 Lincoln Boulevard, Santa Monica, CA 90406. Oriented toward professionals in portraiture. (*rangefindermag.com*)

Popular Photography, 1633 Broadway, New York, NY 10019. A magazine for hobbyists that mixes information about equipment with portfolios and how-to articles. (*popphoto.com*)

Shutterbug, 1419 Chaffee Drive, Suite #1, Titusville, FL 32780. A classified ad magazine for new, used, and vintage camera equipment. (*shutterbug.net*)

Photographic Organizations

Most of these nonprofit membership organizations publish magazines and newsletters. If you live near one, you may also wish to join for their sponsored workshops, lectures, or exhibitions.

Center for Photography at Woodstock, 59 Tinker Street, Woodstock, NY 12498. Publishes *Photography Quarterly.* (*cpw.org*)

CEPA Gallery, 617 Main Street, Buffalo, NY 14202. Their occasional magazine is *CEPA Journal.* (*cepagallery.com*)

George Eastman House, 900 East Avenue, Rochester, NY 14607. A museum of photography and cameras, as well as the restored mansion and gardens of Kodak's founder. Publishes *Image.* (*eastmanhouse.org*)

Houston Center for Photography, 1441 West Alabama, Houston, TX 77006. Publishes *Spot.* (*hcponline.org*)

The Light Factory, 345 N. College Street, Charlotte, NC 28202. (*lightfactory.org*)

Light Work, 316 Waverly Avenue, Syracuse, NY 13244. Sponsors artist's residencies, publishes *Contact Sheet* and several elegant exhibition catalogs each year. (*lightwork.org*)

National Press Photographers Association, 3200 Croasdaile Drive, Suite 306, Durham, NC 27705. An organization of working and student photojournalists; publishes the monthly *News Photographer.* (*nppa.org*)

Photographic Resource Center, 832 Commonwealth Avenue, Boston, MA 02215. Publishes *Views: The New England Journal of Photography.* (*bu.edu/prc*)

San Francisco Camerawork, 1246 Folsom Street, San Francisco, CA 94103. Publishes *Camerawork: A Journal of Photographic Arts.* (*sfcamerawork.org*)

Society for Photographic Education, 2530 Superior Avenue, #403, Cleveland, OH 44114. An organization centered around the teaching and practice of photography as a fine art. Publishes *Exposure.* (*spenational.org*)

Visual Studies Workshop, 31 Prince Street, Rochester, NY 14607. Incorporates a degree-granting school with workshops, gallery, and artist's book studio. Publishes *Afterimage.* (*vsw.org*)

Space constrains this list of organizations and periodicals to those in the United States. Many other countries have organizations and publications devoted to photography, which can be found online, through a public library, or by contacting the nonprofits listed here.

Index